A Guide to Chicago's Murals

A GUIDE TO Chicago's Murals

Mary Lackritz Gray

The University of Chicago Press
Chicago and London

MARY LACKRITZ GRAY, a native of Chicago, has lectured and published on Chicago's public art for many years. She is the coauthor of *A Guide to Chicago's Public Sculpture.*

The University of Chicago Press, Chicago 60637
The University of Chicago Press, Ltd., London
©2001 by The University of Chicago
All rights reserved. Published 2001
Printed in Hong Kong

10 09 08 07 06 05 04 03 02 01 1 2 3 4 5
ISBN: 0-226-30596-1 (CLOTH)
ISBN: 0-226-30599-6 (PAPER)

Library of Congress Cataloging-in-Publication Data
Gray, Mary L. (Mary Lackritz)
 A guide to Chicago's murals / Mary Lackritz Gray.
 p. cm.
 Includes bibliographical references and index.
 ISBN 0-226-30596-1 (alk. paper)—ISBN 0-226-30599-6 (paper: alk. paper)
 1. Mural painting and decoration, American—Illinois—Chicago—
Guidebooks. 2. Mural painting and decoration—20th century—
Illinois—Chicago—Guidebooks. 3. Street art—Illinois—Chicago—
Guidebooks. 4. Chicago (Ill.)—Guidebooks. I. Title.
ND2638.C4 G73 2001
751.7'3'0977311—dc21 00-041167

Contents

Illustrations

Maps

Foreword

In view of the ample literature thus far published on the visual arts in Chicago, it is curious that so little has dealt with the subject of this book. The city's art museums have been exhaustively chronicled, its architecture has been even more celebrated, and in recent generations serious attention has been paid to the painting and sculpture produced by Chicago artists. In sharp contrast is the paucity of information about the murals that have been created in and around Chicago for more than a century. The comprehensiveness of Mary Gray's research goes a long way to compensate for the lack of record; still, in a sense the richness of her findings only adds to the question of why so little local or national interest has been shown toward a genre that in its local aspect, as she convincingly demonstrates, has had so much to offer. Moreover, the mystery deepens with the reflection that the mural art is a social art, meant to be seen by more rather than fewer people and historically devoted to subjects generally familiar to their audiences and easy to understand.

Are we simply slow off the mark? Perhaps to some extent, especially if one recalls that reputations often accrue more to artists than to their individual efforts. Most Chicago muralists are not household names, and even if some few of their works have become well known, they themselves have not—at least not yet. A case in point is a painting that, oddly enough, was taken down several years ago and has not been seen in the meantime but that is engraved in the memories of many Chicagoans who long identified it for what it is rather than for who executed it. It is the mural that covered the ceiling of a public corridor in the old Chicago Daily News Building (now Riverside Plaza), a work that symbolically addressed the activities of a major daily newspaper. Moreover, whereas most murals in Chicago and elsewhere tend to be composed of representational forms, this one was noticeably more abstract than naturalistic. Yet early and late, it was customarily

referred to as "the Daily News mural" rather than as the work of John Warner Norton.

Indeed, one of the major reasons the painting absorbed those who saw it is that it was in a place visible to countless people every day—the hallway that connected a large metropolitan commuter railroad station with the street. That observation points to another of the reasons for the relative obscurity of many of the murals in Mary Gray's book: their sites. Public they may be, but they are situated—one might even say sequestered—in places with publics that are relatively narrow and specific: in schools, or park fieldhouses, or even private clubs and private offices. Moreover, their locales are often in Chicago neighborhoods or suburbs removed from the well-frequented spaces downtown. Paradoxically, an art intended to be accessible to any kind of viewer often turns out to be less public than—to cite a memorable example—an object known more by the name of its colossally famous artist than by what it "means": the huge Cor-Ten steel sculpture on the Daley Civic Center Plaza, familiar to the city and the world as the Chicago Picasso but understandable to a relatively small number of people—cognoscenti, in effect—among the thousands who pass by it every day. (For the record, it represents the head of a woman, not an Afghan hound, or a baboon, or a sea horse, or any comparably exotic subject.)

Yet whatever the reasons for the meager historical coverage of the Chicago muralists, the publication of this book is certain to redress much of that grievance, and not least among its virtues is the wide assortment of reasons for examining it. It consists most obviously of a catalog of pictures, and many readers will be preoccupied with assessing the artistic quality of the works shown. Yet while it is an art book, it is much more than that. One of its most illuminating aspects is the astonishing amount of information it conveys about topics that extend well beyond the strictly aesthetic. It is sure to alert those with an interest in history, reminding them of things they know, instructing them in those they don't, while affirming that there are histories in a variety of fields and any number of ways their contents can be related in visual form. Some readers with a surpassing taste for a lively tale animatedly told will find that preference by itself amply rewarded. Even controversial subjects are part of the fabric woven here, inviting still another kind of judgment.

Thus this wide-ranging text cum illustrations can be construed as a menu of sorts, yet one in which no limits on selections are imposed. Indeed, the best way to approach it may be to opt for all of the offerings.

What comes most readily to mind is the multitude of murals that were commissioned during the Great Depression by the Federal Art Project of the Works Progress Administration (WPA), a program of President Franklin D. Roosevelt's New Deal that was meant to put people to work. That policy, which helped support many American painters whose later work set the stage for this country's emergence as a world art power, is well known to all students of modern art. But the WPA experience as a whole is more renowned than the murals that grew out of it, and, happily, many of the examples done in Chicago are discussed in this volume for the first time.

Worthy of further note is a temporal contrast in narrative themes that sheds light on certain aspects of art history as seen against the backdrop of the national social order. Normally, the paintings of the depression period featured events and characters recognizably contemporary and American, usually expressive of optimism and faith in the future. On the other hand, several decades earlier, at the beginning of the twentieth century, subjects were far more frequently taken from mythology and the classics, acted out in allegorical settings remote from the immediate moment. Clearly the difference says a great deal about the values held dear by two generations separated by major intervening national and global developments. In turn the viewers of today, who may have little direct knowledge of the depression years, or who may welcome the opportunity to see the wonderful mythological tales take on visible form, may find their own reasons for being seized by the narratives of the murals contained in this book.

And there are other lessons, more localized but no less engaging. Chicago is a city of neighborhoods, each with its own identity—ethnic, social, and economic—and the murals that adorn some of the outdoor walls in districts like Pilsen, Altgeld Gardens, and Rogers Park are exceptional in the clarity and inventiveness with which they communicate something about the character and the heritage of the people who live nearby (some of whom assisted in more than a few of these paintings). Variety abounds. Horses popularized by their place in world literature—such as Pegasus, Black Beauty, Rocinante, and the Trojan horse—furnish the subject of a North Side mural, Mozart and Michelangelo that of another on the West Side. Each painting, interestingly, was commissioned by the WPA, evidence that the Federal Art Project was not confined to depression-related themes. Both paintings, furthermore, are in Chicago grammar schools, where they provide students with the sort of lesson that adds a dimension to what they might learn in the classroom.

Is it your intent to know more about Chicago artists? Names like Gustaf Dalstrom, Nina Smoot-Cain, Gordon Stevenson, Ethel Spears, Andrene Kauffman, Karl Kelpe, and Grace Spongberg—to mention only a few—seldom appear in accounts of art in this city done before this book, but many observers will be grateful for the light now shed on them. And while some names are familiar in other contexts, to those who remember Marion Mahony Griffin as one of the most gifted architects in the circle around Frank Lloyd Wright it may come as a surprise to learn that she was a skilled painter (as well as architectural renderer) whose work decorates the lobby of a North Side public school.

Indeed, one of the special assets of Gray's achievement is the attention given to subthemes that may not have occurred to anyone who opens her book for the first time. There is much to learn here about the collaboration of architects and artists in the mural-making process and about the nature of the media employed, which extend well beyond painting. Works done in mosaic, sandblasted glass, stoneware, terra-cotta, and glass tile are included here, adding a variety of form to a variety of content. We read that Albert G. Lane Technical High School is the site of no fewer than sixty-six murals, too many to be covered in a survey, even one as thorough as this. Surely some readers will be fascinated to learn that Frederic Clay Bartlett, known to Chicago art lovers as the collector who, with his wife, gave the Art Institute a painting—Georges Seurat's *Sunday Afternoon on the Island of La Grande Jatte*—that is probably the most famous single work in the museum's collection, was also one of the city's most accomplished and prolific mural artists, as several of his efforts recorded here eloquently testify. That information and more can be gleaned from the biographical sketches that make up a significant portion of the text.

It is also important to point out that while Gray's book is principally devoted to the murals now visible throughout the metropolitan area, the author has remained forever mindful of what can no longer be seen, and of the reasons—various in themselves—for those absences. Many murals that have been destroyed over the years are remembered only by name. More than a few have been painted over, and some of those that have been discovered in that sorry state have been brought back to life by the conservator's art. Preservation, in fact—one of the major, and growing, concerns of the contemporary community of architects and urban planners—has become of equal consequence among those (like Gray herself, in her very decision to write this book) to whom the legacy of Chicago murals is precious. Her story is filled with almost endless twists and turns. Some murals

have been vandalized, including one (later restored) by the distinguished New York painter Alex Katz. Some have been retrieved from dumpsters, no less. And some have simply disappeared, most notably the renowned triptych created by Mary Cassatt for the Woman's Building of the 1893 World's Columbian Exposition, and the extraordinary group of standing figures representing *The Lively Arts,* by Ivan Albright, Malvin Albright, Aaron Bohrod, Vincent D'Agostino, Ric Riccardo, William Schwartz, and Rudolph Weisenborn, that many of us recall admiring when they hung behind the bar in Riccardo's old restaurant on Rush Street—the city's prime post–World War II artists' haunt.

Further to all these accounts: when a pair of murals in Oak Park was taken down in 1995 on grounds that they reflected offensive racial stereotypes, the decision set in motion an argument over whether their removal constituted an act of censorship even more reprehensible than the message conveyed by the images themselves.

This amalgam of stories is evidence enough of both the extensiveness and intensiveness of the labor that led to the composition of Mary Gray's book. It is no exaggeration to maintain that anyone who reads it, especially anyone who has some sense of the magnitude of the city of Chicago and its suburbs and the sheer number of places where murals now hang (or have hung), must be impressed by the miles she covered, the hours she spent, and the discoveries she made in assembling the finished product. A major lacuna in the history of art in Chicago has been filled, with the thoroughness of the research proportionate to the richness of the material revealed.

— **Franz Schulze**

Acknowledgments

During this decade-long project I have been encouraged, sustained, and helped in many ways by many people. I am grateful to them all for their constructive criticism, invaluable suggestions, and varied contributions, which together have made this book a reality.

For providing the principal funding for an extensive two-year photographic undertaking, so critical to the book's usefulness, I especially thank the Graham Foundation for Advanced Studies in the Arts. I also acknowledge a very generous grant from the Richard H. Driehaus Foundation, which guaranteed that each entry would be illustrated, most in full color, with new, high-quality photographs.

At the beginning of my research, explorations with the Chicago Park District's research and planning supervisor Julia Sniderman Bachrach and Chicago Historical Society architectural curator Tim Samuelson were particularly helpful in alerting me to older murals in the schools and parks. My gratitude is boundless for the guidance they gave me, the information they shared, and the time they took to read the manuscript.

Mary Woolever and Bart H. Ryckbosch of the Ryerson and Burnham Library of the Art Institute of Chicago and its staff were especially helpful and encouraging, providing much assistance and many leads. I also want to thank Marguerite Gross at the Harold Washington Library and the staff of the Chicago Historical Society Library for their help.

I am greatly indebted to Barbara Bernstein, who shared her extensive research on New Deal murals. Her archives, the film she made for the 1976 United States bicentennial, and her correspondence with many of the artists who were alive at that time were priceless. My investigation of the public schools began with the list of murals in the Chicago public schools that she compiled in the 1970s, updating it from the original WPA list, and with the listings in the 1990 publication by George J. Mavigliano and Richard A. Lawson.

Special thanks go to Bob Sideman, whose generosity of spirit, imaginative discoveries, and relentless pursuit of information made this guide infinitely richer.

Among the many others who were liberal in the information they shared and the help they gave me were Sylvia Rohr of the Education Department of the Art Institute of Chicago, "The City in Art" project; Flora Doody of Lane Tech; Judith Lloyd of the State of Illinois Gallery; John Pounds of the Chicago Public Art Group; Noah Hoffman; Emily Nixon; Lee Kelly, Barbara Koenen, and Mike Lash of the Public Art Program; and Barry Bauman, John Vinci, Ward Miller, and Judith Kirshner. Carol Parden helped organize and expedite the large task of gathering photographs for the book. Visiting more than a hundred public schools in the Chicago area over a period of several years became a wonderful adventure in the company of Heather Becker, who was pursuing her own research. My thanks also go to the many artists and other people, too many to name, who not only were helpful but made my investigations more enjoyable by their shared interest, concern, and enthusiasm for the subject. Before my manuscript could truly become a book, it was fortunate to land in the hands of an expert editor. I am grateful to Alice Bennett for helping to organize, correct, clarify, and shape it and to Faith Hart for her final touch.

Finally, I thank my husband Richard, who endured my long preoccupation with this project. Without his help and expertise, I could not have brought it to a conclusion. This book is dedicated to him.

Introduction

The genesis of this book was a moment of curiosity I experienced one evening while sitting in the beautifully restored Auditorium Theater. I had been there many times over the years, attending the ballet and other events, but this time, waiting for the performance to begin, I looked up at the dancing figures painted on the proscenium of the stage, and began to wonder what they were all about. These classical figures that scaled the heights echoed the movements of the real dancers below. The two rather contemplative scenes of nature, beautifully enclosed within arches covered with foliate reliefs on the side walls, seemed to bear a relation to the paintings above the stage. In the research library of the Art Institute nearby, I learned that architect Louis Sullivan, with his partner Dankmar Adler, had designed the Auditorium to function as an opera house, and Sullivan had also written the poem, called "Inspiration," that provided the theme for the murals and the other decorations. His lines "The utterance of life is a song, the symphony of nature" are inscribed on the proscenium. Sullivan meant the murals to be visual equivalents of the music that would fill the hall. For him the rhythms of nature were like those of music; the ascending and descending musical scales were equated to life and death. These murals, painted in 1889, are the earliest that survive in the city, and they serve as the first chapter to the many other murals included in this guide. This is where my research on Chicago murals began.

A word about the definition of a mural: the word comes from the Latin for wall. In this guide a mural is generally an oversized painting, or a composition in mosaic or some other medium, that is an integral part of a wall or ceiling. It is either painted or applied directly to a wall or is created on some other backing and then mounted on the wall. The murals in this guide were made with the public in mind, and as Chicago muralist John Pitman Weber said, "a public mural is a public expression." The French artist Fernand Léger, who was a champion of mural paint-

ing, praised them as a "collective enterprise,"in contrast to the "strictly individualist" nature of easel painting.

Using old lists, delving into archives, looking through books and their bibliographies, following suggestions from many people and sources in my mural research, I spent months in the city's libraries, primarily the Art Institute's Ryerson and Burnham Libraries, the Chicago Historical Society, and the Harold Washington Library. Of course I toured throughout the city and suburbs, finding that one discovery led to another. Murals, I concluded, are an important kind of public monumental art, and Chicago's considerable collection can properly take its place with our architecture and sculpture. Murals reflect aspects of the city's cultural history much as public sculpture does, and even more often do they say something that actively engages and moves us.

I saw hundreds of murals but could not include them all, so I had to make choices. The mere survival of many of the older murals gave them a special historical significance. Other murals interested me as representative of a specific period, an unusual use of material, an uncommon venue, or the work of a well-known artist. Some presented strong messages, others exerted special aesthetic appeal, and some stood for an entire class of murals. Even after I completed my selections, additional murals came to my attention, and some of these are included in an addendum.

The modern mural is part of a historic tradition, as old and primitive as the paintings of the hunt on the walls of Paleolithic caves and the cryptic pictographs of early Native Americans. The rituals of life and death of the ancient Egyptians, Romans, Etruscans, and Greeks and the glorious religiously inspired frescoes and stained glass windows of the Renaissance and the baroque period are all part of the continuum leading to the murals of our time. Although the earliest murals in Chicago, those done at the turn of the century, are often rarefied mythological scenes in the grand European-inspired manner, in the next decades there emerges a truly American art with an interest in the modern world and the local scene. Regionalist artists of the Middle West give a heroic twist to their rural subjects, and their work becomes one of the models for New Deal art. Always realistic in their depictions, Chicago's murals become more naturalistic as the interest in American themes grows after the First World War. Very little of the modernist, abstract trend coming from Europe appears in the city's mural art.

Arranged by geographic areas of the city and mostly in chronological order within these groupings, the murals in the guide are in all corners of the city and

beyond. Those in the central area, where the Auditorium Theater is located, are among the very earliest, and many are close enough to each other to be visited on foot.

Soon after the Auditorium complex was built, Chicago's World's Columbian Exposition of 1893 opened, commemorating the four hundred years since Columbus discovered America. With a great emphasis on the arts, the fair brought European traditions of decorative arts to Chicago. Leading painters, architects, sculptors, and landscape designers of the day came to the city to work together on a plan that integrated architecture, sculpture, and painting. Their famous "White City" encompassed the ideals of the Beaux Arts tradition, a natural choice for these architects and artists, influenced by their training in the academies of France and Italy. Believing in "the ennobling and civilizing power of art," they chose images of the European past to create a public art that celebrated the American experience. The art was "didactic, allegorical and classical," writes Barbara Haskell in her catalog for the Whitney Museum's 1999 exhibition *The American Century*. This reverence for the past informed the murals of the Auditorium and other works in Chicago during the early decades of the twentieth century.

The School of the Art Institute of Chicago, whose precursors date from 1866, began to offer training in mural painting shortly after the turn of the century. Students came from all over the world, and even today the school continues to educate most Chicago muralists. In the first two decades of the twentieth century senior students would compete for commissions in public buildings such as schools. The school paid for paint and canvas, and the winners were awarded expenses and a bonus. Students were asked to paint "moving incidents in the development of our country in graphic fashion" and specifically "to project great characters of our history against some scene suggestive of their environment." They also created the murals for fieldhouses being built in the South Side and West Side parks, which were to be an "effective agent in making good citizens of [the] foreign population." Many of the murals were funded by the Chicago Public School Art Society, chaired by philanthropist Kate Buckingham. A special fund for the decoration of buildings in the South Side parks, to be administered by the Art Institute, was created by John Barton Payne, who was president of the South Park Commission, one of three distinct Chicago park districts formed after 1869 (the others were the West Park and Lincoln Park Commissions).

During the building boom of the 1920s and 1930s, many handsome downtown office buildings were constructed in the art deco style. The privately financed Civic

Opera House and Merchandise Mart, both completed in 1930, contain murals by Jules Guerin, who worked closely with the architects in realizing them. This ideal collaboration, resulting in the art's complementing the architecture, has been all too rarely repeated.

Surprisingly, more murals were painted in Chicago during the Great Depression than at any other time in its history. During his first hundred days in office, in 1933 President Franklin D. Roosevelt formulated his New Deal, its most important mission being to put people to work. The federal government became the major sponsor of public art, and the Federal Art Project (FAP) of the Works Progress Administration (WPA), called the Work Projects Administration after July 1939, was the largest such program ever attempted anywhere. Inspired by the Mexican government's broad sponsorship of muralists during the previous decade, the FAP developed projects in art, theater, music, and writing from 1935 to 1943. Roughly five thousand artists nationwide created some 108,000 easel paintings, 17,700 sculptures, and 2,500 murals. Its local arm, the Illinois Art Project, was based in Chicago, and it put three hundred qualified but unemployed artists and even more assistants to work decorating public buildings. Muralists were directed to focus on "the American scene," to speak directly to the people, and to reflect a faith in the future. Most murals were done in a naturalistic style, and there was very little abstraction. The Illinois director, Increase Robinson, was said to have decreed, "No nudes, no dives or social propaganda." Of the roughly 200 mural locations in greater Chicago, about two-thirds have survived. A few of these had been painted over and will be restored in the coming years. Twenty-six either are lost or have been destroyed.

Credited with launching this mural renaissance was a program created in 1934, one year earlier than the Federal Art Project. Sponsored by the Treasury Department, and not created to provide jobs for the unemployed, the Treasury Section of Fine Arts, called "the Section," was responsible for the decoration of new federal buildings, which often meant post offices. It was funded by 1 percent of the construction budget and selected its artists through anonymous competitions, run either locally or nationally. To avoid portraying "the calamitous present," writes Karal Ann Marling in *Wall to Wall America,* muralists often chose to depict the past with scenes of "working, building, achieving" that represented "articles of faith" in the future. Although artists had to please (or at least not offend) their public, guidelines could be "as simple as a passable picture of an acceptable theme."

The federal, state, and local governments continue today to fund art for new public buildings and spaces, with Percent for Art programs. The one in Chicago, created by the city in 1978 and now called the Chicago Department of Cultural Affairs Public Art Program, is credited with over four hundred works of art in police stations, firehouses, libraries, and transportation and health centers. Many of the murals in this guide were funded through this program: the $1 million collection in the Harold Washington Library, featuring fifty-five artists, is the largest public art project undertaken by the city to date.

The art of the great Mexican muralists José Clemente Orozco, Diego Rivera, and David Alfaro Siqueiros, called *los tres grandes,* whose accomplishments so impressed the shapers of the New Deal, has been the greatest influence on New Deal painters of the 1930s and the community muralists of today. The leading Mexican muralists returned home from study in Paris in the 1920s and adapted the fresco technique of the Italian Renaissance for use on public buildings in Mexico City. Funded by their government, they created an art of political expression and a way for the grievances of the working class to be heard. Many of the Chicago muralists of the New Deal era went to Mexico to study with these great innovators, whose storytelling techniques have informed mural art ever since.

Most visible in increasing numbers in Chicago are the outdoor community murals, part of a movement that was born in Chicago in the late 1960s when William Walker and a group of African American artists decided to use the wall of a building on the South Side as a canvas for their expression of the black experience. It was the time of great civil rights activism, and the artists wanted to create a positive image for their community. Walker, John Pitman Weber, and Eugene Eda organized the Chicago Mural Group in 1970, and the mural idea quickly spread to other cities across the country, encompassing many other ethnic groups (see Cockcroft, Weber, and Cockcroft, *Toward a People's Art: The Contemporary Mural Movement*). Today the multiethnic Chicago Public Art Group (CPAG) continues to paint socially significant murals "about enlightenment [and] intervention in the community . . . murals that might change the lives of people around them," as art historian and teacher Victor Sorell described them. The group helps to raise funds for community-based murals, works with children in the public schools, and has begun to restore some of the older outdoor murals that have deteriorated over time.

A number of groups in the city are responsible for the creation of murals both temporary and permanent. These are nonprofit organizations that offer programs

in the visual arts to supplement and enrich school curriculums. A.R.T., Gallery 37, Urban Gateways, and the Marwin Foundation, each in its own way, introduce children to the visual arts through participatory education. Their programs are led by professional artists and take place in the schools and in other locations and are often meant for teachers and adults as well. The total number of murals these organizations have created is in the hundreds. I have described them more fully in the glossary.

In writing this book, I have hoped to surprise and delight readers with the variety and richness of Chicago's mural-making traditions and its collection of murals. I have tried to illuminate their cultural importance and make a case for their historical value and contemporary relevance. But I must also point out their fragility. Murals are always endangered: as you will become aware in using this guide, they can be removed, defaced, discarded, or painted over, or the walls they are mounted on can be demolished. As you discover and learn about these treasures, I hope you will become an advocate for their continued existence and preservation.

It is heartening to report that in the past few years two city agencies have recognized the urgent need for conservation of the murals in the public schools. The Board of Education and the Public Building Commission are now funding the restoration of many of the murals I examined, murals often untouched since they were first installed in the 1930s and 1940s. Conservator Barry Bauman and his Chicago Conservation Center staff have completed the restoration of dozens of these public school murals and continue to work in an ongoing program. Tim Lennon and Rick Strilky and other conservators have also treated a significant number of murals in schools, churches, fieldhouses, and private collections. And the public schools' largest single collection of historic murals at Lane Technical High School has inspired the initiation of a program called the City in Art. Developed by the Museum Education Department of the Art Institute in cooperation with Lane Tech teachers, the program uses murals as cultural resources to "enhance the arts curriculum and make links between the arts and other subjects." This important educational program, supported by the Polk and Metropolitan Life Foundations, helps to ensure that this and future generations will continue to cherish all the city's murals for their artistic, historical, and cultural value. These trends in conservation and education point to a new level of public awareness that bodes well for Chicago's murals.

Central Area

CHICAGO RIVER TO TWELFTH STREET

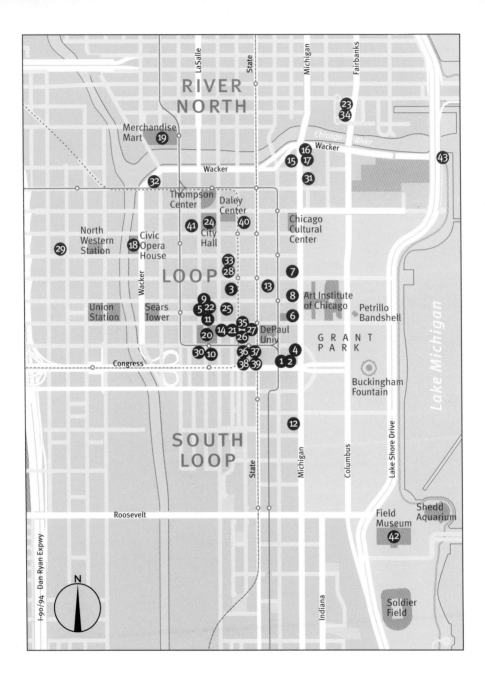

1 **Auditorium Theater (1889)**
50 East Congress Street
ALBERT FRANCIS FLEURY AND
CHARLES HOLLOWAY

2 **Auditorium Dining Hall (1889–90)**
430 South Michigan Avenue
OLIVER DENNETT GROVER

3 **Marquette Building (1895)**
140 South Dearborn Avenue
JACOB ADOLPHE HOLZER,
TIFFANY COMPANY

4 **Fine Arts Building (1900)**
410 South Michigan Avenue
EIGHT ARTISTS[†]

5 **Rookery Building (1902)**
209 South LaSalle Street
GEORGE MANN NIEDECKEN

6 **Santa Fe Center (1904)**
224 South Michigan Avenue
EDGAR SPIER CAMERON

7 **University Club (1908–9)**
76 East Monroe Street
FREDERIC CLAY BARTLETT

8 **Cliff Dwellers Club (1909–10)**
200 South Michigan Avenue
JOHN WARNER NORTON

9 **Rookery Building (1910)**
209 South LaSalle Street
GORDON STEVENSON

10 **Traders Building (1913–14)**
401 South LaSalle Street
EDGAR SPIER CAMERON

11 **Bank of America (1923–24)**
231 South LaSalle Street
JULES GUERIN

12 **Hilton and Towers Hotel (1927)**
720 South Michigan Avenue
A. BONANNO

13 **Palmer House Hilton (1926)**
102–29 South State Street
LOUIS PIERRE RIGAL

14 **Union League Club (1926)**
65 West Jackson Boulevard
EDWIN HOWLAND BLASHFIELD

15 **Wacker Tower (1927–28)**
68 East South Water Street
JOHN WARNER NORTON

16 **Tavern Club (1927–28)**
333 North Michigan Avenue
JOHN WARNER NORTON

17 **Tavern Club (1950s)**
333 North Michigan Avenue
EDGAR MILLER

18 **Civic Opera House (1929)**
20 North Wacker Drive
JULES GUERIN

19 **Merchandise Mart Lobby (1930)**
Merchandise Mart Plaza between
Wells and Orleans Streets
JULES GUERIN

20 **Chicago Board of Trade Building (1930)**
141 West Jackson Boulevard
JOHN WARNER NORTON

21 **Union League Club (1935)**
65 West Jackson Boulevard
MIKLOS GASPAR

22 **Rookery Building (1936)**
209 South LaSalle Street
ATTRIBUTED TO GUSTAF OSCAR
DALSTROM

[†]*See page 12*

23 **NBC Building (1937)**
455 North Cityfront Plaza Drive
ATTRIBUTED TO GUSTAF OSCAR
DALSTROM

24 **City Hall (1937)**
LaSalle and Randolph Streets
EDWARD MILLMAN

25 **Loop Station Post Office (1938)**
219 South Clark Street
GUSTAF OSCAR DALSTROM

26 **Standard Club (1954)**
320 South Plymouth Court
EDGAR MILLER

27 **Standard Club (1954)**
320 South Plymouth Court
EGON WEINER

28 **Bank One Plaza (1974)**
1 Bank One Plaza, Monroe and
Dearborn Streets
MARC CHAGALL

29 **Social Security Administration
Building (1976)**
600 West Madison Street
ILYA BOLOTOWSKY

30 **Chicago Board Options
Exchange (1976)**
400 South LaSalle Street
RUTH DUCKWORTH

31 **225 North Michigan (1983)**
225 North Michigan Avenue
RICHARD JOHN HAAS

32 **333 West Wacker (1985)**
333 West Wacker Drive
JIM DINE

33 **Bank One Building (1988–89)**
1 Bank One Plaza, Dearborn and
Madison Streets
KARL WIRSUM

34 **NBC Building (1989)**
200 East Illinois Street
ROGER BROWN

35 **Standard Club (1990)**
320 South Plymouth Court
SOL LEWITT

36 **Harold Washington Library (1991)**
400 South State Street
JACOB LAWRENCE

37 **Harold Washington Library (1991)**
400 South State Street
NANCY SPERO

38 **Harold Washington Library (1991)**
400 South State Street
KARL WIRSUM

39 **Harold Washington Library (1991)**
400 South State Street
SIX ARTISTS[‡]

40 **Commonwealth Edison
Substation (1991)**
117–21 North Dearborn Street
KARL WIRSUM

41 **Savings of America Tower (1991)**
120 North LaSalle Street
ROGER BROWN

42 **Field Museum (1992)**
Lake Shore Drive at Roosevelt Road
CAROL CHRISTIANSON

43 **Riverwalk Gateway (1999–2000)**
The underpass at Riverwalk and
Lake Shore Drive
ELLEN LANYON

[‡]*See page 82*

Central Area

Central Chicago (the Chicago River to Twelfth Street) contains many murals that can be visited on foot—in public buildings, clubs, theaters, and banks. The earliest ones to survive are in the Auditorium Building, built between 1886 and 1890, the first in the series of buildings of related size and scale that form the great "wall" facing Grant Park and determine the present character of South Michigan Avenue. The decade of the 1890s also saw the founding of many of Chicago's cultural institutions: the Art Institute, the Chicago Orchestral Association, the Field Museum, and the University of Chicago. During this period Chicago hosted the World's Columbian Exposition of 1893, which both celebrated the city's growth and inspired continued development. Murals were part of the original planning for such Loop buildings as the Marquette Building, the Civic Opera House, the Merchandise Mart, Continental Illinois Bank (now Bank of America), the University Club, and the Hilton and Blackstone Hotels, and they are important components of their decorative schemes. It is an ideal situation when artist and architect collaborate in the integration of art and architecture.

The public art collection at the Harold Washington Library, completed in 1991, contains over fifty works of art, including four murals created expressly for the building. They were commissioned by the city of Chicago's Percent for Art Program, brought into law in 1978 as an ordinance stipulating that a certain percentage of the cost of constructing or renovating municipal buildings must be set aside for the purchase of artworks. Administered by the Chicago Department of Cultural Affairs, the program appoints panels of architects, arts professionals, community representatives, and city personnel to recommend artists for each site. Many other Percent for Art projects throughout the city are illustrated in this guide.

1 ► Auditorium Theater

The Auditorium Theater Murals, 1889

Auditorium Theater, 50 East Congress Street
Proscenium: oil and gold leaf on dry plaster; side walls: oil on woven linen, 24' x 20' each
ARTISTS: Albert Francis Fleury (1848–ca. 1932) and Charles Holloway (1859–1941)
COMMISSIONED AND FUNDED BY: the Chicago Auditorium Association (Ferdinand Peck and others including Marshall Field, Martin Ryerson, and Nathaniel Kellogg)

The Auditorium was the largest and most innovative theater of its day, with four thousand seats and superb acoustics and sight lines. An early example of mixed use, the Auditorium complex was the vision of prominent Chicago businessman Ferdinand Peck, who wanted to create a permanent opera house that could be sup-

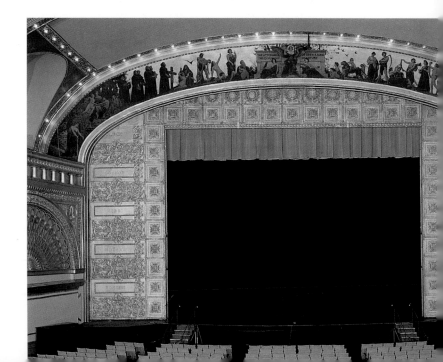

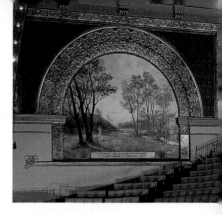

ported by rentals from the adjoining hotel and office building. Theatrical deficits occurred almost immediately, however, and over the years the theater was repeatedly threatened with demolition. In 1946 its existence seemed assured when the newly founded Roosevelt University bought the complex, and nearly twenty years later the theater was restored by several million dollars of privately raised funds. Now protected by landmark status, what has survived is Dankmar Adler and Louis Sullivan's masterpiece, a space of exquisite beauty with a unified decorative program that presents Sullivan's idea of architecture as nature. The foyer, with its colossal columns, mosaics, and stained glass panels, leads into the great auditorium, all ivory and gold. Three large mural paintings, based on Sullivan's own poetry, are integrated into an interior dominated by four elliptical gilded arches with swirling foliate patterns and tiny carbon filament bulbs that are part of the decoration, forming glimmering bands on the vaulted ceilings and curved balconies. Each of the murals illustrates his theme of growth and decay as two great rhythms in nature. Although it is difficult to see in the subdued light that repli-

cates the original illumination, Charles Holloway's frieze of forty-five life-size classical figures above the proscenium arch is a pictorial expression of the words "the utterance of life is a song, the symphony of nature," from Sullivan's poem "Inspiration." The procession of monks and young men and women represents the cycles of life and death, past, present, and future or, in musical terms, allegro and adagio. Under each of Albert Fleury's dreamlike lunette-shaped landscapes, on the side walls at the balcony level, is a quotation from Sullivan's poem: for "Spring Song," "O soft melodious springtime! First-born of life and love" and for "Autumn Reverie," "A great life has passed into the tomb and there awaits the requiem of winter's snows." Fleury sketched the scenes in the Wisconsin Dells and on Chicago's North Shore.

Auditorium Theater: ◄ proscenium arch; ▲ *Spring/Summer*.
Photographs © 1999, Judith Bromley.

2 ▶ Auditorium Dining Hall (Roosevelt University)

Duck Hunting Scene and *Fishing in the River*, 1889-90

Murray-Green Library of Roosevelt University, tenth floor
(originally the Auditorium Hotel dining hall)
430 South Michigan Avenue
Oil on canvas, two lunettes
ARTIST: Oliver Dennett Grover (1861–1927)
COMMISSIONED BY: the Chicago Auditorium Association

The great tenth-floor dining hall of the former Auditorium Hotel was converted by Roosevelt University into a library and reading room. Overlooking Michigan Avenue, the enormous space has a curved vaulted ceiling beginning at the floor with five trussed arches that divide it into bays. Originally the ceiling had decorative gold stenciling and sculptured plaster relief panels with lights. Smaller rooms at each end, now used as book stacks, are separated from the main space by handsome mahogany columns with hand-carved capitals supporting murals mounted above a wide frieze of richly ornamented plaster. The elliptical murals, rendered in muted shades of brown, feature hunting scenes, perhaps suggesting the fish and game that would have been served in the restaurant. In one, hunters stand in a blind and aim their rifles at wild birds; in the other a fisherman casts his line into a stream. Ever since Roosevelt University acquired the building for taxes in 1946, tremendous ongoing efforts have been made toward stabilizing it and restoring some of the impressive ornamentation. These murals were rediscovered accidentally during a restoration, after being hidden for many years under multiple layers of paint.

▶ Roosevelt University, *Fishing in the River,* one of two lunettes. Photograph by Ted Lacey, courtesy of Roosevelt University.

8

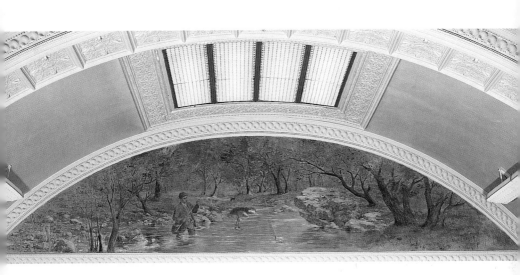

3 ► Marquette Building

Joliet and Father Marquette's Travels in Illinois, 1895

Marquette Building lobby balcony, 140 South Dearborn Street
Glass and mother-of-pearl mosaics, about 90' around fascia of gallery
ARTIST: Jacob Adolphe Holzer (1858–?), Tiffany Glass and Decorating Company of New York

Shimmering mosaic murals on the hexagonal second-floor gallery of the Marquette Building lobby rotunda depict events in the life of Père Marquette, for whom the building is named. Designed by Holabird and Roche and completed in 1895, the building was given Chicago landmark status in 1975. Three long pictorial panels on the balcony walls, made of tiny bits of glass and mother-of-pearl,

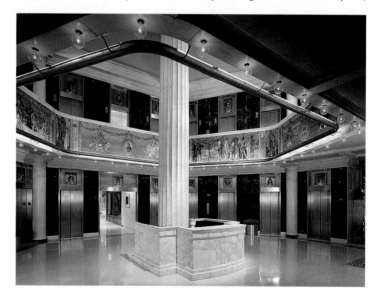

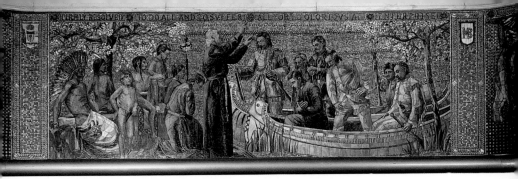

show events in the life of Jacques Marquette, a Jesuit missionary and explorer who was the first European to describe the site of Chicago. He accompanied French Canadian cartographer Louis Joliet on his explorations, and they spent the winter of 1674–75 on the south bank of the Chicago River, with plans to establish a mission in Illinois. Marquette is depicted meeting with Native Americans of the Illinois tribe, accepting a peace pipe, and lying desperately ill in the forests of Michigan, where he died. Three trophy panels show the armor and weapons of the period and the heads of Marquette and Joliet, and six portraits of Native American chiefs separate the narrative panels and complete the design. The explorers and chiefs are also portrayed in bronze relief panels and portraits above the elevators and on the exterior facade of the building. The architects saw Louis Comfort Tiffany's Favrile glass mosaics at the 1893 Chicago World's Columbian Exposition, where they were exhibited for the first time. Tiffany had tried to replicate the iridescence of ancient glass vessels by infusing gold and other metal oxides into the panels of his stained glass windows. He later expanded the technique to mosaics, which soon become his hallmark. His designer, Jacob Adolphe Holzer, cut and shaped pieces of glass and mother-of-pearl into many different sizes to create the dramatic effects that highlight details of clothing, faces, and scenery. Tiffany mosaics can also be seen in the Chicago Cultural Center, also executed by Holzer, and at Marshall Field and Company's downtown store.

Marquette Building: ◄ lobby and gallery view; ▲ *Joliet and Father Marquette's Travels in Illinois: Meeting with Native Americans of Illinois,* detail. Photographs by Hedrich Blessing.

4 ► Fine Arts Building
Tenth-Floor Murals, Begun 1900

Fine Arts Building, tenth floor, 410 South Michigan Avenue
Oil on canvas, eight panels
ARTISTS: Martha Susan Baker (1871–1911), Frederic Clay Bartlett (1873–1953),
Charles Francis Browne (1859–1953), Ralph Clarkson (1861–1942), Oliver Dennett Grover
(1861–1927), Frank Xavier Leyendecker (1877–1924), Joseph Christian Leyendecker
(1874–1951), and Bertha Sophia Menzler-Peyton (1874–ca.1950)

Built originally by the Studebaker Brothers Carriage and Wagon Company as show-
rooms, the building was converted to a new use in 1898 and renamed the Fine Arts
Building. It was called Chicago's first art colony because of its location near the
Art Institute, the Auditorium Theater, and Orchestra Hall, and its light-filled stu-
dios and high ceilings attracted people working in the arts. Artists, musicians, ac-
tors, architects, music and dance teachers, art and antique dealers, rare book-
sellers, decorators, and arts organizations became tenants. At various times
sculptor Lorado Taft, cartoonist John Tinney McCutcheon, the Kalo Shop, the *Sat-
urday Evening Post,* and *Poetry* magazine had offices there. There were two legit-
imate theaters on the ground floor. A group of artist-tenants, including many who
came to Chicago to work at the 1893 World's Columbian Exposition, initiated the
mural project on the top floor, which has high ceilings and skylights. Actually eight
large framed paintings, the murals are hung at the top of the stairwell, in the ad-
jacent light well, and to the right of the bank of elevators. With the exception of
one landscape, all are figural and present allegorical depictions of the arts in the
same European tradition of the École des Beaux-Arts that predominated at the
1893 fair. The artists who stayed in Chicago participated actively in the cultural
life of the city as artists, teachers, and critics. Remarkably, the building remains
much as it was: the elevators are open cages, the halls of its ten floors still house

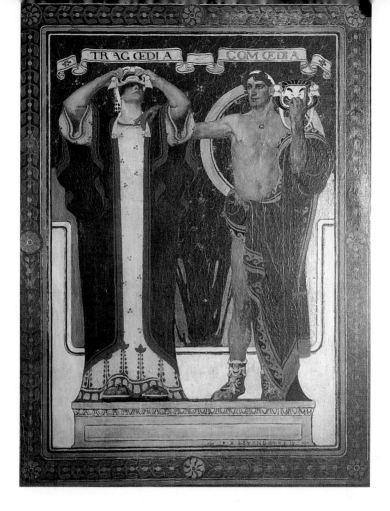

architects, musicians, and arts organizations, and the sounds of violins, pianos, and voices still emanate from behind the old-fashioned transomed doors. The two ground-floor theaters now show "art" films.

Fine Arts Building, *Tragedy and Comedy,* one of eight panels. Photograph by Ted Lacey, courtesy of the Fine Arts Building.

5 ➤ Rookery Building
Mural Fragment, 1902

Private offices, Rookery Building, 209 South LaSalle Street
Oil on canvas, 2'10½" x 13'5"
ARTIST: George Mann Niedecken (1878–1945)
COMMISSIONED BY: Arthur Heun for the Sedgwick S. Brinsmaid House, Des Moines, Iowa

A large mural, painted in lovely muted colors, depicting a dense forest of ever-greens, hardwood trees, and birches, hangs in one of the meeting rooms of a private firm in the Rookery Building. It is a segment from a much larger work that encircled the dining room walls of a 1902 Prairie school house in Iowa. When the house, designed by Arthur Heun, was demolished in the 1970s, the mural (painted in many sections), art glass windows, and lighting fixtures were saved. The artist,

George Niedecken, collaborated with Frank Lloyd Wright two years later on a similar mural for the Dana House in Springfield, Illinois, and shared his belief in the integration of art with architecture. Niedecken often designed all the decorative elements in a house, from the art glass windows, woodwork, textiles, lighting, and murals to the furniture. He found inspiration and stylistic ideas during his travels in Germany, Austria, Italy, and England and also from his formal studies in Milwaukee, Chicago, and Paris. The Arts and Crafts, Prairie school, Vienna secessionist, and art nouveau movements are all influences in his work. In 1907, after years of working with Wright and other Prairie school architects, he opened his own firm, Niedecken-Walbridge, in Milwaukee and established a cabinetmaking shop. Among his other collaborations with Wright in the Chicago area are the Robie and Coonley houses. The Rookery Building, where the mural hangs, designed by Burnham and Root and erected in 1885–88, was given Chicago landmark status in 1972.

Rookery Building, mural fragment from the Brinsmaid House.
Courtesy of Michael FitzSimmons Decorative Arts.

6 ▶ Santa Fe Center
Conference Room Murals, ca. 1904

Santa Fe Center (formerly the Railway Exchange Building), 224 South Michigan Avenue
Oil on canvas
ARTIST: Edgar Spier Cameron (1862–1944)
COMMISSIONED BY: Daniel H. Burnham, Chicago Architecture Foundation

A corner of the two-story enclosed-court lobby of this handsomely restored land-mark building, designed by D. H. Burnham and Company and built in 1903–4, functioned as a grill or "saloon" for nearly eighty years. Such grills were a typi-cal feature of office buildings of this period, considered an amenity for the build-ing's primarily male tenants. Remarkably, the room has retained its original mural decorations and long counter-bar. Burnham, the coordinating architect for Chicago's 1893 World's Columbian Exposition, chose Edgar Cameron, who had worked as an assistant to several painters at the fair, to decorate this space. It is now used as a conference room for the Chicago Architecture Foundation, whose offices and bookstore are across the lobby. On the walls are scenes of ancient Rome, ceremonial revels, and rituals appropriate to food and drink, celebrated by men and women in togas and flowing robes. Two large lunettes are recessed in the wall over the bar: in one a group of people, many bearing jugs, gather at a well to prepare for a feast; in the other a procession of musicians playing flutes, cym-bals, and harps is followed by men bearing large jugs of wine. These subjects and their renderings were inspired by the work of Sir Lawrence Alma-Tadema (1836–1912), an English artist whose scenes of classical Greece and Rome were exhibited at the 1893 exposition where Cameron might have seen them. Friezes of reclining banqueters, musicians, and dancers decorate the two surrounding walls. The borders of leaves, garlands, urns, and putti that delineate two rows of nine figures each are reminiscent of Pompeian frescoes. Cameron became one of the most successful muralists in the Midwest.

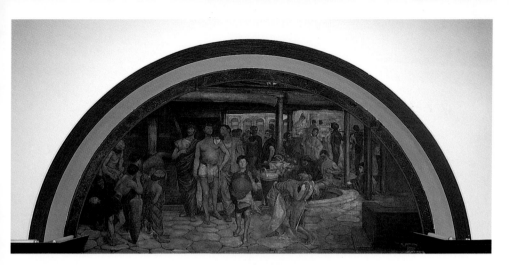

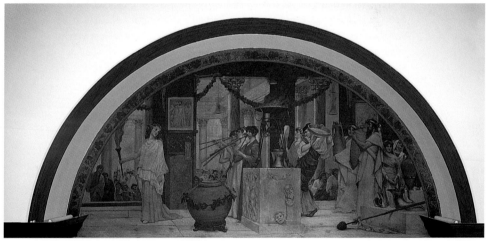

Santa Fe Center, conference room murals, detail. Photograph by Ted Lacey, courtesy of the
Chicago Architecture Foundation.

7 ▶ University Club
Michigan Room Ceiling, 1908–9

University Club, Michigan Room, second floor, 76 East Monroe Street
Oil on canvas, fifty-six small panels, 1908–9
ARTIST: Frederic Clay Bartlett (1873–1953)

In 1905 the University Club chose members William Holabird and Martin Roche to design their new neo-Gothic clubhouse and Frederic Bartlett to plan the interior decor and furnishings. Especially fine are Bartlett's stained glass windows in the soaring three-story dining room on the top floor and the coffered ceiling, with its inlaid painted panels, in the second-floor Michigan Room. The carved wood-paneled walls, the imposing limestone fireplace, and the coffered ceiling with its heavy wooden beams and sunken square panels blend harmoniously to create an inviting space for small dinners and meetings. In describing his ceiling Bartlett wrote, "I have designed fifty-six panels, representing a Gothic chase and a feast. In the outer panels, there are knights and ladies, pursuing game. In the center is the feast, with groups of musicians." Bartlett's other murals are at Second Presbyterian Church and the University of Chicago's Bartlett Gymnasium, named for his brother, who had died earlier. An accomplished artist, Bartlett is even better known as the art collector who, with his wife, gave the Art Institute of Chicago its renowned painting *Sunday Afternoon on the Island of La Grande Jatte*, by Georges Seurat.

▶ University Club, Michigan Room ceiling, detail. Photograph © by Don DuBroff, courtesy of the University Club.

18

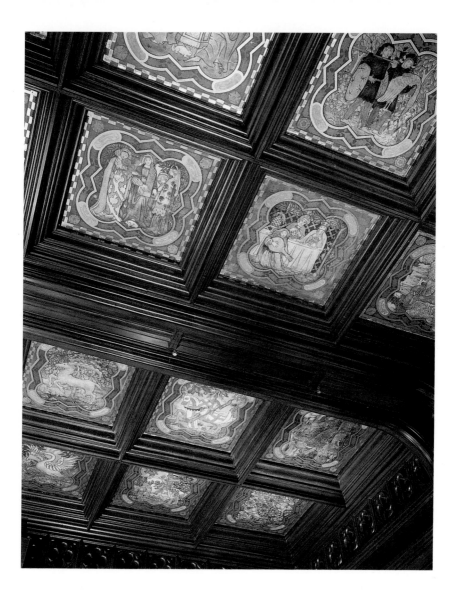

8 ► Cliff Dwellers Club

Navaho, 1909–10

Cliff Dwellers Club, Borg-Warner Building, twenty-second floor
200 South Michigan Avenue
Oil on canvas mounted on rigid support, 7'1" x 4'10"
ARTIST: John Warner Norton (1876–1934)
COMMISSIONED BY: the Cliff Dwellers Club

Navaho hangs in the entrance hallway leading to the handsome new clubrooms of the Cliff Dwellers Club, designed by Booth/Hansen. When the club relocated in 1996 the painting was moved from its place on the stairway leading to the original clubrooms atop Orchestra Hall, designed by Howard Van Doren Shaw. Its creator, John Norton, was a charter member of the club, which was not named after Henry B. Fuller's 1893 novel about Chicago, *The Cliff-Dwellers,* as was commonly believed, but was meant "to point a finger toward the ancient cliff-dwelling Indians of the Southwest . . . whose cultural level was high." Members, who were primarily artists, writers, musicians, and other people in the arts, also saw themselves as cliff dwellers, "perched on high ledges during their working hours in art studios, music conservatories, etc." *Navaho* was Norton's first large-scale painting and reflects his interest both in Native Americans of the Southwest and in the composition of Japanese art. Norton might also have been using the depiction of Native Americans as allegory, to suggest civic values and a connection to Chicago's past, as was often the case with monumental sculpture of this period. Arranged asymmetrically on the canvas is a dignified Navaho family in traditional dress, marching toward the viewer. In his catalog for the Norton retrospective exhibition of 1992–93, Jim Zimmer suggests that the mural may refer to the pageant performed by club members at the club's opening in 1909, in which, dressed as Native Americans, Spanish explorers, French missionaries, and other settlers, they filed past a pageant master who recited appropriate verses. Norton placed his

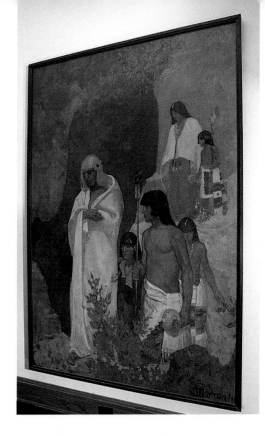

mural where the procession would have passed, descending the stairs from the clubroom above. The colors are muted. Norton's travels through Arizona, financed by design work for the Santa Fe Railroad, took him to Native American villages, and this and subsequent journeys to the West provided the subject matter for many of his paintings. He liked the challenge of architectural decoration and believed that a mural should be an integral part of the space it was created for, reflecting both its shape and its function. Other Norton murals nearby are at Wacker Tower, the Chicago Board of Trade Annex, Loyola University Library, and the Tavern Club.

9 ► Rookery Building

La Salle, 1680, 1910

Private offices, Rookery Building, 209 South LaSalle Street

Oil on canvas, 4'11¾" x 11'8"

ARTIST: Gordon Stevenson (1892–1984)

This large mural is in the private offices of a firm in the historic Rookery Build-
ing, designed by Burnham and Root and built in 1885–88. The scene is of the
French explorer René-Robert Cavelier, Sieur de La Salle (1643–1687), backed by

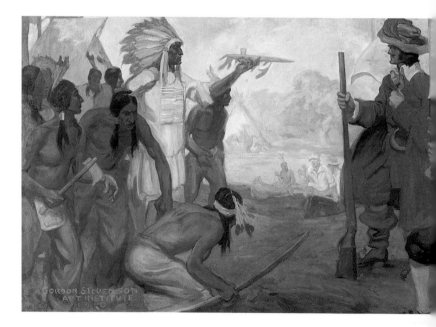

other explorers, pioneers, and missionaries, meeting a group of Native Americans. La Salle, who is credited with establishing the first fort near present-day Chicago, was one of an intrepid group of men who set off from "new France" in Canada to explore the waterways of the Middle West and who descended the Mississippi River, carrying trade goods to be exchanged with the Indians for furs and hides. Given grants of land by the king of France and trading privileges in the west by the governor of Quebec, La Salle reached the present site of Peoria and established Fort Crevecoeur there in 1679. Chicago later became an important port on the route to the Mississippi. The artist, Gordon Stevenson, was a student at the School of the Art Institute when he painted this mural as part of his training. Students were selected to execute murals for a number of Chicago public schools and Park District fieldhouses through competitions in the early 1900s, and many of these murals are still in place today. The history of this mural and its original location are not known, but another large mural by Stevenson from the same period hangs at Lane Technical High School.

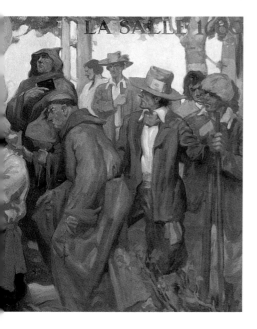

Rookery Building, *La Salle, 1680*. Photograph by Michael Tropea.

10 ▶ Traders Building

Indians Trading with Settlers at Fort Dearborn and Indians and Settlers at Fort Dearborn, 1913–14

Traders Building lobby (formerly the Fort Dearborn Hotel),
401 South LaSalle Street
Oil on canvas mounted on metal panels, 6'4½" x 15'8" each
ARTIST: Edgar Spier Cameron (1862–1944)
Restored in 1986

The two panoramic murals on the mezzanine level of the two-story lobby were commissioned for the Fort Dearborn Hotel, designed by Holabird and Roche in 1912, which operated for seventy years. They were removed from their original location behind the hotel's registration desk when the building was converted to office space for traders from the nearby exchanges, then restored and reinstalled opposite each other on the balcony level. The building is an excellent example of adaptive reuse, and the renovation by Booth/Hansen is sensitive to the spirit of the original. The wood paneling, black-and-white tile floor, and color scheme of the lobby have been re-created, and the original ornamental bronze stair and balcony railings were reused. Fort Dearborn, which appears in both paintings, was a frontier military post established on the banks of the Chicago River in 1803 (now the corner of Michigan Avenue and Wacker Drive). Erected to house soldiers and protect settlers, the fort was named for Henry Dearborn, then secretary of war. The paintings show the city's early history as a frontier trading post and depict friendly relations and lively commerce between American Indians and settlers.

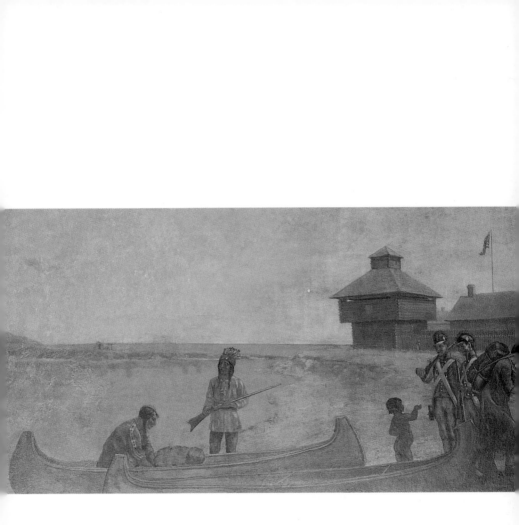

Traders Building, *Indians and Settlers at Fort Dearborn,* one of two panels. Photograph by Ted Lacey, courtesy of the Traders Building.

11 ▶ Bank of America

A Testimonial to World Trade, 1923–24

Bank of America, Grand Banking Hall, second floor (formerly Continental Illinois Bank, originally Illinois Merchants Bank), 231 South LaSalle Street
Oil on linen canvas, eight large murals: two 50' long, two 30' long, and four 22' long
ARTIST: Jules Guerin (1866–1946)

The Illinois Merchants Bank of 1923–24, more recently Continental Illinois Bank and now Bank of America, was built in a more formal age, and its elegant two-story banking hall has been fortunate to retain most of its original interior design through changes in ownership. The large hall is lined with a colonnade of twenty-eight tall marble pillars that support a cornice bearing a frieze of delicately colored pictorial murals and inscriptions celebrating world trade and commerce. In her book on Graham, Anderson, Probst and White, the bank's designers, Sally A. Kitt Chappell writes that the architectural elements were chosen for the messages they could convey: "The tall Ionic columns suggest strength, the lavish materials wealth, the vast spaces power." The murals emphasize commerce through allegory, using symbolic figures with flags and products characteristic of their countries to depict international trade among the major nations during the 1920s. The United States is represented by a figure holding a locomotive and standing in a wheat field; Switzerland by a robed figure with a timepiece; Japan by a figure with a bolt of silk; and Holland by a basket of flower bulbs. For Spain the panels show Columbus's three ships; for Germany, a naval cruiser; for England, an ocean liner; and for Russia, a fur pelt. Other figures represent the concepts of intelligence, industry, finance, and equity. Buildings from the White City of Chicago's 1893 World's Columbian Exposition form backdrops to the scenes. Inscriptions between the panels convey the fundamentals of finance, ranging from Cicero's "In the family, as in the state, the best source of wealth is economy" to Hartley Withers's "Capital is what you and I have saved out of yesterday's wages."

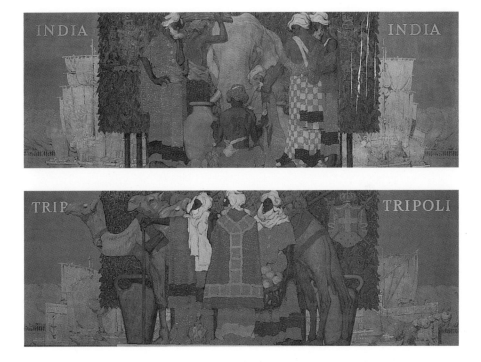

Bank of America: *A Testimonial to World Trade: India; A Testimonial to World Trade: Tripoli,* two of eight
panels. Photographs by Michael Tropea, courtesy of the BankAmerica Corporation Art Collection.

12 ▶ Hilton and Towers Hotel

Windows to the Sky, 1927

Hilton and Towers Hotel Great Hall (formerly the Stevens Hotel)
720 South Michigan Avenue
Oil on canvas, 30' x 100'
ARTIST: A. Bonanno (dates unknown)
COMMISSIONED BY: the Stevens Hotel

When it opened in 1927 as "the Stevens," it was the largest hotel in the world. The three-thousand-room structure, designed by Holabird and Roche, has been owned by the Hilton family since 1945. The name was changed in 1951, and the hotel has undergone several extensive renovations since the 1980s. The marble, paint, and gilding of the heavily ornamented public spaces have been renewed, and the towering entrance lobby on Michigan Avenue once more displays its ornate elegance. A double grand staircase curves upward from the lobby to the second-floor lounges and ballroom under the newly cleaned painted sky with its clouds. The ceiling mural called *Windows to the Sky* was an original feature of the hotel, meant to give the vast space the illusion of the outdoors. The colonnade and wall with arched openings that enclose the stairway also contribute to the alfresco effect. A fountain with bronze figures by Chicago sculptor Frederick Hibbard, likenesses of James W. Stevens's sons, once stood on the landing.

▶ Hilton and Towers, *Windows to the Sky.* Courtesy of the Chicago Hilton and Towers.

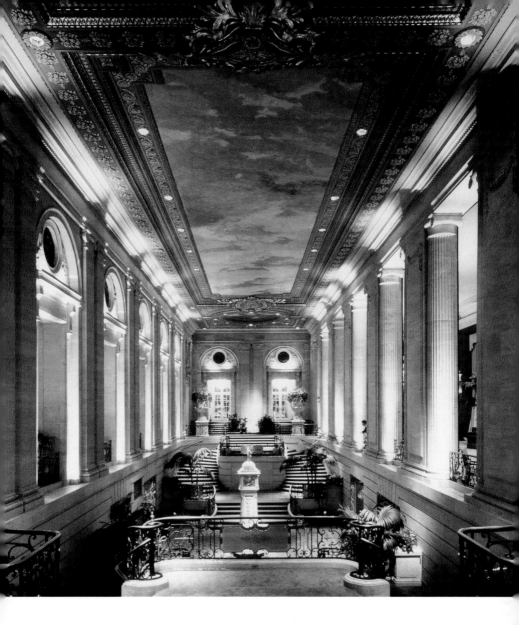

13 ▶ Palmer House Hilton

Lobby Ceiling Mural, 1926

Palmer House Hilton lobby, 102–29 South State Street
Oil on canvas, 50' long
ARTIST: Louis Pierre Rigal (1889–1955)

The colonnaded two-story reception lobby of the Palmer House Hilton is on the second floor, above ground-level shops and restaurants. Created as the hallmark of a fine hotel when it was originally built, this "great room" was given an atmosphere of Old World elegance and tradition with furnishings in the style of the Napoleonic French Empire. Dominating the enormous space is the ceiling mural, spanning the entire fifty-foot length of the lobby. As part of an extensive program of renovation and remodeling that began in the 1960s, the mural received professional cleaning and restoration. It is actually composed of twenty-one separate segments. Three large circular panels illustrate scenes from Greek mythology, set within an intricate overall pattern of geometrical shapes, classical figures, and foliage. The central theme has been identified as the birth of Aphrodite, goddess of love and beauty. At the north end is the story of Apollo, god of the sun, music, and poetry, and his pursuit of Daphne, and at the south end is the legend of Pluto, god of the underworld, his wife Demeter, goddess of the harvest, and their daughter Persephone. A decorative design of geometric and floral motifs forms a framework for the various scenes. The paintings were executed in France by French artist Louis Pierre Rigal and shipped to Chicago in 1926. The present Palmer House replaces two earlier structures: the first opened in 1871 and burned to the ground soon afterward in the Great Fire; the second, completed in 1873, was replaced in 1925 by the present hotel. It was commissioned by the Palmer estate, set up by nineteenth-century real-estate baron Potter Palmer. He and his wife Bertha were

CENTRAL AREA

30

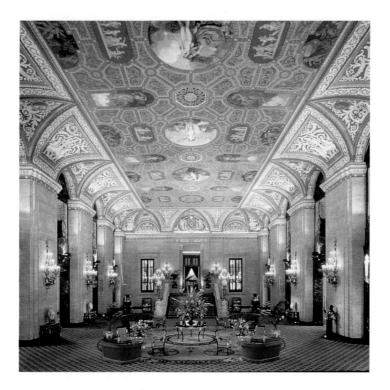

leaders of Chicago society, and they played important roles in the city's history. Today it has the distinction of being the oldest continuously operating hotel in the country.

Palmer House Hilton, undated view of lobby. Courtesy of the Palmer House Hilton.

14 ▶ Union League Club

Patria, 1926

Union League Club main lounge, 65 West Jackson Boulevard
Oil on canvas, 12' x 7'10"
ARTIST: Edwin Howland Blashfield (1848–1936)
COMMISSIONED BY: the Union League Club of Chicago

Edwin Blashfield was commissioned by the board of directors of the Union League Club to create a mural that would symbolize the club's patriotic motto. Adopted at its founding in 1887 and inscribed on the fireplace below the mural, it reads: "Welcome to Loyal Hearts. We join ourselves to no party which does not carry the flag and keep step with the music of the union." Blashfield received his academic training in Paris, and his work represented the European Beaux Arts tradition that also dominated the art and architecture of Chicago's 1893 World's Columbian Exposition. His allegorical composition relies heavily on symbolism and eschews realism for idealization. Five female figures are arranged in formal poses around a shield that bears the motto "Patria," or "country." The proud figure of Columbia stands in front of furled American flags and holds the Constitution to her bosom. Blindfolded Justice sits to the left with her scale raised. To the right is Fortitude, leaning on her shield, helmet and sword ready to protect Justice. The handmaidens of Loyalty sit below and rest their arms on a wreath of laurel that stands for victory and is bound by white ribbons signifying peace. Only a few years after the mural was completed, the club's art committee briefly questioned its style and considered replacing it with something more "virile and colorful" that would suggest "the progressive and masculine spirit of [the] club." Now welcoming women members, the Union League Club received its first work of art as a gift in 1886, and today it has over 750 artworks. As of 1996, the collection continues to grow through purchases funded by the allocation of one-half percent of annual membership dues.

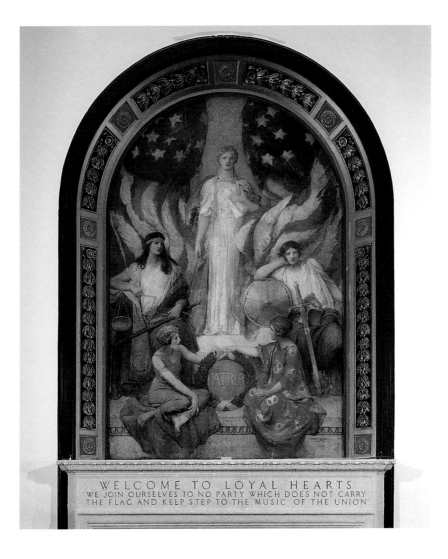

Union League Club, *Patria,* by Edwin Howland Blashfield, 1926. Oil on canvas, 12' x 7'10". Photograph by Michael Tropea, commissioned by and in the collection of the Union League Club of Chicago, UL1926.1.

15 ▶ Wacker Tower

United States Map, 1927–28

Wacker Tower lobby (formerly the Chicago Motor Club Building)
68 East South Water Street
Oil on canvas, 19' x 29'
ARTIST: John Warner Norton (1876–1934)
COMMISSIONED BY: the Chicago Motor Club

High above the elevators in the two-story lobby of this art deco building is a giant mural map of the United States showing nineteen major auto routes across the country during the 1930s. It was considered useful as well as decorative. The building was designed for the Chicago Motor Club, erected in 1927–28, and the map suggests the help the club offered its members in planning automobile travel. Holabird and Root, architects of the building, chose artist John Warner Norton, whose modernist style marks a change from his earlier, more academic work. Norton has rendered the map as a flat expanse, using geometric motifs to depict cities, parks, mountains, lakes, and rivers. He used pale green, grays, tan, and orange red, with lettering in red and blue. The lobby has been restored; its beautiful glass-and-metal hanging light fixtures and floral patterned trim echo the lines of the slim, symmetrical facade of the building. No longer the home of the Chicago Motor Club, the former office building may be converted to luxury apartments.

▶ Wacker Tower, *United States Map*. Photograph by Ted Lacey, courtesy of Wacker Tower.

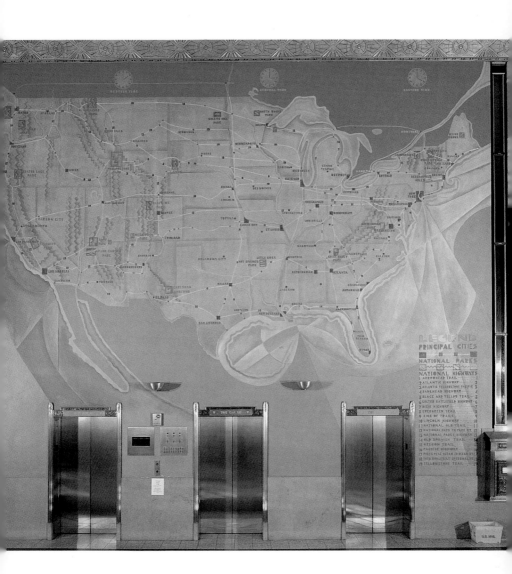

16 ► Tavern Club

Pagan Paradise, 1927–28

Tavern Club, Palm Room, 333 North Michigan Avenue
Oil on canvas, three walls
ARTIST: John Warner Norton (1876–1934)
COMMISSIONED BY: the Tavern Club

Artist John Warner Norton was a founding member and later president of the Tavern Club, whose members were mostly artists, architects, musicians, and writers. Norton created murals for the walls of a lounge called the Palm Room, which was furnished and decorated by Winold Reiss of New York and Johns Hopkins of Holabird and Root, who used colors to complement the artist's palette of gray, blue, and yellow green. Although the room has been refurnished, the murals have survived. Lush scenes of tropical vegetation inhabited by exotic birds and beautiful native figures cover three of the walls. The club, which overlooks the Chicago River and Lake Michigan, is on the top floor of a beautiful art deco building designed by Holabird and Root. John Root, son of the earlier Root who designed the Rookery with Daniel Burnham, called the murals "truly modern" and commented that they "divert one's mind to a pre-Adamite Garden of Eden." He added that the figure of the philosopher in one panel might indicate that "thought as well as pleasure is a part of the Tavern's ideals." In 1931 the murals won the Architectural League of New York's Gold Medal of Honor for mural painting.

CENTRAL AREA

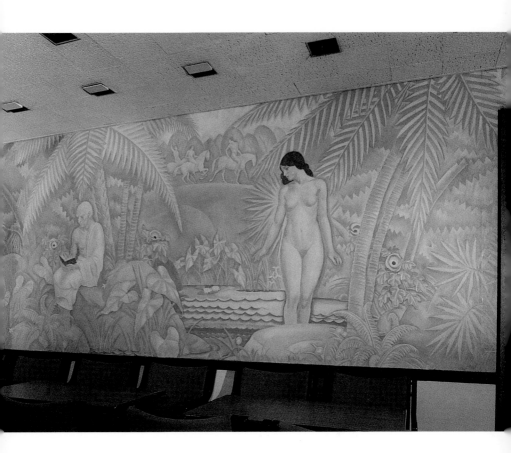

Tavern Club, *Pagan Paradise*, detail, one of three walls. Photograph © by Don DuBroff, courtesy of the Tavern Club.

17 ▸ Tavern Club
Love through the Ages, 1950s

Tavern Club, Edgar Miller Room, twenty-sixth floor
333 North Michigan Avenue
Oil on canvas
ARTIST: Edgar Miller (1899–1993)

Love through the Ages begins with the amoebas and protozoa. Advancing through time, panel by panel, artist-craftsman Edgar Miller depicts pairs of lovers in appropriate settings as cave dwellers, Sumerians, Egyptians, Greeks and Romans, Crusaders, and Renaissance men and women. Cortés and the Conquistadors introduce "love" to America, and the Puritans, antebellum Southerners, Gold Rush miners, Brigham Young and the Mormons, World War I soldiers, and Frankie and Johnnie from the Prohibition era continue the theme. The final scene is the rape of Peace by Hitler, Mussolini, and Hirohito and the depiction of the future as the age of space travel. Club member Edgar Miller had painted an earlier version of *Love through the Ages* for the same space in 1933, but it was removed when the room was modernized. Those canvases were divided into eighty individual panels and sold at auction. Years later, the club has recovered some of them, which now hang in a nearby hallway, providing an interesting comparison in techniques. Miller was both an artist and a craftsman who worked in many mediums and created architectural ornamentation in stained glass, tile, and mosaics during his long career in Chicago.

▸ Tavern Club, *Love through the Ages,* two details. Photograph by Larry Zgoda.

18 ► Civic Opera House

Fire Curtain, 1929

Civic Opera House, 20 North Wacker Drive
Oil on canvas mounted on steel, 35' x 55'
ARTIST: Jules Guerin (1866–1946)

A lively mural in shades of vermilion, salmon, and gold with accents of blue, green, and ivory is hand painted on the steel fire curtain of the Civic Opera House, built in 1927–29. When the curtain is lowered before performances and during inter- missions, it is the dramatic focal point of the large auditorium. Richly patterned side walls and ceiling lead the eye toward the proscenium arch, which serves as a deep golden frame for the curtain. Its painted frame and partitions match the real architectural paneling and echo the basic colors of vermilion and gold used throughout the auditorium and its grand foyer and lobby. Described in a 1930 ar- ticle as "high carnival," the mural depicts characters from over forty operas as a crowd of merrymakers, dancers, and musicians waving banners and pennants, carrying lanterns, beating drums, clanging cymbals, and blowing horns. Costumed figures suggest operas such as *Carmen, Madama Butterfly,* and *Pagliacci.* Jules Guerin worked closely with the building's architects, Graham, Anderson, Probst and White, in designing all the interior spaces. Although compatible with the art deco space, Guerin's mural retains some of the Beaux Arts style of the 1893 fair that characterizes his earlier work. The complex, built during the 1920s boom for an earlier opera company, contains both opera house and office towers and has been home to the Lyric Opera Company since its inception in 1954.

► Civic Opera House, fire curtain. Photograph by John Miller, © Hedrich Blessing/Lyric Opera of Chicago.

19 ► Merchandise Mart

Merchandise around the World, 1930

Merchandise Mart lobby
Merchandise Mart Plaza between Wells and Orleans Streets
Oil and gold leaf on canvas, seventeen panels
ARTIST: Jules Guerin (1866–1946)
Restored in 1991

Although it was built over seventy years ago, the Merchandise Mart remains the world's largest wholesale buying center, with nearly four million square feet of offices and showrooms for home furnishings and gift items. The Marshall Field estate completed the handsome art deco building in 1930 for its administrative offices and as a centralized market for manufacturers, distributors, and importers. The Kennedy family bought the building in 1945 but recently sold it. Its spacious two-story ground-level lobby faces the river and features "a panorama of the

world's commerce and industry," as depicted in seventeen panels mounted at the second-story height above a frieze of American Indian and Mayan decorative elements. Visible between the imposing square marble pillars that form an inner colonnade, but at a height that makes details hard to see, the murals are delicately colored in shades of rose, green, brown, and cream, with backgrounds of gold leaf made to resemble tiny inlaid squares. On each panel is a market scene from a different country: Turkish rugs and textiles are sold in a bazaar near a mosque; silk and pottery markets flourish near Japan's Mount Fuji; sleighs carry furs past the Kremlin in Russia; commercial ships sail along Germany's Rhine; a caravan of camels bearing Egyptian cotton files past a pyramid; and merchants sell their wares in the public square of Berne, Switzerland, with oversize watches in the lower corners of the composition. Jules Guerin, who was influenced by the Beaux Arts style of Chicago's 1893 fair, collaborated with architects Graham, Anderson, Probst and White on two other Chicago buildings. The Merchandise Mart murals illustrate the transportation aspect of trading and are closely related to Guerin's murals at the Bank of America, which depict the act of trading.

Merchandise Mart: *Merchandise around the World:* ▲ *Turkey;* ◄ *Switzerland,* two of seventeen panels. Photograph by Ted Lacey.¨

20 ▶ Chicago Board of Trade Building
Ceres, 1930

Chicago Board of Trade Building, twelve-story atrium addition
141 West Jackson Boulevard
Oil on canvas, 31'6" x 8', with frame 57'6" x 15'
ARTIST: John Warner Norton (1876–1934)
COMMISSIONED BY: Holabird and Root

The free-standing painting of Ceres, whom traders called "lady luck," provides a focal point for the soaring twelve-story atrium of the 1980 addition to the Chicago Board of Trade Building, built in 1929–30. Originally the mural presided over the trading room, attached to the walls with a lead glue that presented difficulties when the lowering of the ceiling necessitated its removal in 1974. Beautifully restored and remounted, it now stands over fifty feet—five stories—high in its structural framework of grid-patterned steel that repeats the blue green of the atrium. Ceres and her frame present a focus, both visual and psychological. John Warner Norton portrayed her as an exotic and statuesque goddess of fertility, standing in a field of tall wheat, corn, and oats, the symbols of her bounty and central to the Board of Trade's activity. In the background is the city's skyline. Ancient Greeks and Romans worshiped Ceres as a mother goddess and patroness of agriculture. The steel and glass atrium, designed by Murphy/Jahn, pays tribute to the excellence of Holabird and Root's handsome limestone building, once the tallest in the city, while imaginatively blending old with new. It has been acknowledged as a sensitive postmodern adaptation of the historical art deco structure and considered a worthy offspring to the "mother building."

▶ Chicago Board of Trade Building, *Ceres*. Courtesy of the Chicago Board of Trade.

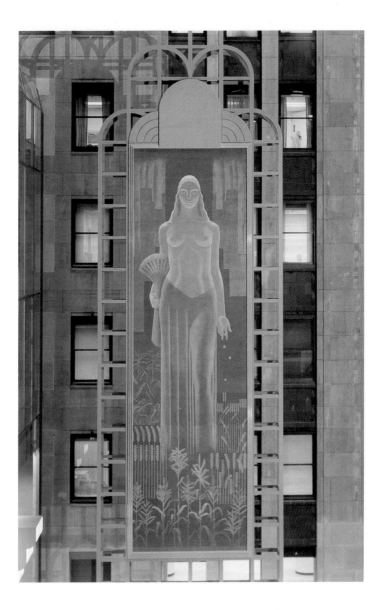

21 ▶ Union League Club
Scenes from the Union League Club Boys' and Girls' Clubroom, 1935

Union League Club, eighth floor, room 816, 65 West Jackson Boulevard
Oil on canvas
ARTIST: Miklos Gaspar (1885–1946)
COMMISSIONED BY: the Union League Club of Chicago

The Boys Club was founded originally by the Union League Club in 1919 because of the members' concern for the many "underprivileged" boys living in congested neighborhoods on the West Side of the city. They believed the boys lacked the guidance and direction to become "good citizens." Its mission today is to "promote the "social, moral, educational, physical and vocational development of [both] boys and girls." Raising the necessary funds by subscription, the members formed a foundation and turned an old building on the West Side into Boys Club number one. In the next few years a second clubhouse and a two-hundred-acre summer camp near Kenosha, Wisconsin, were developed. By the 1950s more than fifty thousand boys were alumni of the club. The murals in the Union League "Boys' and Girls' clubroom," dedicated in 1935, familiarized the members of the Union League Club with the activities of the Boys Club summer camp, both recreational and educational. Boys of all ages served as models for the charming and often amusing vignettes that fill all four walls of the room, from floor to ceiling. Among the illustrations are scenes of arts and crafts, swimming, boxing, wrestling, band practice, dramatic performances, hiking, physical exams, and counseling. The record states that artist Miklos Gaspar was paid $500 for his work.

▶ Scenes from the Union League Club Boys' and Girls' clubroom: (a) *Tug of War;* (b) *Saluting the Flag;* (c) *At the Lake;* (d) *In the Swimming Pool.* Photographs by Michael Tropea, oil on canvas, commissioned by and in the collection of the Union League Club of Chicago, UL1935.1.

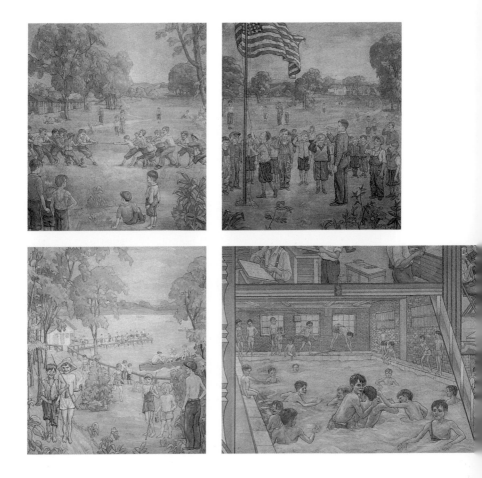

22 ▸ Rookery Building

History of Ships, 1936

Private offices, Rookery Building, 209 South LaSalle Street

Oil on canvas, two segments: 4'8" x 21'3" and 4'7" x 7'3"

ARTIST: Unsigned, attributed to Gustaf Oscar Dalstrom (1893–1971)

COMMISSIONED BY: the Works Progress Administration, Federal Art Project

Two mural panels dominate a very large meeting room in the business offices of a private firm, part of its collection of early Chicago art and artifacts. Originally one long mural measuring thirty-one feet, it has been divided into two unequal sections. In the larger one, five carefully detailed large ships illustrate the history of shipbuilding, from a tall-masted schooner to a paddle-wheel boat, river boat, and modern (1930s) steamer. They are shown along a river, with mountains in the

background. In the other section, three figures in period dress watch the older boats while two workmen and a shipbuilder, looking at his blueprint, stand in front of the steamer and appear to be working on a new assembly. It is believed that the mural was commissioned in 1936 by the WPA for the Lawson School, built in 1896 and demolished sometime after 1982. It was one of a pair of murals that were mounted on the third floor of the school; the other was called *History of Transportation*. Although unsigned, the murals bear stylistic similarities to work by Gustaf Dalstrom, Chicago muralist and Illinois Art Project supervisor, who worked in several other Chicago public schools. Although it is not known how these historical murals came to be "found" in an antique dealer's shop, it is fortunate that they were saved from destruction. They were subsequently restored professionally and are now part of a significant collection of early Chicago paintings and architectural fragments.

Rookery Building, *History of Ships*, detail. Photograph by Ted Lacey.

23 ▶ NBC Building

History of Transportation, 1937

Brinks, Hofer, Gilson and Lione
NBC Building, suite 3600, 455 North Cityfront Plaza Drive
Oil and tempera on canvas, two panels: 3'5½"x 11'8" and 3'5½" x 10'4½"
ARTIST: Unsigned, attributed to Gustaf Oscar Dalstrom (1893–1971)
COMMISSIONED BY: the Works Progress Administration, Federal Art Project

History of Transportation is believed to be one of a pair of murals commissioned
by the WPA for the Lawson School in Chicago. The other mural is titled *History of
Ships.* When the school was demolished sometime after 1982, it was assumed
that the murals were also destroyed. Instead, through unknown but fortunate cir-
cumstances, they were recovered in an antique dealer's shop and professionally
restored. Each is now in a downtown office, part of a private collection. *History*

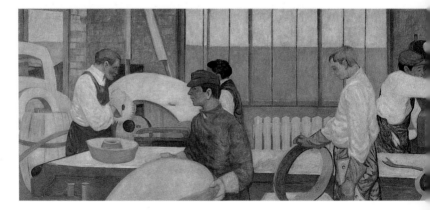

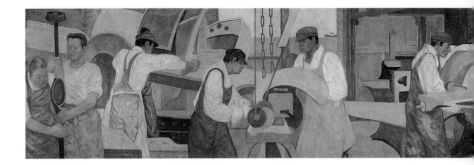

of Transportation hangs on the walls of Brinks, Hofer, Gilson and Lione, a large law firm specializing in patent law and intellectual property. According to New Deal records, the mural commissioned for Lawson School was one long panorama thirty-one feet in length. Its present length may be due to damage incurred in its removal from the school walls, and it is thought to have been divided into two more manageable segments during restoration. The two panels illustrate an automobile plant along a river or lake, with a ship and water visible through the windows in the background. The depiction of machinery and tools from the 1930s appealed to the lawyers in this firm, who see a variety of inventions in their legal practice. In one panel, a 1930s car in the background demonstrates the finished product being created by the six busy men working along an assembly line. In the

second, the prow of a large ship depicted at the rear of the scene may represent the means of transport for the automobiles the men are assembling, or it may be a clue to the location of the plant. The scene is thought to resemble the Ford Motor Company plant on the Rouge River in Detroit. Although the murals are unsigned, they are attributed, through stylistic similarities, to Gustaf Dalstrom, who was active in the Chicago WPA program as a muralist and an administrator.

NBC Building, *History of Transportation:* ◄ left portion: ▲ right portion. Murals commissioned by the Works Progress Administration, Federal Art Project, reprinted by permission of Brinks, Hofer, Gilson and Lione.

24 ▶ City Hall

The Blessings of Water, 1937

City Hall, Service Center (formerly the Water Bureau)
LaSalle and Randolph Streets
Fresco, 10' x 27'
ARTIST: Edward Millman (1907–64)
COMMISSIONED BY: the Works Progress Administration, Federal Art Project
RESTORED BY: the Department of General Services, 1995

When the ground-floor Water Bureau at City Hall was remodeled in 1970 the room was divided into two spaces, and the WPA mural painted in 1937, called *The Blessings of Water,* was covered by a false wall. The fresco, with its dramatic depiction

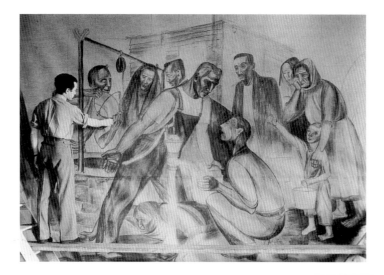

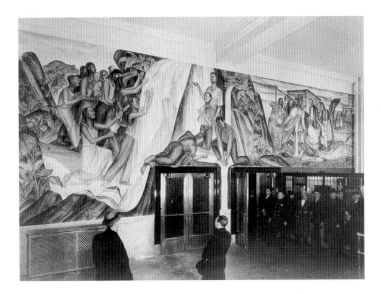

of the terrible suffering in the dust bowl areas of the country during the 1930s, was hidden for twenty-five years. But in 1995 the space was redesigned and the wall removed, revealing a mural that could be successfully restored. It is an especially fine example of the artworks commissioned for public buildings during the depression years, when President Roosevelt's New Deal created the WPA and its Federal Art Project to provide needed work for artists. Using the fresco technique he had learned from Diego Rivera in Mexico, Edward Millman painted on freshly applied damp plaster, thus permanently fusing paint with the plaster as it dried. The benefits of water counterbalance the miseries pictured by its absence in an exuberant scene of people raising their arms toward an abundant waterfall. "Water," the Bureau's 1936 circular said, "is nature's gift to man, beast and vegetation. It heals the sick and refreshes the thirsty. It cools in summer and warms in winter. Without it life cannot exist."

City Hall: ◀ Artist Edward Millman at work on *The Blessings of Water*; ▲ *The Blessings of Water*. Courtesy of the Art Institute of Chicago, Works Progress Administration, Federal Art Project Photographs Collection, Ryerson and Burnham Archives; mural commissioned by the Works Progress Administration, Federal Art Project.

25 ► Loop Station Post Office

Great Indian Council—1833, 1938

Loop Station Post Office, 219 South Clark Street

Oil on canvas, 5' x 15'

ARTIST: Gustaf Oscar Dalstrom (1893–1971)

COMMISSIONED BY: the Treasury Section of Fine Arts for the Chestnut Street Post Office

This busy downtown post office is one of three buildings that constitute the Federal Center, built between 1964 and 1991, and it is typical of architect Mies van der Rohe's concept of the single-story pavilion. Hanging above the service windows

facing Adams Street and visible from the street is a large painting originally com-
missioned for the Chestnut Street Post Office during the New Deal era. It was one
of a pair; the other mural, titled *Advent of the Pioneers,* was painted by Dalstrom's
wife, Frances Foy, and has since disappeared.§ They were removed when the
Chestnut Street Post Office was converted to a movie theater in the 1980s. It had
been commissioned by the Treasury Section of Fine Arts, responsible for the em-
bellishment of post offices and other federal buildings being built or renovated,
and not by the better-known WPA. The appeal of the "almost naive pattern of trees
and tepees as well as . . . dignified portrayal of the Indians" in Gustaf Dalstrom's
mural was noted in the catalog for a 1940 Canadian exhibition of murals for fed-
eral buildings. A group of seated Native American men give their attention to their
leader, whose hands are outstretched as if imploring them to listen. The details
of dress, "authenticated by the most careful research," are lovingly rendered by
the artist, who favored this subject. The men are arranged in small groups fac-
ing the leader, some seated, others standing, and a few on horseback. The suc-
cess of this mural led to the much more extensive commission for the St. Louis
Post Office Dalstrom shared with fellow Chicago artist Mitchell Siporin.

Loop Station Post Office,
Great Indian Council —1833.
Photograph © by Don DuBroff,
courtesy of the U.S. Postal Service;
mural commissioned by the Trea-
sury Section of Fine Arts.

§*See "But Not Forgotten" section*

26 ▶ Standard Club

The Great Chicago Fire of 1871, 1954

Standard Club Lounge, 320 South Plymouth Court
Sandblasted and stenciled glass doors, each panel 18" x 18½"
Carved linoleum block panels, four panels, 6' x 12' each
ARTIST: Edgar Miller (1899–1993) COMMISSIONED BY: the Standard Club

Artist and designer Edgar Miller used the theme of the Great Chicago Fire to dec-
orate the doors and walls of the ground-floor cocktail lounge of the Standard Club.
The two glass-paneled doors have identical sets of motifs on their six panels. To
symbolize the fire, Miller has pictured a firehouse dog, a striding fireman, an over-
turned pail and stool, an upset oil lamp, a warning bell, and an 1871 city view. The
dim lighting of the lounge adds drama to the narrative depictions in the four black
linoleum panels that are mounted on the walls of the lounge. Miller said he chose
scenes that "catch the human pattern rather than the disaster itself." Using wood-
carving tools on the linoleum, he worked without preliminary sketches, saying
that "one line led me to another." He portrayed Mrs. O'Leary's barn and the sur-
rounding neighborhood, horse-drawn fire teams fighting the fire, various modes
of transportation used to escape the fire, and the rebuilding of the city. Below each
of the panels is a portion of the traditional story, still accepted at that time, and
told in the artist's own words:

It was a night no different than any other. In the dusk the lamplighter was finishing his round. Peo-
ple were getting married, having babies, and mourning over the newly dead. Near DeKoven Street
in the Patch as some called it, Mrs. O'Leary carried her milk pail into the barn with her stool and a
lamp to see by. A drunk dozed in the hay loft. Everything was as it should be. About three inches
of milk had gone into the milk bucket when the cow kicked. Over went Mrs. O'Leary, the milk and
the lamp. In no time the barn was afire and the house next door. No one knew as yet that Chicago
had started to burn.

Standard Club:
◄ glass doors; ▼ Great Fire
of 1871, one of four panels.
Photograph © by Don DuBroff,
courtesy of the Standard Club.

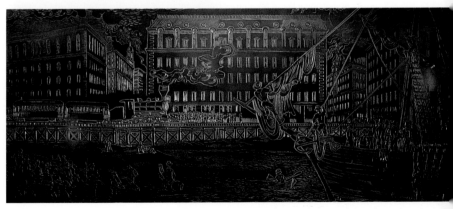

27 ► Standard Club
Transportation, Industry, Nuclear Research, Medicine and Science, Commerce, and *Art and Music* 1954

Standard Club Grill, second floor, 320 South Plymouth Court
Sandblasted glass, six windows
ARTIST: Egon Weiner (1906–89)
COMMISSIONED BY: the Standard Club

The windows of the second-floor grill with their decorative inset glass panels are a striking feature of the room. Designs created by the technique of sandblasting represent different attributes of Chicago in the 1950s. *Transportation* is suggested by a streamlined train, airplanes, and an open bridge; downtown skyscrapers and one of Ivan Mestrovic's equestrian sculptures, called *The Bowman and the Spearman,* stand for *Commerce.* The Art Institute and its bronze lions, Grant Park bandshell, and Buckingham Fountain depict *Art and Music;* and tall smokestacks, an explosive burst, and the university complex indicate *Nuclear Research. Medicine and Science* are illustrated by the Planetarium and crenellated university towers; and high-tension wires, a crane, and steel braces symbolize *Industry.* Both daylight and artificial lighting illuminate the designs. The artist Egon Weiner was active in Chicago primarily as a sculptor.

► Standard Club, *Commerce,* one of six windows. Photograph © by Don DuBroff, courtesy of the Standard Club.

CENTRAL AREA

58

28 ▶ Bank One Plaza

The Four Seasons, 1974

Bank One, 1 Bank One Plaza, Monroe and Dearborn Streets
Hand-chipped stone and glass mosaics, 10' x 70' x 14'
ARTIST: Marc Chagall (1887–1985)
COMMISSIONED AND FUNDED BY: Art in the Center and Mr. and Mrs. William Wood
Prince, the Prince Foundation, in memory of William Henry Prince

The Four Seasons, in the outdoor plaza of Bank One, is one of Chicago's best-loved
monuments. Russian-born French artist Marc Chagall was eighty-seven when he
presented his design to the city, saying he hoped his work of art would be "quiet
and restful." What he created is a fanciful view of the city as he remembered it from
thirty years before, incorporating familiar elements from his paintings such as
floating figures. Each season has its own prominent sun, and pictorial murals are
on all four sides. When Chagall came to Chicago two weeks before the unveiling,
he not only supervised the final work but brought it up to date by adding the Han-
cock Center with its cross-bracing, completed in 1970. Chagall's design was real-
ized in his studio in Biot, France, where the three thousand square feet of tiny
hand-cut stone and glass fragments of more than 350 different shades were cre-
ated. Mosaics are part of a long tradition, but outdoor mosaic surfaces are bet-
ter suited to a milder climate, and after more than twenty Chicago winters, *The
Four Seasons* required extensive restoration. The happy result is a handsome
structural canopy that not only protects it from harsh weather but functions as
an "outdoor room" that "appropriately showcase[s]" it. In praising the structure,
Tribune architecture critic Blair Kamin also wrote that the lighting hidden in the
opaque glass roof gives it a "wonderfully diffuse light," making the "newly reno-
vated . . . jewel-like tiles glisten."

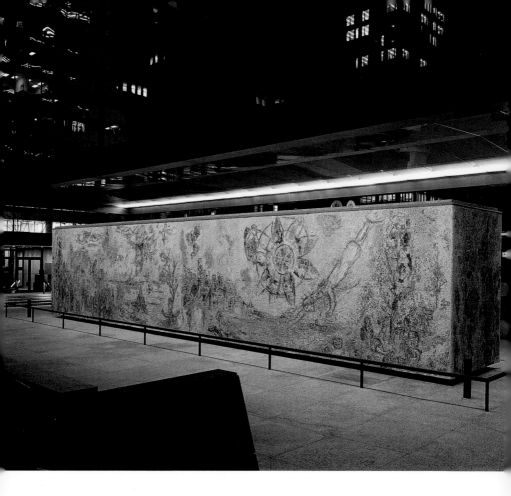

Bank One Plaza, *The Four Seasons*. Courtesy of Hedrich Blessing.

29 ➤ Social Security Administration Building
Chicago Murals, 1976

Great Lakes Program Service Center lobby and cafeteria
Social Security Administration Building, 600 West Madison Street
Lobby: Baked porcelain enamel on steel panel, 14' x 45'
Cafeteria: two panels, one 10' x 42' and one 10' x 60'
ARTIST: Ilya Bolotowsky (1907–81)
COMMISSIONED BY: the General Services Administration,
Art in Architecture Program

The horizontal stripes and blocks of bold colors of Ilya Bolotowsky's enormous lobby mural are visible through the glass entrance of the Social Security Administration Building. When the General Services Administration commissioned the murals, the architect of the building requested that they be constructed of baked enamel on porcelain and that the lighting be an unusual mercury vapor system. Bolotowsky was concerned about the use of these lights and felt challenged by being asked to create a mural in porcelainized steel, although he found it "perfectly legitimate . . . to use something that is strong and washable—and in texture a part of the building." He choose bold shades of blue, red, yellow, black, and white for the main lobby, "because as you enter you should have the strongest effect," and he picked a more subdued pastel color scheme for the smaller cafeteria space. The baked-enamel process made it difficult to obtain the exact shade of blue he wanted, and he feared that the mercury vapor lights would distort it further. To his great surprise, the distortion created by the lights worked to his advantage, and when he saw the mural he exclaimed, "Between the light—which many people disliked—and the limitations in the porcelainized steel colors, I managed to get the colors I really wanted." The three contiguous panels designed for the cafeteria are now in storage awaiting a new configuration of the space to accommodate a child-care facility.

Social Security Administration Building, *Chicago Murals*, lobby mural. Courtesy of the Fine Arts Program, Public Buildings Service, U.S. General Services Administration.

30 ▶ Chicago Board Options Exchange

Clouds over Lake Michigan, 1976

Chicago Board Options Exchange lobby (Relocated from Dresdner Bank)
400 South LaSalle Street
Glazed stoneware, 10' x 20'
ARTIST: Ruth Duckworth (1919–)
COMMISSIONED BY: the Dresdner Bank
DONATED BY: the Chicago Architecture Foundation, 1987

When the Dresdner Bank shifted its offices from the ground floor of the Board of Trade building to a higher one, it did not take the large stoneware relief it had commissioned from Ruth Duckworth because of the prohibitive cost of moving it. Instead, the bank decided to donate it to the Chicago Architecture Foundation. The foundation, finding a less expensive way, was able to relocate the work to the lobby of the Options Exchange, where it is now installed. *Clouds over Lake Michigan* is set into one of the marble walls of the irregularly shaped lobby space and can be seen from the street. Duckworth based her design on an enlarged map, just adding another river. The three-dimensional surface is made up of protruding fins and knobs that are characteristic of the artist's ceramic work. The large shape representing the lake is blue, and the land is rendered in a yellowish color. The lighting does not do justice to this impressive work.

▶ Chicago Board Options Exchange, *Clouds over Lake Michigan*. Photograph by Ted Lacey, courtesy of the Chicago Board Options Exchange, Inc.

31 ➤ 225 North Michigan

Chicago Architecture, 1983

Lohan Associates, 225 North Michigan Avenue
Oil on linen, 7'10" x 18'1"
ARTIST: Richard John Haas (1936–)
COMMISSIONED BY: Lohan Associates

As one of the first tenants in this building, architect
Dirk Lohan wanted to capture the splendid view of
Michigan Avenue he first saw in his unfinished of-
fice space, since he knew he would have to build
a partition that would block it. He chose Richard
Haas, who once said that his architectural murals
were "reinventions of things that didn't deserve to
die." Finding the view unworkable, Haas instead
created an imaginary scene of sixty-two significant
and historic buildings that constitute a virtual his-
tory of Chicago architecture. *Chicago Architecture*
hangs in the reception space of the Chicago offices
of Lohan Associates, a firm specializing in archi-
tecture, planning, and interior design. Included are
many firsts, such as the first Fort Dearborn of 1803;
the old Chicago courthouse of 1835; the Henry B.
Clarke house, oldest surviving house from 1836;
the First Baptist Church of 1853; the old Chicago
Water Tower of 1869; and the first Ferris wheel of

1893. He has also represented structures no longer standing, including Adler and
Sullivan's 1893–94 Stock Exchange Building, H. H. Richardson's Marshall Field
Wholesale Store of 1885–87, the 1893 World's Columbian Exposition "White City,"

CENTRAL AREA

and Frank Lloyd Wright's Midway Gardens of 1913–14. In the middle distance of the mural are some of the buildings put up during the boom that preceded the 1929 crash: the Chicago Board of Trade, Wrigley Building, Merchandise Mart, and Tribune Tower. Contemporary buildings form the backdrop of the composition and are rendered in a monochrome grisaille, in contrast to the full color of earlier structures. Marina City, Lake Point Tower, First National Bank, 333 West Wacker, the Hancock Center, and 860–80 Lake Shore Drive are some of these. Massed as if they stood on an island, the structures dwarf a tiny canoe and sailboat that drift by on the waters that delineate the foreground.

Private viewings by appointment only

225 North Michigan, *Chicago Architecture*. Photograph by Barbara Karant, Karant and Associates, Inc., courtesy of Lohan Associates.

32 ▶ 333 West Wacker
The Nuveen Painting, 1985

John Nuveen Company, thirty-third floor, 333 West Wacker Drive
Oil on canvas, eighteen panels, two sets of nine panels each
ARTIST: Jim Dine (1935–)
COMMISSIONED BY: the John Nuveen Company

In 1985 the John Nuveen Company, an asset management and investment bank-
ing firm, commissioned a major piece of art for its new headquarters. *The Nuveen
Painting,* the largest ever done by Jim Dine, is composed of two nine-panel seg-
ments that together nearly form a circle. The panoramic composition incorporates
most of the objects that have appeared in Dine's past work. Arranged side by side
across the two curving expanses of the company's oval reception area are per-
sonal images from Dine's own world: sculptural figures, bathrobes, trees, chairs,
hearts, and gates. The gnarled tree grew outside his Vermont studio, the tools
on the back of the chair are from childhood memories of his father's hardware
store, and the wrought iron gate refers to the studio entrance of his Paris printer's

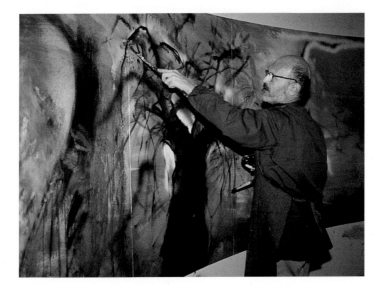

workshop. The robe first appeared in the 1960s, when Dine was identified with the pop art movement. He has used the image of the classical armless female torso in both painting and sculpture. Every image, whether it is the legs and back of a chair, the trunk of a tree, or the heart-shaped curves of the gate, suggests attributes of the human figure. The heart also refers to the artist's emotional self, and its varying colors express the spectrum of human feelings. All of Dine's uniquely expressionistic work is autobiographical. As he has said, "I paint the inside world . . . not the outside world."

Private viewings by appointment only

333 West Wacker, ◄ *The Nuveen Painting*, east wall; ▲ Jim Dine at work on mural. Courtesy of the John Nuveen Company.

33 ▶ **Bank One Building**
Untitled Mural, 1988-89

Bank One employee cafeteria
1 Bank One Plaza, Dearborn and Madison Streets
Lead-free oil paint, six walls in a one-block span
ARTIST: Karl Wirsum (1939–)
COMMISSIONED BY: the First National Bank

Karl Wirsum's expansive mural was commissioned by the First National Bank (now Bank One) to enhance the walls of the newly redesigned fifth-floor employee cafeteria. It was part of the bank's art program, begun in 1968. The mural covers six large interior walls, spanning an entire block from Dearborn Street to Clark Street and accommodating doorways, clocks, and signage. Wirsum has taken characteristically playful images from his own personal vision and spread them exuberantly across the long expanse. Composite characters, faces, bees, masks, flags, signs, toylike machines, and musical notes that also look like golf clubs are all recognizable. Many of the images are familiar from earlier paintings but are now more abstract and geometricized, using a range of colors that is more subdued. A second artist, Bruce Thorne, transferred Wirsum's designs onto the walls by enlarging the artist's small-scale drawings into full-size paper patterns. He then pricked holes along the outlines of the images and held these patterns against the walls, forcing powdered charcoal through the holes to define each image. This method, called "pouncing," has been used since the days of Michelangelo. With paint mixed to Wirsum's specifications, Thorne filled in the outlines. These full-scale patterns or templates can be used again for necessary repairs. Although the cafeteria is exclusively for the use of bank employees, the murals have been viewed by the many art-affiliated groups that tour the bank's considerable collection of paintings, drawings, tapestries, sculpture, and graphics.

Bank One Building, untitled mural, detail. Courtesy of the Art Collection of Bank One.

34 ▸ NBC Building
City of the Big Shoulders, 1989

NBC Building, west lobby, 200 East Illinois Street
Oil on canvas, 6' x 18'
ARTIST: Roger Brown (1941–97)
COMMISSIONED BY: Equitable Real Estate Investment Management

In 1916 Illinois poet Carl Sandburg described Chicago as "hog butcher for the world . . . city of the big shoulders." Taking the title from Sandburg's poem, Roger Brown has depicted Chicago as a string of skyscrapers stretched out along the lake, sitting atop a vast rural land-scape, in his first site-specific commission for the NBC Building. At the top of the composition he groups the tall downtown buildings in the center. He specifically delineates the NBC Build-ing, John Hancock Center, Sears Tower, and Amoco Building. At the very edges of the canvas are the nuclear cooling tower at Zion, Illinois, and the coal-op-erated power plant at Michigan City, In-diana. Beneath this cityscape is a vast grid with forty rectangular compart-ments. Just below the lake, on the next level, sixteen large trucks speed in both directions along an unseen high-way. Beneath them are green and brown fields, a few containing farm-

houses, barns, and silos. The lowest compartments are black, perhaps signifying both nightfall and the rich dark earth of Illinois farmlands. Brown was always interested in the darks, lights, and shadows of the city. He said that "light can come from anywhere; it doesn't have to come from one source" and that by not creating something exactly as it appears he "creates a sense of mystery." He cited the influence of southwestern artist Georgia O'Keeffe, who reverses the forms of her flowers, painting the high surfaces darker and the light as coming from behind. Although his work sometimes contained elements of humor, Brown also made his point of view clear. As one critic said, "Brown certainly is a painter of the American nightmare."

NBC Building, *City of the Big Shoulders*. Courtesy of the School of the Art Institute and the Brown Family.

35 ➤ Standard Club

Complex Forms with Color Ink Washes Superimposed, 1990

Standard Club Dining Room, 320 South Plymouth Court
Color ink washes on wall, 16' x 27'
ARTIST: Sol LeWitt (1928–)
COMMISSIONED BY: the Standard Club

The remodeling of the Standard Club's main dining room by Powell-Kleinschmidt called for the removal of a large tapestry that had hung on the back wall for many years. A committee of members from this more than a century old private club asked ten artists to submit their work, and from them they chose Sol LeWitt to create the large mural for this space. The four studies LeWitt submitted are exhibited just outside the dining room, a gift from the artist. Sol LeWitt is known for his three-dimensional structures and wall drawings. From his earliest work, exhibited in 1967, until about 1980 he limited his artistic vocabulary to basic geometric forms and primary colors. Describing his art in 1967, he wrote: "In conceptual art the idea of concept is the most important aspect of the work." He told art critic Alan Artner that listening to music, especially Bach, and reading about its structure has been a big influence in his thinking about art. LeWitt believes his job is to *conceive* the ideas for works but not necessarily to carry them out himself. Once he has made the plans for his wall drawings and prints, he lets others realize them. The Standard Club mural differs from the artist's previous wall drawings in its use of many colors and large, irregular planar shapes. Its rich, dramatic colors depart from the earlier, more limited palette, and the asymmetrical forms contrast with the regularity of previous linear drawings.

➤ Standard Club, *Complex Forms with Color Ink Washes Superimposed.* Photograph © by Don DuBroff, courtesy of the Standard Club.

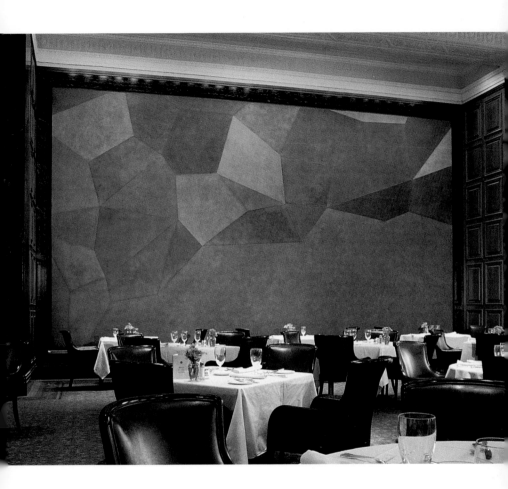

36 ➤ Harold Washington Library

Events in the Life of Harold Washington, 1991

Harold Washington Library main lobby, first floor, 400 South State Street

Ceramic mosaic tiles, 10'6" x 15'3"

ARTIST: Jacob Lawrence (1917–2000)

COMMISSIONED BY: the Chicago Department of Cultural Affairs, Percent for Art Program

A colorful mosaic mural at the end of the Congress Street corridor in the main lobby of the library celebrates the life and accomplishments of Harold Washington, the man for whom the new main library is named. It is one of the fifty artworks for the library commissioned through the city's Percent for Art Program. The long-awaited building has been called a fitting tribute to Chicago's first African American mayor, who was known as an avid reader. Pages of a book spread across a huge desk tell the story of the mayor's life and together form the metaphorical mountain he ascends to become the elected mayor of Chicago. Jacob Lawrence deliberately left the faces blank so that anyone can identify with the lessons of success through learning and hard work. Washington is portrayed as student, soldier, lawyer, congressman, and ultimately mayor and coalition leader. Through a deceptively simplified and unique style in which cubism, folk art, primitive art, and patterning merge, Lawrence has given powerful expression to the African American experience. He has been described as "an epic painter [who] reduces things to their essence," and this is exemplified by his sixty-panel *Migration Series* of 1940–41, one of his best-known works.

➤ Harold Washington Library, *Events in the Life of Harold Washington.* Photograph by Michael Tropea, courtesy of the City of Chicago Public Art Collection.

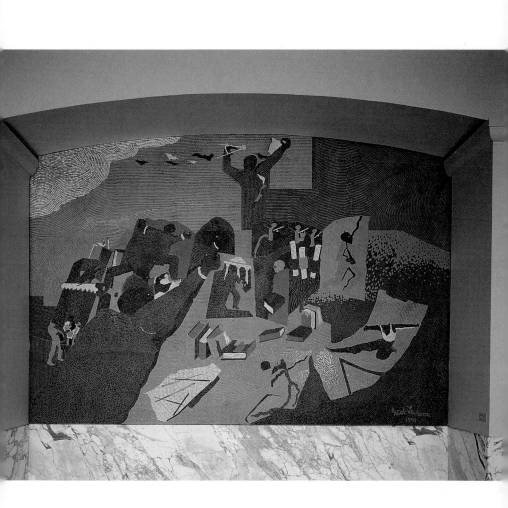

37 ▸ Harold Washington Library

To Soar III, 1991

Harold Washington Library main floor corridor, 400 South State Street
Acrylic hand-printed images, 20' x 120'
ARTIST: Nancy Spero (1926–)
COMMISSIONED BY: the Chicago Department of Cultural Affairs, Percent for Art Program

When the feminist art movement was developing in the 1970s, Nancy Spero de-
cided to use images of women exclusively in her work. Since 1988 she has made
a number of hand-printed installations documenting "women's transcendence,
throughout history," directly onto the walls of galleries and museums in this coun-
try and abroad. She described her Chicago commission as a visual response to
the existing architecture of the Congress Street corridor of the Washington library,
calling it "a processional frieze to run, march, leap along the center portion of the
corridor ceiling offering a non-sequential narrative, which will invite and provoke
all entering the institution." Concerned with rhythm, stylization, and contrast of
body types, Spero's images juxtapose past and present, and disparate cultures
and figures, presenting woman as "activator and protagonist." Often repeated
in multiple series, we see prehistoric fertility torsos, Celtic goddesses, Arab
women, classical Greek and Roman figures, Egyptian acrobats, body builders, run-
ners, and so on in varying sizes and scales. The sources for her imagery include
Paleolithic caves, Greek vases, classical friezes, and Egyptian tombs. The Harold
Washington Library, housing the city of Chicago's largest public art project, was
erected in 1991, designed by Hammond, Beeby and Babka, who won the com-
mission through competition with four other firms.

──────────

▸ Harold Washington Library, *To Soar III,* detail. Photograph by Michael Tropea, courtesy of the City of
Chicago Public Art Collection.

38 ▶ Harold Washington Library

Hi! We're Already Here, Back to Everything and Lemonade, 1991

Harold Washington Library, Thomas Hughes Children's Library
400 South State Street
Seven half-inch-thick plywood figures with acrylic paint; two large, three medium,
and two small
ARTIST: Karl Wirsum (1939–)
COMMISSIONED BY: the Chicago Department of Cultural Affairs, Percent for Art Program

The children's library on the second floor is spacious and cheerful. Its eighteen thousand square feet make it larger than most Chicago branch libraries. It has its own orientation area, a well-equipped learning center, a space for programs and presentation, more than seventy thousand volumes, and a children's lunchroom. The site-specific commission by Karl Wirsum in the children's semicircular amphitheater alcove features imaginative figures both mythological and technorobotic. The brightly colored images suggest a variety of cultures and are meant to inspire both children and adults to make up stories of their own. Wirsum wrote that in this modern alcove filled with his characteristic figures, he tried to recreate the warmth and intimacy of earlier times when "tales were told by the fireplace" and "staring into the flames the listener[s] created visions to accompany the stories they heard." Another of Wirsum's creatures, called "Plug Bug," is four blocks north on State Street.

▶ Harold Washington Library, *Hi! We're Already Here, Back to Everything and Lemonade,* detail. Courtesy of the Phyllis Kind Gallery and the City of Chicago Public Art Collection.

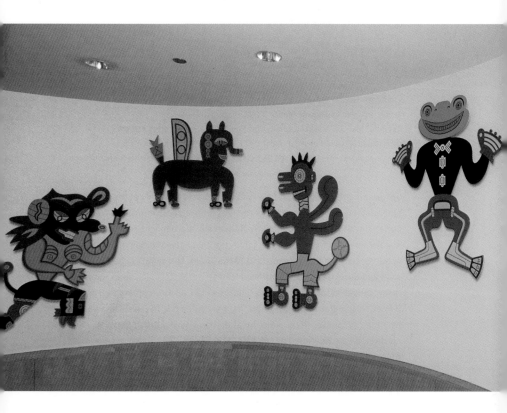

39 ► Harold Washington Library

Communidad Si, It Takes a Vision, 1991

Harold Washington Library Special Collections, ninth floor foyer
400 South State Street
Acrylic on linen, 500 square feet
ARTISTS: Marcus Akinlana (1966–), Nina Smoot-Cain (1943–), Hector Duarte (1952–),
Olivia Gude (1950–), Roberto Valadez (1962–), and John Pitman Weber (1942–)
COMMISSIONED BY: the Chicago Department of Cultural Affairs, Percent for Art Program

Six prominent Chicago muralists whose work was primarily outdoors have col-
laborated on this lively mural. For the first time, a popular form of street art as-
sociated with a specific community was seen in a prominent downtown location
and preserved indoors instead of left to the elements. Situated at the south end
of the Winter Garden on the top floor of the library, the mural wraps around door-
ways and down the length of the foyer leading to Special Collections. It integrates
many themes associated with the Chicago Public Art Group that also concerned
Harold Washington. This not-for-profit organization has been creating murals all
over the city for over thirty years. Neighborhood power, urban renewal, and eth-
nic diversity are illustrated by separate vignettes showing activities involving chil-
dren and adults of many races. Inscribed above the inner doorway against a view
of the Chicago skyline is this quotation from Harold Washington:

Most of our problems can be solved
Some of them will take brains
Some of them will take patience
and all of them will have to be wrestled like an alligator in a swamp.

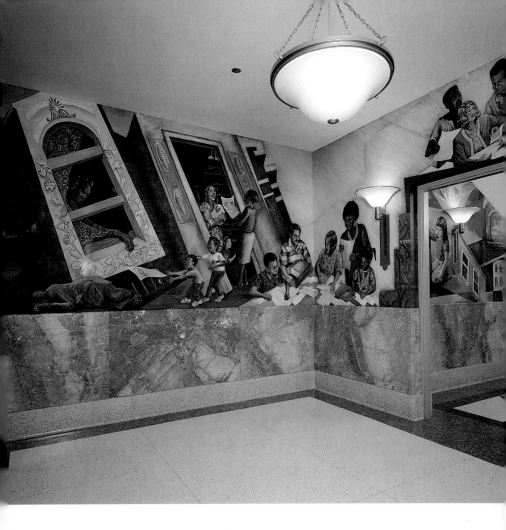

Harold Washington Library, *Communidad Si, It Takes a Vision*, detail. Courtesy of the City of Chicago Public Art Collection.

40 ▶ Commonwealth Edison Substation
Plug Bug, 1991

Commonwealth Edison Dearborn Street Substation, east wall
117–21 North Dearborn Street
Acrylic paint, 77' high
ARTIST: Karl Wirsum (1939–)
COMMISSIONED BY: Gallery 37

Karl Wirsum's futuristic firefly is painted on the east wall of the only surviving building of a three-acre site cleared by the North Loop Project. Victim of the early 1990s recession, the block is now scheduled for redevelopment. It became Gallery 37 through the collaboration of private and public funds, and hundreds of school-children have participated in hands-on training under tents set up on the lot during the summers. In winter it has operated as an outdoor ice skating rink. The giant mural is highly visible from State Street looking west. "I wanted the design to represent both nature and technology," said Wirsum, "so I combined the concept of a lightning bug as a natural source of energy with the fact that electricity makes society run like an efficient machine." Painted in bright Day-Glo colors, this purely imaginary creature is typical of the playful, good-natured images that constitute Wirsum's personal vision.

▶ Commonwealth Edison Substation, *Plug Bug.* Courtesy of the Phyllis Kind Gallery and Gallery 37.

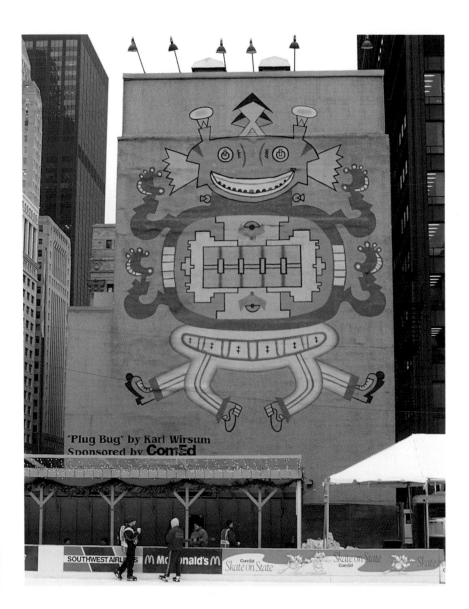

"Plug Bug" by Karl Wirsum
Sponsored by **ComEd**

41 ► Savings of America Tower

Arts and Sciences of the Ancient World: The Flight of Icarus and Daedalus and *Arts and Sciences of the Modern World: LaSalle Corridor Withholding Pattern,* 1991

Savings of America Tower, exterior facade and lobby
120 North LaSalle Street
Alcove above entrance: glass mosaic tiles, 22' x 57'; Lobby: glass mosaic tiles, 2'3" x 4'6"
ARTIST: Roger Brown (1941–97)
COMMISSIONED BY: Murphy/Jahn Architects and Ahmanson Commercial Development Company

An unusual presence along LaSalle Street is Roger Brown's large pictorial mosaic mural, his first project in this medium, installed over the entrance to the slim modern tower designed by Murphy/Jahn. The mural illustrates the ancient Greek myth

of Daedalus and Icarus, depicting father and son (the figures actually are identical) with outstretched wings, soaring in midair. In the story Daedalus, the architect and inventor, built a labyrinth where King Minos could confine the Minotaur, a monster who was half bull and half man. Later he angered the king and was imprisoned in his own labyrinth with his son Icarus, but he managed to escape by fashioning wings of feathers and wax. Icarus, the impetuous son, forgot his father's warning not to fly too high; the heat of the sun melted his wings, and he plunged into the sea. A smaller companion mosaic composition, mounted on a wall inside the lobby, has many of the characteristics of Roger Brown's paintings and represents Chicago's architectural and technological achievements. Here he presents a personal and rather mysterious scene of LaSalle Street with many-windowed skyscrapers, a silhouetted figure in each opening. and a strangely illuminated sky with planes overhead. Brown described the scene on a nearby plaque:

In the modern world, Chicago represents the great achievements in architecture and in the other arts and sciences as well. The goddess Ceres stands atop the Board of Trade building at the end of LaSalle Street watching over the "city of the big shoulders." On either side of the street, classical Greek facades of older buildings harmonize with the technology of newer ones. At any moment a plane may be seen circling overhead waiting its turn at O'Hare Field . . . the former myth of human flight now a reality. Daedalus, the mythological architect, may have felt at home here. He certainly foreshadowed the art and technology that brought this beautiful city into being.

Savings of America Tower: ◄ exterior, *Arts and Sciences of the Ancient World: The Flight of Icarus and Daedalus;* ▲ lobby, *Arts and Sciences of the Modern World: LaSalle Corridor Withholding Pattern.* Courtesy of the School of the Art Institute of Chicago and the Brown Family.

42 ▶ **Field Museum**
The Rift Valley of the Serengeti Plain, 1992

The Field Museum, Daniel and Ada L. Rice Wildlife Research Station
Lake Shore Drive at Roosevelt Road
Acrylic on canvas, 16' x 36'7"
ARTIST: Carol Christianson (1954–)
COMMISSIONED BY: the Field Museum

The Rice Wildlife Research Station is part of the larger Animal Kingdom exhibit called "Messages from the Wilderness." A replica of a research outpost on Tanzania's Serengeti Plain, the station is actually a resource center containing a library, videos, and computer programs for visitors to use. It is one of the Field Museum's eighteen re-creations of wilderness parks and wildlife preserves, from the Arctic Circle to Patagonia, created to focus attention on issues of conservation, overpopulation, and the fragile environment. The setting is enhanced by a large mural of the Rift Valley, with its vast plains, rocky outcrops, and distant mountains, which forms a dramatic backdrop and establishes the sense of place. Christianson came to the museum from her home in Victoria, British Columbia, and worked by herself for over a year during off hours. Using photographs and her imagination, she created a scene that people who have been to the Serengeti would swear they have seen. Many of the backgrounds of the dioramas and habitats throughout the museum have been preserved from earlier times. They were painted by Charles Abel Corwin, Julius Moessel, Arthur George Rueckert, and Charles K. Knight, whose dinosaur paintings have gained new interest, and by other remarkable artists working at the museum from the early 1900s through 1940. The beautiful Beaux Arts building, inspired by the ancient Greek temple, is the work of D. H. Burnham and Company, Graham, Burnham and Company, and Graham, Anderson, Probst and White.

Field Museum, *The Rift Valley of the Serengeti Plain.* Courtesy of the Field Museum, #GN86212c.

43 ➤ Riverwalk Gateway

Riverwalk Gateway Project, 1999–2000

Open pedestrian corridor, the underpass at Riverwalk and Lake Shore Drive, South bank of
the Chicago River
Sixteen pictorial murals, 6' x 9' each, painted on ceramic tiles, and
twelve linking tiles, 6' x 9' each
ARTIST: Ellen Lanyon (1926–)
COMMISSIONED BY: Chicago Public Art Program and the Chicago Department
of Transportation, Bureau of Bridges and Transit

In the summer of 2000, an open pedestrian corridor was completed that passes
under the Outer Drive bridge linking the south bank riverwalk to the southbound
lakefront waterway. It stands where the Chicago River meets Lake Michigan and

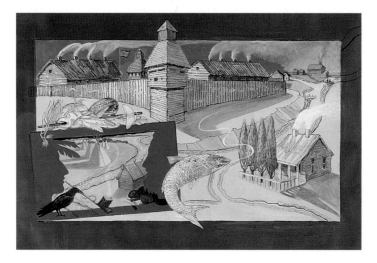

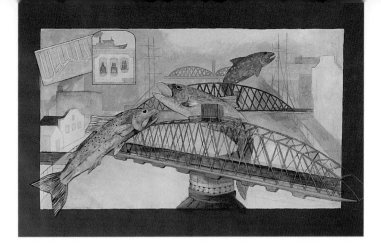

was designed by Skidmore, Owings and Merrill as a structure 170 feet long by 28 feet wide, of cast concrete with a well-lighted steel trellis overhead. Ellen Lanyon has created sixteen narrative vignettes illustrating the history of the Chicago River, painted on ceramic tile, fabricated by Sherle Wagner International, and mounted on the inner walls of the passageway, eight on each side. Events that have taken place along the river, the early and present-day bridges, and landmarks that border the river are depicted in composite scenes accompanied by explanatory text. Among the illustrations are the explorations of Marquette and Joliet along the Illinois and Chicago Rivers in 1673, Jean Baptiste Point du Sable's log cabin of 1784, the first house on the river's north bank, the first Fort Dearborn, 1802–12, the first Dearborn Street bridge, the Illinois-Michigan Canal with towpath, the reversal of the river's flow in 1900, the old Water Tower and filtration plant, Buckingham Fountain, and others. Connecting these scenes are twelve tiles that depict local vegetation and wildlife, the flora and fauna of Illinois, framed by geometric "river-flow-like" shapes, as artist Ellen Lanyon has described them. For this project she created individual six-by-nine-inch sketches, enlarged them to half the eventual size, and finally made full-size drawings. These were transferred to the tiles and then finished by the artist, who describes them as a work of art that carries a history lesson.

Near South
and Near West Sides

N

BUCKTOWN

DEPAUL

Milwaukee

Lincoln

Clark

Halsted

OLD
TOWN

North

LaSalle

LaSalle

State

Division

WICKER
PARK

GOOSE
ISLAND

Division

Elston

56

Chicago

NEAR WEST SIDE

Michigan

Fairbanks

Grand

I-90/94

Western

Damen

Ogden

Ashland

Halsted

Wacker

58

Madison

Wacker

LOOP

GRANT
PARK

Lake Shore Drive

Lake
Michigan

I-290 Eisenhower Expwy

61

Harrison

Congress

State

Michigan

Columbus

TRI-
TAYLOR

53 54 52
51

University
of Illinois
at Chicago

LITTLE
ITALY

University
of Illinois
at Chicago

Roosevelt

45

Dan Ryan Expwy

Meigs
Field

63

62

59

PILSEN

I-90/94

44

Archer

Indiana

King Dr

Cermak

CHINA-
TOWN

Lake Shore Drive

Blue Island

King Dr

I-55 Stevenson Expwy

31st

BRIDGEPORT

Illinois
Institute of
Technology

57

65

Archer

35th

Comiskey
Park

BRONZEVILLE

McKinley
Park

Pershing

64

DOUGLAS

Western Ave

Ashland

Halsted

SOUTH
SIDE

King Dr

Cottage Grove

44 **Second Presbyterian Church (1900–1901)**
1936 South Michigan Avenue
FREDERIC CLAY BARTLETT

45 **Smyth School (1910)***
1059 West Thirteenth Street
SIX ARTISTS†

46 **Gary School (1915)***
3740 West Thirty-first Street
PHILIP AYER SAWYER

47 **Gary School (date unknown)**
3740 West Thirty-first Street
ATTRIBUTED TO ROBERTA ELVIS

48 **Columbus Park Fieldhouse (1922)**
5701 West Jackson Boulevard
EDWIN TERWILLIGER

49 **Legler Library (1934)**
115 South Pulaski Road
RICHARD FAYERWEATHER BABCOCK

50 **Legler Library (1995)**
115 South Pulaski Road
JAMES KERRY MARSHALL

51 **UIC Medical Center (1937)***
833 South Wood Street
JEFFERSON LEAGUE

52 **UIC Medical Center, (1938)***
Polk and Wood Streets
RAINEY BENNETT AND RALPH GRAHAM

53 **UIC Medical Center (1938)***
1819 West Polk Street
EDWIN BOYD JOHNSON

54 **UIC Medical Center (1938–39)***
1819 West Polk Street
RAINEY BENNETT

55 **Lucy Flower High School (1940)***
3545 West Fulton Boulevard
EDWARD MILLMAN

56 **Chopin School (1940)***
2440 West Rice Street
FLORIAN DURZYNSKI

57 **Pilgrim Baptist Church (1943)**
3301 South Indiana Avenue
WILLIAM EDOUARD SCOTT

58 **United Electrical Workers Hall (1974)**
37 South Ashland Avenue
JOHN PITMAN WEBER AND
JOSÉ GUERRERO

59 **Casa Aztlan (1975–93)**
1831 South Racine Avenue
MARCOS RAYA

60 **Engine 44 Firehouse (1982)**
412 North Kedzie Avenue
MARK ROGOVIN AND
BARBARA BROWNE

61 **Reliable Corporation (1984)**
1001 West Van Buren Street
RICHARD JOHN HAAS

62 **Lozano Library (1990)**
1805 South Loomis Street
CYNTHIA WEISS AND
HECTOR DUARTE

63 **Orozco Academy (1991–)***
1645 West Eighteenth Place
FRANCISCO GERARDO MENDOZA

64 **Donnelley Youth Center (1994–95)**
3947 South Michigan Avenue
MARCUS AKINLANA

65 **McKinley Park Library (1995)**
1915 West Thirty-fifth Street
AMY YOES

*Visits to schools marked with an
asterisk must be arranged with the principal †See page 100

Near South and West Sides

The murals in this section are in some of Chicago's oldest neighborhoods. Not too far from the central area are the communities of Back of the Yards, Bridgeport, Canaryville, and Pilsen. Gage Park and McKinley Park are farther out. They were settled by people, often immigrants, who came to work in the nearby slaughterhouses of the mammoth Union Stock Yards and the factories in the Central Manufacturing District, developed at the turn of the century.

The growth of the Illinois Central Railroad was also a continuing source of new job opportunities. And the development of the South Park system, with its educational and recreational facilities and programs, contributed importantly to the process of assimilation for the mostly first-generation American population.

During the 1930s and early 1940s, the Works Progress Administration commissioned murals for a number of public schools in these communities and an ambitious series at the University of Illinois at Chicago Medical Center.

Pilsen has been a port of entry for Mexican immigrants since the late 1960s, but it also houses an artist colony of Anglos. Representing its predominant Mexican American population, the many colorful outdoor murals affirm their heritage, depict their history, and pay homage in a special way to the great Mexican muralists of the 1920s. The Mexican Fine Arts Center is an important presence in the community.

44 ▶ Second Presbyterian Church
Tree of Life, 1900–1901

1936 South Michigan Avenue
Oil on canvas, 40' x 30'
ARTIST: Frederic Clay Bartlett (1873–1953)
COMMISSIONED BY: Howard Van Doren Shaw

Frederic Clay Bartlett's large mural recalling the Pre-Raphaelite school is one of the many artistic treasures that contribute to the beauty of this historic church. The original neo-Gothic structure, built in 1874, was modified in 1900 after it was damaged by fire. Architect Howard Van Doren Shaw and Bartlett collaborated to rebuild the nave and redo the interior, blending Arts and Crafts and Pre-Raphaelite styles. Many decorative elements of the church incorporate liturgical and medieval motifs: small painted plaster figures of bats, birds, snakes, and other grotesquerie at intersections of ceiling beams, a delicate grape and vine design on the bronze organ screens, and large carved angels set at several levels. Bartlett's mural, framed by a broad Gothic arch, rises high above the choir loft at the west end of the sanctuary. In their fine booklet on the church, Erne R. Frueh and Florence Frueh describe the "gigantic Tree of Life [that] dominates the foreground. Above this arches a great rainbow, and higher still, under a deep blue sky bursting with galaxies of twinkling stars, hovers a hierarchy of angels who sing and play medieval instruments." Its muted shades of red, green, blue, and gold are in harmony with the other decorations. Along both sides of the nave are twenty-two rare and exquisite stained glass windows by English and American masters including Louis Comfort Tiffany, Sir Edward Burne-Jones, John La Farge, and Louis J. Millet, dating from the 1890s through 1918.

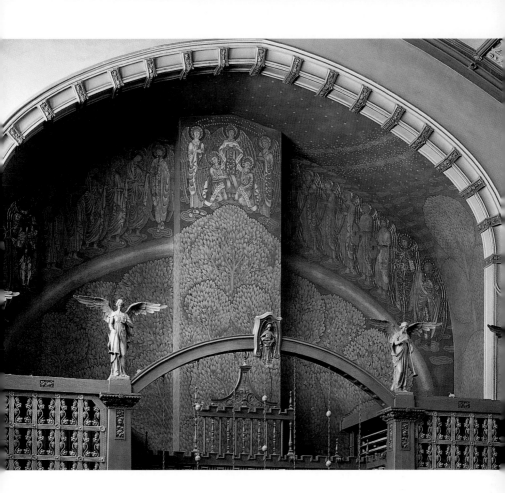

Second Presbyterian Church, *Tree of Life.* Photograph © by Don DuBroff, courtesy of Second Presbyterian Church.

45 ► Smyth School
Scenes from American History, 1910

John M. Smyth School auditorium, 1059 West Thirteenth Street
Oil on canvas, six murals
ARTISTS: S. B. Braidwood, Roy S. Hambleton, Dorothy Loeb (1887–?), Paul Turner Sargent (1880–1946), Gordon Stevenson (1892–1984), and G. Werveke
COMMISSIONED BY: the Smyth School
RESTORED BY: the WPA, 1936, and the Board of Education, 1998

Murals were increasingly popular as architectural decoration in the early decades of the twentieth century, and advanced students at the School of the Art Institute had the opportunity to create murals for a number of public schools. After instruction in the technical requirements of mural painting and study of the spaces to be decorated, students entered competitions for these commissions. The winner received a bonus for his or her work. Mounted on the walls of the Smyth School auditorium are six murals by different student artists that illustrate scenes from American history. Dorothy Loeb depicted Columbus and his three ships landing in the New World, and Gordon Stevenson painted the arrival of the Pilgrims. French explorers La Salle and Marquette are shown with a group of Native Americans in S. B. Braidwood's mural. George Washington and his troops are the subject of Roy S. Hambleton's painting. Paul Turner Sargent represented Revolutionary War soldiers and hunters crossing a frozen river, and G. Werveke pictured Abraham Lincoln in front of the White House.

► Smyth School, *Scenes from American History: Gordon Stevenson, Arrival of Pilgrims,* one of six panels. Photograph by Ted Lacey, courtesy of Chicago Public Schools, murals commissioned by the Works Progress Administration, Federal Art Project.

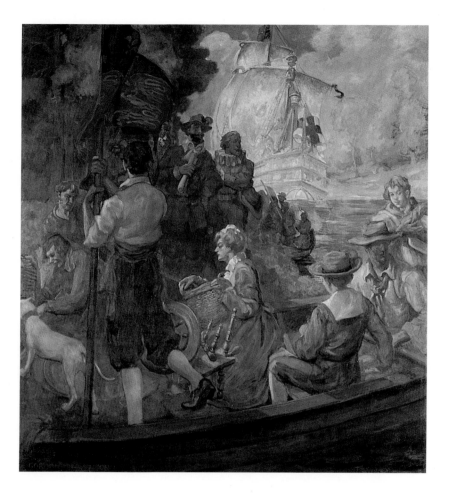

46 ► Gary School

Scenes from Chicago History, 1915

Joseph E. Gary School auditorium, 3740 West Thirty-first Street
Oil on canvas
ARTIST: Philip Ayer Sawyer (1863–1949)
RESTORED BY: the Board of Education, 1998

On the back walls of the stage in the Gary School auditorium, above the wainscoting, is a large, picturesque mural that celebrates the settlement of Chicago. It covers both back and side walls, and its scenes take place at sunrise along Lake

Michigan, depicted as a calm, very blue lake. On the side walls are scenes of early Chicago. To the left, encircling the doorway, Native Americans stand in front of a wooden fort, bargaining with a trader dressed in buckskin. Also in the scene are a missionary holding a book, probably the Bible, and a family in front of a tepee. On the right wall are settlers in a farmlike setting and several men standing guard. The larger mural on the back wall mixes allegory with history, presenting a central female deity as the spirit of Chicago, holding a torch and a large shield emblazoned with the emblem of Chicago, an inverted Y that stands for the three branches of the Chicago River. She sits on a ceremonial bench at the top of a grand stairway, and below her are the symbolic figures Music, Art, and Literature. To the right, on the horizon, are Columbus's three sailing ships and a group of historical and contemporary figures, including Abraham Lincoln. On the left is a modern industrial scene. The words "History" and "Progress" appear on the staircase risers.

Gary School, *Scenes from Chicago History,* detail. Photograph by Ted Lacey, courtesy of the Chicago Public Schools, mural commissioned by the Works Progress Administration, Federal Art Project.

47 ➤ Gary School

Characters from Fairy Tales, date unknown

Joseph E. Gary School, room 204, 3740 West Thirty-first Street
Oil on canvas, 5'3" x 21'
ARTIST:Unsigned, attributed to Roberta Elvis
COMMISSIONED BY: Undocumented but may have been commissioned by the Works
Progress Administration, Federal Art Project
RESTORED BY: the Board of Education, 1998

Spanning one wall above a bookcase, the mural features well-known characters
from fairy tales and was designed for this fifth-grade room when it served as the
school library. The panoramic mural includes Little Black Sambo, the Gingerbread

Boy, Jack and the Beanstalk, the Three Bears, Little Red Riding Hood, Mary, Mary Quite Contrary, and Jack and Jill. The depiction of familiar aspects of the stories makes them easy for children to recognize: for example, the wolf lurks behind Little Red Riding Hood, and Jack climbs his beanstalk. The mural was not included in the official WPA inventory, and there is no signature, although one may be obscured by a heavy bookcase that was obviously a later addition to the room. A rubber stamp legend along the edge says "Property of Board of Education—Gary School." The style is almost identical to other WPA school murals by Roberta Elvis in the Belding and May Schools. The presence of the WPA is also suggested by an easel painting that hangs in the room, labeled "WPA—Gift of the Class of 1939."

Gary School, *Characters from Fairy Tales*. Photograph by Ted Lacey, courtesy of the Chicago Public Schools, mural possibly commissioned by the Works Progress Administration, Federal Art Project.

48 ► Columbus Park Fieldhouse

Columbus's Ships, 1922

Columbus Park Fieldhouse refectory, 5701 West Jackson Boulevard
Oil on canvas
ARTIST: Edwin Terwilliger (1872–?)
COMMISSIONED BY: the West Park Commission
RESTORED BY: the Chicago Park District, 1992

Columbus Park is considered Jens Jensen's masterpiece. It was the talented land-
scape architect's first opportunity to create a large park in Chicago. It included
open meadows, a golf course, and ball fields. It also had a "swimming hole" pool,
playground, and council ring, Jensen's unique circular stone bench designed for
children's gatherings and storytelling. The Columbus Park Fieldhouse, designed
by Chatten and Hammond in the Mediterranean Revival style, is a handsome build-
ing, although not in the Prairie style that Jensen preferred. In the spacious meet-
ing hall, with its large arch-shaped windows, is a tympanum shaped mural paint-
ing of the three famous sailing ships of Christopher Columbus, mounted above
two doorways at one end of the room. Ornate ceiling beams and pilasters are dec-
orated with representations of the arms of Spanish explorers of the Golden Age.

───────────────

► Columbus Park Fieldhouse, *Columbus's Ships.* Photograph © by Don DuBroff, courtesy of the Chicago
Park District.

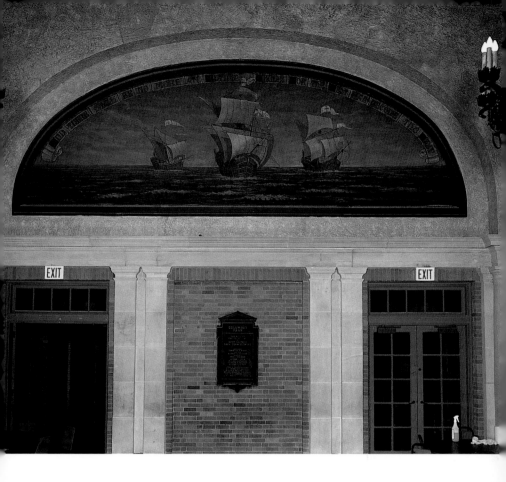

NEAR SOUTH AND NEAR WEST SIDES **107**

49 ▶ Legler Library

Father Marquette's Winter in Chicago, 1934

Henry E. Legler Regional Library, 115 South Pulaski Road (at Madison Street)
Oil on canvas, 11' x 18'
ARTIST: Richard Fayerweather Babcock (1887–1954)
COMMISSIONED BY: the Works Progress Administration, Federal Art Project
RESTORED BY: the Chicago Public Libraries, 1998–99

The Henry E. Legler Library was the first regional library in Chicago's Public Library system and is named for the man who believed that libraries should be "within walking distance of home for every person." As head librarian from 1909 until his death in 1917, Legler worked to make books available to all the neighborhoods. The handsome Beaux Arts style building, designed by Alfred S. Alschuler and erected in 1919, has been called a "distinctive landmark in an inner city landscape." Above the shelves in a small study room is a mural that depicts Native Americans and Jesuit missionary-explorer Jacques Marquette during his stay in the Chicago area in the winter of 1674–75. The scene is set on the snowy banks of a river or lake. Standing beside a Native American, wrapped in a blanket, Marquette watches as traders unload pelts and a dead deer from a canoe paddled by a Native American. In the background, a family stands in front of their tepee set among the trees, and a settler with a rifle is in front of a large log cabin. Marquette accompanied fellow Frenchman and cartographer Louis Joliet in his explorations in the New World and was the first European to describe the site of Chicago in his journals. He died that winter traveling back to his mission on the straits of Mackinac.

▶ Legler Library, *Father Marquette's Winter in Chicago.* Photograph © by Don DuBroff, courtesy of the Chicago Public Libraries, mural commissioned by the Works Progress Administration, Federal Art Project.

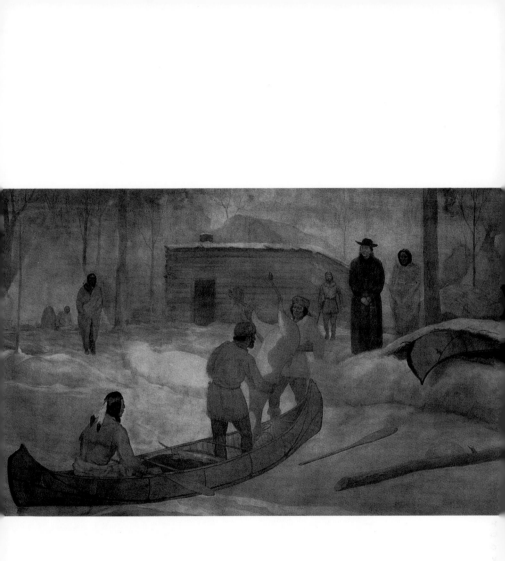

50 ▸ Legler Library
Knowledge and Wonder, 1995

Henry E. Legler Regional Library, 115 South Pulaski Road (at Madison Street)
Acrylic on canvas, 9'6" x 23'
ARTIST: Kerry James Marshall (1955–)
COMMISSIONED BY: the Chicago Department of Cultural Affairs, Percent for Art Program

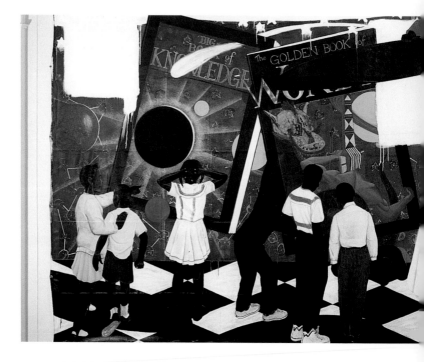

Addressing his mural to youthful viewers, artist Kerry James Marshall writes that he tried to incorporate "the kinds of things that young minds think and dream of: Outer Space, Monsters and Heroes and The Life Process." He hopes that young readers looking at the painting will identify with the life-size figures and enter the imaginary world he has depicted. With their backs to the viewer, these stylized figures, both children and adults, gaze at planets and stars, alternating with cells and molecules suggesting the origin of life and the vastness of the universe. Marshall was awarded a MacArthur Foundation "genius" grant in 1997. In addition to *Knowledge and Wonder,* the Legler Library has a mural commissioned by the WPA and a contemporary carved wood sculpture called *Floating Family,* by Elizabeth Catlett.

Legler Library, *Knowledge and Wonder.* Courtesy of the City of Chicago Public Art Collection.

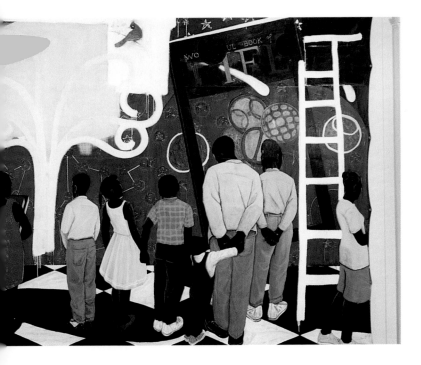

51 ► University of Illinois at Chicago Medical Center
The Story of Natural Drugs, 1937

University of Illinois at Chicago Medical Center, College of Pharmacy, rooms 32 and 36
833 South Wood Street, Chicago
Oil on Masonite, five panels: two 7'6" x 5'6" and three 7'6" x 2'
ARTIST: Thomas Jefferson League (1892–?)
COMMISSIONED BY: the Works Progress Administration, Federal Art Project

These brightly painted and highly decorative murals hang as framed panels on the walls of two large basement lecture halls in the College of Pharmacy. The subject matter is appropriate for pharmacological students, although the placement of the murals, moved from the original location for which they were commissioned, is not ideal. They illustrate the use of the indigenous Native American remedies, derived from natural sources, by Spanish explorers in the New World and their subsequent adoption into European medical practice. The two large murals in room 32 are arranged to be "read" chronologically from top to bottom, with more recent times given the most prominent position in the composition. In one the New World drug quinine is traced from the gathering of bark by Peruvian Indians, to manufacture by Spanish explorers and Jesuits, to transport to Europe in the seventeenth century. In the second, early settlers are being taught by Native Americans to identify and collect plants and bark, and an elaborately fitted out nineteenth-century apothecary shop is pictured, with a pharmacist, clerks, and two elegantly dressed women customers. In room 36 three narrower panels show foxglove plants being transformed into digitalis to treat sufferers from heart disease, mood-altering drugs manufactured from coca plants and cactus, and opium made from poppies and used to treat World War I soldiers.

► University of Illinois at Chicago Medical Center, College of Pharmacy, *The Story of Natural Drugs*, one of five panels. Photograph © by Don DuBroff, courtesy of the University of Illinois at Chicago, murals commissioned by the Works Progress Administration, Federal Art Project.

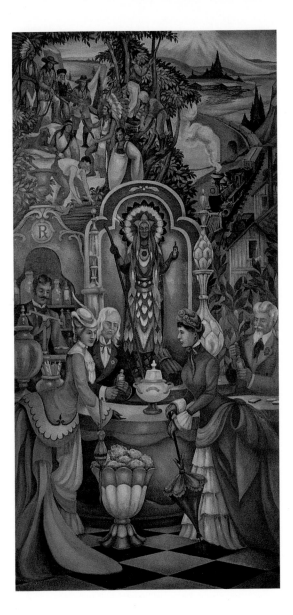

52 ▶ University of Illinois at Chicago Medical Center
The History of Anatomy, 1938

University of Illinois at Chicago Medical Center, Department of Emergency Medicine,
room 618 (formerly the Anatomy Museum), Polk and Wood Streets
Simulated stained glass oil washes and casein tempera on glass, ten windows with
individual panes 8" x 10" each
ARTISTS: Rainey Bennett (1907–98) and Ralph Graham (dates unknown)
COMMISSIONED BY: the Works Progress Administration, Federal Art Project
RESTORED BY: the University of Illinois at Chicago, 1981

Ten painted windows representing the study of human anatomy are hidden in a
large space that once housed the Anatomy Museum at the University of Illinois
Medical Center. Room 618 is currently the Department of Emergency Medicine and
has been partitioned into small individual offices from which the beautiful win-
dows that once illuminated the entire room must be viewed. In 1938 the museum
commissioned WPA artists Rainey Bennett and Ralph Graham to find a way to pro-
tect some of their fragile exhibits from the glare of sunlight. Working with the head
of the Anatomy Department, the artists developed an elaborate pictorial scheme
inspired by old books and manuscripts. Instead of just "daub[ing] some paint on
the windows," as had been suggested, they sandblasted the glass to create a
rough surface so the paint would stick, then used "thick black paint to simulate
leading and clear colors to look like stained glass." They then covered the pan-
els with another sheet of glass and sealed it with leading. More than two hundred

▶ University of Illinois at Chicago Medical Center, Department of Emergency Medicine, details from *The
History of Anatomy,* four of ten windows. Photograph © by Don DuBroff, courtesy of the University of Illi-
nois at Chicago, windows commissioned by the Works Progress Administration, Federal Art Project.

intricate individual illustrations trace the beginnings of the study of anatomy from a Cro-Magnon medicine man to Egyptian canopic jars containing embalmed organs and dissection of cadavers in the Middle Ages, also showing the course of evolution from protozoa to humans and depicting thirty-five great anatomists. The illusion of leaded stained glass is remarkable, and the multipaned casement windows have regained much of their original brilliance through a 1981 restoration.

53 ➤ University of Illinois at Chicago Medical Center

Great Men of Medicine, 1938

University of Illinois at Chicago Medical Center, College of Medicine West, room 119
Ground-floor faculty alumni center (formerly the Medical Library)
1819 West Polk Street
Fresco, nine panels, 2'6" x 1'6" each
ARTIST: Edwin Boyd Johnson (1904–?)
COMMISSIONED BY: the Works Progress Administration, Federal Art Project
RESTORED BY: the University of Illinois at Chicago

Portraits of nine men who were important to the history of medicine hang on the walls of the faculty alumni center, a handsome neo-Gothic room that was once the Medical School Library. They are individually framed fresco panels, placed above the bookcases and between the tall Gothic-arch windows. Represented are well-known scientists: the Frenchman Louis Pasteur, inventor of pasteurization, the Englishmen Charles Darwin, who propounded the theory of evolution, and Joseph Lister, who inaugurated antiseptic surgery. Also pictured are Ambroise Paré, a Frenchman who "made surgery a respected profession," Rudolf Virchow, a German who explained the cellular basis of disease, the Englishman Edward Jenner, who originated vaccination, the German Robert Koch, who discovered the tubercle bacillus, the Italian anatomist Marcello Malpighi, and William Harvey, who discovered the circulation of the blood.

➤ University of Illinois at Chicago Medical Center, College of Medicine West, *Great Men of Medicine: Louis Pasteur,* one of nine panels. Photograph © by Don DuBroff, courtesy of the University of Illinois at Chicago, mural commissioned by the Works Progress Administration, Federal Art Project.

54 ▶ University of Illinois at Chicago Medical Center

Map of the University of Illinois at Urbana-Champaign, 1938–39

University of Illinois at Chicago Medical Center, College of Medicine West, vestibule
outside room 106, 1819 West Polk Street
Oil on canvas, 8' x 12'
ARTIST: Rainey Bennett (1907–98)
COMMISSIONED BY: the Works Progress Administration, Federal Art Project

This map of the campus of the University of Illinois at Urbana-Champaign was
probably moved from another location. The medical center in Chicago was con-
solidated with Circle Campus in 1982 to form the University of Illinois at Chicago.
The mural is thought to have been designed by Rainey Bennett and executed by
other WPA artists. Bennett was supervisor of the WPA/FAP project at the univer-
sity from 1935 to 1938. In her 1995 *Guide to Art at the University of Illinois,* Muriel
Scheinman described the map as painted in "pale greens, violets, and other toned-
down (probably faded) hues Streets, trees, buildings, objects, and symbols
arranged in a grid pattern." Along the left side are a few buildings and Lorado
Taft's monumental sculpture "Alma Mater." Another mural of equal size, designed
by Bennett for the space, was titled *Apple Harvest and Farm Animals,* but it no
longer exists. The two-square-block University of Illinois medical and dental com-
plex was developed by Schmidt, Garden and Martin in 1920 but was altered
through the next four decades by subsequent architects. The original buildings
have hidden courtyards with sculpture and an archway decorated with attractive
mosaics, also from the New Deal period.

▶ University of Illinois at Chicago Medical Center, College of Medicine West, *Map of the University of Illi-
nois at Urbana-Champaign.* Photograph © by Don DuBroff, courtesy of the University of Illinois at Chicago,
mural commissioned by the Works Progress Administration, Federal Art Project.

55 ► Lucy Flower High School

Women's Contribution to American Progress, 1940

Lucy Flower High School, first-floor foyer, 3545 West Fulton Boulevard
Fresco, four walls, six panels: two 7'9" x 9', two 4'5" x 9', and two 9'2" x 9'
ARTIST: Edward Millman (1907–64)
COMMISSIONED BY: the Works Progress Administration, Federal Art Project
RESTORED BY: the Field and Bay Foundations and the Board of Education, 1996

Lucy Flower High School, now a coed institution, was established in 1911 as a girls' vocational school and remained so in 1940 when Edward Millman painted his powerful murals. Commissioned by the WPA, the murals covered the four walls of a foyer and were dedicated to the Lucy Flower student body, "the women of tomorrow," and to the "great figures of the past [who] have done much toward improving living conditions and raising cultural standards of America." Seven women, leaders and visionaries all, are depicted in scenes illustrating their re-

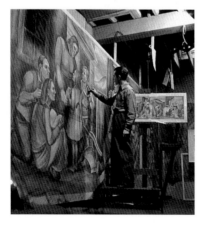

markable achievements. Jane Addams was a social worker and founded Hull House in 1900. Susan B. Anthony campaigned for women's suffrage during the nineteenth century. Grace Abbott, chief of the Child Labor Division of the Children's Bureau, 1921–34, focused on child labor. Clara Barton founded the American Red Cross after the Civil War. Lucy L. Flower worked to introduce kindergartens and technical training into public schools. Frances Perkins, labor secretary in Franklin Roosevelt's cabinet, 1933–45, was the first woman cabinet member. Harriet Beecher Stowe, best known for *Uncle Tom's*

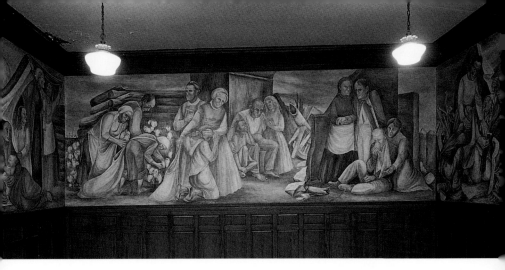

Cabin, was an ardent abolitionist whose writings in 1850–60 helped mobilize sentiments in the North against slavery. Harriet Tubman, a former slave, organized the Underground Railroad to help slaves escape from the South. Despite the excellence of the murals, painted in the tradition of the Mexican mural movement, with the subject matter agreed on beforehand, the finished mural offended some members of the Board of Education. Although the mural celebrates the bravery and vision of these women, it also depicts the suffering and deprivation they sought to alleviate. Members of the board deemed the subject matter, especially the representation of poverty, "depressing and misery-laden" and ordered the walls to be whitewashed in 1941, just eighteen months after the murals were completed. They remained invisible under a layer of calcimine for fifty-five years. In 1996, through the strenuous efforts of many interested people, led by the school principal Dorothy Williams, a combination of private and public funds made removal of the calcimine possible. The forceful images are vivid and fresh and "look as though they were painted yesterday," wrote a newspaper reporter after they were unveiled at a splendid ceremony.

Lucy Flower High School: ◄ Artist Edward Millman painting *Women's Contribution to American Progress.* Courtesy of the Art Institute of Chicago, Works Progress Administration, Federal Art Project Photograph Collection, Ryerson and Burnham Archives). ▲ *Women's Contribution to American Progress,* detail. Photograph by Tom Van Eynde, courtesy of the Chicago Public Schools.

56 ➤ Chopin School

Chopin and *Stephen Collins Foster,* 1940

Frederic Chopin School auditorium, 2440 West Rice Street
Oil on canvas with casein, two murals, 5' x 85' each
ARTIST: Florian Durzynski (1902–69)
COMMISSIONED BY: the Works Progress Administration, Federal Art Project
RESTORED BY: the Board of Education, 1998

The surprisingly beautiful auditorium of this school erected in 1917 has a barrel-vaulted ceiling, graceful balcony, and large mural mounted above the dado on each of the side walls, spanning the entire length of the room. Frederic Chopin and Stephen Foster are represented through imaginative recreations of their musical compositions. Chopin, who lived from 1810 to 1849, is shown in a contemplative pose, eyes closed, while an enchanting corps de ballet in pink costumes dances to his music. The romantic landscape at the other end of the painting may be a depiction of Poland, his native land. Seated at one end of the other mural, holding a sheet of music, is Stephen Foster, in a nineteenth-century setting of the American South. Foster, whose dates are 1826–64, composed over two hundred minstral songs and other pieces such as "Oh! Susannah." Beautifully costumed men and women who resemble the cast of an elaborately staged musical sing and dance, enacting scenes from Foster's songs. In the background, men unload bales of cotton at the side of a river, probably the Mississippi, while others look on.

Chopin School: (a) *Frederic Chopin;* (b) *Stephen Foster.* Photographs by Tom Van Eynde, courtesy of the Chicago Public Schools, murals commissioned by the Works Progress Administration, Federal Art Project.

57 ➤ Pilgrim Baptist Church
Scenes from the Life of Christ, 1943

Pilgrim Baptist Church (Formerly Kehilath Anshe Ma'ariv Temple)
3301 South Indiana Avenue
Oil on plaster
ARTIST: William Edouard Scott (1884–1964)
COMMISSIONED BY: Pilgrim Baptist Church

Dankmar Adler and Louis Henry Sullivan designed this structure for KAM Temple, Chicago's oldest Jewish congregation, just after they completed the Auditorium Building. Among its many similar elements are exterior Romanesque arches, gilded terra-cotta ornamentation, stained glass windows by Louis Millet, and the sanctuary's superb acoustics. In 1922 Pilgrim Baptist Church, founded in 1915, purchased the building from KAM when the congregation moved farther south. Restored in 1986, the structure remains an extraordinarily beautiful space for worship. The curved pews can seat fifteen hundred and are surrounded by a balcony banded above and below by geometric floral patterns of terra-cotta relief that extend across the half dome containing the pulpit. Overhead is an unusual tunnel-vaulted ceiling with clerestory windows. William Edouard Scott's murals were added in the 1940s and have taken their own place in the history of the building. Applied to the flat walls that surround the altar and the interior of the half dome are eight mural segments that illustrate important incidents in the life of Christ and also in the life of the church. These figural paintings, which incorporate quotations from the New Testament, stand out in bold relief against the neutral tones of the walls. There are additional murals in the foyer of the church painted by Scott, who studied at the School of the Art Institute. The building was given Chicago landmark status in 1981.

124

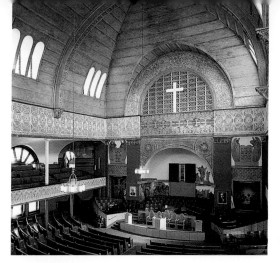

Pilgrim Baptist Church:
◄ interior. Photograph ©
by Judith Bromley 1999,
courtesy of Pilgrim Baptist
Church. ▼ *Scenes from
the Life of Christ,* detail.
Photograph by Ted Lacey,
courtesy of Pilgrim
Baptist Church.

58 ▶ United Electrical Workers Hall

Solidarity Murals, 1974

United Electrical Workers Hall, 37 South Ashland Avenue
Oil or acrylic on canvas, interior stairway walls
ARTISTS: John Pitman Weber (1942–) and José Guerrero (1938–), assisted and advised by
W. Walker, A. Ray, J. Yanagisawa, E. Weber, and M. Thrailkill
Concept and creation donated by the artists
Materials funded by the United Electrical, Radio and Machine Workers Union

The spirit of the great Mexican muralists is alive on South Ashland Avenue in a
area called Union Row, where a small building is home to Local 1114 of the United
Electrical, Radio and Machine Workers of America. Suggestive of an earlier and
more elegant neighborhood, the handsome red brick building housed the West
End Women's Club, which sold it to the union in 1947. In 1973 John Weber and José
Guerrero offered to illustrate the union's story by creating a visual history of its
workers and leadership on the walls surrounding the spacious two-story interior
stairway. Donating their time, they spent nearly a year developing and complet-
ing the enormous composition. Weber speaks of his conscious effort at "master-
ing" the technique of the Mexican muralists Orozco, Rivera, and Siqueiros and
of his desire to "digest" it. A viewer stepping into the stairway is completely sur-
rounded and almost overwhelmed by the oversize figures that completely cover
the walls, showing vigorous men and women in their roles as leaders and founders
of the union and workers in a variety of occupations. There are men working at a
fiery drop forge, California farmworkers marching with determination, people
handing out leaflets, carrying signs, organizing workers, marching, negotiating
for better working conditions, and struggling against the military-industrial com-
plex. Dedicated "to the builders of the future, the men and women who work in
the mines, mills, and factories," the mural is filled with the faces of real workers,

sketched by the artists in the people's workplaces. Since its founding in 1936, the union's stated mission has been to unite workers by industry, with rank-and-file control, regardless of craft, age, sex, nationality, race, creed, or political beliefs, and to win a better life for all working people.

United Electrical Workers Hall, *Solidarity Murals,* detail. Photograph © by Don DuBroff, courtesy of the United Electrical Workers.

59 ► Casa Aztlan

Casa Aztlan, 1975–93

Casa Aztlan Community Center, 1831 South Racine Avenue
ARTIST: Marcos Raya (1948–)
Pilsen Community Project

Casa Aztlan is one of the oldest social service agencies in Pilsen, the Near South-west Side neighborhood that stretches from Sixteenth Street to Twenty-second Street and Halsted to Western and is one of the largest Mexican American com-munities in the country. It was established in 1970 to serve the immigrant Mexi-can families that began arriving in great numbers two decades earlier. Providing advocacy, counseling, and other services, including an important after-school pro-gram, it also operates as a community and cultural center. The building functioned as the Bohemian Settlement House when Pilsen was home to Czechs, Germans, and other European ethnic groups in the nineteenth century. A dense concentra-tion of murals in the neighborhood displays a deeply rooted sense of Mexican his-tory and culture that celebrates the mural movement in Mexico of the 1920s and its leaders, Diego Rivera, José Clemente Orozco, and David Alfaro Siqueiros, as well as the earlier Amerindian period. The exterior walls of Casa Aztlan, now a neighborhood landmark, are covered with brightly colored murals that reflect many of the concerns of the neighborhood. When the original murals of the 1970s, by Ray Patlan and Aurelio Diaz, began to fade, they were replaced by artist Mar-cos Raya, who used area teens to help him. Raya depicted important figures in Chicano and Mexican history such as Che Guevara, Pancho Villa, Emiliano Zapata, Benito Juarez, Caesar Chavez, Rudy Lozano, and Frida Kahlo. Raya, who has said he paints in the tradition of Rivera, has also included the Mexican flag and some pre-Columbian images. The name Aztlan refers to the southwestern United States, once part of the Aztec empire, and also stands for the many legends and ancient

NEAR SOUTH AND NEAR WEST SIDES

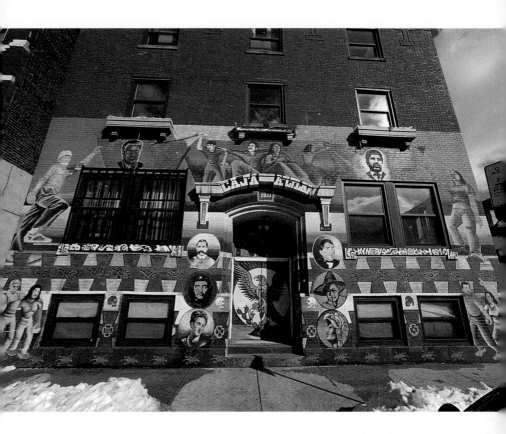

history of Mexico. The nearby Mexican Fine Arts Center and the Lozano Library, with its large collection of Spanish-language books, are great assets to the community. Contributing to the diversity of the neighborhood are the many artists who have studios in Pilsen and live there.

Casa Aztlan, exterior, detail. Photograph by Ted Lacey.

60 ➤ Engine 44 Firehouse

Children's Mural, 1982

Engine 44 Firehouse, 412 North Kedzie Avenue
Porcelain-enamel on steel, eight panels 10' x 12', six 3' x 5', and two 3' x 3'
ARTISTS: the Public Art Workshop under the direction of Mark Rogovin (1946–) and Barbara Browne (dates unknown)
COMMISSIONED BY: the Chicago Department of Cultural Affairs, Percent for Art Program and Public Art Workshop

This lively scene showing the bravery of firemen, who put out fires and save lives, is made up of interlocking panels that form one large work of art. It is mounted behind the mullioned glass front entrance to the firehouse, on the inside wall of a narrow entryway, so one must step outside to see all of it. The artists worked with children at the nearby Sterling Morton School, taking their drawings and enlarging, shrinking, and transferring them to form a unified composition. Signatures of the artists and the children appear on the lower left. The modern brick structure and its mural, funded by the city's Percent for Art Program, are an attractive addition to the urban street. Since a bullet pierced the glass door and made a small hole in the mural, however, the front door has to remain locked.

➤ Engine 44 Firehouse, *Children's Mural.* Courtesy of the City of Chicago Public Art Collection.

61 ➤ Reliable Corporation

Reliable Corporation Mural, 1984

The Reliable Corporation warehouse, 1001 West Van Buren Street
Silicone-based paint, three buildings two blocks long, six stories high, 180' x 360'
ARTIST: Richard John Haas (1936–)
COMMISSIONED BY: the Reliable Corporation

Thousands of drivers along the Eisenhower Expressway see this giant mural that spans three separate buildings along a two-block expanse. Although it is painted on the flat brick exterior walls of the buildings that were occupied by the Reliable Corporation, it gives the illusion of three-dimensionality, described as "deceptive eye-tricking." Haas has created a painted facade with curving walls, receding windows, and pilasters that appear to project into space. The painted downtown skyline view features a section of the civic center from Daniel H. Burnham's *Plan for Chicago,* the Sears Tower at sunset (with the real thing just to the left), medallions showing Chicago as a transportation hub, and many other effects. Haas uses walls as his canvas, creating trompe l'oeil murals that pay tribute to master builders. A team of painters worked from the artist's scale drawings using paints mixed to his specifications. They applied ten tons of paint to the sandblasted, sealed, and primed surfaces, using rollers, brushes, and sprayers. Although Haas said at the time it was painted that it would last one hundred years, this remarkable mural has suffered considerable loss of paint and is in need of restoration.

─────────────

➤ Reliable Corporation warehouse, exterior, detail. Courtesy of Rhona Hoffman Gallery.

62 ► Lozano Library

Chic-Chac, 1990

Rudy Lozano Branch Library, 1805 South Loomis Street
Mosaic tiles of Venetian glass set on brick wall, 8' x 13'
ARTISTS: Cynthia Weiss (1948–) and Hector Duarte (1952–)
COMMISSIONED BY: the Chicago Department of Cultural Affairs, Percent for Art Program

Decorative Mexican motifs brighten the walls of this branch library in Pilsen that suggest the ancient culture of many of its residents. The library is named for Rudy Lozano, a union organizer and community activist who worked as part of Harold Washington's transition team to improve the neighborhood for its Latino and African American residents. He was tragically slain by an unknown assailant in his Pilsen home in 1983. On the rear brick wall of the reading room is a modern interpretation of the ancient Toltec rain god Chac-Mool, whose reclining figure appears in archaeological sites throughout Mexico. Instead of the traditional sacrificial offerings to the gods, the figure in *Chic-Chac* holds an open book in its lap. The title of the mosaic figure can also be "read" as a pun. "Chic" refers to the city of Chicago (Chic-a-go), to its Chicano citizens, and to its being chic to read, and "Chac" refers to the Mexican figures. On its surface are motifs and symbols from ancient and modern Mexican cultures. References to Latin American literature appear on the pages of the book. The quetzal bird from Guatemala and the owl, which stands for knowledge, are meant to convey the canopy of sky for the Chac-Mool figure. They perch on the pre-Columbian-inspired frieze that encircles the room. This site-specific project was a joint effort, inspired by a doodle made by Hector Duarte that reminded his collaborator Cynthia Weiss of the Chac-Mool figure.

───────────

► Lozano Library, *Chic-Chac.* Courtesy of the City of Chicago Public Art Collection.

63 ▶ Orozco Academy
Mosaic Facade, 1991–

José Clemente Orozco Community Academy, 1645 West Eighteenth Place
Venetian glass mosaic tiles
DIRECTED BY: Francisco Gerardo Mendoza (1958–) and assistant Noë Milan
FUNDED BY: the Mexican Fine Arts Center

An undistinguished school building facade has been transformed into a vibrant panorama of colorful mosaic tile portraits and pre-Columbian motifs that dramatize the significant contributions to this country of Mexican and Mexican American men and women. Since 1991, with the initial help of Chicago muralist Cynthia Weiss, Orozco Academy art teacher Francisco Mendoza has directed students in the design and execution of Venetian glass mosaic tile murals that, when combined, form the largest outdoor mural in the city. Installed on the main face of the school building, with great pride and skill, are pictorial representations of such distinguished people of Mexican descent as labor leader Cesar Chavez, artist Frida Kahlo, Mexican revolutionary Emiliano Zapata, and muralists Diego Rivera, David Alfaro Siqueiros, and José Clemente Orozco, for the last of whom the school is named. Also depicted are Lydia Mendoza, first Mexican to record music in the United States, and Maria Henriques Allen, mother of Chicago's first Mexican American muralist, Mario Castillo. On three longer columns are mosaic designs honoring music, Olympic games, and the Aztec sun and moon gods. The Orozco Academy project is to be completed in the next few years. In 1993–94 Mendoza also directed the creation of a mosaic mural and painted decoration that vibrantly covers the walls and stairways of the nearby Eighteenth Street CTA station.

Orozco Academy, mosaic facade, detail. Photograph by Ted Lacey, courtesy of the Chicago Public Schools.

64 ▶ Donnelley Youth Center

The Great Migration, 1994–95

Elliott Donnelley Youth Center outdoor art park, 3947 South Michigan Avenue
Acrylic, 2,700 square feet, ca. 30' x 90'
ARTISTS: Marcus Akinlana (1966–), assisted by Juan Angel Chavez, Stephanie George, Dorian Sylvain, and others
COMMISSIONED BY: the Chicago Public Art Group

The Elliott Donnelley Youth Center opened in 1959 as an outgrowth of three earlier organizations. Surrounded by public housing, it is the oldest continuing social service agency in Chicago serving the African American community. In its outdoor space, two large murals provide a background for playground equipment, a community garden, and several sculptural structures. The earlier mural from 1979 by Mitchell Caton and Calvin Jones conveys a strong sense of African American identity and a "historical specificity of time and place" that was new in "people's art." The larger mural tells the story of the mass migration of African Americans from the South to Chicago beginning in 1916, with a text by Fatu Akinlana that is woven into the pictorial representations. It speaks of the combination of growing industrial production in the North, the desire for the rights of citizenship denied in the Jim Crow South and the mechanization of cotton cultivation that motivated this exodus, and the encouragement of the *Chicago Defender* newspaper and affordable rates on the railroad that made it possible. The energy and determination of the migrants is apparent as travelers on Illinois Central trains notice the beautiful farmlands and remember their sharecropping existence and the horrors of segregation. The children, dressed in their best clothes, are full of excitement about a place they can't even imagine. Arriving in Chicago, they locate in the Grand-Douglas Bronzeville area on the South Side of the city and find jobs as meatpackers, nurses at Provident Hospital, and factory workers. Since they bring

with them their talent for music and "the sounds of the South," the blues become an important sound of Chicago, and "many great musicians" are born. The text ends with these words addressed to the children: "It is important that we remember what our grandparents came to Chicago for so we can continue to build on their dreams."

Donnelley Youth Center, *The Great Migration, detail.* Courtesy of the Chicago Public Art Group.

65 ► McKinley Park Library

Seasons Pursuing Each Other, 1995

McKinley Park Library Reading Lounge, 1915 West Thirty-fifth Street
Acrylic and oil
ARTIST: Amy Yoes (1959–)
COMMISSIONED BY: the Chicago Department of Cultural Affairs, Percent for Art Program

Amy Yoes created this unusual two-part mural composed of overlapping patterns and calligraphic flourishes by a complex three-step process. She began with patterns she manipulated by computer, stretching and distorting them into dramatic images. Then she made slides of the images, projected them onto the canvas, and traced them to form an initial sketch. Finally she began to paint with opaque and transparent colors, adding layer upon layer of paint, creating a great sense of space. Yoes compares the "excessive accumulation and transmutation of cultural and stylistic references" in her painting to the purpose of a library: "to gather under the same roof a universe of cultural legacies and human experiences."

► McKinley Park Library, *Seasons Pursuing Each Other.* Courtesy of the City of Chicago Public Art Collection.

NEAR SOUTH AND NEAR WEST SIDES

South Side

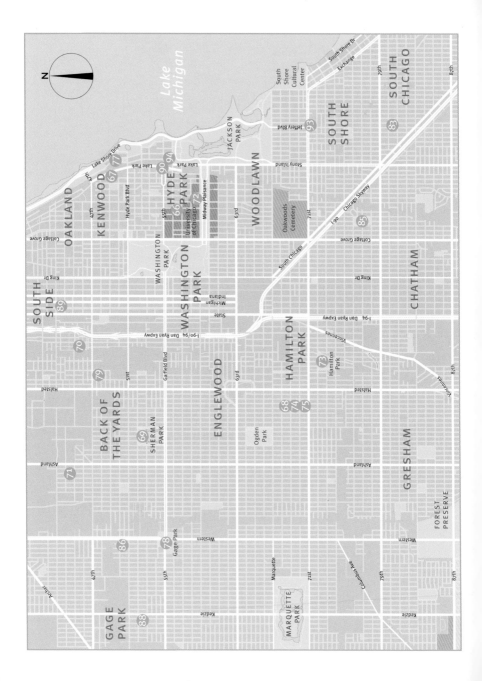

66 **Bartlett Gymnasium (1904)**
5640 South University Avenue
Frederic Clay Bartlett

67 **Blackstone Library (1904)**
4904 South Lake Park Avenue
Oliver Dennett Grover

68 **Wentworth School (1904)***
6950 South Sangamon Street
Norman Philip Hall

69 **Sherman Park Fieldhouse (1911–16)**
1301 West 52nd Street
Eight artists†

70 **Fuller Park Fieldhouse (1913–14)**
331 West 45th Street
John Warner Norton

71 **Davis Square Fieldhouse (ca. 1915)**
4430 South Marshfield Avenue
William Edouard Scott

72 **Ida Noyes Hall (1918)**
1212 East 59th Street
Jesse Arms Botke

73 **Hamilton Park Fieldhouse (1916)**
513 West Seventy-second Street
John Warner Norton

74 **Wentworth School (1927–28)***
6950 South Sangamon Street
James Edward McBurney

75 **Wentworth School (1937)***
6950 South Sangamon Street
Florian Durzynski

76 **Calumet Park Fieldhouse (1927–29)**
9801 Avenue G
Tom Lea

77 **Powhatan Building (1929)**
4950 South Chicago Beach Avenue
Charles L. Morgan

78 **Gage Park Fieldhouse (1931)**
2415 West 55th Street
Tom Lea

79 **Tilden High School (1931–44)***
4747 South Union Avenue
James Edward McBurney

80 **Palmer Park Fieldhouse (1934)**
11100 South Indiana Avenue
James Edward McBurney

81 **Bennett School (1936–37)***
10115 South Prairie Avenue
Gustaf Dalstrom

82 **Bennett School (1940)***
10115 South Prairie Avenue
Grace Spongberg

83 **Mann School (1937)***
8050 South Chappel Avenue
Ralph Christian Henricksen

84 **Morgan Park Post Office (1937)**
1805 West Monterey Avenue
J. Theodore Johnson

85 **Grand Crossing Park Fieldhouse
(date unknown)**
7655 South Ingleside Avenue
Chester Dryan

86 **Christopher School (1939)***
5042 South Artesian Avenue
Arthur Hershel Lidov

*Visits to schools marked with an asterisk must be arranged with the principal
†See page 156

87 **West Pullman School (1940)***
11941 South Parnell Avenue
Ralph Christian Henricksen

88 **Sawyer School (1940)***
5248 South Sawyer Avenue
Lucille Ward

89 **First Church of Deliverance (1946)**
4315 South Wabash Avenue
Fred Jones

90 **Metra Viaduct (1977)**
56th Street and Stony Island Avenue
William Walker

91 **Altgeld Gardens Parent/
Child Center (1980)**
975 East 132nd Street
William Walker

92 **Metra Viaduct (1988)**
113th Street and
Cottage Grove Avenue
Olivia Gude, Jon Pounds, and
Marcus Akinlana

93 **Walgreen Drug Store (1990)**
71st Street and Jeffery Boulevard
Marcus Akinlana and Jeffrey Cook

94 **Metra Viaduct (1992)**
56th Street and Stony Island Avenue
Olivia Gude

95 **Walker Library (1995)**
11071 South Hoyne Avenue
Oscar Romero

96 **Pullman Library (1995)**
11001 South Indiana Avenue
Bernard Williams

97 **Pullman Library (1995)**
11001 South Indiana Avenue
Nina Smoot-Cain and Kiela Smith

98 **Metra Viaduct (1995)**
103rd Street and
Cottage Grove Avenue
Bernard Williams

South Side

Extending from Hyde Park to the Far South Side, this section includes the diverse communities of South Shore, Beverly, Morgan Park, Roseland, and Pullman. South Side development was greatly influenced by two historical factors. The passing of a parks bill by the city legislature in 1869 established a unified, landscaped park system on the South Side, as well as on the West Side and in the Lincoln Park area, and the design of a landscaped boulevard system linked these parks in the various neighborhoods to the city center. Declaring that parks would be "the daily resort of all classes of the community, Park commissioners developed extensive indoor as well as outdoor facilities. The handsome fieldhouses in Fuller, Davis Square, Hamilton, Calumet, Gage, and Grand Crossing Parks attest to their ambitious planning.

Hyde Park, originally a suburb, was annexed by the city in 1889, and in a few years it was altered dramatically by the almost simultaneous construction of the University of Chicago and World's Columbian Exposition campuses. Sometimes referred to as the "Gray City" and the "White City," their buildings were distinctly different. The Gothic buildings of the university were modeled after medieval European institutions, whereas the 1893 exposition followed the European Beaux Arts tradition. Murals compatible with the spirit of the architecture were commissioned for each location.

Beverly and Morgan Park, more suburban in nature, were annexed to the city in 1890 and 1914, respectively, and grew with the establishment of railroad connections.

Workers were attracted to the communities of Pullman and Roseland by the founding of the Pullman Palace Car Company Works in 1880 and the promise of better living quarters in the model town developed by George Pullman. There have been changes in these areas over the years, including the gradual withdrawal of industry from the area by the 1960s, but landmark status now offers protection for many of the fine buildings.

66 ➤ Bartlett Gymnasium

Athletic Games in the Middle Ages, 1904

Frank Dickinson Bartlett Memorial Gymnasium, University of Chicago
5640 South University Avenue
Oil on canvas
ARTIST: Frederic Clay Bartlett (1873–1953)
COMMISSIONED BY: Shepley, Rutan and Coolidge

Bartlett Gymnasium is one of the more than fifty buildings constructed in the Gothic style on the University of Chicago campus between 1892 and 1932. The artist Frederic Bartlett worked with the architects to create an interior that blended Gothic with the English Arts and Crafts style, a movement popular in Chicago at the turn of the century, which emphasized craftsmanship and handwork. Built as

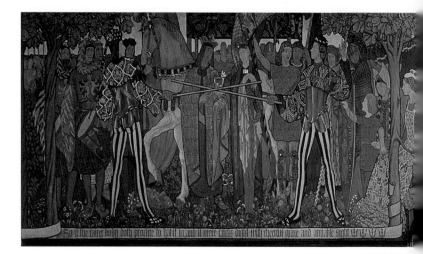

a men's gym and donated by Bartlett's father in memory of another son who had recently died, the building features a mural that depicts an athletic tournament set in the Middle Ages. Bartlett thought the "age of chivalry" could be inspiring to the students. The panoramic frieze is mounted between the dark oak wainscoting and the cornice on each side of the doorway. In the center is a painted shield bearing the dedication: "To the advancement of Physical Education and the Glory of Manly Sports this gymnasium is dedicated to the memory of Frank Dickinson Bartlett, 1880–1900." An inscription under one of the scenes reads: "How happy is he born and taught that serveth not another's will: whose armor is his honest thought and simple truth his utmost skill." In describing the mural Bartlett wrote, "The crowd looking on the games are in gorgeous holiday attire—brocades stiff with gold, cut velvet, and rich silks, with jewels of equal splendor. Many of the ornaments are raised in 'gesso' and gilded in antique gold leaf after the manner of early English and Italian decorations." The building is to be converted to a dining hall, but the murals will remain in place.

Bartlett Gymnasium, University of Chicago, *Athletic Games in the Middle Ages,* detail. Photograph by Jim Prinz Photography, courtesy of the University of Chicago.

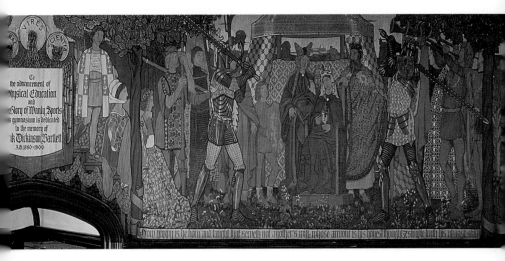

67 ➤ Blackstone Library
Literature, Science, Labor, and *Art,* 1904

Timothy Beach Blackstone Branch Library, 4904 South Lake Park Avenue
Oil on canvas, four lunettes, ca. 9' x 14' each
ARTIST: Oliver Dennett Grover (1861–1927)

The Blackstone Memorial Library is a fine example of Beaux Arts classicism, a system of design based on classical Greek and Roman models. Known for his creation of the town of Pullman, Chicago school architect Solon S. Beman modeled the library after the ancient Athenian temple called the Erechtheion. Blackstone was the first branch library to be built in the city and was funded by Isabella Norton Blackstone in memory of her husband, who had been an industrialist, philanthropist, and president of the Chicago and Alton Railroad. In the lunettes beneath the Tiffany-style dome of the interior's central rotunda, Oliver Dennett Grover, an artist active in Chicago's 1893 fair, painted four murals, titled *Literature, Science, Art,* and *Labor.* Grover, whose studio was in the Fine Arts Building, said he wanted "to produce something in harmony with the other appointments of the room . . . something decorative, something serious and dignified yet pleasing." Although the palette differs for each, the composition of each lunette features a symbolic winged figure in front of a marble throne surrounded by other figures that illustrate its theme. A painter, sculptor, architect, and harpist group themselves around the figure of Art. Labor is joined by men holding an ax and a scythe, a woman carrying a train, and a child with a cornucopia of money. A man with a beaker, a woman holding a slide rule, another woman feeding a peacock, and a child with a bellows surround Science. Figures holding a book, lute, flowers, and the mask of tragedy join with the symbol of Literature.

➤ Blackstone Library, three of four lunettes: (a) *Labor;* (b) *Science;* (c) *Art.* Photographs by Jim Prinz Photography, courtesy of the Chicago Public Libraries.

SOUTH SIDE

68 ▸ Wentworth School

King Arthur and *King Arthur Meeting Lady Gwenevere,* 1904

Daniel S. Wentworth School, 6950 South Sangamon Street
Oil on canvas, two panels
ARTIST: Norman Philip Hall (1885–1967)
RESTORED BY: the WPA, 1936, and the Board of Education, administered by the Public
Building Commission, 1999

Two beautiful murals illustrating events in the life of King Arthur decorated the walls of the former library of the Wentworth School. The fourth-floor space had been used for storage for many years after it had been declared unsafe for use by students, and when the murals were removed and restored in 1999 they were relocated to a school corridor. The richly ornamented scenes are painted in a decorative style known as Pre-Raphaelite, popular at the end of the nineteenth century, which looked back admiringly at the simplicity of Italian paintings before those of the Renaissance artist Raphael. The titles, in Old English, describe the scenes and are part of the composition. *Arthur Draweth Forth Ye Sword from Ye Anvil* is the first, and *King Arthur Meeteth Ye Lady Gwenevere* is the second. Arthurian legends, based on folklore from the ninth century onward, relate the feats of the king and his knights, the romances of chivalry, and the love of Lancelot and Guinevere. The murals are signed "Norman Hall 1904" and also state that they were "Restored WPA 1936."

▸ Wentworth School, *King Arthur.* Photograph by Ted Lacey, courtesy of the Chicago Public Schools.

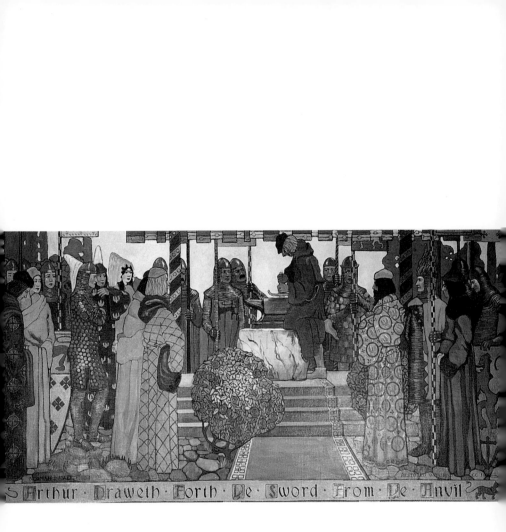

Arthur · Draweth · Forth · Ꝑe · Sword · From · Ꝑe · Anvil

69 ➤ Sherman Park Fieldhouse

Scenes from American History, 1911–16

Sherman Park Fieldhouse assembly hall, 1301 West Fifty-second Street
(between Racine and Loomis)
Oil on canvas, six murals ca. 7'2" x 12'10" each; twelve murals ca. 6' x 13' each
ARTISTS: S. B. Braidwood, Anita Parkhurst (1892–?), Lucille Patterson, Paul Turner Sargent
(1880–1946), Novart Seron, Gerritt V. Sinclair (1890–1956), George F. Steinberg, and Roy Tyrell
COMMISSIONED AND FUNDED BY: John Barton Payne, president of the
South Park Commission

Sherman Park's beautiful landscape, designed by the Olmsted Brothers to include
a large lagoon and an island with bridges, has been described as "a sixty-acre
oasis." The park also has open-air gyms, a running track, a swimming pool, and a
handsome fieldhouse. It is one of Chicago's ten original neighborhood parks and
was named for John Sherman, a founder of the Union Stock Yard and Transit Com-

pany and a public-spirited citizen who did much for the parks. Edward H. Bennett of D. H. Burnham and Company designed the Beaux Arts style fieldhouse, built in 1904–5. It is enhanced by eighteen separate mural panels, executed by students from the School of the Art Institute "with a marked emphasis on the constructive phases in the history of the Middle West," said a report of the period. They were underwritten by John Barton Payne, a patron and collector, and then president of the South Park Commission, who set up a fund to decorate and embellish South Side fieldhouses. The murals form a band around the upper part of the assembly hall, complementing and conforming to the neoclassical ornamentation of the large space. They are an example of one of the important missions of Chicago parks in the early part of the century: to educate the neighborhood children and adults, many of whom were foreign born, and familiarize them with the history of their new country. All the paintings in the series depict scenes from American history, from its discovery to the westward exploration and expansion. Above the doorways on each of the east and west walls are three large murals. Depicted on the east wall are Christopher Columbus on the *Santa Maria* in 1492, the landing at Jamestown in 1607, and the Pilgrims at Plymouth in 1620. On the west are Louis Joliet and Jacques Marquette in 1673, René-Robert Cavelier de La Salle and Henri de Tonty in 1682, and George Rogers Clark at Kaskaskia in 1778. Twelve smaller murals are placed in lunettes between the windows of the large arched window walls to the north and south. These are a continuation of the historical pageant. Pictured are Native American traders, the evacuation of Fort Dearborn, crossing the prairies, pioneers of the Middle West, Puritan settlement, King Philip's War, pioneers of the South, the settlement of Kentucky, and the colonial army wintering at Valley Forge in 1777.

Sherman Park Fieldhouse, two of eighteen panels: ◀ *Colonial Army in 1777, Winter in Valley Forge;* ▲ *George Rogers Clark—1778.* Photographs by Tom Van Eynde, courtesy of the Chicago Park District.

Explorers in American History, 1913–14

Fuller Park Fieldhouse assembly hall, 331 West Forty-fifth Street
(Forty-fifth Street and Princeton Avenue)
Oil on canvas, nine murals
ARTIST: John Warner Norton (1876–1934)
COMMISSIONED BY: the South Park Commission

Fuller Park was conceived in 1904 as part of a revolutionary plan to provide "breathing space" in congested working-class areas of the rapidly growing city. The Olmsted Brothers, who were landscape designers, worked with architect Edward H. Bennett of D. H. Burnham and Company to create "people's parks" with areas for both passive and active recreation. Fieldhouses were a new type of building, and Fuller Park's reflects a refinement of Bennett's earlier park designs. In 1907 President Theodore Roosevelt called Chicago's system of neighborhood parks, with its innovative social planning and community services, "one of the most notable civic achievements in any American city," wrote Julia Bachrach and Will Tippins in an article for the Chicago Park District Office of Research and Planning. Nine historical murals were added to the assembly hall nearly ten years later: there are three arch-shaped panels above the doorways and four small panels on the long wall opposite one of tall arched windows. At one end of the room are two narrow panels mounted on each side of a window. The murals depict such sixteenth- and seventeenth-century French and Spanish explorers as Daniel Duluth, Jean Ribault, René-Robert Cavelier de La Salle, and Alvar Cabeza de Vaca, who explored the New World and went westward. Francisco Vasquez de Coronado is portrayed setting out on his journey to the Pacific, and La Salle is pictured at Starved Rock in Illinois as he gazes across the prairie. Forest and desert scenes form decorative panels, and a Viking ship sails over the central doorway. "It is rare that money in America is spent on pure decoration," said a newspaper critic at the

SOUTH SIDE

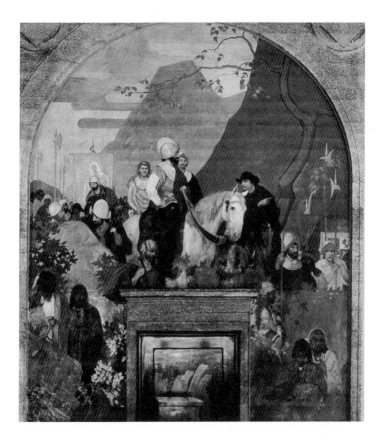

time, commending the park commissioners and praising the artist, John Warner Norton, for his fresh and innovative ideas. "Decorations of unusually pleasing merit, yet with sufficient story interest to satisfy those who demand more of a picture than mere beauty," stated a *Daily Inter Ocean* article of March 22, 1914.

Fuller Park Fieldhouse, *Francisco Vasquez de Coronado*, one of nine panels. Courtesy of the Art Institute of Chicago, Ryerson and Burnham Libraries Archives.

71 ➤ Davis Square Fieldhouse

Constructive Recreation, the Vital Force in Character Building, ca. 1915

Davis Square Fieldhouse lobby, 4430 South Marshfield Avenue
Oil on canvas, 6' x 25'
ARTIST: William Edouard Scott (1884–1964)
COMMISSIONED BY: the South Park Commission

In the lobby of the Davis Square Fieldhouse, built in 1904–5, is an allegorical mural
that has been mounted above a tall doorway, framed by columns. The message in-
scribed across the top, "Constructive Recreation, the Vital Force in Character Build-
ing," was clearly meant to inspire the young men and women who used the build-
ing. The mural was moved from its original location at Washington Park and
trimmed slightly to fit the new space. Designed by Edward H. Bennett of D. H. Burn-
ham and Company, the fieldhouse in this small park operated as a community cen-
ter intended to meet many of the neighborhood's needs with its gymnasiums,
showers, meeting rooms, library, and cafeteria. Three distinct sections compose
the mural. In the center, two allegorical female figures flank an enthroned image
of Columbia or Liberty, who holds aloft a torch and wreath. One is the figure of
Drama, in Old World dress, reading from a manuscript, backed by a globe and the
mask of tragedy. The other, Art, is a modern woman with palette and brushes.
On the right side is a group of young women in costumes, representing the many
nationalities that made up the Davis Park neighborhood when the fieldhouse was
built. Included are Dutch, Spanish, Mexican, Czech, and other representatives.
On the left is a group of young male figures wearing clothes that suggest sports
offered by the park district, such as football, baseball, tennis, pole vaulting,
discus throwing, and track. They form a frieze against a neoclassical architectural
background. Celebrated here is the balanced life that attends to both mind
and body.

Davis Square Fieldhouse, *Constructive Recreation, the Vital Force in Character Building*. Photograph by Tom Van Eynde, courtesy of the Chicago Park District.

72 ▶ Ida Noyes Hall
The Masque of Youth, 1918

Ida Noyes Hall, third-floor theater, University of Chicago
1212 East Fifty-ninth Street
Oil on canvas, panels 5'6" high, on north, south, east, and west walls
ARTIST: Jesse Arms Botke (ca. 1883–1929)
COMMISSIONED BY: La Verne Noyes
RESTORED BY: the University of Chicago, 1995–97

In 1916 some three hundred students, alumni, and schoolchildren participated in a dramatic, allegorical outdoor presentation called "The Masque of Youth," celebrating both the quarter centennial of the University of Chicago and the opening of Ida Noyes Hall, a new building for women students. Two years later the picturesque pageant was recreated on the walls of the small third-floor theater. The

inspiration of the art of the early Italian Renaissance and the later Pre-Raphaelite movement is apparent in these highly decorative murals. A series of panels mounted between the windows and on the walls of the room depict the procession of costumed figures that had paraded past the Gothic buildings of the university campus. The Spirit of Gothic Architecture and Alma Mater, in long white gowns, stand in front of the Law School, where the masque was presented. Youth, crowned with spring flowers, is followed by children dressed in blue representing Lake Michigan. Veiled figures carry a symbolic moon, and dancers energetically pull the golden sun chariot past Harper Memorial Library. The blue-robed spirit of Worship carries the sacred book, and Knowledge bears her lighted lamp. Finally, the personification of the city follows two pages waving the blue banner that denotes the lake, and a group of figures portray the endless cycle of Youth. Also represented are the university coat of arms and symbols of the divisions of the university: Archaeology, Chemistry, Medicine, Literature, and Art. In 1995 an ongoing process of cleaning and restoration was begun, revealing again the freshness of the mural's images and its glowing colors. Patron La Verne Noyes, who had funded the building in memory of his wife, called the murals "a crowning halo."

Ida Noyes Hall, University of Chicago, *The Masque of Youth,* details: ◀ *Spirit of Gothic Architecture, Page with University Coat of Arms,* and *Alma Mater;* ▲ *Treaders and Harvesters, Contestants of Olympic Games,* and *Persian Dancers.* Photographs by Jim Prinz Photography, courtesy of the University of Chicago.

73 ► Hamilton Park Fieldhouse
Historical Murals, 1916

Hamilton Park Fieldhouse lobby, 513 West Seventy-second Street
Oil on canvas, twenty panels
ARTIST: John Warner Norton (1876–1934)
COMMISSIONED AND FUNDED BY: John Barton Payne, president of the
South Park Commission

Hamilton Park is one of the first of the ten progressive Chicago parks designed in a collaboration between the Olmsted Brothers and Edward H. Bennett of D. H. Burnham and Company. The spacious entry hall of the Beaux Arts style fieldhouse, built in 1904–5, retains much of its original grandeur, and John Warner Norton's murals harmonize perfectly with the architecture. The murals were part of the socialization and Americanization that took place in the fieldhouses of many Chicago neighborhoods and were addressed to the largely immigrant population that used the parks. As described in a 1913 *School Arts Magazine* article, they were to help

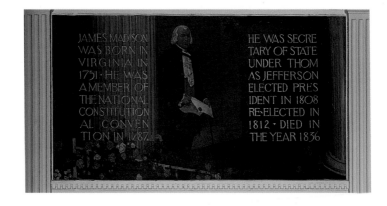

THOMAS JEFFERSON WAS BORN IN VIRGINIA 1743 AUTHOR OF THE DECLARATION OF INDEPENDENCE OF THE STATUTE OF VIRGINIA FOR RELIGIOUS FREEDOM·MINISTER TO FRANCE SECRETARY OF STATE UNDER WASHINGTON PRESIDENT 1801-1809·DIED·1826

foreign-born children "grope their way into American traditions." Social reform-ers in this Progressive Era believed that controlled environments such as those of the parks and their fieldhouses could build and mold moral character. These "les-sons in American history" were commissioned by John Barton Payne, an active pa-tron and collector, then president of the South Park Commission, who used his salary to set up a fund, administered by the Art Institute of Chicago, to underwrite the "decoration and embellishment" of South Side fieldhouses. The murals pri-marily honor famous American statesmen from his home state of Virginia and are mounted on the upper part of the walls and over doorways. Included are fron-tiersman and Revolutionary War officer George Rogers Clark; Henry Clay, who tried to reconcile the North and South before the Civil War; founding father Alexander Hamilton; Thomas Jefferson, third president of the United States; James Monroe, fifth president of the United States; and George Washington. Except for Abraham Lincoln, who is also depicted, and Alexander Hamilton, for whom the park is named, all are Virginians. Some men appear in full-length portraits, others are shown in narrative scenes. Exploration of the West is illustrated through scenes of a Native American family, pioneers, and early settlers.

Hamilton Park Fieldhouse, two of twenty panels: ◁ *James Madison*; ◮ *Thomas Jefferson*. Photographs by Tom Van Eynde, courtesy of the Chicago Park District

74 ➤ Wentworth School

The Lives of Daniel S. Wentworth and Abraham Lincoln, 1927–28

Daniel S. Wentworth School, auditorium, 6950 South Sangamon Street
Oil on canvas, twenty-six panels
ARTIST: James Edward McBurney (1868–1947)
COMMISSIONED BY: the Wentworth School Parents and Teachers Association
RESTORED BY: the Board of Education, administered by the Public Building Commission, 1999

The school principal is credited with realizing this ambitious mural project that was installed during the 1927–28 school year. The murals had such an effect on the students that the principal reported, "It is far less essential that teachers accompany their pupils to assembly," as they "are now interested in looking about, studying the pictures and reading the inscriptive titles beneath them, rather than getting into mischief." There are twenty-six separate panels in the large school auditorium that illustrate three distinct themes: Native Americans and the settlement of the United States, events in the life of Abraham Lincoln, and the life of Daniel S. Wentworth. Three views of Wentworth's life (born 1824) are depicted to the right of the stage: his birthplace in Parsonfield, Maine; his portrait; and the Cook County Normal School in 1865, the year he was chosen as its first principal. Above the entire length of the proscenium is a panoramic view of the country's settlement from Plymouth Rock westward to the west coast by ship, canoe, horseback, and covered wagon. To the left of the stage are three episodes in Lincoln's life: as a young man in a boat in New Orleans watching a slave auction, with the quotation, "If I ever get the chance to hit I shall hit it hard"; as circuit rider; and as an orator with a quotation from the Gettysburg Address. To the right are three scenes of Native American life. Five geographical scenes suggesting the westward exploration and settlement of the country are mounted across the front of the balcony: Plymouth, 1620; the Hudson River, 1609; Chicago, 1681; Denver, 1858; and

SOUTH SIDE

166

COLN'S FATHER MOVES HIS FAMILY FROM KENTUCKY TO INDIANA

San Francisco, 1775. The murals continue on the back walls of the balcony with scenes from Native American life and a panel showing Lincoln's father moving his family from Kentucky to Indiana. These are signed "McBurney Studios [ap]26." In the outer foyer, above the doors leading into the auditorium, are three arched panels with illustrations and dedicatory inscriptions signed "J. E. McBurney [ap]28."

Wentworth School, James Edward McBurney, one of twenty-six historical scenes: *Abraham Lincoln's Family Moves from Kentucky to Indiana,* detail. Photograph by James Prinz Photography, murals commissioned by the Wentworth School Parents and Teachers Association, © 1999, the Art Institute of Chicago, all rights reserved.

75 ► Wentworth School
American Youth, 1937

Daniel S. Wentworth School, fourth floor, 6950 South Sangamon Street
Oil on canvas, three panels: one 7'10" x 8'3", one 7'9" x 8'32", and one 10' x 5'9"
ARTIST: Florian Durzynski (1902–69)
COMMISSIONED BY: the Works Progress Administration, Federal Art Project
RESTORED BY: the Board of Education, administered by the Public Building Commission, 1999

Three large murals were commissioned in 1937 by the Works Progress Adminis-
tration, Federal Art Project, for the spacious fourth-floor library of this very old
school building, built in 1893, with an addition in 1925. Many years later, changes
in the fire code ruled the room unsafe for student use, and it became a storage
space. Over the years, the murals suffered considerable damage. In 1998 the
Board of Education funded the removal of these murals, their restoration, and their
relocation in the school, where they can again be enjoyed by the children. The
theme of children playing in highly stylized outdoor settings is represented in
three distinct time periods. In the contemporary scene a boy flies a toy plane while
others build models, sail toy boats, play with bows and arrows, and read. Girls cut
out paper dolls, talk to each other, and read. Young people of the nineteenth cen-
tury enjoy walking outdoors, fishing, and playing with their pets. The third scene
is set in the early twentieth century. Florian Durzynski's distinctive landscapes fea-
ture graceful, rolling hills and billowing trees, creating a very appealing picture of
nature. Durzynski was one of the most productive muralists in the Illinois Art Pro-
ject, and his work is at several other Chicago public schools: Bateman, Chopin,
Falconer, and Harvard; unsigned murals at Howe and McKay are probably also his.

► Wentworth School, *American Youth,* one of three panels, detail. Photograph by Ted Lacey, courtesy of the
Chicago Public Schools, mural commissioned by the Works Progress Administration, Federal Art Project.

SOUTH SIDE

76 ➤ Calumet Park Fieldhouse

Indian Ceremony, Father Marquette with Traders and Indians,
Hunting Party Returns to Village, and *Indians and Fur Traders,* 1927–29

Calumet Park Fieldhouse assembly hall/gymnasium, 9801 Avenue G
Oil on canvas, four panels
ARTIST: Tom Lea (1907–)
COMMISSIONED BY: the South Park Commission

In a spacious room with floor-to-ceiling windows and a small proscenium stage
are four handsome murals, mounted at the corners of the room. The space func-
tions as both auditorium and gymnasium in this park fieldhouse, which was
erected in 1924 as a recreational, educational, and social center. Its design by
South Park Commission architects reflects the influence of the earlier park build-
ings of D. H. Burnham and Company. The historical murals depict scenes of trade
between Native Americans and the early explorers and settlers in the Chicago
area. Artist Tom Lea came from the West to study at the School of the Art Institute
and was given the commission by Robert B. Marshe, then director of the Art In-
stitute, with the freedom to choose his own subject. He worked in an unused class-
room at the school. Lea has said that only two of the paintings are his work, and
he remembers that he was paid several hundred dollars for each. In his first mural,
a gathering of Native American men sit around a fire. In his second, Father Mar-
quette preaches to a group of Native Americans of the Illinois tribe as traders un-
load goods from a canoe. Hunters return to the village bearing fowl they have shot
with their bows and arrows, and in the third panel the women welcome them. The
fourth scene shows kitchen utensils, beads, guns, and knives spread out on the
ground as traders display the wares they want to exchange for fur pelts.

SOUTH SIDE

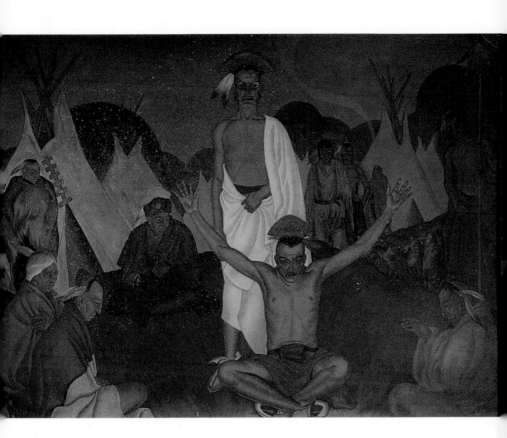

Calumet Park Fieldhouse, *Indian Ceremony,* one of four panels. Photograph © by Don DuBroff, courtesy of the Chicago Park District.

77 ▶ Powhatan Building

The Powhatan Building Mosaics, 1929

The Powhatan Building lobby, 4950 South Chicago Beach Drive
Pigmented plaster "sgraffito" mosaics
ARTIST: Charles L. Morgan (1890–1947)
RESTORED BY: Vinci-Hamp Architects, 1996–97

The twenty-two-story Powhatan Building is a superb example of the art deco style, with much of its interior design intact. It was designed by Robert S. de Golyer and Charles L. Morgan, who called its style "modern American," and was given land-mark status in 1993. Built as luxury apartments in 1927–29, the building is clad in Indiana limestone, with multihued terra-cotta spandrels enhanced by stylized geo-metric forms. The name of the building refers to the story of the Powhatan Con-federacy of Algonquin Indians, who lived in what is now Virginia, and of their chief, also named Powhatan. According to legend, in 1608 his daughter Pocahontas in-tervened in a struggle between one of his warriors and a Jamestown settler named John Smith, saving his life. She was later captured by the English, became a con-vert to Christianity, and married another settler named John Rolfe, bringing about an eight-year peace between the Native Americans and settlers. The Native Amer-ican theme continues in the interior public spaces, with depictions of animals and their relation to the sun and moon. Eight mosaic panels in subdued colors are set into the curved walls of the oval outer lobby. There are scenes of various cultures through the ages with youths and others in fanciful dress, performing rituals of music and dance. Obscured for many years behind false partitions installed in the 1950s are the slender, brightly colored mosaic panels with exotic designs that line the walls of the spacious inner lobby, alternating with curved wooden panels. The effect is of a vividly colored tropical rain forest. These mosaics were rediscovered by architects John Vinci and Ward Miller during an extensive restoration in 1996–97, when the space was returned to its original design. They were made of

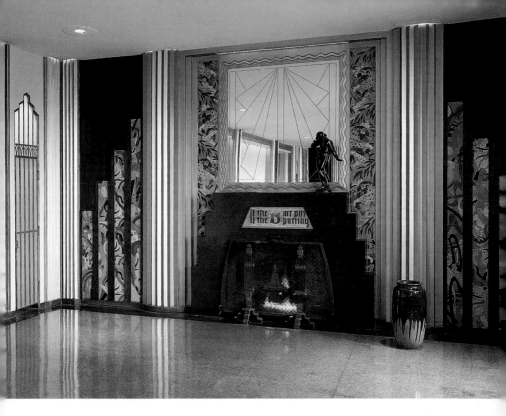

a plasterlike substance to which color and perhaps wax was added; when dried, it was dipped in wax to give it permanence and luster. Charles L. Morgan worked with Newton A. Wells to develop this formula, from which he was able to create 430 different hues, but he took his secret to the grave. Developing their own secret formula, Jo Hormuth and Jon Phillips of Chicago Architectural Arts were able to simulate Morgan's process, which was a variation of the sgraffito technique. The design of the mosaic panels that line the walls around the lower-level swimming pool is quite different and reflects Morgan's onetime association with Frank Lloyd Wright.

The Powhatan Building lobby, detail. Photograph © by Judith Bromley 1999, courtesy of Vinci-Hamp Architects, Inc.

78 ▶ Gage Park Fieldhouse
Pioneers, 1931

Gage Park Fieldhouse auditorium, 2415 West Fifty-fifth Street
Oil on canvas, ca. 8' x 4'
ARTIST: Tom Lea (1907–)
COMMISSIONED BY: the South Park Commission

After 1869 Chicago began to create its remarkable park system, acquiring and landscaping many large open areas on the North, South, and West Sides of the city. The six original major parks were linked by a ring of streets and boulevards. Gage Park, named for George Gage, a member of the South Park Commission, began as a small square at the intersection of two of these boulevards and grew over many years to its present size. To complement the outdoor recreational facilities and provide space for indoor activities, a fieldhouse was commissioned in 1926. It included gymnasiums, locker rooms, an auditorium, and club rooms and was designed by South Park Commission architects, inspired by the work of D. H. Burnham and Company. A handsome mural hangs on one of the auditorium's long walls, set within a slightly recessed arch that is an architectural feature of the room. Artist Tom Lea, who was born in the West, portrays the French explorers, missionaries, and fur traders René-Robert Cavelier de La Salle, Jacques Marquette, and others who first traveled to the Chicago area and the pioneering families who later came by covered wagon and settled there. Hovering overhead in the compisition is a symbolic figure pointing the way and rendered in grisaille, a technique using various shades of gray. Lea painted the mural in John Warner Norton's studio on Clark Street, where he worked as his assistant, and he remembers being paid several hundred dollars by the South Park Commission.

▶ Gage Park Fieldhouse, *Pioneers.* Photograph © by Don DuBroff, courtesy of the Chicago Park District.

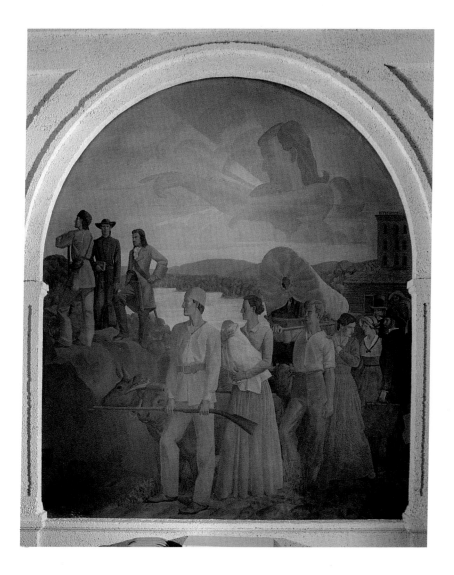

79 ► Tilden High School

Themes of Architecture and Engineering and *Great Men in History,*
1931–32, 1935, 1944

Tilden Technical High School, lobby and library, 4747 South Union Avenue
Oil on canvas, six panels in lobby, over fifty in library
ARTIST: James Edward McBurney (1868–1947)
RESTORED BY: the Board of Education, 1999

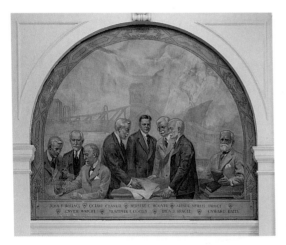

Tilden Technical High School, now coed, was designed by Dwight H. Perkins and built in 1905 as a boys' school. In its grandly proportioned two-story entrance lobby are six semicircular murals, three on each side, mounted along the walls of twin stairways that lead to the arcaded second floor. As inspirations for the students, the murals depict outstanding and creative midwestern men, many of whom were both teachers and planners in the fields of engineering and architecture. In one mural there are eight men who were involved in the development of the aerospace industry: mechanic-inventor Orville Wright; mining engineer and thirty-first president Herbert Hoover; engineer-inventor Bion J. Arnold; structural engineer Onward Bates; pioneering inventor-aviator Octave Chanute; engineering-college dean Mortimer Cooley; developer of reinforced concrete Arthur Newell Talbot; and chief engineer of the Panama Canal John E. Wallace. An-

SOUTH SIDE

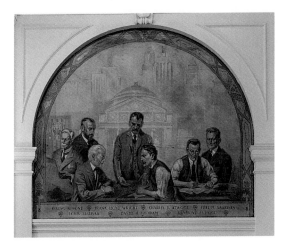

other panel depicts Wilbur and Orville Wright at an imaginary moment in their "conquest of the air." In a third mural, architects who designed some of Chicago's early buildings stand in front of the projects they created. Pictured are Charles B. Atwood, Daniel H. Burnham, Raymond M. Hood, Irving K. Pond, Eliel Saarinen, Louis Sullivan, and Frank Lloyd Wright. In two other panels Daniel H. Burnham's famous statement "Make no little plans" underscores the dramatic depiction of Chicago's early skyscrapers, and Robert Louis Stevenson's words describe a scene representing music and art. Tilden's second-floor library is remarkable for its picture gallery of famous men of arts, letters, and sciences illustrating the theme "man the builder, man the maker." Of the more than fifty panels, forty are small portraits, individually framed and mounted on four main columns in the spacious room, depicting such great men as Gutenberg, Copernicus, Shakespeare, Marconi, Pasteur, Bach, Lincoln, Aristotle, and Columbus. Tilden students were the models for younger men at the beginning of their careers such as Franklin, Darwin, Michelangelo, Washington, Galileo, Newton, and Edison. Funds for these murals came from the proceeds of Liberty Bonds bought by students during the First World War, funds left by graduating classes, and money raised from senior proms.

Tilden High School, *Themes of Architecture and Engineering,* two of six panels: ◄ *Engineers;*
▲ *Architects.* Photographs © by Don DuBroff, courtesy of the Chicago Public Schools, murals commissioned by the Works Progress Administration, Federal Art Project.

80 ► Palmer Park Fieldhouse

Dutch Farmer, His Wife and Dog; Native Americans; and
Father Marquette and Party, 1934

Palmer Park Fieldhouse assembly hall, 11100 South Indiana Avenue
Oil on canvas, three panels: 8' x 13', 8' x 14', and 8'6" x 18'
ARTIST: James Edward McBurney (1868–1947)
COMMISSIONED BY: the South Park Commission

Palmer was one of the ten original neighborhood parks that opened to the public in 1905, with landscaping by the Olmsted Brothers and a handsome fieldhouse designed by Edward H. Bennett of D. H. Burnham and Company. Its large assembly hall doubles as a gymnasium today. On the wall that also holds a basketball hoop are three picturesque murals painted in somber tones, mounted just under the cornice. They depict Native Americans and early settlers of the Chicago area. In the first mural, a Native American man and woman are perched on a sand dune watching the sunset over the lake. In the second, the French missionary-explorers Father Jacques Marquette and Louis Joliet look over the lake as a Native American glides by in his canoe. In the third mural, representing the many Dutch immigrants who settled on the Far South side, are a farmer and his wife wearing wooden shoes. The man holds a large scythe and his wife a rake as they stand in front of the wooden fence of their cottage, surrounded by a beehive, a dog, and some geese.

► Palmer Park Fieldhouse: *Father Marquette and Party,* and *Dutch Farmer, His Wife and Dog;* two of three panels. Photograph © by Don DuBroff, courtesy of the Chicago Park District.

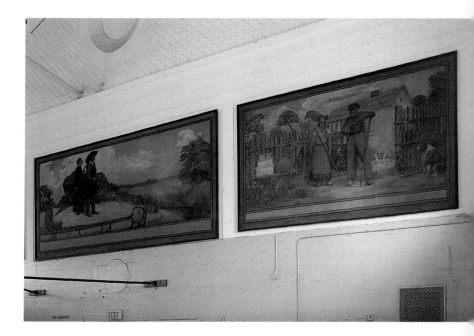

81 ▶ Bennett School

History of Books, 1936–37

Frank I. Bennett School lunchroom, 10115 South Prairie Avenue

Oil on canvas, three panels: 4'6" x 24', 4' x 30', and 4'6" x 23'

ARTIST: Gustaf Oscar Dalstrom (1893–1971)

COMMISSIONED BY: the Works Progress Administration, Federal Art Project

RESTORED BY: the Board of Education, administered by the Public Building Commission, 1998

Created for the library of the Bennett School in the 1930s is a mural that presents the story of the printed word in fifteen distinct scenes. Three long panels, with five scenes each, wind around the upper part of the walls, above blackboards, in the space that is now used as a lunchroom. They depict the historical evolution of the printed word and various methods of reproduction. The Old World is represented by Chinese manuscript block printing, the technique of etching in the Italian Renaissance, Gutenberg's press, the first to use movable type, book binding by hand, and the illuminated manuscript. A large masted sailing ship and a smaller boat carrying pilgrims to the shore mark the transition to the New World. A scene of immigrants studying in a rural classroom is followed by depictions of the dramatic changes brought by mechanization in the twentieth century: sewn-fabric bindings, the rotogravure press, photoengraving, and letterpress. Artist Gustaf Dalstrom, who was active in the WPA's Illinois Art Project, has filled these scenes with much engaging detail.

▶ Bennett School, *History of Books,* one of three panels, detail. Photograph by Tom Van Eynde, courtesy of the Chicago Public Schools, mural commissioned by the Works Progress Administration, Federal Art Project.

82 ➤ Bennett School

Children's Subjects, 1940

Frank I. Bennett School assembly hall, 10115 South Prairie Avenue

Oil on canvas, four panels

ARTIST: Grace Spongberg (1904–92)

COMMISSIONED BY: the Works Progress Administration, Federal Art Project

RESTORED BY: the Board of Education, administered by the Public Building Commission, 1998

In the large and well-maintained auditorium on the ground floor of the Bennett School are four large rectangular murals mounted along the side wall. They depict four basic areas of study: art, literature, science, and music. In the first, against a background of classical columns, buildings, and stained glass, five boys and girls of different ages paint, sculpt, carve, use the potter's wheel, and make a blueprint. The second panel illustrates subjects from literature: two boys whitewash-

ing a fence, a Pilgrim couple with the woman spinning, a Native American youth in front of a tepee, and a white-bearded farmer. In the foreground of the third mural, suggesting science and technology, are two children with a cage of white rabbits. Behind them a man with earphones sits at a control panel, a white-coated technician holds his microscope, a woman conducts experiments in a laboratory, and a bearded man peers at a starry sky through a telescope.

Music is the subject of the fourth. In a lively scene set against musical notes and
organ pipes, a woman is playing an organ and another the violin; a man plays a
xylophone, and a pair of choristers are singing.

Bennett School, *Children's Subjects:* ▲ view of four murals in auditorium; ◀ *Characters from Literature,*
one of the four murals. Photographs by Tom Van Eynde, courtesy of the Chicago Public Schools, murals
commissioned by the Works Progress Administration, Federal Art Project.

83 ► Mann School

Life of Horace Mann, 1937

Horace Mann School, auditorium, 8050 South Chappel Avenue

Oil on canvas, three panels: one 8'7" x 10', two 8'7" x 13'6"

ARTIST: Ralph Christian Henricksen (1907–73)

COMMISSIONED BY: the Works Progress Administration, Federal Art Project

Horace Mann (1796–1859) was an educator and reformer whose ideas revolutionized American public schools. He is considered the founding father of the public school, believing in its power to provide equality of opportunity, social mobility, and intellectual growth. As a lawyer and elected official, he worked for the establishment of teacher institutes and was a vigorous opponent of slavery. Three large murals in the auditorium of the school that bears his name illustrate stages of his life and the application of his educational beliefs. His admonition "Be ashamed to die until you have won some humanity" is inscribed on a small wooden panel beside the entrance. The first mural portrays a boy reading a book outdoors in a rural setting and also a girl indoors holding a slate. In the background are a log-cabin schoolhouse and a church. In the second panel a white-haired Horace Mann is depicted speaking to a gathering of men, women, and children. Against the backdrop of a modern red-brick school exterior, the third panel pictures boys and girls in various classrooms.

► Mann School, Ralph Henricksen painting *Life of Horace Mann,* one of three panels. From the collection of Barbara Bernstein, mural commissioned by the Works Progress Administration, Federal Art Project.

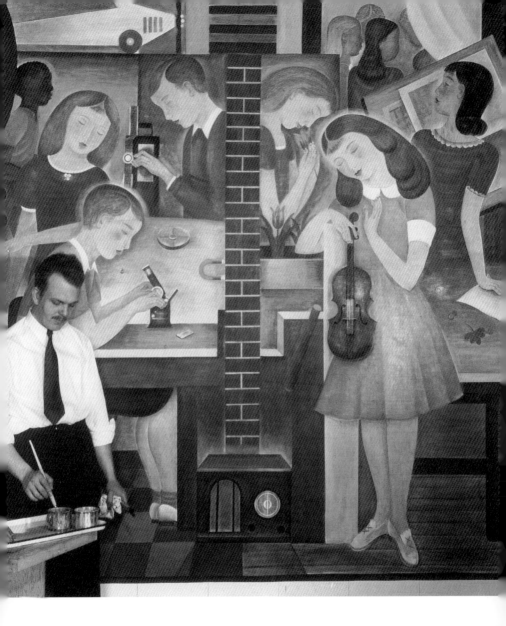

84 ➤ Morgan Park Post Office
Father Jacques Marquette, 1674, 1937

Morgan Park Post Office, 1805 West Monterey Avenue
Oil on canvas, 14' x 8'6"
ARTIST: J. Theodore Johnson (1902–?)
COMMISSIONED BY: the Treasury Section of Fine Arts

During the New Deal era, post office murals and sculpture were commissioned by the Treasury Department's program administered in Washington, D.C. Winners were chosen through competitions judged by either national, regional, or local juries. Artists were not called in until the building was at least 25 percent completed and were then often forced to fit their murals into difficult spaces. Morgan Park follows a rectangular plan very common to post offices of the New Deal period, with the entrance on the long side and the mural on one short end, mounted today above bulletin boards. Set within an architectural framework, the mural appears to have lost parts of its upper and lower portions, probably during a later remodeling when the ceiling was lowered in installing air conditioning. The signature is now missing. The subject, Father Jacques Marquette, was a favorite among Chicago muralists. Born in Laon, France, Marquette came to the New World to establish Jesuit missions among the Indians. He is pictured showing a blanket to a seated Native American. Behind him is another man, standing by a large cross. Both explorer and missionary, he traveled with French Canadian cartographer Louis Joliet, accompanying him on his voyage down the Wisconsin and Mississippi Rivers to the mouth of the Arkansas River and back to Lake Michigan via the Illinois River. Marquette's journal, published in 1681, was the first written record by a European to mention the site of Chicago. He wrote that the two explorers spent the winter of 1674 on the south bank of the Chicago River.

SOUTH SIDE

186

Morgan Park Post Office, *Father Jacques Marquette, 1674*. Photograph © by Don DuBroff, courtesy of the U.S. Postal Service, mural commissioned by the Treasury Section of Fine Arts.

85 ▶ Grand Crossing Park Fieldhouse

An Allegory of Recreation, date unknown

Grand Crossing Park Fieldhouse gymnasium/auditorium
7655 South Ingleside Avenue
Oil on canvas, five panels
ARTIST: Chester Dryan (1904–80)
COMMISSIONED BY: the South Park Commission

Many forms of recreation are depicted on the walls of the large room in the Grand Crossing Fieldhouse that is used as both gymnasium and auditorium. The building, erected in 1915, reflects the influence of D. H. Burnham and Company, although it was designed by South Park Commission architects. Five mural panels are mounted on the curved proscenium arch of the stage at one end of the room. All of the scenes are about recreation and play, both indoors and out. The idealized figures of young men and women are rendered robustly, with details of musculature. The central panel features a large gathering of young people, some dressed for sports and others in regular clothes. Bracketing this are panels with other figures and representations of sporting equipment and outdoor recreation. In what is perhaps a suggestion of park activities over the years, one of the panels depicts such objects as a checkerboard, spinning wheel, small puppet theater, and model airplane. The artist, who directed classes and supervised mural painting in a studio in Washington Park, probably painted the mural there, with the assistance of his student artists.

▶ Grand Crossing Park Fieldhouse, *An Allegory of Recreation,* details, two of five panels. Photographs © by Don DuBroff, courtesy of the Chicago Park District.

86 ▶ Christopher School

Characters from Children's Literature, 1939

Walter S. Christopher School auditorium, 5042 South Artesian Avenue
Tempera on presswood, three semicircular panels, ca. 3'2" radius
ARTIST: Arthur Hershel Lidov (1917–90)
COMMISSIONED BY: the Works Progress Administration, Federal Art Project
RESTORED BY: the Board of Education, administered by the Public Building Commission, 1999

The design of this attractive red-brick school building is not typical of Chicago pub-
lic schools. It was built in 1927 expressly for children who had suffered from polio
and is equipped with special railings and ramps. But today, because the practice
is to "mainstream" students with disabilities, the student body is mixed. Three
murals were commissioned by the WPA, each mounted above one of the three
arched doorways within the auditorium. A separate scene from children's fairy
tales is cleverly fitted into each of the semicircular lunettes. The story of *Rumpel-
stiltskin,* in which a young woman must spin straw into gold, comes from Grimm's
fairy tales. In *Jack and the Beanstalk,* Jack trades his mother's cow for a handful of
beans, which she angrily throws out the window; Jack climbs a thick green vine
that grows from them and finds himself in a strange land. In the illustration of the
Little Mermaid, by Hans Christian Andersen, a muscular man wrestles with an oc-
topus under the sea. The images are highly stylized and beautifully rendered, and
the murals are in excellent condition, having been restored by the Board of Edu-
cation.

▶ Christopher School, *Rumpelstiltskin,* one of three lunettes. Photograph © by Don DuBroff, courtesy of
the Chicago Public Schools, murals commissioned by the Works Progress Administration, Federal Art Project.

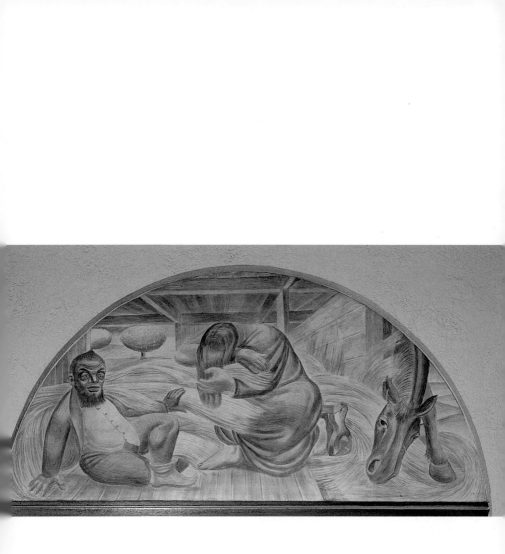

87 ➤ West Pullman School

Americanization of Immigrants, 1940

West Pullman School assembly hall, 11941 South Parnell Avenue
Oil on canvas, two murals 5'6" x 9'2"
ARTIST: Ralph Christian Henricksen (1907–73)
COMMISSIONED BY: the Works Progress Administration, Federal Art Project

The young artist, Ralph Henricksen, lived in the Pullman area when he painted these large murals. They were presented to the school by the West Pullman Woman's Club and Parent-Teacher Association at a ceremony called "Echoes from the Old World," in which students dressed in native costume, a student choir sang, and a representative of the Federal Art Project spoke to the group. The murals represent two distinct time periods. Forming an interesting design, a stylishly portrayed, exotic-looking immigrant family, in turn-of-the century dress and with their luggage, stand ready to move into the country cottage in the background. Behind them, a man with a hammer works on the wooden framework of a new structure. In the second panel, the present is illustrated by a contemporary family posed in front of their brick apartment building in a neighbor-

hood defined by an industrial building and a steelworker in the background. A third mural, a montage of schoolchildren engaged in many activities that is mounted in a ground-floor hallway was also painted by Henricksen.

West Pullman School, *Americanization of Immigrants:* ◄ artist Ralph Henrickson viewing his mural; ▲ one of two panels. From the collection of Barbara Bernstein, murals commissioned by the Works Progress Administration, Federal Art Project.

88 ▶ Sawyer School

History of Chicago, 1940

Sidney Sawyer School, auditorium, 5248 South Sawyer Avenue
Oil on canvas glued to wooden panels, five murals: two 6' x 10' and three 9' x 10'
ARTIST: Lucille Ward (1907–)
COMMISSIONED BY: the Works Progress Administration, Federal Art Project
RESTORED BY: the Board of Education, 1997

The Parent-Teacher Association of the Sawyer School was active in the creation of these historical murals sponsored by the WPA in 1940; the principal chose the five episodes in Chicago history to be represented. Artist Lucille Ward spent several months researching her subject in Chicago libraries before she began to paint. The first scene illustrates the arrival of Father Jacques Marquette in 1773. He is greeted by Native Americans, who present him with an ornamented ceremonial pipe called a calumet. In the background is a map of the five Great Lakes showing the route Marquette traveled. The Indians' name for the city, Checagou, is supposed to have come from their words for "skunk" and "onion," and these images are present. The second panel shows that the purchase from the Miami Indians of the first six square miles of the land on which Fort Dearborn was built in 1804 was paid for by bolts of cloth, and made possible by the Greenville Treaty of 1795. The third panel depicts the Chicago Fire of 1871. Pictured are Mrs. O'Leary and her cow, who watch in dismay as firemen attempt to extinguish the flames, and also workmen who are eagerly con-

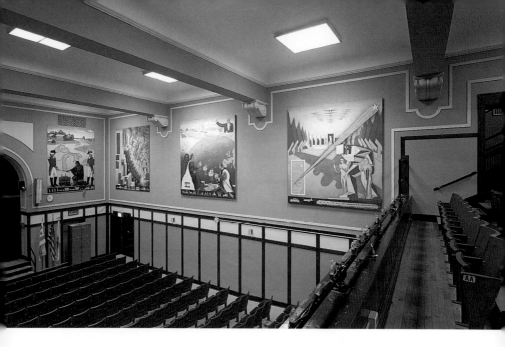

structing a new city of skyscrapers. In the fourth panel, United States president Grover Cleveland presses the button that signaled the opening of the World's Columbian Exposition of 1893 by turning on all the lights. Commemorating the five hundredth anniversary of Columbus's discovery, the fair also marks one of the first public uses of electricity in this country. Chicago's second fair, the Century of Progress Exposition of 1933–34, celebrated the centenary of the founding of the city and is shown in the fifth panel, dramatizing the ray of light from the distant star Arcturus that activated the lights of that fair. Also pictured is the now controversial arrival and enthusiastic greeting of twenty-four seaplanes from Italy, led by General Italo Balbo, soon to become instrumental in Mussolini's rise to power. The large shadow they cast on the ground symbolizes man's great achievements but warns also of the possibility of destruction from such man-made "vultures of the air."

Sawyer School, *History of Chicago:* ◣ four of five murals in the auditorium; ◀ *The Arrival of Father Marquette in 1773.* Photographs by Tom Van Eynde, courtesy of the Chicago Public Schools, murals commissioned by the Works Progress Administration, Federal Art Project.

89 ➤ First Church of Deliverance
Neighborhood People Flocking to the Lord and
Saints around Reverend Cobbs, 1946

First Church of Deliverance foyer and sanctuary, 4315 South Wabash Avenue
Oil on canvas
ARTIST: Fred Jones (1915–96)
COMMISSIONED BY: Rev. Clarence H. Cobbs, founder
RESTORED BY: Fred Jones, 1992

Nat King Cole sang with the choir, Earl (Fatha) Hines made a record in the sanctuary, and many other celebrities have worshiped at the First Church of Deliverance, known as a showcase for gospel music. The building, with its art deco facade of green-and-white terra-cotta and glass brick, was constructed around the core of an existing industrial structure in 1939. In the foyer, over the inner doors to the sanctuary, are murals by Fred Jones, who also designed the carved wooden exterior doors of the church. A pair of winged angels at each end of the long mural bracket a procession of colorfully dressed men, women, and children in worshipful poses. They move toward the central figure of Christ, who raises his hand in

blessing. The background is the Chicago skyline, with the addition of a "golden sanctuary" high in the clouds. Another more somber scene of saints, depicted in muted colors, surrounds the figure of the church's founder in the mural mounted behind the altar. Jones worked closely with Cobbs to create these murals that represent the church's relationship to the community. Jones restored the mural in 1992.

First Church of Deliverance, *Neighborhood People Flocking to the Lord.* Photograph by Jim Prinz Photography, courtesy of First Church of Deliverance.

Childhood Is without Prejudice, 1977

Metra viaduct, Fifty-sixth Street and Stony Island Avenue
Enamel on concrete
ARTIST: William Walker (1927–)
SPONSORED BY: William Walker
RESTORED WITH ACRYLIC PAINTS BY: Olivia Gude and Bernard Williams, 1993

William Walker painted this mural as a tribute to Bret Harte School, to express his appreciation to the Hyde Park elementary school his daughter attended for its efforts in promoting racial harmony in the classrooms. The message of the mural, he said, is that interracial friendships are difficult but that he hoped people would take the challenge. Its design is a pattern of overlapping children's faces, rendered by simple lines, that represent different races. Fellow Chicago muralist John Weber has said that Walker believes he has a moral obligation as an artist and "a teaching obligation to society." Olivia Gude and Bernard Williams of the Chicago Public Art Group recently restored the mural as a service to the community and to recognize the accomplishments of William Walker, who was a cofounder of the Chicago Mural Group, the predecessor of the CPAG, and "spiritual father" of the Chicago mural movement. Walker has created over thirty indoor and outdoor murals in the city and is best known for the *Wall of Respect,* which stood in his neighborhood at Forty-third Street and Langley Avenue and was the first outdoor mural created specifically for a community. Working with some twenty other black artists in its creation, Walker helped to put forth a strong message of pride and self-esteem in portraits of political and religious leaders, musicians, writers, and sports figures. The building was demolished in 1971, but the wall became the inspiration for a new mural movement in Chicago, with Walker as the "main link" to the muralists who followed in the 1970s.

Metra viaduct, Fifty-sixth Street and Stony Island Avenue, *Childhood Is without Prejudice,* one of four sections, detail. Courtesy of the Chicago Public Art Group.

91 ▶ Altgeld Gardens Parent/Child Center

Reaching Children/Touching People, 1980

Altgeld Gardens, Dorothy Gautreaux Parent/Child Center

975 East 132nd Street

"One shot enamel oil paints," 8'6" x 40'

ARTIST: William Walker (1927–)

COMMISSIONED BY: the Chicago Department of Cultural Affairs,
Percent for Art Program

William Walker was the first contemporary muralist
and African American to be commissioned by the
Chicago Percent for Art Program, established in 1978,
one of the first such programs in the nation. That year
the Chicago City Council "unanimously approved an
ordinance stipulating that a percentage of the cost of
constructing or renovating a municipal building be set
aside for the commission or purchase of artworks."
Walker's mural is in the Parent/Child Center at Altgeld
Gardens public housing project, mounted on one of
the walls of a room devoted to the Head Start Pro-
gram. *Reaching Children/Touching People* was the
theme of the fifteenth anniversary of Head Start, the
program that has pioneered preschool education. It is

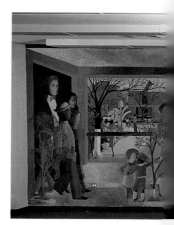

a lively work that covers an entire wall, with men, women, and children all busily
engaged in a variety of activities, some mirroring those that take place in this
room. Portions of the mural are obscured by children's artwork and signs delin-
eating areas of play and study, which have been tacked up on its lower parts. The
program, however, is well organized, directed, and equipped, and the children are
happily and constructively occupied.

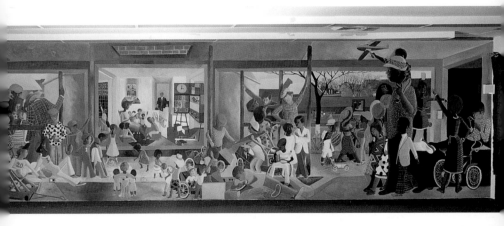

I Welcome Myself to a New Place: The Roseland-Pullman Mural, 1988

Metra viaduct, 113th Street and Cottage Grove Avenue
Acrylic, 7,000 square feet, both viaduct walls
ARTISTS: Olivia Gude (1950–), Jon Pounds (1948–), and Marcus Akinlana (1966–)
COMMISSIONED BY: the Roseland-Pullman Community

This large community project was conceived by Olivia Gude and Jon Pounds, who lived in Pullman, and Marcus Akinlana, who came to Chicago from Washington, D.C., and it was completed with the assistance of one hundred residents who helped raise the necessary funds over a period of nine months. The artists created the mural to help form bonds between the largely white community of Pullman and the mostly African American neighborhood of Roseland. The title is taken from a poem by Walter Ward. Selecting the 113th Street railroad underpass because it gets a lot of foot traffic, the muralists completely covered the walls on both sides with brightly colored images. Depicted are the nineteenth-century Dutch farmers who settled the Roseland area in the 1840s and a contemporary black family representing the community today, interspersed with patterns that derive from African, European, and Native American crafts. The muralists hoped it would act as a bridge to connect the two communities that border on Cottage Grove Avenue but are physically separated by the railroad tracks. The artists are members of the Chicago Public Art Group and have participated in many neighborhood mural projects.

➤ Metra viaduct, 113th Street and Cottage Grove Avenue, *I Welcome Myself to a New Place: The Roseland-Pullman Mural,* detail. Courtesy of the Chicago Public Art Group.

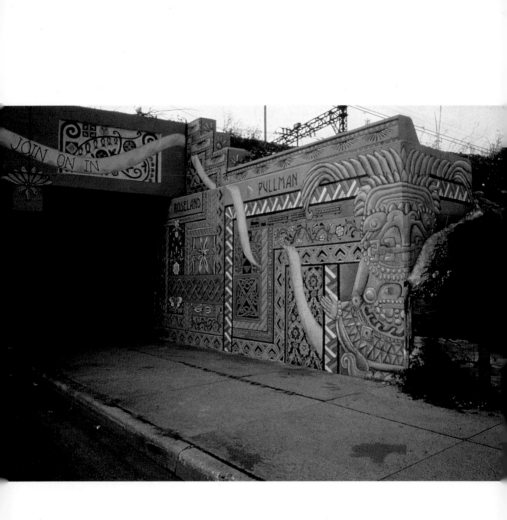

93 ➤ Walgreen Drug Store
Benu: The Rebirth of South Shore, 1990

Walgreen Drug Store, east wall. Seventy-first Street and
Jeffery Boulevard, southeast corner
Acrylic
ARTISTS: Marcus Akinlana (1966–) and Jeffrey Cook (dates unknown)
COMMISSIONED BY: the Chicago Public Art Group and the Neighborhood Institute
FUNDED BY: the Walgreen Company, the City of Chicago Department of Economic
Development, the South Shore Bank, Jason Associates, Dominick's Finer Foods, the City
Lands Corporation, the Material Services Corporation, the Center for Neighborhood
Technology, the Butz Foundation, and the Chicago Public Art Group

The mural conveys a strong message of opti-
mism and the determination of the people of
South Shore to turn their neighborhood around.
The artists have used the symbol of the
phoenix, a mythical bird, fabled to rise from the
ashes of its predecessor, to suggest the hoped-
for resurrection of the troubled community. The
scene is one of dramatic movement: the figures
of men and women, depicted in progressively
larger scale, move across the wall, thrusting for-
ward out of the huge, far-reaching flames to-
ward a more hopeful future. Covering the entire
east wall of the Walgreen store, the mural was
funded by many neighborhood organizations
and businesses. The artists, active members of
the community mural movement, have in-
scribed this message on the mural:

SOUTH SIDE

Ancient myths of Khemit (Egypt) speak of a golden bird in Saudi Arabia called B-N-U (Benu) by the priests of the ancient Egyptian city of Helio[polis]. This bird would die and resurrect itself every 500 years. When nearing death Benu would build a nest of myrrh and wait until the sun's burning rays would ignite. From the ashes a new phoenix would arise and gather together a flock of birds and return to the metropolis to be received by the ancient priests. Since then the phoenix has become a universal symbol of rebirth. Therefore we have chosen it in our mural. Now it's time we begin to rebuild our community here in South Shore. We must understand our roots in order to revitalize the positives in our culture Our destiny is in our hands now.

Walgreen Drug Store, *Benu: The Rebirth of South Shore.* Courtesy of the Chicago Public Art Group.

94 ► Metra Viaduct

Where We Come from . . . Where We're Going, 1992

Metra viaduct, Fifty-sixth Street and Stony Island Avenue
Acrylic on concrete, 11' x 120'
ARTIST: Olivia Gude (1950–)
COMMISSIONED BY: the Chicago Public Art Group

In the spring of 1992, using a tape recorder, Olivia Gude and her assistant Rolf
Mueller stood in front of Hyde Park's Fifty-sixth Street Metra station interviewing
passersby and asking them about themselves. People spoke of their families and
work, their hopes and fears, and commented that although their culturally diverse
neighborhood was integrated, it was also segmented. From these oral histories
Gude observed that most of the people in the community didn't really listen or talk
to each other. In painting the mural, she hoped that the stories she incorporated
into it would represent the beginning of a conversation that would encourage a
"community of discourse." Full-length, more than life-size portraits of men and
women extend along the brick wall of the underpass. Superimposed on these im-
ages are quotations from their stories and also other figures at a much smaller
scale. The dark days of Chicago's long winter are suggested by the mural's muted
colors.

────────────

► Metra viaduct, Fifty-sixth Street and Stony Island Avenue, *Where We Come from . . . Where We're Going,*
detail. Photograph by Olivia Gude, courtesy of the Chicago Public Art Group.

Knowledge That Books Give, 1995

George C. Walker Branch Library, 11071 South Hoyne Avenue
Oil on canvas, 7'4" x 18'10"
ARTIST: Oscar Romero (1954–)
COMMISSIONED BY: the Chicago Department of Cultural Affairs, Percent for Art Program

This fine Prairie style library building was built in 1890 for $12,000 by George C. Walker, a generous local resident. Walker, who was a developer, also provided $1,000 for the initial purchase of books. The large mural in the reading room, commissioned by Chicago's Percent for Art Program during a recent renovation of the library, was painted more than one hundred years later and contains many familiar historical images that symbolize the library as a seat of knowledge. Muralist Oscar Romero writes that the central images are the hands, which "represent the legacy, the gift, the showing of the way, the confidence, the warmth, the friendship and the clarity." The book, with its representation of the earth, symbolizes "all the imagination, the fantasy and the passion of humanity to discover the world." On the right are references to the earliest cultures: the Assyrian/Persian bull, Egyptian pyramid, and African woman surrounded by flowers representing fertility. In the center are the dinosaur of a million years ago and the astronaut, "like a new baby, tied as if by a placenta to the capsule." On the left are a caryatid, representing Greek culture, a Tibetan lama with a scroll, a Viking ship, and the Mexican god Chac-Mool. In contrast to these ancient symbols, Romero includes Chicago's Picasso sculpture, commenting that both he and the sculpture call Chicago home.

► Walker Branch Library, *Knowledge That Books Give.* Photograph by Steven Blutter, courtesy of the Chicago Public Libraries.

96 ▶ Pullman Library

Forces of Pullman Labor, 1995

Pullman Branch Library children's reading area, 11001 South Indiana Avenue
Acrylic on canvas, 10' x 11'6"
ARTIST: Bernard Williams (1964–)
COMMISSIONED BY: the Chicago Department of Cultural Affairs, Percent for Art Program

In the 1880s George Pullman, who developed the first railway sleeping car, built a model town to house his plant and his workers, because he wanted to remove them from the "evil influences" of the city. The design of Pullman was highly praised as an early example of American town planning, but its many restrictions and lack of self-government brought heavy criticism. Pullman's paternalism and subsequent neglect of the workers' welfare caused great discontent that eventually erupted in the strike of 1894. Although the strike was put down, a commission called by President Cleveland ruled against George Pullman and his company and ordered that the houses be sold to the residents. Chicago artist Bernard Williams used the Pullman Branch Library as a child; he illustrates highlights of this story in his mural by focusing on the men and women who worked for the Pullman Company and their spokesmen in the labor movement. Pullman is pictured, along with Asa Philip Randolph, national leader of the Brotherhood of Sleeping Car Porters, and Milton Webster, its Chicago leader. Eugene Debs, the founder of the American Railway Union and leader of the Pullman revolt, is also shown. The mural was commissioned by Chicago's Percent for Art Program, which is funded by a percentage of the cost of construction or renovation of municipal buildings.

▶ Pullman Library, *Forces of Pullman Labor.* Courtesy of the City of Chicago Public Art Collection.

SOUTH SIDE

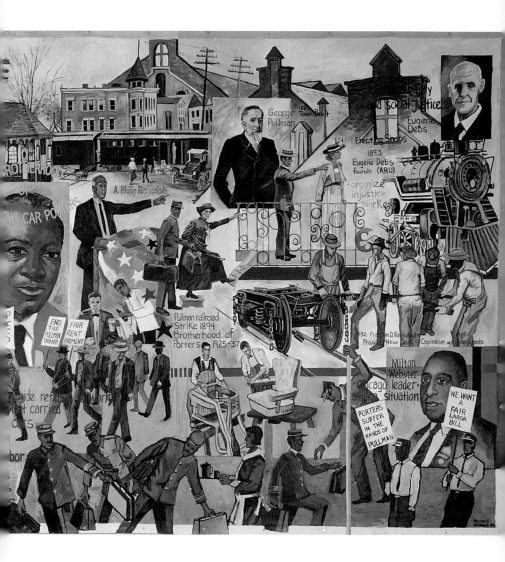

97 ▶ Pullman Library

Come Journey through Corridors of Treasures, 1995

Pullman Branch Library, adult reading room, 11001 South Indiana Avenue
Glass and ceramic tile mosaics
ARTISTS: Nina Smoot-Cain (1943–) and Kiela Smith (1970–)
COMMISSIONED BY: the Department of Cultural Affairs, Percent for Art Program

The artists worked as a team and said they wanted to illustrate the dramatic power of life's stories and experiences. The colorful mosaic figure they have created is a female guardian, representing the keeper of both the stories of the community and its culture. She watches over the written and oral word and is also a symbol for the library itself. The figure seems to move across the wall above an inside window, from doorway to doorway, thus suggesting the evolution of our histories and the passage of time. A technique dating back to ancient times, in recent years mosaics have enjoyed a revival for use in public art. Nina Smoot-Cain and Kiela Smith are among the growing number of artists who are using mosaics for murals and decorations in schools, institutions, and commercial buildings, both inside and out.

SOUTH SIDE

98 ▸ Metra Viaduct

Tribute to Pullman Porters, 1995

East side of Metra viaduct, 103rd Street and Cottage Grove Avenue
Acrylic, two sections, 13' x 55' each
ARTISTS: Bernard Williams, (1964–), assisted by Chris Salmon,
Julia Sowles, and D. J. Williams
COMMISSIONED BY: the Historic North Pullman Organization and the
Chicago Public Art Group
FUNDED BY: the National Endowment for the Arts, the Illinois Arts Council,
and the City of Chicago Department of Cultural Affairs

This mural in the Pullman neighborhood commemorates the founding of the first African American labor union by Asa Philip Randolph. Through a interesting juxtaposition of figures in both large and small scale, Williams tells the story of the struggle of the railroad porters to win a fair labor bill. After a long fight against unfair treatment of black workers, the Brotherhood of Sleeping Car Porters was organized in 1925. "Service not servitude" was its motto. The Pullman Company did not sign a contract with the union until 1937. Randolph, who remained its president until 1968, is shown pointing an accusing finger at the company's founder. George Pullman developed the folding berth and began manufacturing his sleeping cars in 1865. He chose blacks to be sleeping-car porters because he had liked their deferential behavior as servants, wrote Donald Miller in *City of the Century.* Pullman began construction of his model town in 1880 on Chicago's Far South Side, to house many of his fourteen thousand workers as well as to accommodate his factories. He collaborated with architect Solon S. Beman, the designer of his

▸ Metra viaduct, 103rd Street and Cottage Grove Avenue, *Tribute to Pullman Porters,* two details. Courtesy of the Chicago Public Art Group.

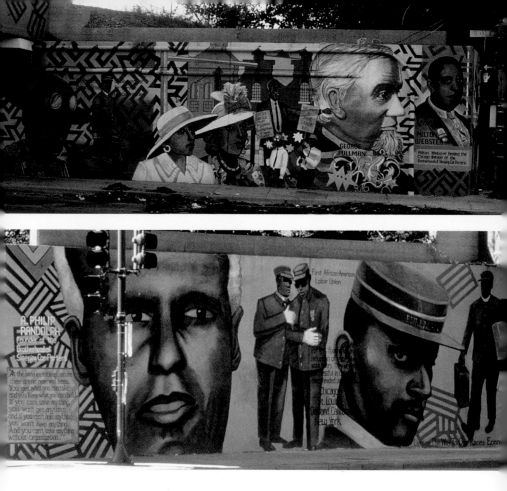

Prairie Avenue mansion. Although he offered the workers clean, healthful, modern living conditions, he controlled every aspect of their lives; one visitor described it as "well-wishing feudalism." In 1894, preferring "independence to paternalism," the workers revolted against terrible working conditions and lack of representation. George Pullman won the strike, but his health was ruined and the court ordered his town to be sold to the people who lived there. Today the community and the many original buildings that still stand have received landmark status, and the area has a more diverse population.

North Side

N

Loyola
University
109

Devon

Ridge

Broadway

Sheridan

Peterson

Lincoln

Western

ROSEHILL
CEMETERY

Ridge

Hollywood

Ashland
Clark

107

EDGEWATER
Foster

Lake Shore Dr

Marine Dr

LINCOLN
SQUARE

126

Lawrence

UPTOWN

115

116
131
132

Broadway

Montrose

Lincoln

GRACELAND
CEMETERY

Sheridan

LINCOLN PARK

Lake Michigan

Irving Park

119

134

Clark

Addison

Wrigley
Field

Broadway

Lake Shore Dr

100 111
101 112
102 113
103 114
115

Belmont

121 122

Western

Damen

Ashland

LAKE VIEW

Clark

Broadway

Sheridan

Diversey

127

108

Elston

I-90/94 Kennedy Expwy

Fullerton

DePaul
University

LINCOLN
PARK

Lincoln Park Zoo

BUCKTOWN

DEPAUL

Lincoln

Clark

99

Milwaukee

Halsted

North

LaSalle

OLD
TOWN

105

GOOSE
ISLAND

Division

LaSalle

State

Lake Shore Drive

129

WICKER
PARK

Division

110

125

Elston

130

123

Chicago

Fairbanks

Grand

133

Navy
Pier

Wacker

Lake Shore Drive

Mural 133 is located at Navy Pier
see inset

99 Café Brauer (1908)
Lincoln Park South Pond Refectory
ARTIST UNKNOWN

100 Lane Technical High School
(1909–10)*
2501 West Addison Street
MARGARET A. HITTLE

101 Lane Technical High School
(1909–10)*
2501 West Addison Street
GORDON STEVENSON

102 Lane Technical High School
(1909–10)*
2501 West Addison Street
WILLIAM EDOUARD SCOTT

103 Lane Technical High School (1913)*
2501 West Addison Street
HENRY GEORGE BRANDT

104 Linné School (1910)*
3221 North Sacramento Avenue
DATUS E. MYERS

105 Pulaski Park Fieldhouse (ca. 1918)
1419 West Blackhawk Street
JAMES J. GILBERT

106 Linné School (1939–40)*
3221 North Sacramento Avenue
ETHEL SPEARS

107 Peirce School (1924–25)*
1423 West Bryn Mawr Avenue
JOHN WARNER NORTON

108 Elks Memorial (1929–30)
2750 North Lakeview Avenue
EUGENE SAVAGE AND
EDWIN HOWLAND BLASHFIELD

109 Loyola University Library (1930)
6525 North Sheridan Road
JOHN WARNER NORTON

110 Palette and Chisel Academy (1930s)
1012 North Dearborn Street
OTTO HAKE

111 Lane Technical High School (1933)*
2501 West Addison Street
MIKLOS GASPAR

112 Lane Technical High School
(1936 or 1937)*
2501 West Addison Street
JOHN EDWIN WALLEY

113 Lane Technical High School (1937)*
2501 West Addison Street
EDGAR E. BRITTON

114 Lane Technical High School
(1937 and 1943)*
2501 West Addison Street
THOMAS JEFFERSON LEAGUE AND
CHRISTIAN AASGAARD

115 Lane Technical High School (1938)*
2501 West Addison Street
MITCHELL SIPORIN

116 Old Town School of Folk Music (1937)
4544 North Lincoln Avenue
FRANCIS F. COAN

117 Mozart School (1937)*
220 North Hamlin Avenue
CHARLES FREEMAN

*Visits to schools marked with an asterisk must be arranged with the principal

118 **Mozart School (1937)**[*]
220 North Hamlin Avenue
ELIZABETH GIBSON AND
HELEN FINCH

119 **Lakeview Post Office (1938)**
1343 West Irving Park Road
HARRY STERNBERG

120 **Armstrong School (1938–39)**[*]
2111 West Estes Avenue
MARION MAHONY GRIFFIN

121 **Nettelhorst School (1939)**[*]
3252 North Broadway
RUDOLPH WEISENBORN

122 **Nettelhorst School (1940)**[*]
3252 North Broadway
ETHEL SPEARS

123 **Lake Shore Center (1938)**
850 North Lake Shore Drive
OTTO HAKE

124 **Schurz High School (1940)**[*]
3601 North Milwaukee Avenue
GUSTAVE A. BRAND

125 **Wells High School (1941)**[*]
936 North Ashland Avenue
HENRY SIMON

126 **Uptown Post Office (1943)**
4850 North Broadway
HENRY VARNUM POOR

127 **Holy Covenant Church (1973–74)**
925 West Diversey Parkway
JOHN PITMAN WEBER AND
OSCAR MARTINEZ

128 **Horwich Jewish Community Center (1980)**
3003 West Touhy Avenue
CYNTHIA WEISS AND
MIRIAM ANNE SOCOLOFF

129 **LaSalle Towers (1980)**
1211 North LaSalle Street
RICHARD JOHN HAAS

130 **Chestnut Place (1982)**
850 North State Street
RICHARD JOHN HAAS

131 **Sulzer Library (1984)**
4455 North Lincoln Avenue
IRENE SIEGEL

132 **Sulzer Library (1984)**
4455 North Lincoln Avenue
SANDRA JORGENSEN

133 **Navy Pier's Gateway Park (1998)**
600 East Grand Avenue
FIVE ARTISTS[†]

134 **Brown Health Center (1997)**
4025 North Sheridan Road
ROGER BROWN

[†]*See page 292*

North Side

North Side neighborhoods lie west of Chicago's lakefront Lincoln Park, which stretches northward along Lake Michigan from Ohio Street to Hollywood Avenue. The park, Chicago's largest and oldest, was established in 1860 and expanded over the years from a small unused portion of an old cemetery to its present size of nearly twelve hundred acres.

Many of the public school buildings in these North Side communities are ninety to one hundred years old and boast historical murals of great merit. During the first two decades of the century, when mural decorations were becoming increasingly popular, students at the School of the Art Institute were given special training in its Mural Department, and when sufficiently advanced they could enter competitions for commissions in the schools and other public buildings. These were sponsored and funded by the Chicago Public School Art Society, founded in 1894 and led by Kate Buckingham, the philanthropist who gave Chicago its famous Buckingham Fountain. Under the name Art Resources in Training (A.R.T.), the organization is still active in the public schools.

In the 1930s and early 1940s the federal government also became the sponsor of murals for schools and other public buildings through the Works Progress Administration (WPA), Federal Art Project. Created by President Roosevelt during this period, the program was part of the New Deal and sought to put unemployed artists, writers, and other people in the arts to work. About four hundred murals were commissioned for Chicago, with perhaps two-thirds surviving.

With sixty-six murals, Lane Technical High School has the largest and most comprehensive collection of any school in Chicago and possibly the country. Murals were created as early as 1909 for its earlier building, and many site-specific works were commissioned by the WPA. The school's unique Mural Restoration Project, initiated in 1995 by school principal David Schlichting and teacher Flora Doody, has restored over fifty murals to date with funds from the Board of Education, the Alumni Association, and various student groups. A joint program with the Art Institute's Department of Museum Education, funded by grants from Polk and Metropolitan Life Foundations, has developed a curriculum guide for teachers and a program that teaches "the historical and cultural significance of the school's murals" and develops "connections between the murals and the humanities." The guide will also be used in other schools whose murals are being restored.

99 ➤ Café Brauer
Terra-Cotta Murals, 1908

Café Brauer Great Hall, second floor, Lincoln Park South Pond Refectory
Terra-cotta tiles (probably Teco Ware or Rookwood)
ARTIST: Unknown
COMMISSIONED BY: Perkins and Hamilton

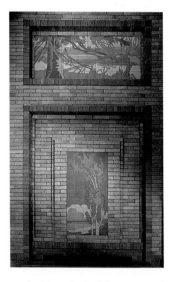

The Lincoln Park South Pond Refectory, popularly known as Café Brauer after the original proprietor, Paul Brauer, is an outstanding example of Prairie school architecture. Designed by Dwight H. Perkins, it opened in 1908 as a restaurant and social gathering place, the first such to be built in a Chicago park. The ground floor was intended as a cafeteria and as a "shelter for skaters and for the boats and the people using them." The Great Hall on the second floor functioned as a more formal dining room until 1941, when a state law was passed prohibiting the sale of liquor on park property. After that it was used only for storage until the repeal of the law made its use viable again. Awarded landmark status, the building was meticulously restored to its original appearance through a partnership of private and public funds, aided by the discovery of thousands of documents and photographs in a basement vault. Perkins's masterpiece reopened in 1990, with a simple snack bar on the ground floor and the Great Hall available to rent for special events. The textured brickwork of the hall is enhanced

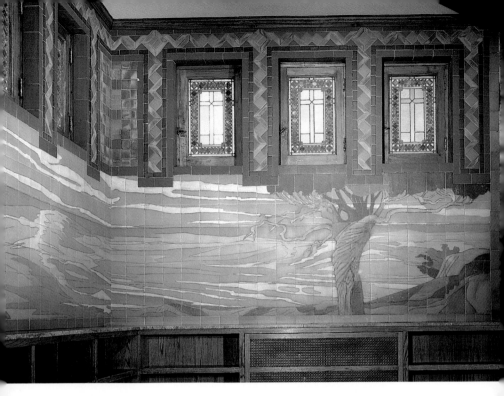

by panoramic landscapes composed of glazed terra-cotta tiles set into the walls. The murals depict outdoor park scenes and are rendered in muted shades of buff, brown, blue gray, and green that repeat the colors in the room. Each panel features a different variety of tree and season of the year. The original leaded glass fixtures hang from the trusses of the high, skylighted ceiling. Both the American Terra Cotta and Ceramic Company, which made Teco Ware, and Rookwood Potteries have been suggested as the manufacturers of the tiles. Perkins was known to use Teco Ware in other buildings he designed. The murals may have been designed by Perkins's wife, Lucy Fitch Perkins, who executed murals for the Chicago Beach and Congress Hotels.

Café Brauer, Lincoln Park, Great Hall interior, two details. Photographs © by Don DuBroff, courtesy of the Chicago Park District and the Levy Organization.

100 ► Lane Technical High School
Steel Mill, 1909-10

Albert G. Lane Technical High School, second floor
2501 West Addison Street
Oil on canvas, 5' x 20'
ARTIST: Margaret A. Hittle (1886–after 1939)
COMMISSIONED AND DONATED BY: the Chicago Public School Art Society,
Kate Buckingham, president. Initial funds raised by Lane Tech, restored by the Board
of Education, administered by the Public Building Commission, 1994–95

In 1909 the Chicago Public School Art Society chose three students from the School of the Art Institute to create murals about modern industry for the new Lane Technical High School, then at Division and Sedgwick Streets. In his note of thanks to Kate Buckingham, head of the Society, the Lane Tech senior class president, Charles I. Gingrich, described the large mural called *Steel Mill* as "a representation of men in a steel mill, toiling bare-armed and sweaty by the glare of the molten steel." He wrote that "gargantuan steel rollers and huge, ponderous cranes lend a sense of massiveness to the picture." The three murals were moved to the present building when it was erected in 1934, and each represents an aspect of Chicago's flourishing industrial development. The artist, Margaret Hittle, a student in the Mural Department of the School of the Art Institute, painted it the same year that Daniel H. Burnham published his great *Plan of Chicago.* Both reflect pride and optimism about the growth of the city.

226

Lane Technical High School,
Steel Mill. Photograph © by
Don DuBroff, courtesy of
Lane Tech.

Construction Site, 1909-10

Albert G. Lane Technical High School, second floor

2501 West Addison Street

Oil on canvas, 5' x 18'

ARTIST: Gordon Stevenson (1892–1984)

COMMISSIONED AND DONATED BY: the Chicago Public School Art Society,
Kate Buckingham, president. Initial funds raised by Lane Tech, restored by the Board
of Education, administered by the Public Building Commission, 1994–95

The mural is one of three painted at Lane Technical High School by students at the School of the Art Institute to portray industrial life in Chicago. Sponsored in 1909–10 by Mrs. Buckingham as president of the Chicago Public School Art Society, it was created for Lane's original home at Division and Sedgwick Streets and moved to its present location when the new school was built in 1934. In a thank-you note to Mrs. Buckingham, Lane's senior class president, Charles I. Gingrich, described the mural as "a skyscraper in the process of construction. In the foreground are seen brawny men straining every muscle in an effort to control the gigantic girders." For many years the artists of this and the other murals were not known. It was during cleaning and restoration in 1995, as part of a schoolwide conservation program spearheaded by a dedicated teacher, that the signatures were revealed.

Lane Technical High School,
Construction Site. Photo-
graph © by Don DuBroff,
courtesy of Lane Tech.

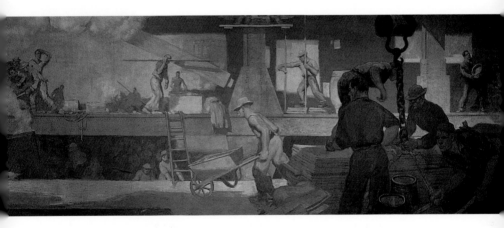

102 ▶ Lane Technical High School

Dock Scene, 1909-10

Albert G. Lane Technical High School, second floor
2501 West Addison Street
Oil on canvas, 5' x 18'
ARTIST: William Edouard Scott (1884–1964)
COMMISSIONED AND DONATED BY: the Chicago Public School Art Society,
Kate Buckingham, president

Dock Scene is one of three murals painted by classmates at the School of the Art Institute, which hung at the head of the main stairway in the original Lane Tech building at Division and Sedgwick Streets. The murals, featuring scenes of Chicago's vigorous industrial life, were moved to the present school building when it was erected in 1934. This work portrays men of all nationalities and colors laboring together with a sense of equality that often informs Scott's murals. In a letter of appreciation to Mrs. Buckingham, president of the Chicago Public School Art Society, a philanthropic organization that worked closely with the Art Institute and sponsored the murals, Lane's senior class president, Charles I. Gingrich, described the scene as follows: "A ship lies at dock, being loaded with divers goods for various countries. The wharf is a seething, teeming mass of humanity as the dock workers toil at their task." Only when the mural was cleaned and restored in 1995 was William Edouard Scott's signature discovered. This artist went on to have a long and distinguished career.

230

Lane Technical High School,
Dock Scene. Photograph ©
by Don DuBroff, courtesy of
Lane Tech.

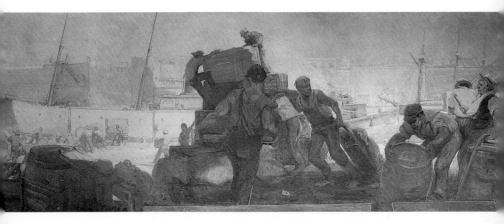

Lane Technical High School

Hiawatha Murals, 1913

Albert G. Lane Technical High School, main lobby

2501 West Addison Street

Oil on canvas, original stretchers with molding frames, seven panels:

six 5' x 15' and one 15' x 30'

ARTIST: Henry George Brandt (1862–?)

COMMISSIONED AND DONATED BY: the Chicago Public School Art Society,

Kate Buckingham, president. Initial funds raised by Lane Tech, restored by the Board

of Education, administered by the Public Building Commission, 1998

Seven panels survive from the original eight that were hung in the auditorium of an earlier school building built in 1909. They were moved in 1934 when the present school was built. The Native American was chosen as the school symbol. It called the student newspaper the *Lane Warrior* and emblazoned a large Native American figure on the fire curtain of the auditorium stage (see number 112

below). The *Hiawatha Murals* portray humans in their natural environment and include illustrations of Native American life such as *Homage to Nature,* which shows a village of tepees set against a glowing sky. Other delicately rendered scenes are titled *Processional, Forest Dance, Indians in Canoes, Buffalo Hunt,* and *Village Scene.* The muted colors, sometimes shot through with golden tones, and the strong sense of patterning are characteristic of both Beaux Art and Arts and Crafts styles. Brandt had been a classmate of the three other Lane muralists, Margaret Hittle, William Edouard Scott, and Gordon Stevenson, who created their murals several years earlier as senior art projects for the School of the Art Institute.

Lane Technical High School, Hiawatha Murals: *Village Scene,* one of seven panels. Photograph © by Don DuBroff, courtesy of Lane Tech.

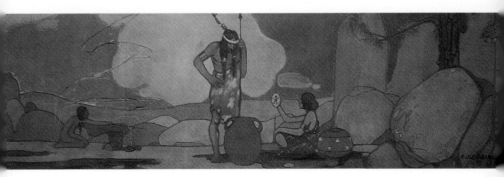

Linné School

Pioneers and Indians, 1910

Carl von Linné School, ground floor, 3221 North Sacramento Avenue
Oil on canvas, ca. 6' x 40'
ARTIST: Datus E. Myers (1907–89)
COMMISSIONED BY: the School of the Art Institute
FUNDED BY: Patrons of the Art Institute
RESTORED BY: the Board of Education, 1999

The Linné School celebrated its centennial in 1995 in its building that had been recently restored by the Chicago Building Commission. On the ground floor is a picturesque mural painted in 1910 depicting the arrival of a group of pioneers at a Native American settlement. At the bottom left corner is an inscription noting two earlier restorations, one in 1937 by the WPA and another in 1977, identified only by the initials MCM. The mural was part of a restoration project funded by the

Board of Education. Arranged across the length of the long mural are several dozen figures: Native American families by their tepees and pioneers and settlers on horseback and near their covered wagons. The scene shows the peaceful intermingling of the two groups. Among the figures are women carrying their babies, a mother and daughter on horseback, children standing before their wagon, and a farmer leading two cows. Two men who appear to be leaders of the pioneer group are speaking to the Native Americans' chief. The Linné School was one of many schools "decorated" by advanced students in the Mural Department of the School of the Art Institute during this period, and Datus Myers executed this mural as part of his studies.

Linné School, *Pioneers and Indians*. Photograph by Ted Lacey, courtesy of the Chicago Public Schools.

105 ▶ Pulaski Park Fieldhouse
Proscenium Arch Mural (ca. 1918)

Pulaski Park Fieldhouse, assembly hall
1419 West Blackhawk Street (West of Noble Street and south of North Avenue)
Oil on canvas
ARTIST: James J. Gilbert (dates unknown)
COMMISSIONED BY: the West Park Commission

Pulaski is one of the Chicago neighborhood parks created by the Progressive Reform movement at the beginning of the century to meet the needs of the city's rapidly growing and largely immigrant population. The West Park Commission carved the park out of a densely built Polish neighborhood, naming it after the Polish American Revolutionary War hero Casimir Pulaski. The imposing fieldhouse, erected in 1912, was made to resemble buildings from the "old country" and is one of the largest of the West Park facilities. Concerned with education and culture as well as with recreation, it contained a gymnasium, branch library, social rooms, and assembly hall to augment its outdoor programs. Recently arrived European immigrants could take classes in English, citizenship, and "Americanization." The allegorical mural that forms a wide band around the arched proscenium of the stage is an example of the grandeur of these fieldhouses, and it is known that the artist was assisted in its painting by students from the School of the Art Institute. The large formal assembly hall measures fifty feet by seventy-one feet, with a high vaulted ceiling, arched balconies, and a sponge painted wall finish that has been carefully restored. On the left side of the mural are scantily clad bent figures straining to reach the peak, while on the right side graceful, erect young men and

▶ Pulaski Park Fieldhouse, untitled proscenium arch mural. Photograph by Tom Van Eynde, courtesy of the Chicago Park District.

NORTH SIDE

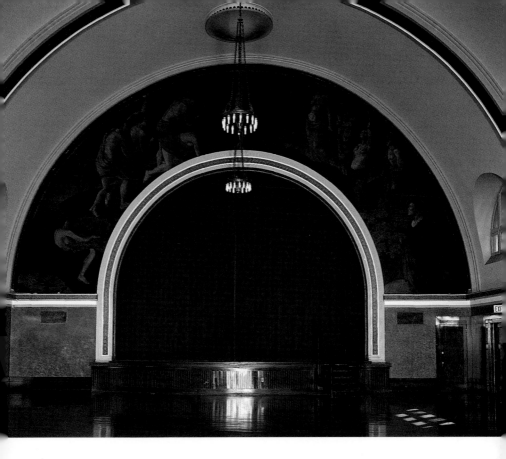

women, looking like gods and goddesses, face them proudly. At the apex of the arch is the idealized nude figure of a youth. The mural uses allegory to illustrate the heights immigrants can attain if they successfully adapt to the New World and is yet another example of the acculturation program so actively conducted in the parks. Today the fieldhouse sits at the edge of an expressway, towering over a neighborhood of scattered small structures and empty lots.

106 ▶ Linné School
The Life of Carl von Linné, 1939–40, dedicated 1944

Carl von Linné School, second-floor classroom, 3221 North Sacramento Avenue
Oil on canvas, 6' high on four walls
ARTIST: Ethel Spears (1903–74)
COMMISSIONED BY: the Parent-Teacher Association of the Linné School
FUNDED BY: the Parent-Teacher Association and several graduating classes
RESTORED BY: the Board of Education, 1999

A mural that tells the story of Carl von Linné (Carolus Linnaeus, 1707–78), who is considered a father of modern systematic botany, wraps around the upper four walls of the former library on the second floor, now used as a classroom. This man for whom the school was named worked in his native Sweden, explored Lapland for the Swedish Academy of Sciences, earned an M.D. in Holland, developed the foundation for modern botanical nomenclature, and practiced medicine. The mural is a panorama of his life, studies, and travels, with delicate landscapes progressing around the walls like the unrolling of a Chinese scroll. Linné is depicted from childhood to the time he was issued the "patent of nobility" by the Swedish king. It was designed by Ethel Spears, who was an active WPA muralist in Chicago, and executed under her direction. Her mural in the former library of the Nettelhorst School employs a similar wraparound style.

▶ Linné School, *Life of Carl von Linné,* detail. Photograph by Ted Lacey, courtesy of the Chicago Public Schools.

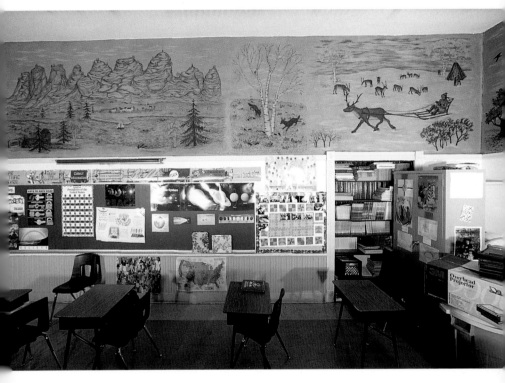

107 ▶ Peirce School
Twelve Months of the Year, 1924–25

Helen C. Peirce School, kindergarten room, 1423 West Bryn Mawr Avenue
Oil on canvas, mounted on board, eleven panels 3' x 4' each
ARTIST: John Warner Norton (1876–1934)
COMMISSIONED BY: the Peirce School
RESTORED BY: the Board of Education, 1999

The kindergarten room of the Peirce School has been called a "historical treasure chest." Prairie school architect George Elmslie and eminent muralist John Warner Norton worked together on the design that was to include an adjacent playground designed by the landscape architect Jens Jensen but was never built. The school was named for Helen C. Peirce, who helped bring the modern kindergarten to Chicago in the late nineteenth century. Norton painted twelve scenes depicting the months of the year, and Elmslie, whose architectural plan remains intact, designed the frames and incorporated the paintings into the overall plan. An architectonic framework on one wall accommodates six panels at a time, and the paintings are changed according to the season. Norton incorporated familiar symbols to designate each month, including a cat sitting by a fireplace for February; rainstorms and new foliage for April; apple blossoms and robins for May; Old Glory waving for July; a sloop running before the wind, high bluffs, and lighthouse for August; a turkey and hen in a farmyard with corn stalks in the background for November; and moonlight on a snowy mountainscape for December. Only June is missing, having disappeared in the 1920s. The school, led by its principal, Dr. Janice Rosales, has a strong interest in the arts and maintains an active art program. In 1991 Nina Smoot-Cain as artist in residence directed students in creating a ceramic mosaic mural as a joint project sponsored by Urban Gateways and inspired by Roger Brown's large mosaic mural of Icarus and Daedalus on the facade of 120 North LaSalle Street. (See Central Area, number 41.)

Peirce School, *Twelve Months of the Year:* four of eleven panels: (a) *February;* (b) *July;* (c) *March;* (d) *November.* Photographs by Tom Van Eynde, courtesy of the Chicago Public Schools.

108 ➤ Elks Memorial
The Beatitudes, Armistice, and Paths of Peace; Charity, Fraternity, and Fraternal Justice, 1929-30

The Elks National Memorial Building, 2750 North Lakeview Avenue
Oil on canvas, fifteen panels
ARTISTS: Eugene Savage (1883–1966) and Edwin Howland Blashfield (1848–1936)
COMMISSIONED BY: the Benevolent and Protective Order of Elks

This imposing neoclassical domed structure was built in 1924–26 as a memorial to the seventy thousand Elks who served in World War I. The richness of the sculpture and sculptural relief ornament on the exterior is matched by the profusion of sculpture, stained glass, murals, and variously colored marble within. "In every direction there is marble," stated the Elk's descriptive 1931 publication *The Story of Elkdom.* Twelve enormous mural panels by Eugene Savage are mounted in the upper colonnade of the central rotunda, above the doorways, alternating with stained glass windows and framed by tall marble columns. The murals were awarded the Gold Medal of Honor by the Architectural League of New York in 1929. Savage chose the Beatitudes, the blessing Jesus is said to have given as a prelude to his Sermon on the Mount, to celebrate the bravery of those who fought and to depict the spiritual rewards of their bravery. Smaller paintings with military figures and symbols that relate to the panels appear between the spandrels of the arcade below. In the reception room, Savage painted scenes of soldiers emerging from trenches and a multigenerational family surrounded by harvest bounty illustrating *Armistice* and *Paths of Peace.* In a more classic manner, Edwin Blashfield's three allegorical murals in the west corridor leading to the reception room express the creed of the Elks: charity, justice, brotherly love, and fidelity. Two large panels and a central lunette portray Charity as a winged figure holding the horn of plenty, Fraternity as a goddess holding an olive branch above a group of men pledging fraternal oaths, and Fraternal Justice with book, sword, and balances.

NORTH SIDE

242

The Elks Memorial: (a) Eugene Savage, *Paths of Peace*, one of twelve panels; (b) Edwin Blashfield, *Fraternity*, one of three panels. Photographs © by Don DuBroff, courtesy of the Elks National Memorial.

109 ► Loyola University

New Lands in North America Explored and Evangelized by Fathers of the Society of Jesus, 1930

Loyola University, Elizabeth Cudahy Memorial Library, 6525 North Sheridan Road
Oil on canvas, 38' x 35'
ARTIST: John Warner Norton (1876–1934)
COMMISSIONED BY: Andrew Rebori (Rebori, Wentworth, Dewey and McCormick, Architects)

The large map mural on the west wall of the reading room of the Cudahy Library illustrates the explorations of Father Jacques Marquette, the Jesuit missionary who traveled in the Great Lakes region and Upper Mississippi Valley during the seventeenth century. Artist John Warner Norton freely adapted Marquette's famous holograph map made after his journey with explorer-cartographer Louis Joliet in 1673. Marquette returned to Illinois and settled near the south branch of the Chicago River, becoming the first white man on record to live in Chicago. He died two years later, revered by the Illinois Indians he had converted. Pictorial vignettes on the map depict episodes in the lives of the missionaries, and geometric symbols mark rivers, forests, villages, and Native American settlements. The legends are in French, and the title is in Latin. This map is one of three painted by Norton, who had a lifelong interest in cartography. In 1928 he executed a map for the Chicago Motor Club, now Wacker Tower (see Central Area, number 15), and three years later he painted a series of wall maps at the University of Notre Dame in Indiana. He was assisted for many years by his former student Tom Lea.

► Loyola University, Cudahy Library, *New Lands in North America Explored and Evangelized by Fathers of the Society of Jesus.* Photograph by Ted Lacey, courtesy of Loyola University.

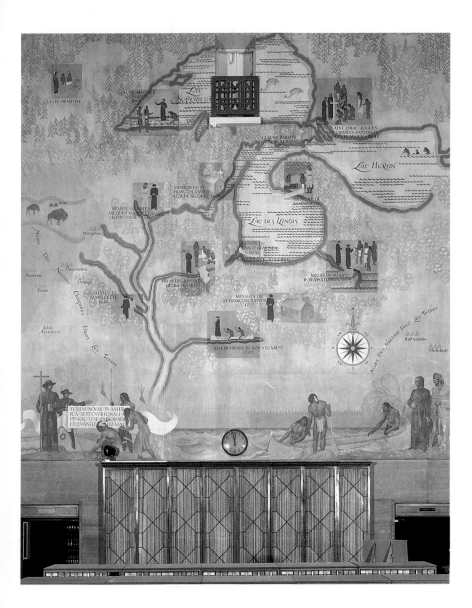

Palette and Chisel Parties, 1930

Palette and Chisel Academy of Fine Arts, lower level
1012 North Dearborn Street
Oil on canvas
ARTIST: Otto Hake (1876–1965)
COMMISSIONED BY: the Palette and Chisel Academy of Fine Arts

The Palette and Chisel Academy of Fine Arts was founded in 1895 to encourage the growth of the visual arts by providing classes, studio space, and the chance for members to meet and mix with other serious artists. Membership included professional, commercial, and amateur artists, many of them prominent businessmen. The club moved to its present building in 1921, converting the original 1870s house into studios and exhibition space. Its English basement, now the club's office, functioned as drama and party space during the early years. In the 1930s club member Otto Hake, who studied in Germany and later at the School of the Art Institute, covered all four walls of the large room facing Dearborn Street with colorful expressionist murals. He pictured many of the imaginative spoofs of grand opera and "frolics" that the members put on during 1897 to 1930. Men and women in elaborate costumes are "immortalized" as dancers, musicians, and acrobats at such evenings as *Il Janitore* of 1897 and *Carmine, Arabian Night,* and *Jungle Ball* of 1930. Camaraderie was obviously an important factor in the club's success. Today these wonderful scenes, some of which have sustained water damage and tears over the years, are background to the office functions of the club.

➤ The Palette and Chisel Academy, Otto Hake painting *Palette and Chisel Parties,* detail. Courtesy of the Palette and Chisel Academy of Fine Arts.

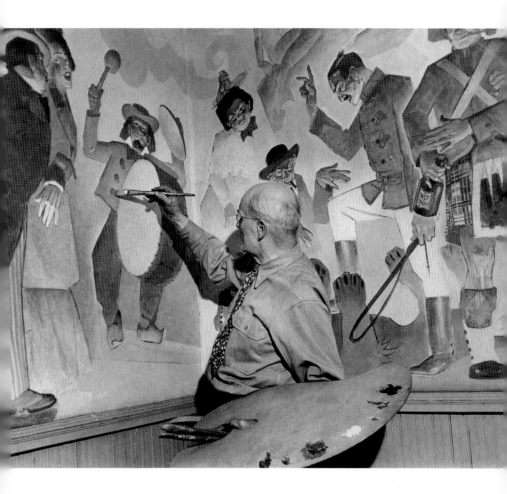

Lane Technical High School

The Forty-eight States, 1933

Albert G. Lane Technical High School, ground-floor corridors, 2501 West Addison Street
Oil on canvas on board, forty panels, mostly 4' x 24' each
ARTISTS: Miklos Gaspar (1885–1946), Axel Linus (1885–1980), and
T. C. Wick (dates unknown)
COMMISSIONED BY: General Motors for the 1933 Century of Progress Exposition.
Initial funds raised by Lane Tech, restored by the Board of Education, administered by the
Public Building Commission, 2000

Forty mural panels depicting "the principal products and manufacturing process"
in the forty-eight states were created for the General Motors Building, designed
by Albert Kahn at Chicago's 1933–34 Century of Progress Exposition. They hung
on the walls of the huge oval balcony, "the Gallery of the States," 420 feet long
and 90 feet wide, where visitors could stand and look down on an assembly line
and see a Chevrolet built before their eyes. One car was produced every day.
Largest of the private exhibition buildings at the fair, its main entrance hall fea-
tured a greater than life size figure by Carl Milles representing the skilled auto-

Lane Technical High School, *The Forty-eight States,* two of forty panels: ▼ *Lumber . . . Washington;*
◀ *Textile . . . South Carolina.* Photographs © by Don DuBroff, courtesy of Lane Tech.

motive worker. The murals were given to Lane at the close of the fair, which coin-
cided with the opening of the technical high school's new building in 1934. Each
panel pictures the contributions of one, two, or three states, with illustrations of
the raw materials and industries involved in making automobiles. The murals had
been attributed to Miklos Gaspar until they were cleaned and restored in the the
winter of 2000, when the signatures of two other artists, T. C. (Gus) Wick and Axel
Linus, were discovered. Gaspar is now credited with thirteen, Wick with nineteen,
and Linus with eight.

Lane Technical High School

Indian Motif, 1936 or 1937

Albert G. Lane Technical High School auditorium

2501 West Addison Street

Oil on canvas, 20' x 43'

ARTIST: John Edwin Walley (1910–74)

COMMISSIONED BY: the Works Progress Administration, Federal Art Project

Initial funds raised by Lane Tech, restored by the Board of Education, administered by the

Public Building Commission, 1998

The imposing Native American figure called "the lean Indian," painted on the steel fire curtain of the school auditorium, was the first of many artworks to be commissioned for Lane Tech, then all male, during the New Deal years. The school had moved to a new building in 1934, and Lane's principal was eager to have new works of art. He eventually assembled the largest public school collection of WPA art in the city. Together with a supervisor and an artist, who were sent to the school from the local WPA office, the principal would determine the subject, medium, and nature of each project. John Walley's first proposal for the fire curtain, depictions of hunting and ceremonial scenes he remembered from his Wyoming childhood, was rejected by the principal, who said it was "too exciting, and it would make the boys crazy." Walley would have liked to back out, but instead he fulfilled the principal's request for something more "static," inspired by sculptor Lorado Taft's colossal statue *Black Hawk* in Oregon, Illinois. Walley was concerned about the large scale of the figure, fearful that for students "in the first twenty rows, all they'll see is knees. But that's what [the principal] wanted and that's what I did." As WPA project supervisor for the school, Walley said that he "opened up Lane for the other artists." The figure on the curtain disappeared from sight in the 1970s, however, when a psychedelic pattern was applied to the curtain. Only through the efforts of Flora Doody, a dedicated and determined Lane

teacher who initiated a restoration program in 1995, was the psychedelic layer painstakingly removed by a professional conservator and the mural restored to its original condition. The work took nearly two years. The composition also includes symbols and patterns used by the Crow Indians. These symbols describe the journey of the student through Lane as he develops "wisdom and a watchful eye" and eventually "embark[s] on another path to reap the harvest and plenty of life."

Lane Technical High School, fire curtain, *Indian Motif.* Photograph by Michael Tropea, courtesy of Lane Tech, mural commissioned by the Works Progress Administration, Federal Art Project.

Lane Technical High School
Epochs in the History of Man, 1937

Albert G. Lane Technical High School cafeteria
2501 West Addison Street
Fresco, seven panels; one 12'1" x 6' and six 12'1" x 14'4"
ARTIST: Edgar E. Britton (1901–82)
COMMISSIONED BY: the Works Progress Administration, Federal Art Project
Being restored 2000–2001

In 1934 the principal of Lane Tech, then an all-male school, welcomed the Federal Art Project into his school. He believed in the importance of the arts in education and thought Edgar Britton's frescoes would inspire his students. The artist was one of many put to work by the WPA during the Great Depression of the 1930s, and Lane students were able to watch him as he painted his fresco mural directly on the cafeteria walls. In the commemorative brochure Britton prepared, he wrote, "If the murals reveal a sense of the pleasure I felt in being given the opportunity to do them, and if they convey a feeling of optimism for the future of Man's achievement they shall have succeeded." With the inspiration of the work of the Mexican muralists of the 1920s, who strongly influenced American painters of this period, these murals emphasize the worker and the family as symbols of their country's strength. They also suggest the continuing social progress under the New Deal. The seven panels depict "the rise and fall of man and his spiritual progress" through seven historical periods: Primitive, Egyptian, Greek, Middle Ages, Renaissance, Contemporary, and the Future. The scene of a modern family looking at the swift waters at Boulder Dam in Colorado shows one of the New Deal's grandest accomplishments. Dominating Lane's large cafeteria space are these dramatic frescoes, which will receive much-needed attention through an extensive program of restoration spearheaded by one of Lane's dedicated teachers.

Lane Technical High School, *Epochs in the History of Man: Medieval Scene,* one of seven panels.
Photograph © by Don DuBroff, courtesy of Lane Tech, murals commissioned by the Works Progress
Administration, Federal Art Project.

114 ▶ Lane Technical High School
Robin Hood, 1937, and *Native American Theme,* 1943

Albert G. Lane Technical High School library
2501 West Addison Street
Oil on canvas, two panels, 15' x 8' each
ARTISTS: Thomas Jefferson League (1892–?) and Christian Aasgaard (1922–99)
COMMISSIONED BY: the Works Progress Administration, Federal Art Project
To be restored 2001–2

Robin Hood, mounted on one of the stairways to the balcony of the Lane Tech library, was painted by a Lane student named Christian Aasgaard from a design by Thomas Jefferson League, who was an art instructor at the school. *Native American Theme* was painted by League himself. The imaginative depictions suggest the roles that European royalty played in backing the explorations and adventures in the New World. The first shows a kneeling figure with a bow being offered an arrow on a satin pillow by a richly dressed woman, perhaps a queen. In the background are figures of hunters, trappers, and explorers paddling along waterways dotted with trees. In the second mural, the great natural abundance of the new land is emphasized by the lush forest setting, with a deer drinking from stream, a bird flying, and two Native American men in native dress, one reclining and the other standing. Also commissioned by the WPA for the library are five fine mahogany wood reliefs by Peter Paul Ott done from 1934 to 1936, titled *Evolution of the Book.*

▶ Lane Technical High School, *Native American Theme.* Photograph © by Don DuBroff, courtesy of Lane Tech, mural commissioned by the Works Progress Administration, Federal Art Project.

115 ▶ Lane Technical High School
The Teaching of the Arts, 1938

Albert G. Lane Technical High School auditorium lobby
2501 West Addison Street
Fresco, four panels, 15' x 3'6" each
ARTIST: Mitchell Siporin (1910–76)
COMMISSIONED BY: the Works Progress Administration, Federal Art Project
To be restored 2001–2

Four vertical panels mounted between the exterior doors of the Lane Tech audi-
torium describe the teaching of the humanities. They were painted when the
school was all male. In each, Mitchell Siporin portrays the figure of a mentor or
teacher standing behind that of a young student. For literature, a wise-looking
older man with his arm outstretched gently leads a young man with book in hand.
Art is suggested by a student holding a palette and painting a still life at his easel.
His teacher stands behind him with his arm on the young man's shoulder. A young
man performing on his violin accompanied by a shadowy figure at the piano per-
sonifies music. In the fourth panel, a boy in Elizabethan costume is embraced by
a figure in classical robes representing drama. In acknowledging the influence
of the Mexican muralists José Clemente Orozco, Diego Rivera, and David Alfaro
Siqueiros on his work, Siporin said, "Through the lessons of our Mexican teach-
ers, we have been made more aware of the scope and fullness of this the soul of
our own environment." It was they, he said, who suggested "the application of
modernism toward a socially moving epic of our time and place."

▶ Lane Technical High School, three of four panels: (a) *Music;* (b) *Drama;* (c) *Art.* Photographs © by
Don DuBroff, courtesy of Lane Tech, mural commissioned by the Works Progress Administration, Federal
Art Project.

NORTH SIDE

116 ► Old Town School of Folk Music

The Children's World, 1937

Old Town School of Folk Music (formerly Hild Branch Public Library)
4544 North Lincoln Avenue
Oil on canvas, two murals, 9' x 34' each
ARTIST: Francis F. Coan (1914–80)
COMMISSIONED BY: the Works Progress Administration, Federal Art Project
RESTORED BY: the Old Town School of Folk Music, 1997–98

Built as a library in 1929–31, this handsome art deco structure was closed in 1984
when the Sulzer Regional Library was constructed nearby to replace it. It was named
for Frederick C. Hild, head librarian of the Chicago Public Library system from 1887
to 1909. In 1998 it opened as the new home of the Old Town School of Folk Music,
founded in 1957 as a nonprofit organization "dedicated to the teaching and pre-
senting of traditional and contemporary folk music, dance, and arts." The dramatic
reuse of the space, its imaginative plan designed by Wheeler/ Kearns, includes a
repositioning of the two large WPA murals from the walls of the second-story chil-
dren's reading room of the original library. Removed and restored, they have been
remounted on the proscenium of the concert hall and in the Joan and Irving Harris
corridor gallery on the second floor. The building is decorated with colors chosen

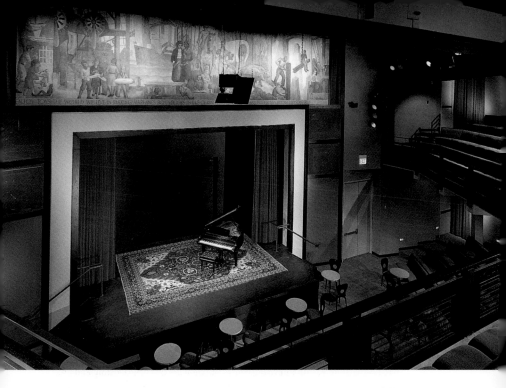

from these brightly hued murals. Both murals contain scenes from children's literature and recreational activities, with descriptive legends below. Inscribed under the first mural is "Enjoy Toys. The World We Live In. Making Airplanes. Boats. Books Tell Us of King Arthur. Costume and Pioneer Days. Building Skyscrapers. Electricity." And the words under the second mural are "Steel. Streamlined Trains. We Watch Waterfalls. We Read About Robin Hood and Rip Van Winkle. We Love a Circus With Animals." In prominent new positions in their old home, the murals take on a special significance as a link between past and present.

Old Town School of Folk Music, *The Children's World*, two panels: ◄ second floor; ▲ concert hall. Photographs by Ted Lacey, courtesy of Hedrich Blessing, murals commissioned by the Works Progress Administration, Federal Art Project.

117 ▶ Mozart School
Characters from Children's Literature, 1937

Wolfgang Amadeus Mozart School, classroom 203
220 North Hamlin Avenue
Oil on canvas, two murals 6' x 20' each
ARTIST: Charles Freeman (dates unknown)
COMMISSIONED BY: the Works Progress Administration, Federal Art Project
RESTORED BY: the Board of Education, 1997

The depiction of characters from children's literature is a typical subject for WPA murals in the libraries of public grade schools. In the former library of the Mozart School, now used as a classroom, two colorful murals are filled with a panorama of literary figures, framed on all four sides by a listing of their names. In one panel Mary and her lamb, the Queen of Hearts, Jack and Jill, Old King Cole, and characters from *Mother Goose* stand side by side with Peter Pan, Rip Van Winkle, Alice in Wonderland, Robinson Crusoe, and the Pied Piper of Hamelin, favorites in the 1930s and still popular today. Illustrated in the other panel are the imaginatively rendered folk of such fairy tales and classic books as *Cinderella, Huckleberry Finn, Alice in Wonderland, Peter Pan, Treasure Island, The Deerslayer, Tom Sawyer,* and *Little Women.* Each character is dressed in the appropriate costume and holds a prop for easy identification: William Tell carries a basket of apples, Aladdin grasps his magic lamp, and the prince holds a glass slipper as he kneels before Cinderella.

Mozart School, *Characters from Children's Literature*, oil on canvas, detail from right panel, one of two.
Photograph by James Prinz Photography, mural commissioned by the Works Progress Administration,
Federal Art Project; © 1999, the Art Institute of Chicago, all rights reserved.

118 ▶ Mozart School

Mozart at the Court of Maria Theresa, 1762 and *Michelangelo in the Medici Gardens, 1490,* 1937

Wolfgang Amadeus Mozart School auditorium
220 North Hamlin Avenue
Oil on canvas, two murals: 6' x 20' and 10' x 15'
ARTISTS: Elizabeth Gibson (dates unknown) and Helen Finch (dates unknown)
COMMISSIONED BY: the Works Progress Administration, Federal Art Project
RESTORED BY: the Board of Education, 1997

Two courtly murals are mounted on each side of the stage of the Mozart school auditorium, which also serves as a gymnasium. In the mural honoring Mozart, for whom the school is named, the scene is Vienna in the eighteenth century, where a youthful Mozart sits at the piano while his sister "Nannerl" sings for the court

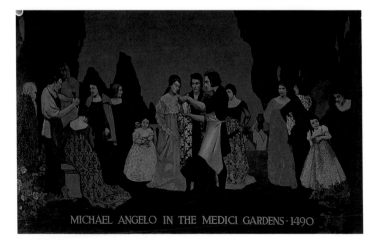

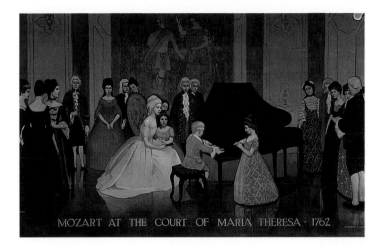

MOZART AT THE COURT OF MARIA THERESA · 1762

of the Archduchess Maria Theresa, who listens attentively. Her young daughter Marie Antoinette stands at her side. Legend has it that her husband, the emperor Francis I, was so impressed with Mozart's talent that he challenged him to play with the piano keys covered and then to play with only one finger. Of course Mozart could do it. Other members of the court stand in the background. The second mural is set in fifteenth-century Florence in the Medici Palace gardens. Michelangelo is pictured working on a block of marble, surrounded by a group of interested admirers. The artist, who became one of the greatest figures of the Renaissance, lived in the palace for two years, attending a school that was set up in the gardens. His first patron was Lorenzo de' Medici, the most famous member of the Medici family and a supporter of the arts, who often set him to copying antique sculpture. The murals were restored by the Board of Education in 1997. Chopin and Schubert are the subjects of WPA murals in two other Chicago schools that bear the names of famous European composers. Typically, however, American subjects predominate.

Lakeview Post Office

Chicago—Epic [sometimes *Epoch*] *of a Great City,* 1938

Lakeview Post Office, 1343 West Irving Park Road
Oil on canvas, 7'7" x 24'2"
ARTIST: Harry Sternberg (1904–)
COMMISSIONED BY: the Treasury Section of Fine Arts

Mounted over the service windows of this well-maintained post office, built in the 1930s, is a large mural that presents the story of Chicago through a dramatic montage of events and places in the city's history. The central image is the Great Fire of 1871 and the city in flames. Fort Dearborn, represented below, stands for the city's beginnings, and the modern skyline above symbolizes the present-day metropolis. At the left are images of labor: factory workers, stockyard employees, a technician working in his laboratory, and steelworkers straining to shovel coal into a furnace. To the right are a farmer with cows, another with pigs, and a welder standing in front of a factory making farm equipment. The artist Harry Sternberg lived and worked in New York, but he spent time in Chicago making sketches and studies for his commission. He had to submit three studies before his design was approved. New Deal muralists were directed to create noncontroversial murals, and at first his supervisors wanted him to use only the center portion of the mural showing the history of the city. In *Wall to Wall America,* Karal Ann Marling explains the demand for "safe" topics: the representation of history cycles in murals was "a visual continuum that covertly promised hope for the future." Typical of New Deal art, Sternberg's mural is one of its finest examples, displaying a pride in Chicago's past and a sense of optimism for the future. Decorative post office commissions were funded not by the WPA's Federal Art Project but by the Treasury Section of Fine Arts. "The Section" was empowered by the Public Buildings Admin-

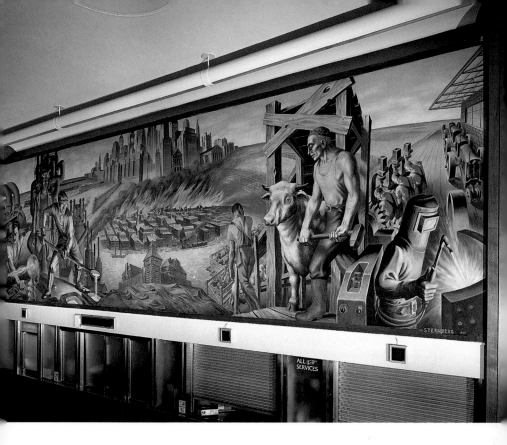

istration to spend 1 percent of the cost of construction of public buildings on such embellishments as murals and sculpture. Not a relief program, it awarded commissions primarily based on anonymous competitions and was in existence until 1943.

Lake View Post Office, *Chicago—Epic of a Great City*. Photograph © by Don DuBroff, courtesy of the U.S. Postal Service, mural commissioned by the Treasury Section of Fine Arts.

120 ► Armstrong School
Fairies, 1938-39

George B. Armstrong School lobby, 2111 West Estes Avenue
Oil on canvas, two panels
ARTIST: Marion Mahony Griffin (1873–1962)
COMMISSIONED BY: the Armstrong School
RESTORED BY: the Board of Education, 1997

George B. Armstrong School was named for the man who founded the U.S. Railway Mail service in 1864. In the front lobby are two imaginative and rather poetic murals. The subject is fairies, and the artist, architect Marion Mahony Griffin, has executed the fanciful scene with the same delicacy she used in the architectural renderings she made for Frank Lloyd Wright during the fourteen years she worked as his assistant. One mural panel depicts a group of dainty childlike creatures with beautiful multicolored butterfly and dragonfly wings, sitting on the top branches of a tall tree and taking little birds from a nest. Two youthful winged creatures, one in a red tunic, the other in green, fly high above a mountainous landscape with outspread wings that resemble those of the birds in the second panel. The muted colors give the compositions an ethereal quality. Marion Mahony Griffin's family had a great interest in art, and it was through her sister, who taught art at the Armstrong School, that she received the mural commission. She is credited with playing an important role in the career of her husband, Walter Burley Griffin, and her drafting skill had enabled her to help him win the commission to design the new capital city for Australia at Canberra, where they spent two decades. It was after his death in 1937 that she returned to the United States, resumed her architectural practice, and created this mural.

► Armstrong School, *Fairies,* detail. Photograph by Tom Van Eynde, courtesy of the Chicago Public Schools.

121 ► Nettelhorst School

Contemporary Chicago, 1939

Louis Nettelhorst School, main corridor, 3252 North Broadway
Oil on canvas, 7' x 23'
ARTIST: Rudolph Weisenborn (1881–1974)
COMMISSIONED BY: the Works Progress Administration, Federal Art Project
RESTORED BY: the Board of Education, 1996

Contemporary Chicago is unlike any other extant WPA mural in Chicago. Most were painted in a realistic manner, but the mural in the main corridor of the Nettelhorst School is abstract. Rudolph Weisenborn's work has been described "as a unique marriage of the modernist formal vocabulary with a contemporary Chicago sub-

ject" in Susan Weininger's essay on modernism in Chicago in *The Old Guard and the Avant-Garde,* edited by Sue Ann Prince. The artist, who spent most of his career in Chicago, was an activist in the flourishing art scene of the twenties and thirties and one of a group of Chicago artists who were considered rebels. Many had seen the radical Armory Show at the Art Institute in 1913 and were familiar with the European movements of cubism, expressionism, and fauvism. They promoted nonjuried art exhibitions and were concerned with freeing themselves from their academic training and its adherence to tradition. Still, Weisenborn's

commitment to the abstract style was rare in the city. Recognizable in the mural, through close inspection, are symbols for night life, as a seated woman in high heels, cigarette in hand, and for commerce and trade, indicated by the suggestion of a city center with boats and planes. Also depicted in the modernist manner are Chicago's famous Union Stock Yards and the meatpacking business, shown by representations of a cow and a cowboy. Elements of steel mills and steelworkers speak of the machine age of the 1930s. The images are arranged along the length of the mural like irregularly shaped pieces of a vibrantly colored abstract puzzle. Weisenborn also created the only nonobjective painting shown at Chicago's 1933 Century of Progress Exposition.

Nettelhorst School, Rudolph Weisenborn, *Contemporary Chicago,* oil on canvas, 1939. Photograph by James Prinz Photography; © 1999, the Art Institute of Chicago, all rights reserved.

122 ▶ Nettelhorst School
Horses from Literature, 1940

Louis Nettelhorst School, classroom (former library), 3252 North Broadway
Oil on canvas, frieze: 3'2" x 86' 6⅝"
ARTIST: Ethel Spears (1903–74)
COMMISSIONED BY: the Works Progress Administration, Federal Art Project
RESTORED BY: the Board of Education, 1996

The narrow strip of murals on the upper walls of a classroom at the Nettelhorst School contains well-researched and imaginative depictions of horses that appear in myths, fairy tales, and classic literature. They were commissioned for the library that once occupied this room. The fifteen legendary horses include the winged Pegasus, Black Beauty, the horses of Poseidon's chariot, the wooden horse of Troy, Don Quixote's horse Rocinante, Gargantua's giant nag, and the Norse god Odin's steed Sleipnir. Artist Ethel Spears was a student of muralist John Warner Norton's at the School of the Art Institute, where she earned her M.A. and later taught. She was active in the WPA in Chicago and executed murals for other city schools including Kozminski, Linné, and Lowell (now demolished).

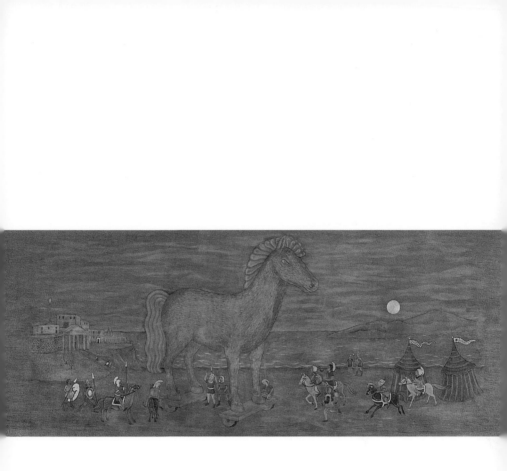

123 ▶ Lake Shore Center
Scenes of Chicago, 1938

Northwestern University, Lake Shore Center (formerly the Lake Shore Club)
850 North Lake Shore Drive
Oil on canvas, four panels, 4' x 18' each
ARTIST: Otto Hake (1876–1965)
COMMISSIONED BY: the Lake Shore Club
RESTORED BY: Northwestern University, 1995

The Lake Shore Center, designed by Jarvis Hunt, was built as a clubhouse in 1927, with rooms and apartments for members. It has served as a dormitory for Northwestern University students for many years and has recently been saved from demolition by the efforts of a group of neighbors who fought against plans for a new high-rise apartment building on the site. Otto Hake's murals were painted for five private dining rooms on the second floor of the club. They were restored in 1995 and rehung on the lower level in a narrow passageway leading to the loading dock, but they deserve a better location. There are five panels presenting fifty handsomely painted scenes from Chicago's history. The artist studied old photographs, paintings, and newspaper accounts and consulted with historian Bessie Louise Pierce, chronicler of Chicago history, then organized his material into five major historical eras. The Indian period illustrates the missionary-explorers Marquette and Joliet, who in 1673 discovered the site that later became Chicago. Also pictured are the massacre of 1812 and the rebuilding of Fort Dearborn in 1816. The pioneer years includes the founding of the city, the opening of the Illinois-Michigan canal, and the first railroad. Pictured in Lincoln's life are his nomination for president in 1860 and his funeral train five years later. The Columbian period begins with the Great Fire of 1871 and climaxes with the 1893

World's Columbian Exposition. Among the images in the centennial era are the creation of Grant Park, the Michigan Avenue skyline, and the 1933–34 Century of Progress Exposition.

Lake Shore Center, Northwestern University, *Century of Progress,* one of four panels. Photograph © by Don DuBroff, courtesy of Northwestern University.

124 ▶ Schurz High School

The Development of the Written Word and *The Spirit of Chicago,* 1940

Carl Schurz High School library
3601 North Milwaukee Avenue
Oil on canvas, four murals 14' x 32' and twenty-seven portraits
ARTISTS: Gustave A. Brand (1862–1944) and students
COMMISSIONED BY: Schurz High School principal and students
RESTORED BY: the Board of Education, 1998

Carl Schurz High School is an imposing structure of red brown brick, terra-cotta, and stone, set on a large triangular lot consisting of a central building and two wings. The main building, given landmark status in 1979, was designed by Prairie school architect Dwight H. Perkins, whose safety features and large, well-lighted, and well-ventilated spaces were a dramatic improvement over earlier school designs. The former auditorium was converted to a domed library space after additions to the school were built. During 1940–41, thirty art teachers and students met with artist Gustave Brand to select a subject for a cooperative project to decorate the school library. Together they chose *The Development of the Written Word* as their theme. The best drawings were selected from competitive sketches submitted by the students and used as the basis for the series of murals to be mounted on the walls and ceiling of the library. Painting took place on the balcony of the boys' gym, a spacious and naturally lighted space that could accommodate four canvases thirty-two feet high and fourteen feet wide and the frieze of twenty-seven portraits as well. A "once in a lifetime experience," said one participant; "the thrill of watching such a project and . . . lending my meager talent toward its success was something I shall never forget," said another. The murals depict Stone Age men painting pictographs, Egyptians inscribing hieroglyphics, medieval monks creating illuminated manuscripts, and Johann Gutenberg with the first printing press. Portraits include such eminent figures as Homer, Dante,

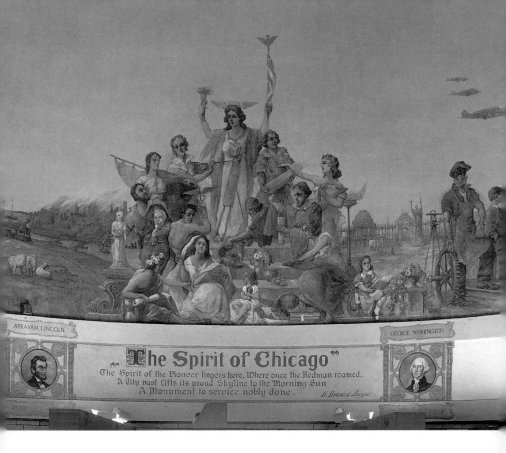

Michelangelo, Shakespeare, Beethoven, Lincoln, Madame Curie, and Ad-
dams. *The Spirit of Chicago,* an allegorical scene, was added the following year.
Gustave Brand was praised for providing "situations for group cooperation,"
"fix[ing] knowledge, skills, attitudes and behavior," and making "school a happy
phase of child life."

Schurz High School, *The Spirit of Chicago,* detail from library apse, central allegorical scene, oil on canvas,
1940–41. Photograph by James Prinz Photography; ©1999, the Art Institute of Chicago, all rights reserved.

125 ▶ Wells High School

The Founding of Mckendree College, Lebanon, Illinois, 1941

Wells High School library, 936 North Ashland Avenue

Egg tempera on gesso-coated panels, three paintings: two 3'4" x 5' and one 5' x 3'4"

ARTIST: Henry Simon (1901–95)

COMMISSIONED BY: the Works Progress Administration, Federal Art Project

RESTORED BY: the Board of Education, 1998

The three large panels that hang above the bookshelves in the Wells High School library are murals that were commissioned for McKendree College in Lebanon, Illinois, by the Illinois Art Project of the WPA. They illustrate episodes in the founding of the school, but they never reached the college. More than thirty years later, the artist Henry Simon learned their whereabouts from an article in the *Chicago Tribune* in 1974. Trying to understand the situation, he wrote, "I attribute this foul up to the fact that this happened at the time when the project [WPA] was being scrapped by Congress and the paintings were simply left in Chicago," adding, "these panels deserve a better fate than languishing in a place where they have no historical meaning." The McKendree panels depict early supporters of the college that was founded in 1828. In *Bishop McKendree at the Site of the College,* the founder, who was a pioneer circuit rider, stands with four fellow pioneers. *Peter Aker's Prophecy* portrays the first president of the college, who foretold the coming of the Civil War in a sermon of 1856 and is surrounded by the death and destruction of that war. The third panel, *The Circuit Rider,* shows a minister named Peter Cartwright preaching to an assembled group of settlers. Simon was influenced by Edgar E. Britton, Mitchell Siporin, and Edward Millman, the three Chicago muralists who were most closely connected to the Mexican mural movement. Although he studied fresco painting with Millman, Simon chose to use the medium of egg tempera on canvas for his murals. The school also has a contemporary mural by Keith Haring.

276

Wells High School, *The Founding of McKendree College,* one of three panels. From the collection of Barbara Bernstein, murals commissioned by the Works Progress Administration, Federal Art Project.

126 ▶ Uptown Post Office
Portrait of Carl Sandburg and *Portrait of Louis Sullivan,* 1943

Uptown Post Office, 4850 North Broadway
Glazed ceramic tile, two panels, 7'6" x 10'6" each
ARTIST: Henry Varnum Poor (1888–1970)
COMMISSIONED BY: the Treasury Section of Fine Arts

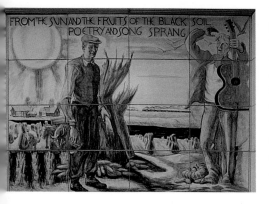

Two eminent and creative Chicagoans, Carl Sandburg and Louis Sullivan, are celebrated on the walls of this post office, which survives in nearly perfect original condition. Painted on ceramic tiles, the two murals are set into recesses above the service windows. They were created during the last year of the federal government program called the Treasury Section of Fine Arts, which ran national competitions to select artists to "embellish" public buildings being built or renovated. The Section, as it was called, preceded the creation of the WPA by one year and was funded by an appropriation of 1 percent of the cost of each new government building. Henry Varnum Poor, a nationally recognized artist and ceramist, was chosen by committee over twenty-nine other artists. He had the tiles manufactured with a special manganese glaze, then decorated them and reglazed them in his own kiln in his studio in New City, New York. Perhaps his choice of subjects was motivated by a speech in which President Roosevelt extolled "the freedom of the human spirit." Carl Sandburg (1878–1967) was a journalist, poet, biographer of Lincoln, and singer-collector of folktales, famous for his poems *Chicago* and *Fog.* Poor had to defend his design for Sandburg's portrait

NORTH SIDE

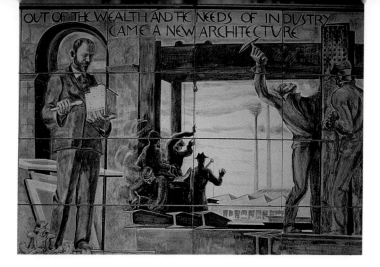

against the objection of the postmaster, who said, "Chicago is not the home of the banjo or guitar." Poor wrote:

[The] flatness & the general levelness of the forms . . . is meant to express the expanse of the fields of the MidWest Back of the young farmer is a plain and simple farmhouse and barn. Back of the tilled fields in the center runs a train, symbolizing the connection of this farmland to Chicago. Two of Chicago's greatest poets, Vachel Lindsay and Carl Sandburg, have recited and sung their poetry to the accompaniment of the guitar—hence the figure of the poet, a sort of American troubadour with a very homey and farm background and tradition. Around his head are seagulls, symbolizing the inspiration of the Great Lakes region & Chicago itself.

Architect Louis Sullivan (1856–1924) was a principal figure in the Chicago school of architecture who, with Dankmar Adler, designed the Auditorium and who also designed the Carson, Pirie, Scott (originally Schlesinger and Mayer Store) building. The mural shows him holding a model of Carson's while laborers put up a new steel structure and smoke rises from the tall stacks of steel mills in the background. Less familiar with this subject, Poor originally drew two towers on the Auditorium Building, which has only one.

Uptown Post Office: ◀ *Portrait of Carl Sandburg;* ▲ *Portrait of Louis Sullivan.* Photographs © by Don DuBroff, courtesy of the U.S. Postal Service, murals commissioned by the Treasury Section of Fine Arts.

127 ▶ Holy Covenant United Methodist Church

For a New World (Para un Mundo Nuevo), 1973–74

Holy Covenant United Methodist Church, 925 West Diversey Parkway
Enamel on brick, restored with acrylic, 1996
ARTISTS: John Pitman Weber (1942–) and Oscar Martinez (dates unknown)
COMMISSIONED BY: the Chicago Mural Group, assisted by the Wieboldt Foundation

The mural *For a New World* follows the shape of the west wall of the church: there are three panels divided by two buttresses. Called "the most hopeful mural in the city" when it was painted in the 1970s, it illustrates the destruction of war and the rebirth of a better world. Artist John Pitman Weber, who was a founding member of the Chicago Mural Group, now called the Chicago Public Art Group, has arranged large-scale figures around the Gothic-arched window in the center of each panel. He has depicted men, women, and children of many ethnic groups. The tragic occurrences of war are pictured in the first panel, in which a woman has fallen after being shot in the head, a man wears a gas mask, and others are trying to escape the flames. Family groups in the central panel look upward hopefully. And in the third panel people are at work: there are men holding tools, a child with a dog, and a scientist with a beaker. John Weber has created over twenty-five murals in the city and helped in the execution of even more in his frequent collaboration with others. His book *Toward a People's Art,* written with Eva and Jim Cockcroft in 1977, was recently reissued.

▶ Holy Covenant United Methodist Church, *For a New World (Para un Mundo Nuevo),* detail. Courtesy of the Chicago Public Art Group.

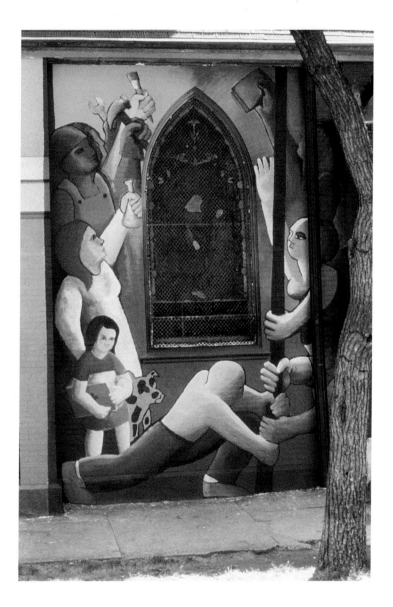

128 ▶ Horwich Jewish Community Center
Fabric of Our Lives, 1980

Bernard Horwich Jewish Community Center, 3003 West Touhy Avenue
Ceramic and Venetian glass mosaic tile, ca. 20' x 12'
ARTISTS: Cynthia Weiss (1948–) and Miriam Anne Socoloff (1949–)
COMMISSIONED BY: the Bernard Horwich Jewish Community Center
FUNDED BY: the National Endowment for the Arts, the Illinois Arts Council, the Jewish
Labor Committee, and community volunteers
Restored and rededicated, 1997

The mosaic mural on the facade of the Bernard Horwich Jewish Community Center depicts the world of the 1880s on Chicago's Maxwell Street, on the city's Near West Side, still remembered today for its street market. The mural was created and produced with the help of community members who participated in its design and actual creation. Recalled are the Eastern European immigrants, primarily Orthodox Jews, who fled from Russian pogroms and settled in the area, establishing synagogues and Yiddish theaters. "Because so many Jewish immigrants got their start as peddlers on Maxwell Street," comments Dominic Pacyga in *Chicago, City of Neighborhoods,* "the market soon became synonymous with the West Side Jewish neighborhood." A series of vignettes depict their struggles through scenes of immigration, work, labor organizing, community life, and Jewish culture. A bearded man from the "old country" stands with his suitcase, a row of women are bent over sewing machines in a sweatshop, and a man sells merchandise from a pushcart. In the background is a typical red-brick tenement building and several distinctly different synagogues. An actor, a singer, a musician, and a labor organizer who holds a sign demanding "a living wage for all" appear on a stage, representing the thriving Yiddish theater. Artist Cynthia Weiss said that "Yiddish culture grew up on the streets . . . a culture that grew directly from the people's day-to-day work experience." The composition is bordered by Jewish symbols and

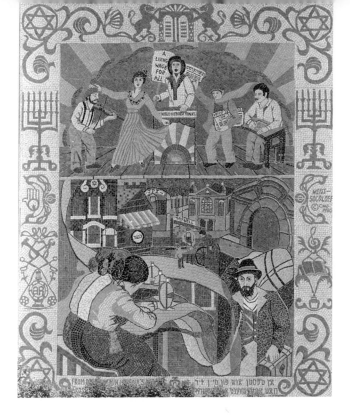

a quotation from Morris Rosenfeld's "The Sweatshop Bard," in English and Yiddish, that says, "From the deep within my soul's despair, arose a striving reaching high." Co-artist Miriam Socoloff remarked that when the mural was restored and rededicated sixteen years later they were still moved by its "sweetness and idealism." The mural was reproduced as a poster and used on a brochure for a Chicago Labor Education Program at the University of Illinois at Chicago, in a display at the Museum of the Diaspora in Israel, and in a Jewish Federation of Chicago newsletter. The artists are members of the Chicago Public Art Group.

Bernard Horwich Jewish Community Center, *Fabric of Our Lives.* Courtesy of the Jewish Community Centers of Chicago.

129 ► LaSalle Towers
Homage to the Chicago School, 1980

LaSalle Towers, 1211 North LaSalle Street
Keim paint, 165' high, 80,000 square feet
ARTIST: Richard John Haas (1936–)
COMMISSIONED BY: the 1211 North LaSalle Corporation

Only the front of this building presented a finished facade when Richard Haas joined with the architects and developer during the conversion of this older twenty-story apartment building. Taking his color cues from the facade, the artist covered the bricked-up north and south walls and many-windowed east expanse with painted trompe l'oeil designs that dramatically "fool the eye." Describing the project as his "first free-standing building which could be read from 360 degrees," Haas pays homage to four historical Chicago architects by borrowing architectural elements from their best-known buildings and rendering them in paint. The conventional east face of the building appears to support three vertical banks of "Chicago-style" projecting bay windows, topped by an ornate cornice and central ocular window. Louis Sullivan's ornamented "Golden Arch" for the Transportation Building of the 1893 World's Columbian Exposition is at the base of the narrower south wall, along with painted bas-relief portraits of Sullivan, Daniel H. Burnham, John Wellborn Root, and Frank Lloyd Wright. Above is the illusionistic depiction of Holabird and Root's Board of Trade Building, "reflected" in eight stories of windows with Sullivan's large ocular window from the Grinnell, Iowa, bank at the top. On the north side is the "reflection" of Adolph Loos's Doric column, one of Haas's favorite submissions to the *Chicago Tribune* competition of 1922. *New York Times* critic Paul Goldberger commented that Richard Haas "is concerned . . . with the righting of what he sees around him that looks wrong." These murals are in urgent need of conservation.

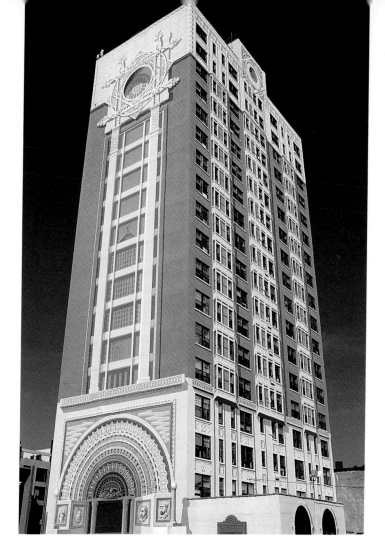

LaSalle Towers, *Homage to the Chicago School,* detail. Courtesy of Rhona Hoffman Gallery.

130 ► Chestnut Place
Piazza, 1982

Chestnut Place lobby, 850 North State Street
Paint on plaster, walls, ceiling, floor
ARTIST: Richard John Haas (1936–)
COMMISSIONED BY: Weese Hickey Weese Architects

The tiny illusionistic lobby of this thirty-story apartment building was inspired by an eleventh-century Florentine church called San Miniato al Monte. The architects chose this scheme from six designs submitted by artist Richard Haas because they "saw similarities in feeling" between their building and the Romanesque church. They also knew that much of the "marble" in the church was actually painted plaster, called in Italy *scagliola.* Using only paint, Haas, a master of trompe l'oeil, has reproduced the intricate green-and-white geometric, patterning and arched colonnades of the stone-and-marble church on the six flat surfaces of the cube-shaped room. The floor is simulated inlaid marble and the ceiling represents open sky, complete with clouds. Hidden in a central column is theatrical lighting that gives the illusion of different times of the day. The result is a three-dimensional mural-like work of art that figuratively transports the viewer to Florence. Haas writes that he has always been interested in "the possibilities offered by paint for altering our perceptions of interior and exterior space."

► Chestnut Place, *Piazza,* detail. Courtesy of Rhona Hoffman Gallery.

NORTH SIDE

131 ➤ Sulzer Library
Virgil's Aeneid, 1984

Conrad Sulzer Regional Library, meeting room
4455 North Lincoln Avenue
Fresco, four walls of a 20' x 40' room
ARTIST: Irene Siegel (1932–)
COMMISSIONED BY: the Chicago Department of Cultural Affairs, Percent for Art Program

For these wall paintings inspired by Virgil's ancient epic poem, Irene Siegel chose a historic painting technique, true fresco. Like the Mexican muralists of the 1920s and classical and Renaissance artists before them, Siegel painted directly on freshly prepared wet plaster walls. The two-thousand-year-old *Aeneid* tells the story of the Trojan War and the founding of the new Roman nation. The influence of the story has been compared to that of Homer's *Iliad* and *Odyssey* and to the Bible. Siegel has incorporated quotations from the *Aeneid* and from the writings of Johann von Goethe, Pablo Neruda, and Nikos Kazantzakis into her composition, borrowing a tradition often seen in other cultures. The south "Red Wall," titled *How They Took the City,* contains the opening lines of the *Aeneid:* "I sing of warfare and a man at war." Included are figures of the narrator, who bemoans "a sorrow too deep to tell," and a Trojan horse, the Cyclops, a skeleton, snakes, and flames, referring to the fall of Troy. The opposite "Dark Wall," called *The World Below,* illustrates Aeneas's journey to Hades, with the goddess Juno and other people he encounters along the way. Dido, the queen of Carthage, who falls in love with Aeneas, is the focal point of the east "Dido Wall." On the central panel of the west wall, Aeneas is surrounded by his friends. Employing a style that one critic called "neo-expressionist with graffiti," Irene Siegel said she wanted her mural to stimulate people, whether they loved it or hated it. At the dedication of the beautiful new library, designed by Hammond, Beeby and Babka, the mural aroused

strong sentiments ranging from admiration to outrage. In responding to her critics, Siegel commented that struggle with the community is a tradition with artists but that "if you try to please everyone in art, art would become advertising."

Sulzer Library, *Virgil's Aeneid,* detail. Courtesy of the City of Chicago Public Art Collection.

132 ▶ Sulzer Library
Children in Garden Landscapes, 1984

Conrad Sulzer Regional Library, children's storytelling room
4455 North Lincoln Avenue
Oil on canvas, eight sections
ARTIST: Sandra Jorgensen (1934–99)
COMMISSIONED BY: the Chicago Department of Cultural Affairs, Percent for Art Program

The murals in the small children's storytelling room were commissioned by the city for this award-winning branch library. Designed by Hammond, Beeby and Babka, the library was named for the area's first European settler, who built a house nearby in 1837. Sandra Jorgensen has painted dreamlike scenes of children standing in formal gardens and grand parks. "I like to convey a great calm in the midst of late twentieth-century vitality and frustration," she writes. Each vista represents a different time of day; the lighting is more theatrical than naturalistic. Noting that children usually see themselves depicted in active play, Jorgensen chooses instead the "quiet and secretive" side of their natures. Children of many races appear as serene and contemplative. On the east wall there are several figures near a large pool, with the Chicago skyline silhouetted on the far-off horizon; above, a bird flies away from the scene. On the opposite wall the composition is repeated, but now it is night and the bird is returning home. A garden with a single figure is shown in daylight and at twilight on the north and south walls.

▶ Sulzer Library, *Children in Garden Landscapes,* eight panels, two details. Courtesy of the City of Chicago Public Art Collection.

133 ▶ Navy Pier's Gateway Park
Water Marks, 1998

Navy Pier's Gateway Park, 600 East Grand Avenue (at Lake Michigan)
Venetian glass tile and ceramic mosaics, four sculptured benches
ARTISTS: Chicago Public Art Group: Olivia Gude (1950–), Jon Pounds (1948–),
Kiela Smith (1970–), Cynthia Weiss (1948–), and Mirtes Zwierzynski (dates unknown)
SPONSORED BY: the Metropolitan Pier and Exposition Authority, the Canal Corridor
Association, and the Chicago Public Art Group
FUNDED BY: the Metropolitan Pier and Exposition Authority, the Illinois Bureau of
Tourism, the John D. and Catherine T. MacArthur Foundation, the Sara Lee Foundation,
and private donors

Navy Pier was built in 1916 to handle commercial shipping traffic on the Great
Lakes, but today it functions primarily as an entertainment and recreational cen-
ter. Its Gateway Park contains a "site-integrated sculptural installation" consist-
ing of four irregularly shaped sculptural benches whose surfaces tell the story of
the 150-year-old Illinois and Michigan Canal. Made of black concrete faced with
pictorial mosaic designs of glass and ceramic, the benches are set along a Y-
shaped winding terrazzo pathway that simulates the shape of the inland water-
ways, including the Chicago River, Sanitary and Ship Canal, I and M Canal, Cal-
Sag Channel, and Illinois River. Called "the canal that built Chicago," the Illinois
and Michigan Canal begins at Navy Pier and extends 120 miles south and west
to Peru–La Salle, Illinois. Its construction transformed the city from one of a num-
ber of small port towns into today's large metropolis and, when completed in
1848, formed a link between the Great Lakes and the Mississippi River, thus con-
necting the eastern seaboard to the Gulf of Mexico. The mosaic designs on the
easternmost, spiraling bench, *The Turning Basin,* are industrial shapes, gears and
axles, and indigenous flora and fauna. The shape of the central structure, called
The Water Bench, suggests a boat moving through the water of the canal. *The Lock*

NORTH SIDE

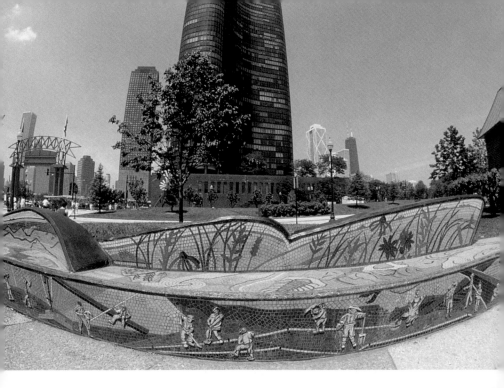

Bench shows the lock structure and scenes of Chicago's growth. The mosaic patterning on *The Silurian Seat Bench* describes the geological formation of the region, with images of glaciers, boulders, silt, sand, fossils, early inhabitants, and later canal workers. The artists of this community project worked with people who live along the canal today, through many organizations, to create hundreds of small ceramic tiles that describe life and work along the canal and its agriculture, geography, and modes of transportation. Set among the mosaic designs, these tiles are impressed or carved with images of leaves, flowers, fish, and fossils and depictions of canal workers. The Cook County Forest Preserve District and American Indian Health Services also participated in the project.

Navy Pier's Gateway Park, *Water Marks: The Silurian Seat Bench,* one of four mosaic benches. Courtesy of the Chicago Public Art Group.

134 ► Brown Health Center

A Tradition of Helping: Hull House, Cook County Hospital, Howard Brown Health Center, 1997

Howard Brown Health Center lobby, 4025 North Sheridan Road
Mosaic tiles, 10' x 27'
ARTIST: Roger Brown (1941–97)
COMMISSIONED BY: the Howard Brown Health Center

"The mosaic represents some of the institutions in Chicago that offer compassion and aid to the many ethnic, economic and minority groups of the city. Jane Addams started Hull House as an aid to the influx of European immigrants in the 19th Century. Cook County Hospital offers medical aid to the poor and outcast. Howard Brown offers health care and treatment to the gay and lesbian community who historically faced fear and shame in seeking medical help" (Roger Brown, La Conchita, California, 1997). Roger Brown's last work is a compelling mosaic mural that dominates the lobby of the Health Center. It is composed of hand-painted tiles that were created in Italy and shipped to the Center in large pieces for assembly. The twenty-thousand-square-foot Center was the first new clinic in Illinois built by a gay, lesbian, and bisexual organization. It opened on October 4, 1997, and dedicated the mural only weeks before Brown died of AIDS, leaving this legacy to the community. In the mural, the large figures of Jane Addams and a young man, perhaps a contemporary physician, stand before the three institutions Brown honored, symbols of past and present. In her obituary for Brown in the *New York Times,* November 26, 1997, Roberta Smith described his "luminescent, beautifully composed paintings" as "a powerful combination of flattened, cartoonish images that featured isometric skyscrapers and tract houses, furrowed fields, undulating hills, billowy clouds and agitated citizens, the latter usually seen in black silhouette at stark yellow windows. . . . Formally dazzling, instantly legible and psychologically charged." Brown was primarily an easel painter, and this powerful mural incorporates many of his prototypical elements.

NORTH SIDE

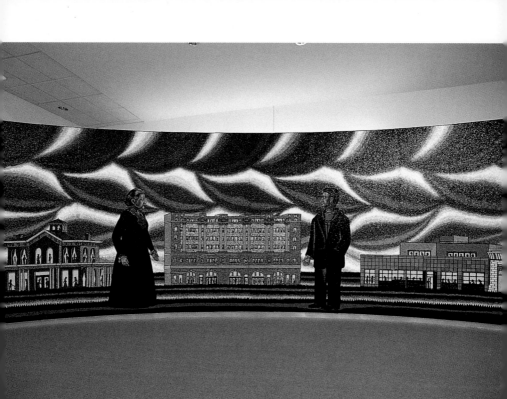

Howard Brown Health Center, *A Tradition of Helping: Hull House, Cook County Hospital, Howard Brown Health Center*. Photograph by Ted Lacey, courtesy of the School of the Art Institute of Chicago and the Brown Family.

Suburbs
and Outlying Areas

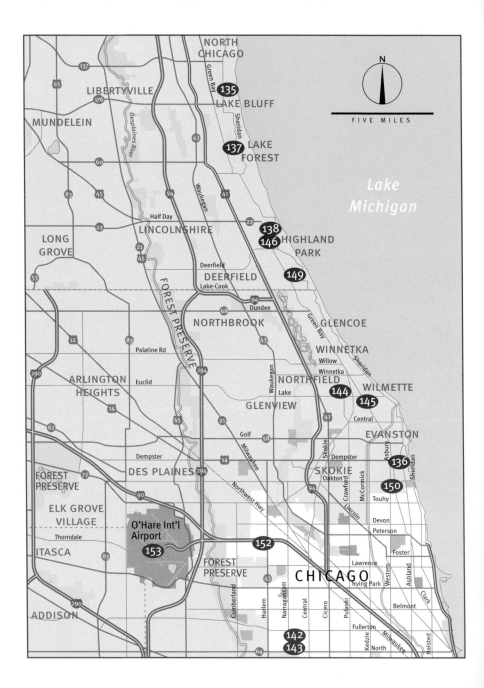

N

FIVE MILES

NORTH
CHICAGO

LIBERTYVILLE

MUNDELEIN

137

45

176

Green Bay

135

LAKE BLUFF

Sheridan

43

60

137

LAKE
FOREST

Desplaines River

Lake
Michigan

83

45

94

Waukegan

41

Half Day

LINCOLNSHIRE

22

22

138

146

HIGHLAND
PARK

LONG
GROVE

21

45

Deerfield

DEERFIELD

Lake-Cook

149

53

FOREST PRESERVE

94

Dundee

68

NORTHBROOK

43

GLENCOE

Green Bay

12

83

Palatine Rd

WINNETKA

Willow

Sheridan

290

ARLINGTON
HEIGHTS

Euclid

294

Winnetka

Waukegan

NORTHFIELD

Lake

144

WILMETTE

145

14

GLENVIEW

Central

45

21

EVANSTON

62

Golf

58

Skokie

Asbury

Dempster

Dempster

136

Sheridan

FOREST
PRESERVE

72

DES PLAINES

294

Milwaukee

SKOKIE

Oakton

Crawford

McCormick

Lincoln

150

90

Northwest Hwy

94

Touhy

ELK GROVE
VILLAGE

Thorndale

Devon

Peterson

ITASCA

83

O'Hare Int'l
Airport

153

FOREST
PRESERVE

43

Foster

Lawrence

Western

Ashland

152

CHICAGO

Irving Park

Clark

290

ADDISON

Cumberland

Harlem

Narragansett

Central

Cicero

Pulaski

Belmont

Fullerton

Milwaukee

142

143

Kedzie

North

Halsted

64

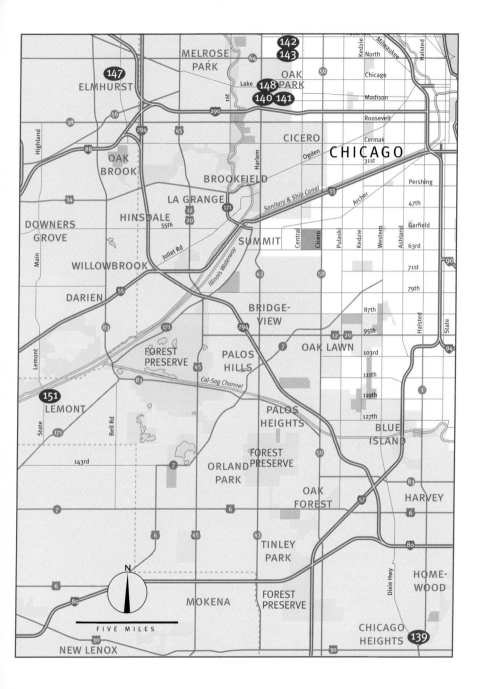

142
143

MELROSE
PARK
64

147
ELMHURST

Lake
148
140 141

OAK
PARK

50

Kedzie
North

Milwaukee

Chicago

Madison

Halsted

56

290

1st

Roosevelt

38

294

45

CICERO

Cermak

Cicero

Ogden

CHICAGO
31st

Highland

88

OAK
BROOK

Harlem

BROOKFIELD

Pershing

34

LA GRANGE

171

Sanitary & Ship Canal

55

Archer

47th

DOWNERS
GROVE

HINSDALE
55th

12
20

SUMMIT

Central

Cicero

Pulaski

Kedzie

Western

Ashland

Garfield

63rd

Main

WILLOWBROOK

Joliet Rd

Illinois Waterway

43

50

71st

79th

90

DARIEN

55

83

171

294

BRIDGE-
VIEW

7

OAK LAWN

87th

12 20

95th

103rd

Halsted

State

94

FOREST
PRESERVE

45

PALOS
HILLS

Cal-Sag Channel

111th

119th

1

151
LEMONT

Bell Rd

State

171

143rd

7

PALOS
HEIGHTS

FOREST
PRESERVE

ORLAND
PARK

50

127th

BLUE
ISLAND

OAK
FOREST

57

83

HARVEY

6

7

6

45

43

TINLEY
PARK

6

80

N

FOREST
PRESERVE

Dixie Hwy

HOME-
WOOD

6

86

MOKENA

FOREST
PRESERVE

FIVE MILES

30

NEW LENOX

30

CHICAGO
HEIGHTS

139

*Visits to schools marked with an asterisk must be arranged with the principal
†See page 338

Suburbs and Outlying Areas

On the outer reaches of the city and beyond—to the north, south, and west—are scattered schools, post offices, and other mural locations. Along the lake north of the city are the affluent suburban communities of the North Shore: Evanston, just across the border from Chicago, is described in a WPA guidebook as "aristocratic and self-sufficient" and is home to Northwestern University, founded in 1855. Continuing north, the white dome of the Baha'i House of Worship is visible from most of the lovely homes in Wilmette. And then Winnetka, incorporated in 1869, is known for its fine public school system. Much of the natural beauty of Highland Park lies in its lakeshore, bluffs, ravines, and woods. Lake Forest, the wealthiest of all, has magnificent estates and Lake Forest College; and Lake Bluff, the northernmost suburb, began as a Methodist camp-meeting ground.

To the west of the city is the village of Oak Park, a virtual Prairie school architecture museum boasting twenty-five buildings by Frank Lloyd Wright, who lived and worked there from 1889 to 1909, as well as hundreds of buildings by other prominent architects of the period. Also to the west is Elmhurst, home to poet and writer Carl Sandburg and Elmhurst College. The town of Lemont, along the Illinois and Michigan Canal, is the site of historic stone quarries that supplied building material for many of the early buildings in Chicago, including the original Water Tower and Pumping Station.

Far to the south of the city is Chicago Heights, traversed in the early days by explorers, hunters, trappers, soldiers, and settlers who came from the eastern seaboard on their way west. It was industrialized in the 1890s and was the site of the earliest steel-producing plant in the Chicago area.

At the northwest corner of the city is O'Hare International Airport, for generations the busiest in the country.

135 ▶ East Lake School
The Meeting of Marquette and Joliet, 1926

East Lake School, 121 East Sheridan Place, Lake Bluff
Oil on canvas
ARTIST: Marguerite Kreutzberg (1886–1978)
COMMISSIONED BY: the East Lake School
Presented by the artist

One of the original rooms of an old schoolhouse, built in the 1890s, contains an unusual historical mural painted by Marguerite Kreutzberg, who was a resident of Lake Bluff. The room is now the nucleus of a modern school complex, with an addition built in 1995. An irregularly shaped canvas is mounted on the tall chimney of a large fireplace and illustrates the meeting of the French missionary Jacques Marquette and explorer Louis Joliet, who are considered the first white men to have set foot in this area. They are believed to have paddled their canoes past the present site of Lake Bluff in 1673 and claimed for their country a portion of the Mississippi Valley. Other French traders established a post in what is now Waukegan as early as 1790. Four years later, a treaty made possible a road from the Detroit River to the mouth of the Chicago River, where in 1801 Fort Dearborn was built. Below the mural is a description of the journey in Marquette's own words: "We left the village of Askansea on the 17th of July, 1673, having followed the Mississippi from the latitude of 42 to 34 and I, having preached the Gospel to the utmost of my power to the nations that we visited. We then ascended the Mississippi with great difficulty against the current, and left it in the latitude of 38 north, to enter another river that took us to the Lake of the Illinois."

▶ East Lake School, Lake Bluff, *The Meeting of Marquette and Joliet.* Photograph by Tom Van Eynde, courtesy of East Lake School.

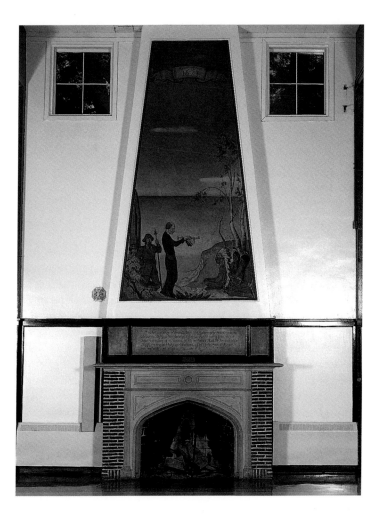

136 ► Nichols School
The Grand Canal, 1929

Frederick William Nichols School
800 East Greenleaf Street, Evanston
Oil on canvas, ca. 12' x 11'4"
ARTIST: Jacques-Marie-Omer Camoreyt (dates unknown)

Two paintings, one by the baroque Italian artist Francesco Guardi, the other by a modern painter who signs himself Zeim, inspired the mural in the Nichols School library. The scene is of the Grand Canal in Venice, with the church of Santa Maria della Salute, built in 1632, in the background. The installation is in a handsome architectural structure in which the mural is viewed through a colonnade of two pointed arches, supported in the center by a black stone column with a Corinthian capital and metal balustrade. Painted in France, the mural was commissioned and funded by Frederick W. Nichols, for whom the school is named. Nichols spent fifty years as an educator and as supervisor of what is now Evanston's district sixty-five, during which time the Lincoln, Washington, Central, and Oakton Schools were added to the district. Under his progressive leadership, music, art, and branches of the public library were introduced into these schools. The unusual design of

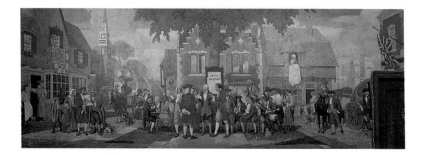

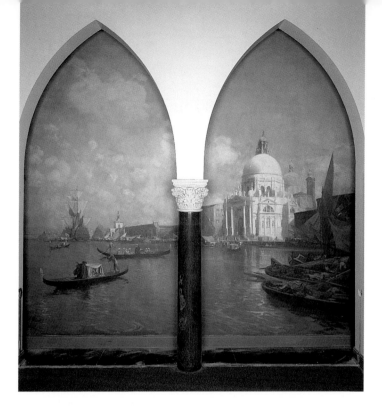

this beautiful school is modeled on the Venetian Palace of the Doges, and it is embellished with stained glass, glazed brick, and mosaic tiles. Some of these were made by Nichols, a well-traveled man who studied art and enjoyed doing handicrafts. His portrait, painted in 1930 by Edwin Burrage Child, hangs in the school. Missing from the building is *Negro Children,* a mural by Archibald Motley Jr., commissioned by the WPA in 1936. There is also an unsigned mural, depicting a colonial scene, in the school office, thought to be a WPA painting from the 1930s.

Nichols School, Evanston: ▲ library, *The Grand Canal;* ◄ school office, untitled mural. Photographs by Ted Lacey, courtesy of Nichols School.

137 ▶ Lake Forest Library

Poets and Writers of Antiquity, 1932

Lake Forest Library rotunda
360 East Deerpath, Lake Forest
Oil on canvas, twelve panels: eight 18' x 7' and four 7' x 7'
ARTIST: Nicolai Remisoff (or Remisov) (1887–1975)
FUNDED BY: Mrs. Stanley Keith, Mrs. Charles Schweppe, and Mrs. Kersey Coates Reed
in memory of Kersey Coates Reed
Restored in 1997, funded by Friends of the Lake Forest Library

The exterior of this handsome building, designed by Edwin Clarke and built in 1931, has been described as Georgian-influenced neoclassic Beaux Arts. A set of twelve mural panels are enhanced by refined architectural details and fit perfectly into the design of the art deco interior. The murals are mounted between fluted pilasters and capped by a cornice; both elements are painted black, neatly delineating the space. Nicolai Remisoff's style shows his study of classical Greek vase painting and something of the spirit of Byzantine Russian icons, with a touch of 1930s art moderne. The Russian-born artist has filled the walls of the library with images of leading poets and prose writers of ancient Greece and Rome. The epic poet Homer is pictured as a storyteller, surrounded by listeners. Greek dramatists Aristophanes and Sophocles, one holding the mask of tragedy, stand behind Euripides, who sits on the ground. With a lamb in her arms, Sappho, the poet of love, is shown with Theocritus, who wrote of the pastoral life. Cicero speaks in the Roman marketplace with statesman, philosopher, and writer Seneca in the audience. Also represented are Aesop, famous for his fables, Greek warriors with the goddess Athena, and philosophers Diogenes, Plato, Socrates, and Aristotle. A bas-relief marble tablet in the center of the back wall with a winged figure, *The Archer,* 1931, carved by Oskar Hansen is inscribed to the memory of Kersey Coates Reed of Lake Forest, who lived from 1880 to 1920 and "cared greatly for good books."

In the children's library on the lower level are a sculpture by Lake Forest artist
Sylvia Shaw Judson and a large mural by Tom Melvin, whose work can also be seen
at the Chicago Place Mall, and the University of Chicago Bookstore at Gleacher
Center.

Lake Forest Library, *Poets and Writers of Antiquity: Aesop, Greek Fighting Men and Athena,* one of twelve
panels. Photograph by Ted Lacey, courtesy of the Lake Forest Library.

138 ▶ Highland Park High School

Scenes of Industry, ca. 1934

Highland Park High School library
433 Vine Avenue, Highland Park
Fresco secco on plywood panels prepared with gesso ground, painted in tempera:
nine panels, 10' x 9' each
ARTIST: Edgar E. Britton (1901–82)
COMMISSIONED BY: the Public Works of Art Project
Restored in 1995

Nine exceptional mural panels commissioned by the PWAP (Public Works of Art Project), the short-lived predecessor to the WPA, were dramatically rediscovered at Highland Park High School in 1995. They were Edgar Britton's first mural project, created for the old school library in the 1930s but removed when the room was torn down in 1955. Stored in the school attic, they were forgotten for more than forty years. It was Hana Field, an eighth-grade student in a Chicago public school, writing a research paper on the WPA in 1995, who tracked down the murals. Her persistence led her to the school's electronic technician, himself a graduate of the school, who had come across the murals twenty years earlier but was told to leave them in the attic because they were out of date. Found propped up against a support column, they were numbered and stamped "Property of U.S. Government" on the back. After careful restoration, they were rehung in the present school library. Britton, who had studied the fresco technique with Diego Rivera in Mexico, depicted workers at their labors and called the series *Scenes of Industry.* There are farmers, steel and coal workers, welders, bricklayers, builders, telephone linemen, and printers, all rendered in muted shades of red, white, blue, and brown. During the Great Depression, when the government-sponsored WPA program was

created to find jobs for the thousands of unemployed, the theme of work was a popular subject. Britton completed other fresco paintings at Lane Technical High School and Bloom Township High School, worked in Washington, D.C., and then returned to Chicago to become director of the Illinois Art Project.

Highland Park High School, *Scenes of Industry,* three of nine panels. Photograph © by Don DuBroff, courtesy of Highland Park High School, murals commissioned by the Works Progress Administration, Federal Art Project.

139 ➤ Bloom Township High School

Occupational Studies and Their Application, 1936

Bloom Township High School foyer
Tenth Street and Dixie Highway, Chicago Heights
Fresco, six panels, approximately 9' x 4'6" each
ARTIST: Edgar E. Britton (1901–82)
COMMISSIONED BY: the Works Progress Administration, Federal Art Project

Six mural panels are mounted within architectural niches along the spacious stairway at the entrance to Bloom Township High School. They were commissioned by the WPA shortly after the school opened at this site and occupy a space designed for them by the architect. They follow the belief of Holger Cahill, director of the Federal Art Project, that "the mural must have a definite relation to its surroundings and be an integral part of the architectural scheme." Attractive grilles and railings line the stairway that leads to the main floor and protect the murals. The handsomely ornamented art deco structure is situated on a large grassy lot and has approximately sixteen hundred students, who take great pride in their school and its artworks. Edgar Britton's style reflects the influence of the great heroic murals that the Mexican government funded in the 1920s. Like the Mexicans, he painted on wet plaster in the true historical fresco manner, even applying the plaster himself. He stayed at the school from Monday to Friday while working on the murals, sleeping on a cot in the library. Using Bloom students as models, the artist painted six scenes that depict different types of "life work" and suggest that the subjects studied in school will help prepare students for their vocations after graduation. Because jobs were scarce during these depression years, the subject of work was uppermost in people's minds. In the foreground of each composition students are pictured in classes related to the work that adults pursue in the background. The panels illustrate the fields of art, agriculture, construction, industry, medicine, and aviation.

Bloom Township High School, Chicago Heights: *Occupational Studies and Their Application,* two of six panels: (a) *Agriculture;* (b) *Medicine;* (c) interior view. Photographs by Tom Van Eynde, courtesy of Bloom Township High School, mural commissioned by the Works Progress Administration, Federal Art Project.

140 ▶ Oak Park Historical Society
Treasure Island, 1936

Historical Society of Oak Park–River Forest, Historic Pleasant Home
217 Home Avenue, Oak Park
Oil on canvas, two panels, 3' x 10' and 2'10" x 3'11"
ARTIST: Frances Badger (1904–97)
COMMISSIONED BY: the Works Progress Administration, Federal Art Project
RESTORED: in part by a grant from the Oak Park Area Arts Council, 1996

Two of the four murals commissioned by the WPA in 1936 for Oak Park's Robert
Louis Stevenson Playground are now in the collection of the Historical Society of
Oak Park–River Forest. In 1966, when the recreation building was demolished,
they were retrieved from a dumpster by the longtime superintendent of buildings
and grounds for the Park District. They survived years of being moved from one

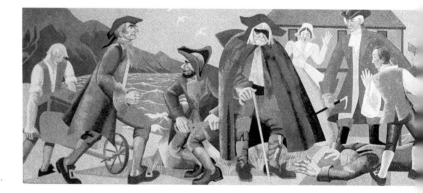

city building to another until the superintendent, now commissioner of the Park District of Oak Park, turned them over to the Historical Society. Several grants, including one from the Oak Park Area Arts Council, made the restoration of these handsome murals possible. Frances Badger's murals depict characters from Stevenson's classic *Treasure Island,* an adventurous tale that has always been a children's favorite. Written in 1883, the story tells of Jim Hawkins, a young man living in the days of pirates and sailing ships, who sets off for Treasure Island to find the treasure buried there by Captain Flint. The evil pirates Long John Silver and Pew, members of the crew, and other figures are also pictured, along with the ship *Hispaniola.* The whereabouts of two other Stevenson Playground murals and of WPA murals from the playgrounds named for Hans Christian Andersen, James Barrie, and Lewis Carroll are not known. The Historical Society is housed on the second floor of the Pleasant Home, a thirty-room mansion designed in 1897 by Prairie school architect George W. Maher and now owned by the Park District of Oak Park.

Oak Park Historical Society, *Treasure Island,* one of four panels. Courtesy of the Art Institute of Chicago, Architecture Study Collection, Ryerson and Burnham Archives, murals commissioned by the Works Progress Administration, Federal Art Project.

141 ▶ Percy Julian Junior High School

Western Movement across USA and *Pioneer Farmers in Our Northern Middle West States*, 1936

Percy Julian Junior High School, front hall (formerly Hawthorne School)
420 South Ridgeland Avenue, Oak Park
Oil on canvas, two panels, 16'11" overall
ARTIST: Karl Kelpe (1898–1973)
COMMISSIONED BY: the Works Progress Administration, Federal Art Project

Only three of the original seven public schools in Oak Park with murals commissioned by the WPA still retain them. At the Percy Julian School, two fine historical murals face each other on opposite sides of the front hall. Originally called the Hawthorne School, its name was changed in 1985 to honor the scientist and humanitarian Percy Julian. Plans are being made to replace the present building with a new one. It is hoped that these especially fine murals, painted on canvas, will not be lost but will be removed from the walls with care by a professional conservator and relocated in the new building. German-born artist Karl Kelpe, who immigrated to the United States in 1925, studied architecture in Germany before turning to painting. An important influence was the work of Swiss artist Ferdinand Hodler, who was very popular in Germany and whose murals Kelpe admired. His description of his murals at the time of their installation is mounted beside the paintings. "I wanted to depict the pioneer farmer whose rugged life was still close to nature. I had in mind those masculine farmers of whom Chateaubriand says, 'When I meet a laborer on the edge of a field I stop and look at the man: born amid the grain he will be reaped and turning up with the plow the ground of his tomb, mixing his burning sweat with the icy rain of autumn, the furrow he has just turned.'"

Percy Julian School, Oak Park, *Pioneer Farmers in Our Northern Middle West States,* one of two panels. Courtesy of the Art Institute of Chicago, Photographs Collection, Ryerson and Burnham Archives, murals commissioned by the Works Progress Administration, Federal Art Project.

142 ➤ Burbank School

Incidents in the Life of Luther Burbank, 1937

Luther Burbank School, classroom 104
2035 North Mobile Avenue, Chicago
Oil on canvas, two panels, 4' x 20' each
ARTIST: Camille Andrene Kauffman (1905–93)
COMMISSIONED BY: the Works Progress Administration, Federal Art Project

For a classroom on the first floor of the Burbank School, Camille Andrene Kauff-man created murals that span the length of two walls. Instead of working at the Illinois Art Project headquarters, she had her studios in three rooms on the third floor of the school, where teachers and students and children from other schools could watch her at work. And although she enjoyed her contact with the students and teachers, she missed the camaraderie of her fellow WPA artists. She worked with the theme suggested by representatives of the school, selecting events that would appeal to children from the writings of Luther Burbank (1849–1926), the American horticulturist for whom the school is named. In one scene Burbank is shown as a child with his mother in a charming garden setting, observing nature. As a young man in his hometown of Lancaster, Massachusetts, he holds the fa-mous "Burbank" potato developed after he had read Darwin, the great naturalist, at age nineteen. Still grown today, the potato resulted from Burbank's systematic experimentation with plant hybridizing. Also illustrated are the scientist as a young man on the train to California, where he established his nursery garden, and as an older man surrounded by Shasta daisies, one of the many varieties of flowers he developed.

Burbank School, Chicago, Andrene Kauffman at work on *Incidents in the Life of Luther Burbank,* one of two panels. From the collection of Robert J. Johnson, murals commissioned by the Works Progress Administration, Federal Art Project.

143 ▶ Burbank School

Circus, 1938

Luther Burbank School auditorium
2035 North Mobile Avenue, Chicago
Oil on canvas, two panels, 10' x 10' each
ARTIST: Camille Andrene Kauffman (1905–93)
COMMISSIONED BY: the Works Progress Administration, Federal Art Project

On each side of the stage of this attractive auditorium is a large mural depicting circus performers. On the left, a group of circus people are shown entering the ring. On the right, in a close-up view, five aerialists swing from trapeze to trapeze, high above the audience, with one dramatically depicted in midair. Although daring and dangerous feats are being performed, the mood of the painting is quiet and subdued. In the swirling compositions there are hints of the French impressionists in both technique and subject matter. These murals were much admired at the Art Institute, where Kauffman had studied, and they were exhibited in the museum before being installed at Burbank.

▶ Burbank School, Chicago, *Circus,* one of two panels. Photograph by Peter Shulz, courtesy of Heather Becker, mural commissioned by the Works Progress Administration, Federal Art Project.

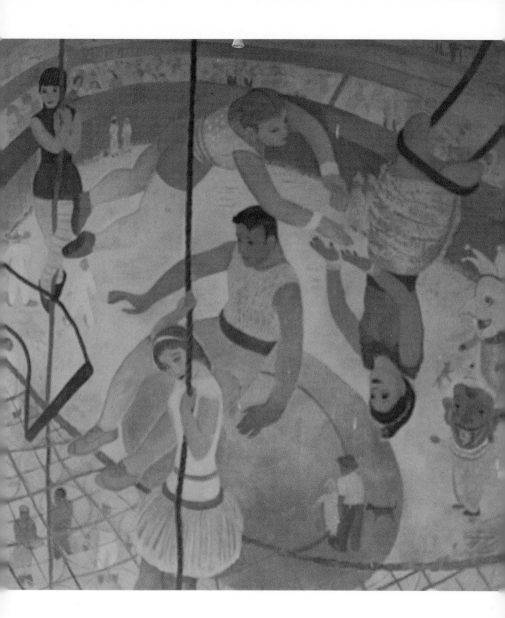

144 ▶ Harper School

Animals and Flowers: Gardening and *Farming,* 1936 and 1938

J. Robb Harper School auditorium
Dartmouth and Greenwood Streets, Wilmette
Oil on canvas, two panels, 9' x 26' each
ARTIST: Gustaf Oscar Dalstrom (1893–1971)
COMMISSIONED BY: the Works Progress Administration, Federal Art Project

Two large murals were commissioned by the WPA in 1938 for a classroom in the Laurel School in Wilmette. They were moved to the auditorium of the Harper School in 1973 when Laurel was demolished. *Farming* is a large pastoral panorama with cows, horses, sheep, ducks, geese, and birds scattered across a rolling green pasture that is dotted with a variety of leafy trees. A boy and girl are placed near a flowering tree. There is little indication of perspective in the airy and idealized scene, which is painted with soft, muted colors. The focal point of *Gardening* is a colorful patch of flowers being tended by workmen with hoe, spade, and wheel-barrow and watered by a young girl. The murals are mounted on the long side walls of the auditorium. The school was named for J. Robb Harper, superintendent of schools at the time it was built. Gustaf Dalstrom's other WPA commissions were for the Bennett, Manley, and Green Bay Schools.

▶ Harper School, Wilmette, *Farming.* From the collection of Barbara Bernstein, mural commissioned by the Works Progress Administration, Federal Art Program, for the Laurel School.

SUBURBS AND OUTLYING AREAS

145 ➤ Wilmette Post Office
In the Soil Is Our Wealth, 1938

Wilmette Post Office
1241 Central Avenue, Wilmette
Oil on canvas, 5'2" x 13'5"
ARTIST: Raymond Breinin (1910–2000)
COMMISSIONED BY: the Treasury Section of Fine Arts

Every federal building in the United States built during the 1930s and early 1940s was entitled to receive works of art from the government through the Treasury Section of Fine Arts, which set aside 1 percent of the total cost of the building for decoration. "The Section" supervised commissions of artwork for federal buildings, many of which were post offices. These highly sought-after commissions were awarded based on competitions, but often runners-up and artists of previous successful commissions were selected. Raymond Breinin, a promising but unknown artist, was chosen over more established artists through the excellence of his sketch. He was directed to present "a complete cross section of Illinois life and ideals" and asked not to design a work "burdened down with somber moods and melancholy." He created a rural scene emphasizing the state's agricultural production by placing stalks of corn in the center and surrounding them with farmers, their horses, and cattle in a vast prairie. Painted in rather sedate colors, it is a handsome mural that complements the attractive neoclassic building designed by Benjamin Marshall. Still in its original location, the mural is now behind a glass window with two wooden mullions that detract from its visibility.

➤ Wilmette Post Office, *In the Soil Is Our Wealth.* Photograph © by Don DuBroff, courtesy of the U.S. Postal Service, mural commissioned by the Treasury Section of Fine Arts.

SUBURBS AND OUTLYING AREAS

146 ► Green Bay Pavilion
Flora and Fauna, 1938

Green Bay Pavilion (formerly Green Bay School)
1936 Green Bay Road, Highland Park
Oil on plaster, two panels, 10' x 10' each
ARTIST: Gustaf Oscar Dalstrom (1893–1971)
COMMISSIONED BY: the Works Progress Administration, Federal Art Project

The auditorium of the former Green Bay School has been converted into a large office, but it retains vestiges of its original configuration. Wooden relief panels mounted over two sets of doors on each side of the room are commissions from the WPA period, as are the two murals. The murals are mounted on each side of a large opening that must have been the original stage and is today another office. Painted directly on the plaster walls, they are in good condition. Each is an inviting outdoor scene of children in a landscape, one depicted in spring, the other in fall. An array of small birds and animals forms the upper and lower borders of the compositions. The former school building, leased by the Board of Education in the 1980s, now houses some Highland Park Hospital offices and a day care and adult community center. Gustaf Dalstrom also painted rural landscape murals at the Harper School in Wilmette.

Green Bay Pavilion, Highland Park, *Flora* and *Fauna*, two panels. Photographs by Tom Van Eynde, murals commissioned by the Works Progress Administration, Federal Art Project.

147 ► Elmhurst Post Office

There Was a Vision, 1938

Elmhurst Post Office, 154 Park Avenue, Elmhurst
Oil on canvas, 7' x 14'
ARTIST: George Melville Smith (1879–?)
COMMISSIONED BY: the Treasury Section of Fine Arts

Smith painted murals for the Elmhurst and Park Ridge Post Offices. He was commissioned by the Treasury Section of Fine Arts, whose program was to provide art and sculpture for federal buildings. Whereas the WPA Federal Art Project was set up to hire unemployed artists, who were then given a monthly salary and expected to produce a certain amount of work, the Treasury Section chose its artists individually through open competitions, either local or national, juried by fellow artists, and awarded the winners specific commissions. Federal Art Project artists painted many murals in the public schools; Treasury Section artists worked in post offices or other federal buildings. Both programs originated in the 1930s, through President Franklin Roosevelt's New Deal, when the country was in a severe depression. Although many post offices were built during these years, 1934–43, it was rare that artists had a chance coordinate their work with architects' plans. They generally had to cope with existing architecture, to fit the work between or above doorways, windows, grilles, and mailboxes. A Treasury Section committee would critique the artist's design, and requests for changes in treatment, color, and even subject matter were common. Scenes of local or postal history were the preferred subjects. The committee praised Smith's mural for its "charming" colors, "beautiful rhythm," and "commendable sense of design," but it questioned the depiction of the foliage of a tree and the scale and rendering of the oxen. True to the pattern of many post office murals is his animated rural scene of farmers plowing a field, leading a team of oxen, and cutting down a tree, while watched by a pioneer farm family.

Elmhurst Post Office, *There Was a Vision*. Photograph © by Don DuBroff, courtesy of the U.S. Postal
Service, mural commissioned by the Treasury Section of Fine Arts.

148 ► Oak Park Post Office

La Salle's Search for Tonti, 1680; The Founding of Fort Crevecoeur;
The "Pioneer," First Train to Oak Ridge (Oak Park); and *The "Osceola,"*
First Shipment of Wheat from Chicago, 1839, 1939

Oak Park Post Office, 901 Lake Street, Oak Park
Oil on canvas glued to concrete block walls: four panels, two 9' x 4' and two 11' x 4'
ARTIST: J. Theodore Johnson (1902–?)
COMMISSIONED BY: the Treasury Section of Fine Arts

During the Federal Art Project years, post office murals were commissioned by the Treasury Section of Fine Arts, which made its selection by regional competitions. A committee representing each post office would send five to ten of the best entries to Washington, where the choice would be made. During this period, 1,300 sites were decorated by over 650 artists. Their realistic depictions of the American scene replaced the former penchant for neoclassic representations. The handsome art deco Oak Park Post Office was designed by Charles E. White, who had been a student of Frank Lloyd Wright's in the early 1900s. The murals were painted eight years after the building was completed, and the artist was paid $3,000 for his work. The choice of J. Theodore Johnson, who lived in New York at the time of the commission, caused some controversy among Oak Parkers, since some of them wanted a local artist. Although he had been born in Illinois and studied at the School of the Art Institute, they were concerned that he might not be sufficiently familiar with the town's history. He chose to illustrate only one scene specific to Oak Park. The four imaginatively portrayed scenes, mounted in pairs at each end of the rectangular building, depict the French explorer La Salle's search for his trusted lieutenant Henri de Tonti, who had been sent on a mission to find deserters; their founding of Fort Crevecoeur in 1680 near present-day Peoria; farm-

ers unloading a shipment of wheat from Chicago in 1839; and a stockholder, farmer, and resident inspecting the site of Oak Park (then called Oak Ridge) as the termination point of the first train west in 1848.

Oak Park Post Office, *The Founding of Fort Crevecoeur,* one of four panels. Photograph © by Don DuBroff, murals commissioned by the Treasury Section of Fine Arts.

149 ► Ravinia School

Robin Hood, 1940

Ravinia School, 736 Dean Avenue, Highland Park
Oil on canvas, two panels, 5'4" x 7'1" each
ARTIST: Unsigned, attributed to Mildred Waltrip (1911–)
COMMISSIONED BY: the Works Progress Administration, Federal Art Project

Two murals commissioned by the WPA, placed above the twin wooden benches of
a niche or inglenook, bracket the entryway into the main building of the hundred-
year-old Tudor-style school building. They illustrate episodes from the life of Robin
Hood, the legendary English outlaw and popular hero who was said to have been
born about 1160. Interwoven among the medieval figures in the first mural are de-
scriptive captions: "Merry Men of Robin Hood; Richard ye Lion-Hearted, King of
England and Robin ye Sheriff of Nottingham." The second mural continues the
story: "Robin Meets Little John; Robin Meets Friar Tuck; and Death of Robin Hood
at Kirklee Priory." A background of leafy green trees and foliage provides the set-
ting and the unifying element for all the episodes. Although the murals are un-
signed, I have attributed them to Mildred Waltrip based on the style of her other
WPA commissions.

► Ravinia School, Highland Park, *Robin Hood*, one of two panels. Photograph by Tom Van Eynde, courtesy
of Ravinia School, murals commissioned by the Works Progress Administration, Federal Art Project.

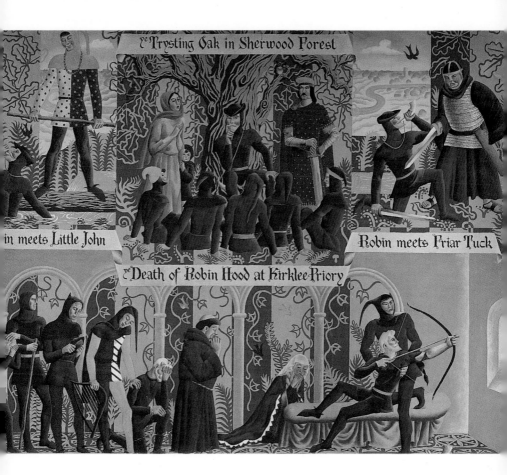

ye Trysting Oak in Sherwood Forest

in meets Little John

Robin meets Friar Tuck

ye Death of Robin Hood at Kirklee Priory

150 ▶ Oakton School

The Legend of Charlemagne, or Knights and Damsels, date unknown

Oakton School assembly hall/gymnasium, 436 Ridge Avenue, Evanston
Oil on canvas, three large panels and eight smaller ones
ARTIST: Unsigned, but may be Carl Scheffler (1883–1962)
COMMISSIONED BY: the Works Progress Administration, Federal Art Project

The combination gymnasium and auditorium of the Oakton School was designed to resemble a great medieval hall with high coffered ceiling and fireplaces. It has been altered and reduced in size but is still an impressive space. The walls are of patterned brickwork, the stage is framed with painted and architectural decoration around the proscenium, and two large murals are mounted above the wainscoting, one on each side. A third large mural and eight smaller portraits of medieval knights are mounted on the two side walls. The large paintings illustrate the story of Charlemagne, king of the Franks, whose successful conquests led the pope to crown him Holy Roman Emperor in A.D. 800. Eight knights who fought in battle with him, including his closest companions Roland and Oliver, are illustrated on the two side walls. Some of the murals have suffered water damage. Other WPA artworks in the school include several mosaic tile murals, two large carved relief panels, and a diorama of the first Chicago railroad.

▶ Oakton School, Evanston, *A Victorious Charlemagne,* one of eight panels. Photograph by Nancy Flannery, murals commissioned by the Works Progress Administration, Federal Art Project.

332

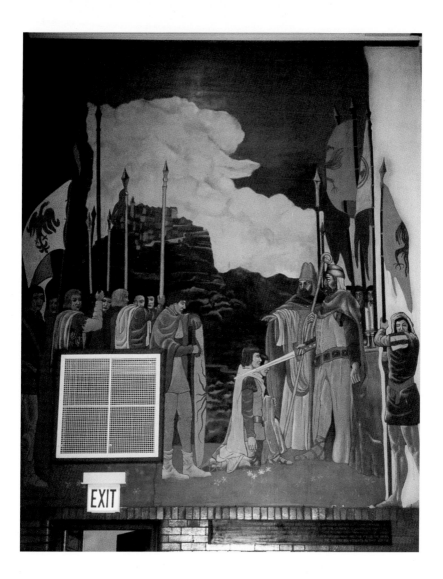

151 ► Bicentennial Mural

The Stonecutters, 1975

316-18 Canal Street, Lemont
Oil-based enamel on concrete blocks, 23' x 60'
ARTIST: Caryl A. Yasko (1941–)
A project of the Lemont 1976 Bicentennial Commission
FUNDED JOINTLY BY: the Lemont Bicentennial Commission and Lemont Historical Society
Restored with Liquitex, 1993

This dramatic mural celebrates the late nineteenth-century workers who mined
the stone quarries of Lemont and commemorates their struggle for better work-
ing conditions. Painted as part of the United States Bicentennial celebration, the
well-loved mural is in the heart of the village, bordered by a pleasant little park.
Chicagoans know the hard, buff-colored Lemont limestone from the facades of the
old Water Tower and Auditorium Building. Many European immigrants came to
Lemont in the nineteenth century to work in the quarries, where they encountered
long hours, difficult conditions, and low pay. When they struck in 1885 to protest,
the Illinois militia was called in and the ensuing violence caused three deaths and
scores of injuries. A year later there was an even greater clash in Chicago when
a bomb was thrown at a large group of uniformed policemen who were marching
against a peaceful group holding a rally to protest the killing of two workers the
day before. Chicago workers were protesting the same difficult working conditions
that the Lemont workers met, but their actions erupted into the infamous Hay-
market riots. Although familiar with stonecutting from her work as a sculptor, Caryl
Yasko spent many weeks in Lemont learning about the quarries and painting the
mural. There are several stonecutters at work in her composition, as well as a
woman struggling to lift a large slab and a young "water boy," a comment on the
use of women and children as labor at this time. In the background are some of

the many churches in the town. The village of Lemont is on the Illinois and Michigan Canal, west of Chicago, and is still considered a workers' town. The mural was threatened with destruction by a controversial suit against the city by the former owner of the building but is now protected for at least twenty years by an agreement between the new owner and the city.

Bicentennial mural, Lemont, *The Stonecutters*. Photograph by Gentle Impressions, Lemont, Illinois.

152 ▶ Harlem Avenue CTA Station

Harlem Station, 1984

Harlem CTA Station, Harlem Avenue and Kennedy Expressway, Chicago
Primed with Imiron and titanium white primer and painted with oil on silicone
aluminum alloy, 8' x 50'
ARTIST: Alex Katz (1927–)
COMMISSIONED BY: the Chicago Department of Cultural Affairs, Percent for Art Program

In one of the largest artworks he has ever done, the New York artist Alex Katz painted an image he thought would engage the public. It is mounted outdoors at the Harlem Avenue CTA station, which was designed by Myron Goldsmith of Skidmore, Owings and Merrill, who also chose the artist. The mural is one of three public pieces funded by the Public Art Program for the O'Hare rapid transit extension. Works by Charles Ross and Martin Puryear are at the Cumberland and River Road stations. Katz created the painting expressly for the Harlem station, depicting Chicago commuters "within the context of the commuting ritual" and thus allowing the real commuters to interact with their counterparts in the mural. Described as a friendly mural, it depicts fifteen "everyday folk" as a crowd of larger than life-size cut-out faces, both young and old. It was set at a low level with no barriers so that people could walk right up to it. Despite the belief that its surface was highly resistant to damage, its very accessibility allowed vandals to scratch, stain, and deface it to such a degree that it had to be removed. But through the combined efforts of private and public donors, funds were raised for extensive repairs and restoration. It was returned to the CTA station many years later, in 1997, this time mounted within a protective Plexiglas enclosure.

SUBURBS AND OUTLYING AREAS

Harlem Avenue CTA Station, *Harlem Station;* © Alex Katz, courtesy of the Marlborough Gallery, New York, and City of Chicago Public Art Collection.

153 ➤ O'Hare International Airport
International Mural Project, 1993

O'Hare International Airport, arrivals corridor
Acrylic or oil on canvas, twelve murals, 4' x 9' each
ARTISTS: Ablade Glover (1934–), Accra, Ghana; Mohammed Chabaa (1935–), Casablanca,
Morocco; Denice Zwetterquist (1928), Gothenburg, Sweden; Olga Antonenko (1963–), Kiev,
Ukraine; Monica Castillo (1961–), Mexico City, Mexico; Angela Occhipinti, Milan, Italy;
Hideo Nakai, Osaka, Japan; Jiří Sopko (1942–), Prague, Czech Republic; Lu Xiang-tai (1941–),
Shanghai, People's Republic of China; Zheng Bo (1957–), Shenyang, People's Republic of
China; John Abrams, Toronto, Canada; Boguslaw Kochanski (1952–), Warsaw, Poland
COMMISSIONED BY: the Chicago Department of Cultural Affairs, Sister Cities International
Program

Twelve colorful murals have been installed to welcome travelers from abroad as
they traverse the long arrivals corridor of the new O'Hare International Terminal.
The paintings represent the visual impressions of twelve artists from as many dif-
ferent foreign cities who spent several weeks in Chicago exploring the city. Their
work reflects the various neighborhoods, museums, restaurants, and nightclubs
they visited, walks and architectural and boat tours they took, and concerts, base-
ball games, and other events they attended. The size of the murals is standard,
but each of the impressions is unique. The artists were chosen by Chicago's Pub-
lic Art Committee from portfolios submitted by each of the twelve cities. Housed
at the Union League Club and in private homes, the artists created their murals in
storefront studio space at the Rookery Building, where passersby could watch the
work in progress. The project was sponsored by the Sister Cities International Pro-
gram, administered by the Chicago Department of Cultural Affairs. Sister Cities
is a volunteer not-for-profit organization that links Chicago to foreign cities and

SUBURBS AND OUTLYING AREAS

works to promote global understanding through people-to-people exchanges. Its goals are to develop international relationships that increase trade, economic development, cultural awareness, and educational opportunities for Chicago and its sister cities. Illustrated is Chinese artist Zheng Bo's view of a verdant Grant Park, peopled with women and pigeons and set against the city skyline.

O'Hare International Airport, *Chicago Impression*, by Zheng Bo, Shenyang, People's Republic of China, one of twelve panels, oil on canvas, 4' x 9". Photograph by Michael Tropea 1994, © the Chicago Public Art Program of the Chicago Department of Cultural Affairs. All rights reserved.

But Not Forgotten

But Not Forgotten

This section presents examples of Chicago's historical murals that that have either been destroyed, lost, or relocated, or whose continued existence is threatened. We are fortunate to have a record of some of these through photographs and old lists. Although the history of mural painting as architectural decoration is a long one, it became popular in America only during the last part of the nineteenth century. Based on traditions brought from Europe by artists and architects trained at schools such as the École des Beaux-Arts in Paris, in this country murals appeared primarily in churches and public buildings.

It was at Chicago's World's Columbian Exposition of 1893 that the American mural movement really began. To commemorate the four hundredth anniversary of Columbus's voyage and demonstrate America's attainments, architect and city planner Daniel H. Burnham assembled the nation's leading architects and artists: "the greatest meeting of artists since the fifteenth century," said sculptor Augustus Saint-Gaudens. Together they created the "White City," a group of neoclassical, Beaux Arts palaces, the most striking and influential architectural grouping of its time. The structures were lavishly adorned with sculpture, sculptural relief, and murals, setting the style for public buildings all over the country and inspiring the City Beautiful movement. The artists had taken some of the ancient Greek and Roman traditions and created a new civic art to express the ideals of their own time. Murals now appeared in many Chicago hotels, such as the Congress, LaSalle, Palmer House, and Sherman, and in private clubs, theaters, and restaurants.

Forty years later a second great outburst of mural activity occurred at Chicago's 1933–34 Century of Progress Exposition, marking the centennial of the founding of the city. Again, architects and artists worked together to create fairgrounds that expressed the latest ideas of design. Interior decoration flourished and was even more popular this time. The fair was so successful that it was extended an extra year. Most of the buildings were designed in the art moderne style, and many featured murals and sculptural relief that served both didactic and decorative purposes. Among the muralists were Frances Badger, Dorothy Loeb, John Warner Norton, Nicolai Remisoff, Edgar Miller, George Melville Smith, and Rudolph Weisenborn. When the temporary buildings were demolished at the end of the fair, only a few of the murals survived.

The WPA came into existence soon after, and the Illinois Art Project employed many of the artists who had worked at the fair. From 1935 to 1943 over four hundred murals were commissioned by the Federal Art Project of the WPA for schools and public buildings in the Chicago area. About two-thirds have survived. Some were destroyed when the buildings were demolished; others were removed during remodeling, sometimes mislaid and rediscovered later. Some murals were simply discarded, and a few of these were retrieved. Some of were carelessly or deliberately covered by paint. Some of these hidden school murals have been identified and are being restored through the city of Chicago's ambitious and ongoing restoration program.

154 ▶ World's Columbian Exposition
Modern Woman and Primitive Woman, 1893

World's Columbian Exposition, Woman's Building, Hall of Honor
Oil on canvas, two murals 12' x 48' each
ARTISTS: Mary Cassatt (1845–1926) and Mary Fairchild MacMonnies Low (1858–1946)

These two large lunette-shaped murals were mounted forty feet off the ground on the tympana of the great hall in the Woman's Building, one at each end. Their theme, "the advancement of women," was suggested by Mrs. Potter Palmer, president of the Board of Lady Managers. Mary MacMonnies's mural, *Primitive Woman,* was preferred by most contemporary critics, who described it as "Pre-Raphaelite" in style and "light, pure, and pleasing" in color. Harsher in their assessment of Mary Cassatt's *Modern Woman,* they found its colors "garish and primitive" and its "frankly realistic character" objectionable. Only the central panel of her large "Young Women Plucking the Fruits of Knowledge or Science" was praised as "a beautiful piece of work." Cassatt had broken with tradition by showing modern woman "apart from her relations to man" and by using her to embody the highest ideals of society. Her colors are typical of her graphic work and also reflect her interest in the Japanese print. After the fair the murals, painted on canvas, were removed from the building before it was demolished. MacMonnies's work was exhibited in France, St. Louis, and at the Art Institute and then put in storage in the basement of Mrs. Palmer's mansion on Lake Shore Drive. Cassatt's mural is known to have been stored in Mrs. Palmer's basement only after 1895, and there is mention of water damage. Attempts to find permanent homes in public buildings for these very large murals were unsuccessful, and after 1910 there is no definite information about their whereabouts, despite repeated efforts and research over the years. Scholars still hope they may turn up someday.

World's Columbian Exposition: (a) *Modern Woman;* (b) *Primitive Woman.* Courtesy of the Chicago Historical Society, ICHi-12290 and ICHi-02294.

155 ► School of the Art Institute
Students at Work, 1908

School of the Art Institute
South Michigan Avenue and East Adams Street
Two photographs from the archives
ARTISTS: Students

The first photograph shows a class in mural decoration at the School of the Art Institute. Notice that the students are using an exhibition hall in the museum as their studio. In the second photograph Harry Lawrence Gage, a student at the school, is painting a large mural titled *Columbus Embarking on a Winter Trip*. What became of it is a complete mystery.

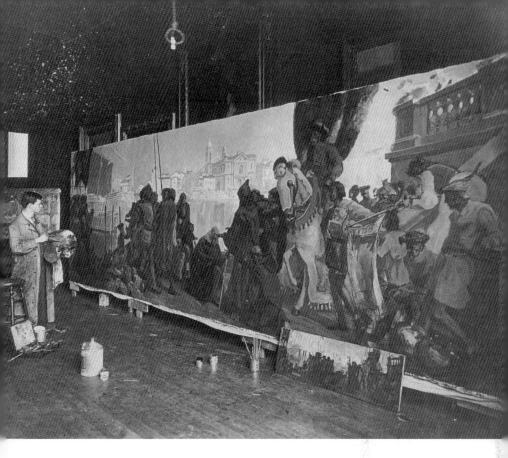

◄ Class in mural decoration at the School of the Art Institute of Chicago, 1908; ▲ Harry Lawrence Gage, student at the School of the Art Institute of Chicago, in 1908, painting a mural titled *Columbus Embarking on a Winter Trip*. Courtesy of the Art Institute of Chicago Photo Archives, Ryerson and Burnham Libraries.

156 ▶ Central Trust Bank of Illinois

Chicago History, 1909

Central Trust Bank of Illinois, 125 West Monroe Street
Oil on canvas, sixteen panels 9' x 16'
ARTIST: Lawrence Carmichael Earle (1845–1921)

Sixteen large semicircular murals painted on canvas were set into separate frames above the marble-paneled walls of the huge ground-floor banking room. They traced the development of Chicago from the explorations of Father Marquette in 1674 to the 1893 World's Columbian Exposition and the engineering of the Drainage Canal. Among the illustrations were Fort Dearborn, the first grain elevator, the first bridge across the Chicago River, the great flood of the Chicago River, and the first railway station. The bank is gone, but many of the paintings have survived and are in the collection of the Chicago Historical Society. Earle also created murals for the Manufacturers and Liberal Arts Building at the World's Columbian Exposition of 1893.

▶ Central Trust Bank of Illinois, *View of Grand Basin, World's Columbian Exposition,* one of sixteen panels. Courtesy of the Chicago Historical Society, P&S-1933.0051.

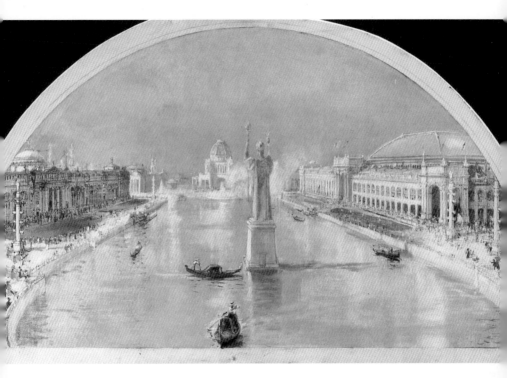

157 ▶ City Hall Council Chamber
The Rise of Commerce in Chicago, 1911

City Hall council chamber, LaSalle and Randolph Streets
Oil on canvas, ten panels
ARTIST: Frederic Clay Bartlett (1873–1953)

Destroyed by fire in 1957 were a series of ten murals painted by Frederic Clay Bartlett for the beautiful wood-paneled council chamber of City Hall, designed by Holabird and Roche in 1908. The murals were said to "typify the active, energetic, democratic spirit of Chicago." The panel on the west had symbolic figures of Labor, Justice, and Truth. On the panel to the east were Law, Order, and Commerce. Electricity was pictured over the mayor's seat, and to his right were Education and *Havoc of the Great Chicago Fire and Aid of the Sister Cities*. Chicago's motto, "I Will," rises from the ruins. To the left of this were *Gifts of Illinois to the Nation* and *Construction*.

BUT NOT FORGOTTEN

▶ City Hall Council Chamber, *Havoc of the Great Chicago Fire and Aid of the Sister Cities,* one of ten panels.
Courtesy of the Art Institute of Chicago, Ryerson and Burnham Libraries.

158 ▶ City Hall Financial Committee Chamber

Spirit of Chicago, 1911

City Hall Financial Committee chamber, LaSalle and Randolph Streets
Oil on canvas, twelve panels
ARTIST: Edgar Spier Cameron (1862–1944)

No longer in their original location in the Financial Committee chamber of City Hall, seven of the twelve Edgar Cameron murals now hang outside the Mayor's Office. They were created for the International Municipal Congress and Exposition that met in September 1911 at the Coliseum in Chicago and were later installed in City Hall. The artist grew up in Ottawa, Illinois, was a resident of Chicago, and had been interested in Chicago history since his boyhood. He assisted muralists at the World's Columbian Exposition. The events and places in Chicago history that Cameron illustrated in this series are *Indian Camp Scene at Wolfs Point; Marquette and Joliet, 1673; Commerce on the Chicago Portage, 1765–78; French Fort at Chicago, 1685; Fort Dearborn and Kinzie House, 1803–4; Fort Dearborn Massacre, 1812; Hubbard's Train, 1827; Illinois-Michigan Canal, 1848; Camp Douglas, 1862; the Great Fire of 1871; The World's Fair of 1893;* and *Shipping and Commerce, 1911.* Pictured here is *French Fort at Chicago, 1685.* A catalog published by the city at the time the murals were originally installed described the French fort as "the first establishment of any civilized government or authority on the site of Chicago." Less familiar than the much later Fort Dearborn, it was the outpost of the French occupation in the Great Lakes area during the time of the explorers Joliet, Marquette, and La Salle.

▶ City Hall Financial Committee Chamber, *French Fort at Chicago, 1685,* one of twelve panels. Photograph by Ted Lacey, courtesy of the Mayor's Office.

354

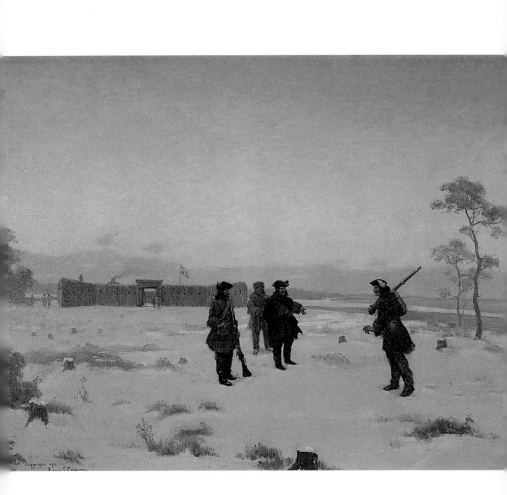

159 ➤ Midway Gardens
Design Study, 1912

Midway Gardens, Cottage Grove Avenue at Sixtieth Street
Tempera and watercolor on paper
ARTIST: John Warner Norton (1876–1934)

The illustration shown here is a detail from one of two surviving designs by John Warner Norton, thought to have been intended for the interior of Frank Lloyd Wright's famous Midway Gardens, an open-air restaurant of 1914 that stood along the old midway of the World's Columbian Exposition. The remarkable pavilion-style restaurant, closed during Prohibition and demolished in 1923, is known only through drawings, photographs, and a few sculptural remnants. Wright, who wanted to create a space of "festive gaiety" in which painting and sculpture would play an important part, hired several local artists, who were experienced muralists and known to be "avant-garde," to design murals. He was familiar with John Warner Norton's work, and they shared an interest in Japanese composition. Although we have studies and details of mural designs by William P. Henderson and by Norton, who exhibited several of his in 1915 at the Chicago Architectural Club, the murals were apparently never completed. "Large panels in the interior entrance promenade—characterized by a repeated circle motif—are generally attributed to Norton," wrote Jim Zimmer in the catalog for the 1993 Norton retrospective at the museum in Lockport, Illinois, and at Chicago's State of Illinois Gallery. This use of geometric shapes and flat colors points to his modernist tendencies, realized in his later work, especially the Daily News Building mural. But the disposition of the Henderson and Norton murals has remained a mystery. In a new study of the Midway Gardens, Paul Kruty points out that only the Henderson mural can be accurately situated. He writes that when Wright saw the approved design on the walls, he objected to the scale and ordered Henderson to change it, but the artist refused. Norton joined Henderson in protest, and both

artists left the project. Wright then prepared his own designs, groups of circles of different sizes, "flat asymmetric ornament," which are related to the original murals but eliminate the figures and "complement the angular patterns of the exterior walls."

Design for Midway Gardens decoration, detail. Courtesy of the Art Institute of Chicago, Architecture Study Collection, Ryerson and Burnham Libraries.

160 ➤ Art Institute of Chicago

Great Walls: The Walls of China and
The Building of a Modern Skyscraper, ca. 1921

Art Institute of Chicago, Burnham Library of Architecture, periodical room
Michigan Avenue at Adams Street
Oil on canvas, two panels
ARTIST: Frederic Clay Bartlett (1873–1953)

Bartlett chose two themes that he thought were appropriate for the Burnham Library of Architecture, which was designed by Howard Van Doren Shaw and functioned as a separate entity until the late 1950s when it merged with the Ryerson collections. He called the great Chinese walls, sketched during earlier travels, "the first and probably the greatest architectural dream ever carried into effect" and chose them for the subject of one of his lunette-shaped murals, titled *Great Walls: The Walls of China.* For his second mural, *The Building of a Modern Skyscraper,* he represented "the latest type of great walls or sky scrapers in any large American city," using a style he said was "somewhat freer and more in our extreme modern spirit of impressionism." Mary Woolever, the architecture reference librarian and archivist, assures us that both

358

murals are still intact, but they are hidden behind the partitions of what are now offices, created during a later renovation of the library space. These photographs were taken in 1933.

Ryerson and Burnham Libraries, two panels: ◄ *Great Walls: The Walls of China;* ▲ *The Building of a Modern Skyscraper.* Courtesy of the Art Institute of Chicago Photo Archives, Ryerson and Burnham Libraries.

Daily News Building

The Chicago Daily News Mural, 1929

Riverside Plaza (formerly the Daily News Building), 400 West Madison Street
Oil on canvas, 17'6" x 180'
ARTIST: John Warner Norton (1876–1934)

John Warner Norton created possibly the nation's longest mural, illustrating the complete process of producing a newspaper, for the ceiling of the concourse that connects the old Daily News Building to the North Western Station. Painted when the now defunct *Daily News* was printed in the building, the mural was perfectly integrated into its architectural setting and was viewed and admired by thousands of commuters daily. It has been called Chicago's Sistine Chapel. As the city's most important example of public art in the modernist style, it refers to the artistic movements of cubism and futurism. Norton divided the process of making a newspaper into three parts that he titled *Gathering the News, Printing the News,* and *Transporting the News.* "Abandoning the conventional ways of wall decoration," wrote the *Daily News* critic when the mural was unveiled, "Mr. Norton makes use of geometric motifs. . . . The composition is an intricate pattern of simplified forms placed within a series of criss-crossing diagonals that line up with the pilasters along the walls of the concourse. Like newspapers rolling off the presses are these diagonal strips that are divided into ribbons of regular panels. Newspaper banners, headlines and descriptive phrases superimposed on the design spell out the division of the mural into three sections." Over the years, water leaks caused some of the panels to pull away from the ceiling, resulting in progressive damage to the painted surface. Apparently some panels had also been nailed or stapled to the ceiling in makeshift attempts to keep them from detaching further. In 1993 the owners of the building had the mural removed. In the process there was further

loss of paint, and the hoped-for restoration and return of the mural has never taken place. Today this work, considered the artist's masterpiece, languishes in a Chicago warehouse.

Daily News Building, *The Chicago Daily News Mural,* detail. Courtesy of the Art Institute of Chicago Photo Archives, Ryerson and Burnham Libraries.

162 ▶ Century of Progress Exposition
Tree of Knowledge, 1933

Century of Progress Exposition, Hall of Science
Oil on canvas, one large panel and six smaller ones
ARTIST: John Warner Norton (1876–1934)

Norton produced a large mural for the facade of the Hall of Science and five smaller ones for the interior. In these works, the last before his death, he simplified the shapes he used almost to the point of abstraction. Three were given to the Museum of Science and Industry. His *Tree of Knowledge* was a multicolored design in the form of a chart, with the names of the basic sciences on the roots of the tree and applications of sciences on the limbs. It was reproduced as a poster, which is illustrated here, and used in several science textbooks.

▶ Century of Progress Exposition, Hall of Science, *Tree of Knowledge,* poster reproduction. Photograph by Richard Gray, courtesy of Robert Sideman.

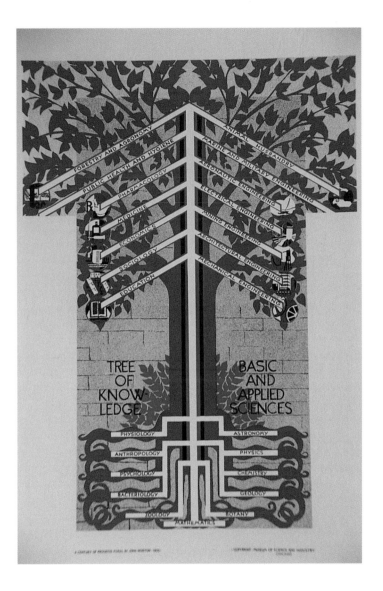

163 ➤ Century of Progress Exposition

Progress of Women, or The Onward March of Women, 1933

Century of Progress Exposition, Hall of Social Science
Oil on canvas, 7' x 60'
ARTIST: Hildreth Meiere (1893–1961)

Painted for the National Council of Women's exhibit in the Hall of Social Science at the Century of Progress Exposition, Hildreth Meiere's mural told the story of women's struggles as they moved from the "narrow confines of home and tradition in 1833 to the broad opportunities and freedom of 1933." The hundred-year span was divided into ten sections, with episodes from each decade to illustrate the remarkable achievements of women. They also show the evolution of feminine attire. Larger than life-size depictions of important women leaders include Lucretia Mott, Elizabeth Cady Stanton, Harriet Beecher Stowe, Julia Ward Howe, Clara Barton, Emily Dickinson, Mary Cassatt, Amelia Earhart, and Helen Keller. During these years, women gained admission to universities, aided the wounded of the Civil War, worked for and achieved women's suffrage, became prominent in business and professions, and worked for peace. An exhibit of historic mementos such as letters, photographs, and clothing of these famous women accompanied the mural. In 1943 a segment of the original sixty-foot mural was given to Smith College in Northampton, Massachusetts, where it was mounted in the archives room of the Library. It remained there until 1962, when the archives relocated and the mural was removed and stored. A twenty-foot segment still exits, in fragile condition, stored at the Smith College Museum of Art. Among Meiere's other Chicago commissions were medallions and panels for the ceiling of the University of Chicago's Rockefeller Chapel.

Century of Progress Exposition, Hall of Social Science, *Progress of Women, or The Onward March of Women*, detail. Photograph courtesy of Louise Meiere Dunn.

164 ► Adler Planetarium
Cascade of the Months, 1932-33

Max Adler Planetarium, esplanade, 1300 South Lake Shore Drive East
Terrazzo, twelve pools, 16' x 26' each
ARTISTS: John Warner Norton (1876–1934) and Tom Lea (1907–)
COMMISSIONED BY: the National Terrazzo Mosaic Association

The original approach to the Adler Planetarium was described as a "broad esplanade with walks and roadways flanking a series of twelve shallow pools, each 16 feet wide and 26 feet long, on the bottom of which in colorful terrazzo are designs symbolic of the months of the year." The National Terrazzo Mosaic Association commissioned and underwrote the esplanade as its exhibit at the Century of Progress Exposition of 1933 and intended it to be a permanent feature of the Planetarium at the close of the fair. Artists John Warner Norton and Tom Lea worked with Ernest A. Grunsfeld, architect of the Planetarium, in its planning. Their design of the twelve months of the year complemented the twelve bronze plaques of the signs of the zodiac by sculptor Alfonso Iannelli that were set into the corners of the roof of the building. The esplanade was sloped so that the water could flow over the twelve pools in a series of cascades. Fifty colors, both pale and bright shades of emerald green, purple, brown, red, yellow, and blue, were used in the terrazzo designs representing the twelve months. January was represented by a giant snowflake, February by a dark sky and barren trees; March shows the sun with extended rays, April huge raindrops, May the first crocus in bloom; June, July, August, and September feature elements of nature in warm tones; October displays grapes ready for harvest, November falling leaves, and December a snow-clad Christmas tree. Built on a man-made structure called Northerly Island that juts into Lake Michigan, the Adler Planetarium was one of eight such museums in the world when it was erected, and the only one in North America.

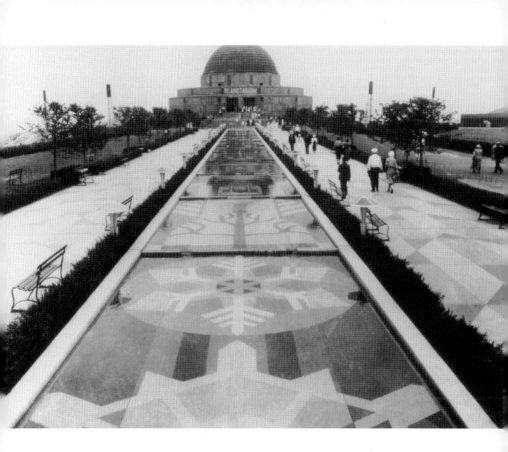

Adler Planetarium's terrazzo esplanade in the 1930s. Courtesy of the Adler Planetarium and Astronomy Museum, Chicago.

165 ➤ Kelvyn Park High School
Stained Glass Panels, 1933

Kelvyn Park High School, library, 4343 West Wrightwood Avenue
Stained glass, five panels, ca. 2' x 3' each
ARTIST: Edgar Miller (1889–1993)
COMMISSIONED AND FUNDED BY: the graduating classes of 1933

In 1999 it appeared that Kelvyn Park High School would be converted to another use and these beautiful stained glass panels would be put in storage. There was concern for their safety, since when relegated to storage artworks often disappear or are forgotten, never to resurface. Fortunately the Board of Education decided against this conversion and continues to use the building as a school. The panels, which were originally mounted inside the windows, were taken out at a later date when there were problems of leakage, and they were never properly reinstalled. They had just been propped up against the outer windows. Now they will be mounted properly. There are five leaded stained glass panels that were commissioned for the windows of the Kelvyn Park High School library. Three were given by the midyear graduating class of 1933 and dedicated to the school principal "in gratitude and appreciation"; the other two were given by the June graduating class "to all leadership." Intricately crafted by Edgar Miller, an artist-craftsman skilled in many mediums, the panels employ the method familiar to many in European Gothic churches from the twelfth and thirteenth centuries, such as Chartres cathedral. Following the artist's pattern, different-colored glass is cut into predetermined shapes, set into a temporary framework, and painted and sometimes etched or scratched with the design. After being fired to make the paint permanent, the pieces of glass are inserted into deeply grooved precut strips of lead that are fastened together and fitted into an iron frame. Following the medieval tradition, Miller painted scenes of historical happenings chronologically arranged across the five panels, which evoke early manuscripts and the famous Bayeux Ta-

pestry that depicts the Norman conquest of England. The panels are a panorama of world history and exploration, illustrated with great leaders and warriors in scenes of action and conquest on land and sea: ancient Egyptians and Greeks; Roman and Ottoman Empires; Charlemagne, Frederick the Great, Peter the Great, and Napoleon; explorers Leif Eriksson, Amerigo Vespucci, Vasco da Gama, and Samuel de Champlain; Aristotle, Constantine, Joan of Arc, Augustus, Queen Elizabeth, Catherine the Great, Garibaldi, Jefferson, and Lincoln.

Kelvyn Park High School, one of five stained glass panels, detail. Courtesy of Larry Zgoda. Photograph by Larry Zgoda.

166 ➤ Wabash Avenue YMCA

African-American History, 1930s?

Wabash Avenue YMCA, 3763 South Wabash Avenue
Fresco secco
ARTIST: William Edouard Scott (1884–1964)

The Wabash YMCA was built in 1911–13 and served the needs of the black community in the Douglas/Grand Boulevard neighborhood during the influx of African Americans from the South, called "the Great Migration." Although it closed in the 1960s, it was put on the National Register of Historic Places in 1986, cited as the place where Carter G. Woodson, historian, author, and educator, originated the idea of Negro History Week in 1926, later expanded into Black History Month. The abandoned building was rescued from demolition in 1991 by a group of four local churches that formed the Renaissance Corporation with plans to turn it into low-income apartments and a recreational facility. The renovation will follow others in this historic Bronzeville district. Lack of heat and general neglect of the building for so many years caused severe damage to murals painted by William Edouard Scott, probably in the 1930s, depicting African American history. They were in very bad condition, and their survival was seriously threatened until it was announced that they would be restored. The date of the restoration depends on completion of structural repairs to the building. Scott was especially active in Chicago between 1935 and the 1950s, when he did a number of murals in Chicago churches, schools, and park fieldhouses. His other murals here are at Pilgrim Baptist Church, Davis Square Fieldhouse, Lane Tech, and Shoop and Wendell Phillips Schools.

➤ Wabash Avenue YMCA, *African-American History,* detail. Courtesy of Wabash Avenue YMCA Project, *Chicago Tribune* photograph by Ovie Carter.

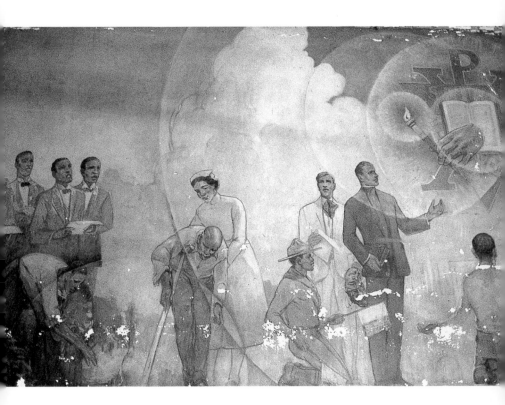

167 ▶ Skokie School

The Two Economic Means of Existence: Humanity, Industry and the Unity of Races, 1934

Skokie School, 520 Glendale Avenue, Winnetka
Fresco secco
ARTIST: Raymond Breinin (1910–2000)
COMMISSIONED BY: the Public Works of Art Project

In 1934 the Public Works of Art Project (PWAP), the short-lived relief program that preceded the WPA, sponsored a fresco mural for the Skokie School. Artists had been directed to paint the "American scene," but Raymond Breinin's mural, with its depictions of social upheaval and workers of different races standing arm in arm, was considered too "leftist" and the Board of Education deemed it unsuitable for schoolchildren. Clark Smith, in his 1965 M.A. dissertation on federally funded art in Chicago, pondered whether it was depictions of the "friendship of the races," the "slightly socialist scene of roaring industrial machines," or "the whole idea of 'humanity'" that was most offensive. The local school board found the figures of the workers to look "dejected and the atmosphere threatening," and the school was permitted to whitewash the wall at its own expense only a year after the mural was completed. All that is left is a small fragment, its paint faded and flaking, that has been hidden behind a storage cabinet all these years.

▶ Skokie School, Winnetka, *The Two Economic Means of Existence: Humanity, Industry, and the Unity of Races,* detail. Photograph by Mary L. Gray, mural commissioned by the Public Works of Art Project.

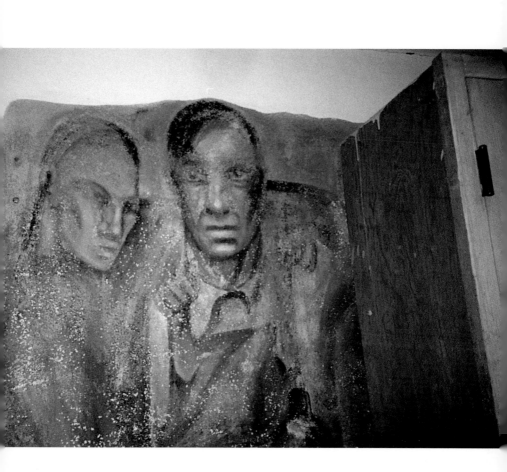

168 ▸ WGN Broadcasting Studio

Music in the Air, 1935

WGN Broadcasting Studio Two, Tribune Tower Building
435 North Michigan Avenue
Oil paint directly on wall
ARTIST: Raymond J. Schwab (1912–80) and Robert Bruce Tague (1912–)

In 1935 the *Chicago Tribune*'s radio station, WGN, built an addition adjacent to Tribune Tower to house its broadcasting studios. The newspaper chose the designers for each of four studios through a competition. Ernest Grunsfeld, architect of the Adler Planetarium, winner of the first prize, was awarded the design of Studio One. Two young postgraduate students at Armour Institute of Technology, which became Illinois Institute of Technology about 1941, were given honorable mention and awarded the design of Studio Two. Their submission included a mural titled *Music in the Air,* described in the *Chicago Tribune* as "studied planes done in vivid coloring, forming an excellent background." Its colors were reds, yellows, and greens, accented by black and white. Armour Institute architectural classes were held in the Art Institute building in the 1930s, and in 1935 Fernand Léger, who also submitted a design to the competition, had a one-man exhibition at the museum, which the students certainly saw. Raymond Schwab and Robert Tague were directed to enlarge their modernistic mural and paint it themselves on the east wall of Studio Two. A wide luminous frame that surrounded the mural provided a dramatic setting, with its lighting concealed behind special louvers. Further emphasis came from the modernistic touch of two bands of lighting strips that also provided illumination for the actors and musicians who used the studio. According to a 1947 article, Studio Two was replaced that year by new facilities for other broadcasting needs, and the mural disappeared.

▶ WGN Broadcasting Studio Two, *Music in the Air.* From the collection of Mrs. Raymond J. Schwab.

BUT NOT FORGOTTEN **375**

169 ► Gorton School Auditorium
Air, Water, Earth, and *Fire,* 1936

Edward F. Gorton School auditorium, 400 East Illinois Road, Lake Forest
Oil on canvas
ARTIST: Ralph Christian Henricksen (1907–73)
COMMISSIONED BY: the Works Progress Administration, Federal Art Project

Ralph Henricksen's four murals were commissioned by the WPA in 1936. At an unknown date they were covered with several layers of white paint, probably by unheeding painters, when the auditorium was given a fresh coat. An elementary school until 1972, the building now operates as the Gorton Community Center of Lake Forest and is in the midst of a capital campaign to raise money for remodeling. The Center is hoping to have funds to uncover the murals, which have been determined by conservator Barry Bauman to still exist under the paint.

► Gorton School, Lake Forest, auditorium, *Air, Water, Earth,* and *Fire.* From the collection of Robert J. Johnson, murals commissioned by the Works Progress Administration, Federal Art Project.

170 ▸ Manley School

Fall, Winter, and *Spring,* 1937

Hugh Manley Career and Preparatory School assembly hall, 2935 West Polk Street

Oil on canvas, three panels, 9'8" x 12'7" each

ARTIST: Gustaf Oscar Dalstrom (1893–1971)

COMMISSIONED BY: the Works Progress Administration, Federal Art Project

Three large murals, commissioned by the WPA for the assembly hall of the Manley School, were painted on canvas by Gustaf Dalstrom, a very active muralist in the Illinois Art Project. At the time of my visit, the murals were hidden under several layers of paint, and a workman was starting to give the walls another coat. When it was determined that the murals still existed and the astonished school principal was informed, the repainting was terminated. As this book was about to go to press, a plan to reveal and restore the murals was announced.

▸ Manley School, Gustaf Dalstrom and assistants painting *Fall, Winter,* and *Spring.* From the collection of Robert J. Johnson, mural commissioned by the Works Progress Administration, Federal Art Project.

BUT NOT FORGOTTEN

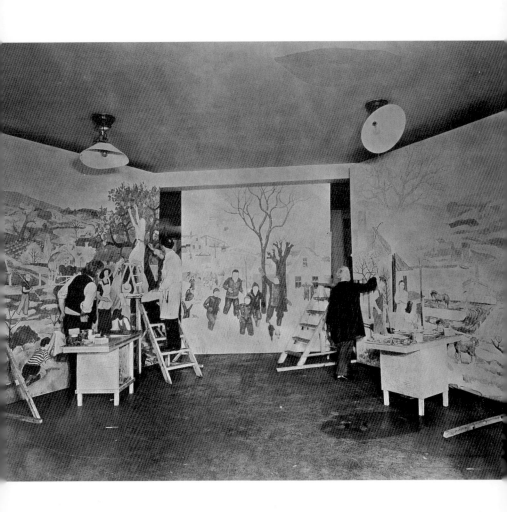

171 ▶ Hatch School

Map of the World and *Map of the Solar System,* 1938

William Hatch School, 100 North Ridgeland Avenue, Oak Park
Oil on canvas
ARTIST: Mildred Waltrip (1911–)
COMMISSIONED BY: the Works Progress Administration, Federal Art Project

A controversy arose in 1995 about the depiction of racial stereotypes in two of the four murals commissioned by the WPA in 1938 for the Hatch School in Oak Park. Painted by Mildred Waltrip, the murals were considered offensive by a group of parents and students who believed they reinforced a negative image. Although removed with care by a professional conservator, the murals lost some paint and are now in storage. Reflecting the ideas of the time, the murals might have been labeled as such and used in the school curriculum to illustrate historical attitudes. "Sensitivity colliding with censorship," commented David Sokol, an Oak Park resident and a professor at the University of Illinois at Chicago. The other two murals, illustrating farmers, steelworkers, cowboys, Native Americans, and Eskimos and titled *American Characters,* remain on the school walls and are scheduled to be restored.

▶ Hatch School, Oak Park, *Map of the World,* detail, one of four panels. From the collection of Barbara Bernstein, murals commissioned by the Works Progress Administration, Federal Art Project.

172 ► Hirsch High School

Rodeo, Circus, Stock Show, and *Amusement Park,* 1936, 1938, and 1940

Emil G. Hirsch Metropolitan High School cafeteria, 7740 South Ingleside Avenue
Oil on canvas, four panels: one 9' x 22', three smaller
ARTIST: Camille Andrene Kauffman (1905–93)
COMMISSIONED BY: the Works Progress Administration, Federal Art Project

There were four murals commissioned by the WPA for the cafeteria of the Hirsch School that are no longer visible. The largest one was *Circus*. Although they have been painted over, ripples on the walls show that the murals, painted on canvas, may still be revealed by restoration.

► Hirsch High School, Andrene Kauffman at work on *Circus,* one of four panels. From the collection of Robert J. Johnson, murals commissioned by the Works Progress Administration, Federal Art Project.

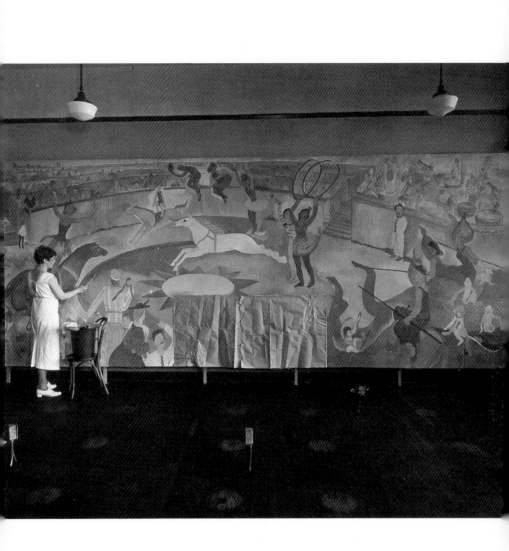

173 ➤ Chestnut Street Post Office
Advent of the Pioneers, 1851, 1938

Chestnut Street Post Office, 830 North Clark Street
Oil on canvas, 5' x 15'
ARTIST: Frances Foy (1890–1963)
COMMISSIONED BY: the Treasury Section of Fine Arts

Frances Foy's was one of two murals commissioned by the Treasury Section for this post office. Both murals were removed when the building was converted to a movie theater in the 1980s. The companion piece, titled *Great Indian Council, Chicago—1833,* by Foy's husband, Gustaf Dalstrom, was relocated to the Loop Station Post Office on South Clark Street (see Central Area, number 25), but Foy's mural disappeared from view. Just before publication I made the surprising discovery of the Foy mural in a storage warehouse and learned that both murals will be restored and hung together in a special historical display at the Main Post Office, 433 West Harrison.

➤ Chestnut Street Post Office, *Advent of the Pioneers, 1851,* detail. Photograph by Barbara Bernstein, mural commissioned by the Treasury Section of Fine Arts.

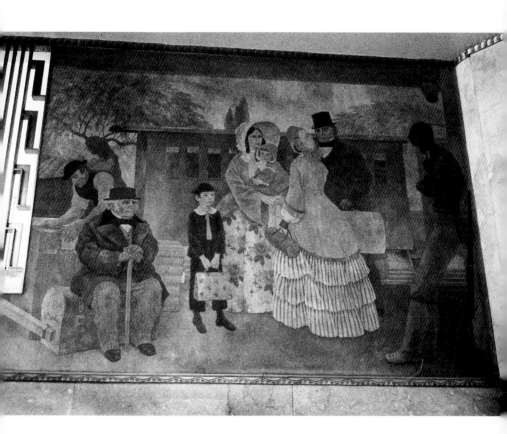

Zoo, Fort Dearborn, Museums, and *Stockyards and Industry,* 1940

Cook County Hospital, Inside main entrance around second-floor balcony
1835 West Harrison Street
Oil on canvas, four panels
ARTIST: Edwin Boyd Johnson (1904–)
COMMISSIONED BY: the Works Progress Administration, Federal Art Project

Orange Harvesting and *Banana Harvesting,* 1940

Cook County Hospital, Reception room and recreation room
1835 West Harrison Street
Egg tempera on gesso, two panels 4' x 14'
ARTIST: Henry Simon (1901–95)
COMMISSIONED BY: the Works Progress Administration, Federal Art Project

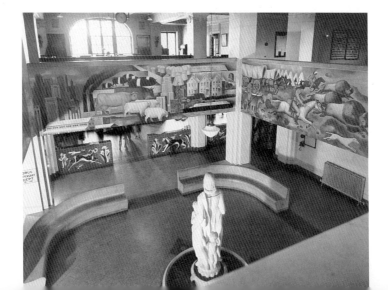

In 1939–40 the WPA received $10,000 to be used for remodeling and decorating the main front entrance, children's wards, and other areas of Cook County Hospital. The project employed a number of WPA mural artists including Frances Badger, Rainey Bennett, Roberta Elvis, Edwin B. Johnson, Camille Andrene Kauffman, Henry Simon, Ethel Spears, Mildred Waltrip, and Lucille Ward. In 1975 and subsequent years, during renovations of the hospital, all the artwork disappeared. As far as we know, nothing was salvaged. Illustrated here are a few of the many works that were created for the hospital. Johnson's four murals were mounted on the walls of the second-floor level of the atrium-like main entrance. In the center of the room was a small stone fountain with figural sculpture by Charles Umlauf.

His depictions of workers in North and South America harvesting oranges and bananas were Simon's first mural commission. Although the rather tropical scenes seem inappropriate for a Chicago hospital, they may be references to the Pan-American unity promoted by the Roosevelt administration and also to the influence of the Mexican mural movement on the muralists working for the WPA.

Cook County Hospital: ◄ (a) inside main entrance, *Zoo, Fort Dearborn, Museums,* and *Stockyards and Industry,* two of four panels; ▲ (b) social welfare room, *Orange Harvesting,* one of two panels; ▲ (c) social welfare room, *Banana Harvesting,* one of two panels. (a) From the collection of Barbara Bernstein; (b and c) from the collection of Norbert and David Simon; murals commissioned by the Works Progress Administration, Federal Art Project.

175 ➤ Museum of Science and Industry
The Story of Steel, 1940s

Museum of Science and Industry, Fifty-seventh Street and Lake Shore Drive
Oil on canvas, four panels
ARTIST: Edward Trumbull (1884–1968)
COMMISSIONED AND FUNDED BY: the Inland Steel Company

Dramatic murals on all four walls of an entrance hall introduced visitors to the new iron and steel exhibit at the Museum of Science and Industry installed in the 1940s, telling the story of steel and its manufacture. The murals were commissioned and donated to the museum by the Inland Steel Company. As advances in technology rendered the exhibit out of date, and with the decline of the steel industry in the 1960s, the museum replaced it, obscuring the murals behind false walls. The rediscovery, and with it a new appreciation for the excellence of these paintings, came in 1998 when the space was again in demand. This time the walls that the murals were mounted on were slated for demolition. Although the murals, painted in oil on canvas, had suffered badly from vandalism and exposure to moisture, a professional conservator was able to remove two of the four. The museum hopes to have them restored and remounted in new locations. The mural titled *How Steel Is Made* shows the mills, where men work with blast furnaces, move large vats of molten steel emitting fiery vapors, observe the process from upper levels, and supervise the heavy machinery turning out massive rolls of steel. Pictured in *Man's Uses of Steel* are a steamship, an automobile, an airplane, holding tanks, beams and girders, a soaring bridge, and construction workers, examples of the significance of steel to modern man. Edward Trumbull has heightened the drama of his depictions, which combine many activities in each composition, by his use of vivid colors and suggestion of motion through the patterns of swirling clouds and steam that form the backgrounds. The artist worked in Pittsburgh and New York and was director of color for Rockefeller Center during its construction in the 1930s.

Museum of Science and Industry, *The Story of Steel*, color lithographic reproductions; (a) *How Steel Is Made;* (b) *Man's Uses of Steel.* Photographs by Joe Ziolowski, courtesy of the Museum of Science and Industry, Chicago.

Addendum

Addendum

These six murals came to my attention just as the guide was about to go to press. They represent both the old and the new.

176 ▶ Lemont Post Office

Canal Boats, 1938

Lemont Post Office, 42 Stephen Street, Lemont
Oil on canvas, 5'2" x 13'2"
ARTIST: Charles Turzak (1899–1986)
COMMISSIONED BY: the Treasury Section of Fine Arts

For Lemont's post office, Charles Turzak painted a historical scene of two flatboats traveling along the Illinois and Michigan Canal, which runs through the town. The boat in front is being poled by a muscular young man. A woman in bonnet and old-fashioned long dress, with her child on her lap and a bundle by her side, sits on the second boat, which is being towed by a horse walking on the banks of the canal. Murals depicting the "American scene," with an emphasis on regional and small-town life, were favored by New Deal federal art programs. Correspondence between the artist and Edward Rowan, superintendent of painting and sculpture of the Treasury Section, which commissioned the mural in 1938, indicates that artists did have to submit to a certain amount of direction. Turzak's first sketch, a factory scene with male workers, was rejected as "too one-sided," and he was asked to represent a greater "cross section of the community." He adapted the canal scene from one of a series of thirty-six woodcuts, *Abraham Lincoln—Biography in Woodcuts,* that he had done five years earlier. The mother and child in the mural comply with the restrictions placed on almost all New Deal art, that is, to avoid any suggestion of the sexual in representing females. Women are generally depicted as wives, mothers, and allegorical figures. On this subject of gender in New Deal public art, in *Engendering Culture* Barbara Melosh writes that "public art was likely to efface women entirely in favor of heroic male figures," so that the objection to Turzak's first sketch reflects an effort to redress this inequity. Federal administrators were eager to introduce the general public into the "privileged dis-

course of art" but believed that "the untutored spectator saw a naked body on the canvas and read it as erotic, unlike the schooled spectator more likely to suppress the sexual association of the female body in favor of responding aesthetically." Records show that the artist was paid $620.

Lemont Post Office, *Canal Boats,* detail. Photograph by Gentle Impressions, Lemont, courtesy of the U.S. Postal Service, mural commissioned by the Treasury Section of Fine Arts.

177 ► Field Museum
The Story of Food Plants, 1938-40

Field Museum, "Plants of the World" exhibit, second floor
Lake Shore Drive at Roosevelt Road
Oil on canvas, eighteen panels, 7' x 9' each
ARTIST: Julius Moessel (1871–1957)
COMMISSIONED BY: the Works Progress Administration, Federal Art Project

The eighteen murals commissioned by the Federal Art Project of the Works Progress Administration for the Field Museum were called "a high water mark in WPA art achievement" by the head of the Chicago WPA office. Critics hailed the murals as "works that wedded science and art" and called them one of the "imperative 'not-to-be-missed' affairs" of the season. They remain today on the second floor of the museum, in the exhibit called "Plants of the World." Described fully in Mark Alvey's article in the May–June 1999 issue of *In the Field,* the museum's membership publication, the murals were envisioned as an "illustrative adjunct" to the displays in the Hall of Food Plants. Under the supervision of the museum's curator of botany and with the museum's extensive resources for research, the German-born artist Julius Moessel spent two and a half years creating detailed depictions of agricultural practices in many regions throughout the world. The series of murals includes two large maps that trace the origins of plants and ancient trade routes. In the narrative scenes are early man as hunter-gatherer in western Asia, pod gathering in New Guinea, Indians harvesting corn in Mexico, rice growing in the Philippines, a colonial coffee plantation in Brazil, a primitive olive press in northern Africa, a caravan north of the Persian Gulf, and plowing and sowing in the United States, among others. Illustrated here is a twentieth-century

ADDENDUM

American scene titled *A Wholesale Vegetable Market,* in which a horse-drawn wagon, still used in the 1930s, enters the modern city of large trucks, ships, warehouses, and tall buildings.

Field Museum, Julius Moessel, *A Wholesale Vegetable Market,* one of eighteen panels. Photograph by Ron Testa, courtesy of the Field Museum, #BF9545c.

178 ➤ Chicago Main Post Office
Mural Maps, 1937

Chicago Main Post Office, Canal and Van Buren Streets
Oil on canvas, waxed
ARTIST: Charles Turzak (1899–1986)
COMMISSIONED BY: the Treasury Relief Art Project

Late in 1999 a set of murals were rediscovered at the former Chicago Main Of-
fice, long hidden under layers of paint. They were thought to be missing, but
through the persistence of Bob Sideman, a dedicated Chicago preservationist who
called in a conservator, a partial removal of paint revealed the presence of at least
one mural. No longer functioning as a post office, the building was being con-
verted into residential condominiums at this time, and the walls the murals were
mounted on were to be demolished. Because they were painted on canvas, how-
ever, they could probably be removed and restored. They were commissioned dur-
ing the New Deal by the Treasury Relief Art Project (TRAP) to decorate the offices
of General McCoy, head of the Sixth Army Corps, whose headquarters occupied
parts of three floors of the post office. According to Treasury Department docu-
ments, twenty-six separate panels were to be painted, the subject matter being
symbols that related to the army and maps of the regions under the general's com-
mand. Historic maps of Illinois, Wisconsin, and Michigan were embellished with
images of forts, early explorers, and explorations in the Great Lakes area, Native
American settlements, early Chicago scenes, and weapons and military para-
phernalia. The illustration here is a detail from a study for one of the murals, a plat
map of Chicago in 1830 showing Fort Dearborn, with Marquette and Joliet visit-
ing the Illinois Nation. Because it is merely a study, the misspelled word
Dearbo[r]n would have been corrected in the finished work.

Chicago Main Post Office, study for *Mural Maps,* detail. Courtesy of the National Archives and Records Administration, mural commissioned by the Treasury Relief Art Project.

179 ▶ Marcos Raya Studio
Cataclysm, 1994-95

Marcos Raya Studio, 1031 West Nineteenth Street
Acrylic on canvas, 8' x 20'
ARTIST: Marcos Raya (1948–)

Cataclysm was painted for the 1997 Historical Society exhibition titled *Pilsen/Little Village: Our Home, Our Struggle.* It was shown again at a one-man exhibition at the Chicago Cultural Center in February 2000. *Cataclysm,* defined as "political or social upheaval," reflects Marcos Raya's particular concern for the Pilsen neighborhood where he lives, which he has called "a place of struggle." One of the largest Mexican communities in the country, its residents have worked for decades to achieve political representation, educational reform, and workers' rights, just as earlier Eastern European residents of the neighborhood did at the turn of the century. Today Pilsen is also known for its artistic traditions, especially the colorful murals that appear on the facades of many of the buildings. Home to many artists, this working-class neighborhood now faces gentrification and the expulsion of the poor, and this is one of Raya's concerns. He sees the transformation of Chicago and urban renewal as a danger to Pilsen while recognizing that this is happening all over the country. The centerpiece of the mural is a stylized Statue of Liberty, part woman and part machine. She is giving birth to a duality: technology for the good of mankind and instruments of war for its destruction. On the left side of the mural, men in gas masks, guns, soldiers, police, and a young black man wearing a prison number loom out of the cityscape that represents "the haves and the have-nots": new skyscrapers of glass, highways, industries and power plants, and rundown structures stand near the elevated train. A figure of Mickey Mouse, who has become a Chicano emblem and is now christened "Migra Mouse," symbolizes California's Proposition 187, the anti-immigration legislation that Disney supported. On the right side of the mural the artist has depicted what

ADDENDUM

he calls "the frenzy of the minorities." Familiar Pilsen structures appear with representations of people struggling, children, rallies, workers, and a nude pregnant woman, to signify the problem of teenage pregnancies in the community. Raya, who has described his art as "on the dark side of the street," paints in the tradition of José Clemente Orozco and the Mexican muralists, dramatizing the ills of his own community.

Marcos Raya and his mural *Cataclysm*. Photograph by Ron Gordon, courtesy of Marcos Raya.

180 ► Erie Terraces
Rora, 1999

Erie Terraces, Erie Street and the Chicago River
Venetian glass mosaics, three segments
ARTIST: Ginny Sykes (1957–)
COMMISSIONED BY: the Chicago Public Art Program

Artist Ginny Sykes named her mosaic mural project *Rora,* the Potawatami word meaning the confluence of things. It is "the place where the north and south branches of the Chicago River converge, where the prairie met the lake, where the west met the east, where biology met the machine," wrote artist and independent curator José Andreu of the work. A very personal vision, *Rora* consists of three mosaic segments that embellish the Erie Terraces, a new bilevel, award-winning waterfront park and lookout point perched above the river. Two horizontal mosaic elements flank the stairway that leads to the lower level, where a tondo-shaped mosaic composition is set into the wall. The forms depicted on the horizontal panels of the upper level refer to indigenous flora along the river and cycles of growth and change, from the Ice Age to the present. On the tondo below is an abstraction of the city, with a suggestion of high-rises, bridges, and other urban elements and a river running through, reminders of the present city. Andreu called *Rora* "a cameo necklace for the queen of cities. The ribbon is a time sequence showing native flora; the cameo is the pearl of the lake."

──────────

► Erie Terraces, *Rora,* one of three mosaic panels. Photograph by Patrick Linehan, courtesy of Ginny Sykes.

181 ➤ The Wall of Respect

The Wall of Respect, 1967

Forty-third Street and Langley Avenue
Building demolished spring 1971 (after fire damage)
House paint on brick and Masonite or cardboard panels
DEDICATED: August 27, 1967
ARTISTS: William Walker (1927–) with Eugene Eda, Sylvia Abernathy, Eliot Hunter,
Jeff Donaldson, Myrna Weaver, Edward Christmas, Darryl Colror, Florence Hawkins,
Will Hancock, Wadsworth Jarrell, Barbara Jones, Roy Lewis, Norman Parish, Wyatt T. Walker,
Carolyn Lawrence, Billy Abernathy Jr., Bobby Sengstacke, Curley Elison, and
Leonore Franklin

"When it comes to art on the wall of Chicago streets, the work of William Walker springs to mind He's the one the others point to," said Studs Terkel in his book *Chicago* (quoted in Victor Sorell's *Images of Conscience: The Art of Bill Walker*). *The Wall of Respect* is considered the beginning of the contemporary mural movement in Chicago. Without it, art historian Edmund Barry Gaither said, "American art wouldn't have regained a sense of social consciousness." William Walker was involved in its conception and creation with members of OBAC (Organization for Black American Culture), which also included writers, musicians, and educators, and the Forty-third Street Community Organization. OBAC determined the theme of black heroes, and Walker directed about twenty artists working together on the wall of a semiabandoned two-story building, painting directly on the brick or on Masonite or cardboard panels that were attached to the wall. As Eva Cockcroft and her coauthors wrote, "It was not exactly a mural nor was it simply a gallery . . . but was meant to use art publicly to express the experience of a people" (*Toward a People's Art*). Addressed to the community, its caption read: "This Wall Was Created to Honor Our Black Heroes and to Beautify Our Community." There were portraits of leaders in politics, religion, literature, music, and

sports that were continually reworked and sometimes replaced over the first summer. At one time or another likenesses of Muhammad Ali, Wilt Chamberlain, LeRoi Jones, Gwendolyn Brooks, H. Rap Brown, Stokely Carmichael, John Coltrane, Marcus Garvey, W. E. B. Du Bois, Frederick Douglass, Martin Luther King Jr., Malcolm X, Thelonius Monk, Elijah Muhammad, Charlie Bird Parker, Nina Simone, Harriet Tubman, and Nat Turner appeared on the wall. Its creation was considered a reaction to racial unrest across the country, and it provoked a great deal of controversy that some believe led to its eventual destruction. The wall became a social gathering place and a tourist attraction. There were poetry readings and music and dance performances, but there was also a civil rights rally when the police were called in. It brought both unity and division to the community. By the time of its demise in 1971, however, "it had sparked a whole movement" that spread to the rest of the country, said community leader Margaret Burroughs. A fragment, one of several believed to have survived, was shown in the 1997 exhibition *Art in Chicago, 1945–95,* at the Museum of Contemporary Art and afterward given to the Du Sable Museum by Victor Sorell of Chicago State University.

Forty-third and Langley Avenue, *The Wall of Respect.* Photograph © 1967, Robert A. Sengstacke.

APPENDIX 1 Other Missing Murals

World's Columbian Exposition (1893)
Manufacturers and Liberal Arts Building
Landing of Columbus and *Columbus before Ferdinand and Isabella,* mosaics
Moved to Columbus Memorial Building,
Washington and State Streets, in 1894;
believed to be in storage in Milwaukee

World's Columbian Exposition (1893)
Manufacturers and Liberal Arts Building
North dome, Edwin Howland Blashfield
Two tympana in northeast corner, Lawrence
Carmichael Earle

First National Bank (1905)
38 South Dearborn Street
(at Monroe Street)
Use and Misuse of Money, panels and
ceiling murals, Oliver Dennett Grover

Congress Hotel Lobby (date unknown)
504 South Michigan Avenue
Industry in Illinois, Louis Grell

LaSalle Hotel (1912–13)
LaSalle and Madison Streets
Four decorative medallions above dining
room doors, John Warner Norton

**Palmer House Hilton, the Chicago Room
(1926)**
102-29 South State Street
Skyscrapers, William Welsh

**Sherman Hotel, the Celtic Room
(date unknown)**
Randolph and Clark Streets
Sing a Song of Sixpence, Maxfield Parrish

McKinley School (date unknown)
North Hoyne Avenue and Adams Street
Painting, Music, Architecture, Sculpture,
and *Science,* five lunettes, John Warner
Norton

Century of Progress Exposition (1933–34)
General Exhibits Building
Paint, Powder, and Jewels,
George Melville Smith
Machine Movement, Rudolph Weisenborn
Business, Machines, People, A. Raymond
Katz

Century of Progress Exposition (1933–34)
Hall of Science, Trustees' Room
Columbian Exposition, Frances Badger
History of Applied and Technical Science,
John Warner Norton

Century of Progress Exposition (1933–34)
Sears Roebuck Building
Constellations, Nicolai Remisoff

Century of Progress Exposition (1933–34)
Hall of Social Science
Man and the Social Sciences, Dorothy Loeb

Century of Progress Exposition (1933–34)
Travel and Transport Building
History of Rock Island Railroad, Edgar Miller
(All buildings demolished at end of fair)

Frederick William Nichols School (1936)
800 Greenleaf Street, Evanston
Negro Children, Archibald Motley Jr.
WPA mural, may be under corkboard

Crane Technical High School (1937)
2245 West Jackson Boulevard
Boilermakers, Pipe Fitters, Architects,
Rudolph Weisenborn
WPA mural

Edward Tilden Technical High School (1937)
4747 South Union Avenue
Steel Mill, Merlin Pollock
WPA mural, room remodeled

Chez Paree (date unknown)
10 North Fairbanks Court
Dances of the Nation, A. Raymond Katz

Cook County Juvenile Detention Home (1937)
Ogden Avenue and Roosevelt Road
Outdoor Landscape with Figures and
Recreation, Frances Badger
WPA murals

George Cleveland Hall Branch Library
(1940–41)
4801 South Michigan Avenue
Fight for Freedom, Charles White
WPA mural

Riccardo's Restaurant (1947)
437 North Rush Street
Seven murals titled *The Lively Arts*
Drama, Ivan Albright; *Literature*, Rudolph
Weisenborn; *Painting*, Vincent D'Agostino;
Architecture, Aaron Bohrod; *Music*, William
Schwartz; *Sculpture*, Malvin Albright;
Dance, Ric Riccardo
Restaurant sold and murals dispersed

Loop Synagogue (1955)
16 South Clark Street
The Ten Commandments, A. Raymond Katz
Destroyed by fire

APPENDIX 2 Public Schools with Extant Murals

Schools with asterisks are included in the guide

Chicago Public Schools with Extant WPA Murals

Newton Bateman School
4214 North Richmond Street
Characters from Children's Literature,
unsigned, 1938; *Decorative Landscape,*
Florian Durzynski, 1940

Hyram H. Belding School
4257 North Tripp Avenue
Children's Activities, Roberta Elvis, 1938

Frank I. Bennett School*
10115 South Prairie Avenue
History of Books, Gustaf Oscar Dalstrom,
1936–37; *Children's Subjects,* Grace Spong-
berg, 1940

Luther Burbank School*
2035 North Mobile Avenue
Circus, Camille Andrene Kauffman, 1938
Incidents in the Life of Luther Burbank,
Camille Andrene Kauffman, 1937

Frederic Chopin School*
2440 West Rice Street
Frederic Chopin and *Steven Foster,* Florian
Durzynski, 1940

Walter S. Christopher School*
5042 South Artesian Avenue
Characters from Children's Literature,
Arthur Herschel Lidov, 1939

Henry R. Clissold School
2350 West 110th Place
Historical Periods, Thomas Jefferson
League, 1938

Arthur Dixon School
8306 South St. Lawrence Avenue
Winter and *Summer,* Mary C. Hauge, 1937

Laughlin Falconer School
3000 North Lamon Avenue
Landscape with Children, Florian Durzynski,
1940

Lucy Flower High School*
3545 West Fulton Boulevard
Outstanding American Women, Edward
Millman, 1940

Joseph E. Gary School*
3740 West Thirty-first Street
Characters from Fairy Tales, unsigned
(probably Roberta Elvis), 1940s

John Harvard School
7525 South Harvard Avenue
Spring and *Fall,* Florian Durzynski, 1939

Julia Ward Howe School
720 North Lorel Avenue
Landscape, unsigned (probably Florian
Durzynski), 1938

Alfred D. Kohn School
10414 South State Street
Covered Wagon and *Indians,* unsigned,
1939

Charles Kozminski School
936 West Fifty-fourth Street
Scenes of Children, Ethel Spears, 1939–42

Albert G. Lane Technical High School*
2501 West Addison Street
Indian Motif, John Edwin Walley, 1936 or
1937; *Epochs in the History of Man,* Edgar E.
Britton, 1937; *Robin Hood,* Thomas Jeffer-
son League, 1937; *Native American Theme,*
Thomas Jefferson League, 1943; *The Teach-
ing of the Arts,* Mitchell Siporin, 1938

Carl von Linné School*
3221 North Sacramento Avenue
The Life of Carl von Linné, Ethel Spears,
1939–40

Horace Mann School*
8050 South Chappel Avenue
Life of Horace Mann, Ralph Christian Hen-
ricksen, 1937

Roswell B. Mason School
4217 West Eighteenth Street
Spring and *Fall,* Grace Spongberg, 1939

Francis M. McKay School
6901 South Fairfield Avenue
Decorative Landscape, unsigned (probably
Florian Durzynski), 1938

Donald L. Morrill School
6011 South Rockwell Street
Children's Activities, Lucille Ward, 1938

Wolfgang Amadeus Mozart School*
220 North Hamlin Avenue
Mozart at the Court of Maria Theresa, 1762,
Elizabeth Gibson, 1937; *Michelangelo in the
Medici Gardens, 1490,* Helen Finch, 1937;
Characters from Children's Literature,
Charles Freeman, 1937

Louis Nettelhorst School*
3252 North Broadway
Contemporary Chicago, Rudolph Weisen-
born, 1939; *Horses from Literature,* Ethel
Spears, 1940

Luke O'Toole School
6550 South Seeley Avenue
Characters from Children's Literature, unsigned (probably Otto Hake), 1940

Cecil A. Partee School (formerly Hookway)
8101 South LaSalle Street
History of the New World, Ralph Christian Henricksen, 1940
Scenes of Chicago, Ralph Christian Henricksen, 1940

Louis Pasteur School
5825 South Kostner Avenue
A, B, Cs, Lucille Ward, 1937

William Penn School
1616 South Avers Street
Explorers, Settlers, William Penn and *City of the Future,* unsigned, 1940

Martin A. Ryerson School
640 North Lawndale Avenue
Discovery of America, Irene Bianucci, 1940

Sidney Sawyer School*
5248 South Sawyer Avenue
History of Chicago, Lucille Ward, 1940

Franz Schubert School
2727 North Long Avenue
The Life of Schubert and *The Erlking (Erlkönig),* George Melville Smith, 1938

Harold Washington School (formerly Perry)
9130 South University Avenue
The Four Seasons, Mary C. Hauge, 1940–41

William Wells High School*
936 North Ashland Avenue
The Founding of McKendree College, Lebanon, Illinois, Henry Simon, 1941

Daniel S. Wentworth School
6950 South Sangamon Street
American Youth, Florian Durzynski, 1937

West Pullman School*
11941 South Parnell Avenue
Americanization of Immigrants, Ralph Christian Henricksen, 1940

Chicago Public Schools with Extant Murals Predating the WPA

George B. Armstrong School*
2111 West Estes Avenue
Fairies, Marion Mahony Griffin, 1938–39

Joseph E. Gary School*
3740 West Thirty-first Street
Scenes from Chicago History, Philip Ayer Sawyer, 1915

Frederick L. Jahn School
3149 North Wolcott Avenue
Indians, Traders and Pioneers, unsigned,
date unknown
The History of Writing, Harry Lawrence
Gage, 1909

Lakeview School
4015 North Ashland Avenue
Thirteen tondo portraits, unsigned, date
unknown

Albert G. Lane Technical High School*
2501 West Addison Street
Steel Mill, Margaret A. Hittle, 1909–10;
Construction Site, Gordon Stevenson,
1909–10; *Dock Scene,* William Edouard
Scott, 1909–10; *Hiawatha Murals,* Henry
George Brandt, 1913; *The Forty-eight
States,* Miklos Gaspar, Axel Linus, and T. C.
Wick, 1933

Lincoln Park High School (formerly Waller)
2001 North Orchard Street
Progress in Education, signature
indecipherable, 1936

Carl von Linné School*
3221 North Sacramento Avenue
Pioneers and Indians, Datus E. Myers, 1910

Parkside School
6938 South East End Avenue
Patriotism and *Service,* unsigned (probably
Herbert C. Ropp), date unknown
Illinois History, James Edward McBurney,
1927

Helen C. Peirce School*
1423 West Bryn Mawr Avenue
Twelve Months of the Year, John Warner
Norton, 1924–25

Wendell Phillips School
244 East Pershing Road
Historical subjects, four murals, one signed
by Dudley Crafts Watson, 1906

Carl Schurz High School*
3601 North Milwaukee Avenue
The Development of the Written Word and
The Spirit of Chicago, Gustave A. Brand and
students, 1940

John D. Shoop School
1460 West 112th Street
Greeting of Frederick Douglass and *Jean
Baptiste du Sable Visits Fort Dearborn,*
William Edouard Scott, 1930s

John M. Smyth School*
1059 West Thirteenth Street
Scenes from American History, S. B. Braid-
wood, Roy S. Hambleton, Dorothy Loeb,
Paul Turner Sargent, Gordon Stevenson,
and G. Werveke, 1910

Leander Stone School
6239 North Leavitt Street
Puss in Boots and *Old King Cole,* students
and parents, 1929?

Mancel Talcott School
1840 West Ohio Street
The Pied Piper, Alson S. Clark, date
unknown

Edward Tilden Technical High School[*]
4747 South Union Avenue
Themes of Architecture and Engineering
and *Great Men in History,* James Edward
McBurney, 1931–44

George W. Tilton School
233 North Keeler Avenue
Pilgrims, Columbus, and *William Penn,*
Janet Scott, date unknown

Daniel S. Wentworth School[*]
6950 South Sangamon Street
King Arthur and *King Arthur Meeting Lady
Gwenevere,* Norman Philip Hall, 1904
*The Lives of Daniel S. Wentworth and Abra-
ham Lincoln,* James Edward McBurney,
1927–28

Suburban and Outlying Public
Schools with Extant WPA Murals

Bloom Township High School[*]
Tenth Street and Dixie Highway,
Chicago Heights
Occupational Studies and Their Application,
Edgar E. Britton, 1936

J. Robb Harper School[*]
Dartmouth and Greenwood Streets,
Wilmette
Gardening and *Farming,* Gustaf Oscar Dal-
strom, 1936 and 1938

William Hatch School
100 North Ridgeland Avenue, Oak Park
American Characters, Mildred Waltrip, 1938

Haven Middle School
2417 Prairie Avenue, Evanston
Untitled historical mural, Carl Scheffler, 1936
Untitled landscape, unsigned, undated

Highland Park High School[*]
433 Vine Avenue, Highland Park
Scenes of Industry, Edgar E. Britton, ca. 1934

**Percy Julian Junior High School (formerly
Hawthorne)**[*]
820 South Ridgeland Avenue, Oak Park
Western Movement across USA and *Pioneer
Farmers in Our Northern Middle West
States,* Karl Kelpe, 1936

Horace Mann School
921 North Kenilworth Avenue, Oak Park
Community Life of Oak Park, 1850–1880,
Emmanuel Jacobson, 1936

New Trier High School
385 Winnetka Avenue, Winnetka
Music, unsigned, 1937

Oak Terrace School
240 Prairie Avenue, Highwood
The Children's Hour, Miklos Gaspar and
J. Maybra Kilpatrick, 1947

Oakton School*
436 Ridge Avenue, Evanston
*The Legend of Charlemagne, or Knights and
Damsels,* unsigned, date unknown

Ravinia School*
763 Dean Avenue, Highland Park
Robin Hood, unsigned (attributed to Mil-
dred Waltrip), 1940

Suburban and Outlying
Public Schools with Extant
Murals Predating the WPA

East Lake School*
121 East Sheridan Place, Lake Bluff
The Meeting of Marquette and Joliet,
Marguerite Kreutzberg, 1926

Frederick William Nichols School*
800 East Greenleaf Street, Evanston
Colonial Scenes, unsigned, date unknown
The Grand Canal, Jacques-Marie-Omer
Camoreyt, 1929

Biographies of Artists

Where dates are missing, I was not able to obtain them.

Christian Aasgaard (1922–99) Christian Aasgaard was a student at Lane Technical High School. He painted one of the WPA murals there from a design by Thomas Jefferson League, who was an art instructor at the school.

John Abrams A graduate of Ontario College of Art, John Abrams lives in Toronto, Canada, where he has completed several murals. His Sister Cities International Program mural at O'Hare International Airport, painted in shades of gray, is called *Cindy Crawford and the Moon.*

Marcus Akinlana (1966–) Marcus Akinlana, originally Mark Jefferson, was born in Washington, D.C., and has also lived in New Orleans and Chicago. The work of muralist William Walker and the Chicago Mural Group attracted him to the city, and he graduated from the School of the Art Institute of Chicago in 1988. He has traced his lineage to the Yoruba people of Benin and Nigeria and often employs African imagery and mythology in his work. With his wife, Fatu, he runs two companies that market his paintings, prints, and greeting cards, which makes possible his many public art projects in Chicago. His murals are at the Elliott Donnelley Center, at the Harold Washington Library, and in South Shore.

Olga Antonenko (1963–) Olga Antonenko was born in Kiev, Ukraine, and graduated from the Kiev Architectural Institute. She created wall paintings in the town of Pereyaslav-Khmelnitski, painted twenty murals in the city of Kiev, and exhibited her work in Basel, Switzerland. Her Sister Cities International Program mural at O'Hare International Airport, called *Spring in Chicago,* evokes the work of the Russian-born French painter Marc Chagall.

Richard Fayerweather Babcock (1887–1954) Born in Denmark, Iowa, Richard Fayerweather Babcock studied at the School of the Art Institute of Chicago, at the Herron Art Institute of Indianapolis, and in Munich, Germany. He lived in Evanston and taught at the Chicago Academy of Fine Arts and the School of the Art Institute, where he had several one-man exhibitions. He also worked as an illustrator for *Encyclopaedia Britannica,* specializing in natural history subjects. His WPA mural is at the Legler Library.

Frances Badger (1904–97) Frances Badger was born in Kenilworth, Illinois, and was educated at the Roycemore School and the School of the Art Institute, where she studied mural painting with John Warner Norton and graduated in 1925. She also attended the University of Chicago and Northwestern University. She was president of the Chicago Society of Artists, and she taught for many years at Roycemore and the Old Town School of Art. She executed a mural for the Hall of Science at Chicago's 1933 Century of Progress Exposition and was active in the WPA's Illinois Art Project. Her commissions also included Cook County Hospital and the Cook County Juvenile Detention Home, Joliet Township High School, and Stevenson Playground in Oak Park. The playground fieldhouse was demolished, and the murals are preserved at the Oak Park Historical Society.

Martha Susan Baker (1871–1911) Martha Susan Baker was born in Evansville, Indiana. She studied and later taught at the School of the Art Institute of Chicago, where her work was shown. Specializing in portraits and miniatures, she won first prize at the 1897 Arche Salon exhibition in Chicago and was awarded a bronze medal for her work at the 1904 St. Louis Exposition. Her mural is in the Fine Arts Building.

Frederic Clay Bartlett (1873–1953) Frederic Clay Bartlett was born in Chicago and became a successful painter, muralist, and decorator. He is even better known as donor of the Art Institute of Chicago's famous *Sunday Afternoon on the Island of La Grande Jatte* by Georges Seurat and for his involvement in the cultural life of the city as a collector and philanthropist. The "miles and miles of pictures" he saw at Chicago's 1893 World's Columbian Exposition inspired him to visit Europe and study at the Royal Academy in Munich. He also studied in Paris, where he came into contact with James Abbott McNeill Whistler and Pierre Puvis de Chavannes, whose murals awakened his interest in mural painting. His murals are

in Bartlett Gymnasium at the University of Chicago, the University Club, and Second Presbyterian Church. Others done for McKinley High School and the council chamber at City Hall were destroyed, and two lunettes at the Art Institute of Chicago Library are no longer visible.

Rainey Bennett (1907–98) Born in Marion, Indiana, Rainey Bennett studied at the School of the Art Institute, the American Academy of Fine Arts, and the Art Students' League, and with George Grosz and Maurice Stern in New York. He graduated from the University of Chicago in 1929. He supervised fresco, stained glass, and mosaic projects at the University of Illinois Medical Center in Chicago from 1935 to 1938 for the WPA's Illinois Art Project and created murals for post offices in Rushville and Naperville, Illinois, and in Dearborn, Michigan. A corporate commission took him to South America, where he created a series of paintings of Venezuela, Brazil, Argentina, Bolivia, Peru, and Ecuador. He redrafted older army war maps during World War II, and afterward he returned to industry and business. As a freelance illustrator, he created ads for Marshall Field and Company, murals for TWA and the Northern Trust Bank, and paintings and illustrations for books and magazines. Noted for his imaginative watercolors, Bennett taught at the School of the Art Institute. His work was shown at the Art Institute and the Museum of Modern Art, in private galleries, and in a retrospective exhibition at the University of Illinois at Chicago.

Edwin Howland Blashfield (1848–1936) Edwin Howland Blashfield, who was born in New York City, became the most important and prolific muralist of his time and enjoyed a very long career. After studying in Paris with French academic painters Léon Bonnat and Jean-Léon Gérôme, he returned to the United States in 1881 to work as a portraitist. He was a leading muralist at Chicago's 1893 World's Columbian Exposition, utilizing his training in the Beaux Arts tradition for his first mural commission in the Manufacturers and Liberal Arts Building. His compositions were consistently allegorical and remained "flamboyantly" so throughout his career, despite the many changes that were taking place in art. His other commissions included the dome of the Library of Congress in Washington, D.C., the state capitols of Iowa, Minnesota, and Wisconsin, and the grand ballroom of the Waldorf-Astoria Hotel. In 1913 he published *Mural Painting in America*. His murals in Chicago are at the Elks Memorial and Union League Club.

Ilya Bolotowsky (1907–81) Ilya Bolotowsky was born in St. Petersburg and came to New York in 1923, where he studied at the National Academy of Design. Although he specialized in easel painting and sculpture, he became involved with mural painting in the 1930s for the government-sponsored WPA and Treasury Section of Fine Arts programs in New York. His murals for the Williamsburg Housing Project and the Hall of Medical Science at the New York World's Fair of 1939 were among the earliest abstract murals in the country. He taught at many schools, including Black Mountain, Brooklyn, Hunter and Queens Colleges, and New Paltz/ SUNY. His strongest influences were cubism and the work of the Dutch artist Piet Mondrian. He described his style as "neoplasticism," an architectural or architectonic form of painting. His murals at the Social Security Administration Building are typical of his characteristic use of geometric form, expressed in primary colors of red, blue, and yellow.

A. Bonanno A. Bonanno's mural is at the Hilton and Towers Hotel.

Jesse Arms Botke (ca. 1883–1929) Both painter and illustrator, Jesse Arms Botke was born in Chicago and studied privately with Albert Herter and at the School of the Art Institute, where she also exhibited her work. She went to New York to design for Herter Looms and executed murals for the Hotel McAlpin there. She returned to Chicago when she married the Dutch-born painter and etcher Cornelius Botke, who was a member of the Chicago Society of Artists and sometimes assisted her in her work. The couple shared a studio in the Fifty-seventh Street art colony in Hyde Park until 1927, when they moved to California. Her murals are in the Ida Noyes Theater at the University of Chicago.

S. B. Braidwood S. B. Braidwood's murals are at the Smyth School and the Sherman Park Fieldhouse.

Gustave A. Brand (1862–1944) Gustave A. Brand was born in Parchim, Germany, where his early talent won him scholarships to academies in Munich, Berlin, and Düsseldorf. In 1887–88 his panoramic mural *The Battle of Gettysburg* was exhibited in Chicago. He came from Germany in 1892 to design the interior and execute murals for the German government's building at Chicago's 1893 World's Colombian Exposition and chose to remain in the city. Commissioned by the French government in 1931, his panorama *Panthéon de la guerre* was exhibited at Chicago's

1933 Century of Progress Exposition and the San Francisco Fair before being re-
turned to France. Brand was Chicago city treasurer from 1935 to 1939. He created
murals for many public buildings in Chicago and elsewhere, including the Audi-
torium Theater and Boston Library. He was seventy-eight when he directed the
Schurz High School mural project.

Henry George Brandt (1862–?) Born in Germany, Henry George Brandt was taught
by his father and also studied in Berlin and Dresden. He came to the United States
in 1882 and was a student at the School of the Art Institute of Chicago from 1911
to 1916. While a student he painted murals for the Monadnock Building Café. He
left Chicago to live in Moline, Illinois, Boise, Idaho, and Portland, Oregon, ulti-
mately returning to the city in 1920. He exhibited as a member of the Hoosier
Salon, Academy of Fine Arts, and Palette and Chisel Club. His *Hiawatha Series* is
at Lane Technical High School.

Raymond Breinin (1910–2000) Raymond Breinin was born in Vitebsk, Russia, and
came to the United States with his family in 1922. As a boy he studied with an early
teacher of Marc Chagall, and he later continued his training at the School of the
Art Institute. In Chicago he worked as a commercial artist and lithographer and
was associated with the Works Progress Administration in the 1930s. The dark and
dreary colors of his WPA mural at the Skokie School in Winnetka may reflect the
disturbing elements of his childhood in Russia during the Bolshevik Revolution
and his family's subsequent flight from the country. Soon after completing a sec-
ond New Deal era mural at the Wilmette Post Office for the Treasury Section he
moved to New York, where he exhibited at the Downtown Gallery until it closed
in 1954. He taught at the Art Students' League from 1961 to 1970 and at the Na-
tional Academy of Design in the 1970s and 1980s. His paintings were collected by
the Metropolitan Museum, Museum of Modern Art, Brooklyn Museum, Art Insti-
tute of Chicago, and Phillips Collection. He also designed theater sets, and he was
working on a theater curtain at the time of his death in Scarsdale, New York. The
words "tender mysticism and sensitive strength," were used to describe his work.

Edgar E. Britton (1901–82) Edgar E. Britton was born in Kearney, Nebraska. He
studied at the University of Iowa for two years and with Grant Wood in Cedar
Rapids, Iowa, from 1920 to 1924. He moved to Chicago in 1925 and for the next ten
years was active in architectural decoration. For the Illinois Art Project of the WPA

he executed fresco murals at a number of sites and acted as technical director from 1940 to 1941. He moved to Colorado in 1942 and taught at the Colorado Springs Fine Arts Center until 1951, when he left for Denver, where he lived until his death. Switching from painting to sculpture, he completed more than forty major nonobjective architectural commissions in the Rocky Mountain area, including large outdoor bronze sculptures, a fountain, bronze doors, and stained glass windows. His commissions for the Treasury Section of Fine Arts included post offices in East Moline and Decatur, Illinois, and in Waterloo, Iowa, and work for the Department of the Interior in Washington, D.C. In the Chicago area he did murals for the WPA at the University of Illinois Medical Center and at Highland Park High School and Lane Technical High School.

Roger Brown (1941–97) Born in Hamilton, Alabama, Roger Brown studied at the American Academy of Art and received his B.F.A. and M.F.A. from the School of the Art Institute. He was associated with the "Chicago imagists" in the 1970s, many of whom were fellow students. As a group, they turned away from the mainstream to focus on social realism, pop culture, outsider art, and cartoon imagery. Chicago critic Dennis Adrian said of the social and political content of Brown's work that "the experience of Roger Brown's painting is the shock of recognition, forceful and even disturbing because of its accuracy." His work has been exhibited in museums and galleries throughout the world and is in many private collections and museums such as the Hirshhorn, Whitney, Smart, Museum of Modern Art, Museum of Contemporary Art, Art Institute of Chicago, and Museum of Twentieth Century Art in Vienna. In his will he left his homes and studios in Chicago, Michigan, and California and a large collection of his own work to the School of the Art Institute. His murals are in the NBC Cityfront Center, the Savings of America Tower, and the Howard Brown Health Center.

Barbara Browne Barbara Browne was a teacher at the Public Art Workshop founded by Mark Rogovin and was his collaborator in *The Children's Mural* at Engine 44 Firehouse.

Charles Francis Browne (1859–1953) Born in Natick, Massachusetts, Charles Francis Browne studied at the Boston Museum School, with Thomas Eakins at the Pennsylvania Academy of Arts, and with Jean-Léon Gérôme at the École des Beaux-Arts in Paris. He came to Chicago in 1892 and was active in the city as a landscape

painter, teacher, lecturer, and critic for the *Chicago Sunday Tribune*. He executed
a mural for the Children's Building of Chicago's 1893 World's Columbian Exposi-
tion and participated in the Fine Arts Building mural project. Sculptor Lorado Taft
was his brother-in-law.

Edgar Spier Cameron (1862–1944) Edgar Spier Cameron specialized in painting
local historical subjects and worked in the academic tradition. Born in Ottawa, Illi-
nois, as a young man he went to work in a Chicago glass factory and managed to
spend two summers studying art at the Chicago Academy of Design. Saving his
money, he spent one year at the Art Students' League in New York in 1882 and con-
tinued his training in Paris at the École des Beaux-Arts and Académie Julian, where
his teachers were Louis Boulanger, Jules-Joseph Lefebvre, Jean-Paul Laurens, and
Benjamin Constant. He married a fellow student, Marie Galon, and returned to
Chicago to become art critic for the *Chicago Tribune* from 1891 to 1900. He assisted
muralists at the Chicago's 1893 World's Columbian Exposition and lived for a time
at the Tree Studios. Among the many awards he won were a silver medal from the
Paris Exposition of 1900 and the Municipal Art League Prize in 1909. He taught
at the School of the Art Institute, winning its Butler Prize in 1913. He painted mural
decorations for many early movie theaters in Chicago and the Midwest. His sur-
viving murals in Chicago are at the Traders and Santa Fe Buildings, and seven
smaller scenes of Chicago history are outside the mayor's office in City Hall, the
remains of a series of twelve that once hung in the building.

Jacques-Marie-Omer Camoreyt Born in Lectoure, France, Jacques-Marie-Omer
Camoreyt was a late nineteenth- and early twentieth-century painter who worked
in Paris. He was a student of Léon Bonnat, Fernand Cormon, and Albert Maignan
and a member of the Société des Artistes Français. He is known to have partici-
pated in the Paris salons of 1899, 1900, and 1905 and to have illustrated several
books. His painting is at the Nichols School in Evanston.

Mary Cassatt (1845–1926) Mary Cassatt was born to a prominent family in Al-
legheny City, Pennsylvania, and studied at the Pennsylvania Academy of Fine Arts
in Philadelphia. She went to Paris for further training and settled there perma-
nently in 1874. Influenced by the impressionists, she became friendly with Edgar
Degas and worked closely with him. She was a superb draftsman and is best
known for her depictions of mothers and children. The remarkable set of etch-

ing/aquatints that she produced in 1890 reflect the influence of Japanese art. She had great success in Europe, and through the advice and help she gave her wealthy collector friends she was instrumental in making impressionist paintings popular in this country. She created a mural for the Women's Building at the 1893 World's Columbian Exposition.

Monica Castillo (1961–) Born in Mexico City, Monica Castillo graduated from the State Academy of Stuttgart, Germany, and has exhibited in New York, Los Angeles, San Francisco, and Mexico. She has served as visiting artist at the School of the Art Institute. In her Sister Cities International Program mural at O'Hare International Airport, titled *Chicago: El viento,* the image of a sash blowing suggests the city's infamous wind.

Mohammed Chabaa (1935–) Mohammed Chabaa was born in Casablanca, Morocco. His work is widely known in Morocco and has been shown in Washington, D.C., Lisbon, and Montreal. In 1985 he exhibited at the Museum of Contemporary Art in Grenoble, France, and in 1987 in S[atil]o Paulo, Brazil. Chicago's landmarks are depicted in his Sister Cities International Program mural at O'Hare International Airport titled *LaSalle Street.*

Marc Chagall (1887–1985) Marc Chagall moved to Paris from his native Vitebsk, Russia, at age twenty-three. He had studied in St. Petersburg, but it was the experimental school directed by theater designer Léon Bakst that influenced him most. He brought vivid memories of the Russian-Jewish traditions of his childhood to Paris and found there the wild colors of the fauve artists and rearranged space of the cubists. He went back to Russia for a few years, and after the revolution he served as commissar of the arts, formed a free academy, and designed for the Yiddish theater until 1923. When he returned to Paris he became interested in the graphic arts, including book illustration, but he continued to paint and to design stage sets and costumes. Other projects included sculptures, ceramics, and stained glass windows such as those at the Art Institute of Chicago. He lived in New York from 1941 to 1948. His mosaic *The Four Seasons* is in the plaza of the First National Bank Building.

Carol Christianson (1954–) Carol Christianson lives and works in Victoria, British Columbia, where she was born. She learned the techniques of architectural model

making, diorama construction, and background painting through her work in museum exhibits at the Royal British Columbia Museum from 1975 to 1986. Now working independently, she has created diorama murals for the New York State Museum in Albany and the "Traveling the Pacific" exhibit at the Field Museum. Her mural is at the Field Museum.

Ralph Clarkson (1861–1942) Ralph Clarkson played an active role in the art world of Chicago at the turn of the century as a portrait painter and as president of the Chicago Society of Artists, the Municipal Art League, and the Art Commission of Chicago and Illinois. Born in Ottawa, Illinois, he was a founder of the Cliff Dwellers Club that grew out of the weekly meetings of a group of artists and other creative people who met in his Fine Arts Building studio. Clarkson maintained a studio in the building until his death, and his mural is on the tenth floor.

Francis F. Coan (1914–80) Born in Chicago, Francis F. Coan graduated from Englewood High School, entered the School of the Art Institute at age sixteen as a scholarship student, and graduated in 1935, having worked under Louis Rittman and Boris Anisfeld. He taught at the School of the Art Institute and earned a B.A. at the University of Chicago under a Ryerson grant. He was employed by the WPA to create murals at Hild and Austin Libraries and Englewood High School and, while a student at the School of the Art Institute, for the Fair Store in Oak Park. During World War II he was an illustrator for the government and taught the art of camouflage. He exhibited at the Art Institute of Chicago, Seattle Museum, DeYoung Museum, and Art Students' League. He lived in Oakland, California, and became a portraitist as well as a painter of the American landscape. His murals are at the Old Town School of Folk Music, formerly Hild Library.

Jeffrey Cook Jeffrey Cook participated in the mural *Benu: The Rebirth of South Shore,* at Seventy-first Street and Jeffery Boulevard.

Gustaf Oscar Dalstrom (1893–1971) Gustaf Oscar Dalstrom came to Chicago with his family from Gotland, Sweden, when he was seven years old. He graduated from Lane Technical High School and the School of the Art Institute, where he studied with George Bellows and Randall Davey, then spent 1927–28 studying in Europe. He was director of the Mural Division of the WPA's Illinois Art Project, and his commissions included murals for the De Kalb Public Library, Manteno State Hospi-

tal, Bennett, Green Bay, Manley, and Harper Schools, and Elmhurst High School. For the Treasury Section of Fine Arts he created murals for the Chestnut Street Post Office and others in Herrin and Gillespie, Illinois. Two murals now in private ownership, salvaged from the demolished Lawson High School, are also attributed to him.

Jim Dine (1935–) Jim Dine was born in Cincinnati and attended the University of Cincinnati, Boston Museum School, and Ohio University, graduating in 1957. Moving to New York in 1959, he took part in the development of "happenings"—nonverbal, unrehearsed, and often spontaneous performances generally given before an audience that sometimes participated. He was also associated with the rise of pop art, a movement that focused on objects of the mass media and popular culture. The personal themes he developed in the 1960s have occupied him throughout his career. To his earliest images of the bathrobe, heart, household tools, necktie, and palette and brushes, Dine added others such as the tree, gate, and classical torso. Many of these appear in his *Nuveen Painting*. A fine draftsman, he also creates sculptural objects in such materials as aluminum, wood, and bronze.

Chester Dryan (1904–80) Chester Dryan was assistant superintendent under James Edward McBurney, director of art for the Chicago Park District, in charge of the studio in the Washington Park Administration Building. He supervised art classes that were held in the studio and directed the painting of some park murals. His murals are at the Grand Crossing Park Fieldhouse.

Hector Duarte (1952–) Hector Duarte was born in Mexico and studied for five years with associates of muralist David Alfaro Siqueiros at his workshop in Cuernavaca, helping to restore some of the Mexican master's works. He painted murals in Cuernavaca, Zacatecas, and Michoacán and came to the United States in 1985 with a scholarship to study art in New York. He lives in Chicago, in the Pilsen neighborhood, and is an active muralist in the city. He collaborated with Cynthia Weiss on the ceramic mural titled *Chic-Chac* at the Lozano Library in Pilsen and with five other artists at the Harold Washington Library.

Ruth Duckworth (1919–) Born in Hamburg, Ruth Duckworth left Germany in 1936 to escape the Nazis and lived with her sister in England, where she attended the

Liverpool School of Art from 1936 to 1940. Eager to help the war effort, she worked for two years in a munitions factory in Manchester and afterward attended the Kennington School of Art in London to learn stone carving. The results of three years spent carving tombstones, primarily female figures, were exhibited in London in 1953. Working also in clay, she went to London's Central School of Art in 1960, where she learned to glaze, and became an instructor there. Her reputation for ceramics that challenge the traditional spread through England, and in 1964 she was invited to teach at Midway Studios at the University of Chicago. She taught there two years then, and again from 1968 to 1977. During this latter time she received her first mural commission, a three-dimensional composition called *Earth, Water and Sky,* for the University of Chicago, composed of undulating, raised, and overlapping segments of glazed clay. Her ceramics are sculptural and increasingly minimal, although her forms are mostly derived from nature. Her studio is in Chicago. *Clouds over Lake Michigan* was her second mural project.

Florian Durzynski (1902–69) Florian Durzynski's WPA murals are at the Bateman, Chopin, Falconer, Harvard, and Wentworth Schools, and probably Howe and McKay.

Lawrence Carmichael Earle (1845–1921) Lawrence Carmichael Earle was born in New York and studied in Munich, Rome, and Florence. He was active in Chicago in the 1880s as painter, muralist, and teacher. He taught at the School of the Art Institute. For the 1893 World's Columbian Exposition in Chicago, he painted two lunettes in the northeast corner pavilion of the Manufacturers and Liberal Arts Building. He also created murals for the banking room of the Chicago National Bank (also known as the Central Trust Bank of Illinois).

Roberta Elvis Roberta Elvis's WPA murals are at the Belding School. Her mural at May School no longer exists.

Helen Finch Helen Finch's WPA mural is at the Mozart School.

Albert Francis Fleury (1848–ca. 1932) Albert Francis Fleury, muralist, painter, and teacher, was born in Le Havre, France, and studied at the École des Beaux-Arts in Paris. Although his early training was in architecture, he soon turned to painting. He came to the United States in 1888 and settled in Chicago a year later, where he taught and exhibited at the Art Institute. His many scenes of the city are

painted in a dreamy, impressionistic style. His murals are at the Auditorium Theater and at Ganz Recital Hall of Roosevelt University.

Frances Foy (1890–1963) Born in Chicago, Frances Foy studied at the School of the Art Institute and later under George Bellows and Randall Davey. She exhibited at the Art Institute, Illinois Wesleyan University, the galleries of Increase Robinson and Marshall Field galleries, and others. The WPA/FAP "married persons clause" prevented her from working for the project because her husband Gustaf Dalstrom was employed by the Illinois Art Project and only one member of a family was allowed. Instead she executed commissions for the Treasury Section of Fine Arts: the Chestnut Street Post Office in Chicago, the Gibson City and East Alton Post Offices in Illinois, and the West Allis Post Office in Wisconsin.

Charles Freeman Charles Freeman's WPA mural is at the Mozart School.

Harry Lawrence Gage (1887–?) Harry Lawrence Gage was a muralist, painter, designer, writer, and lecturer who was born in Battle Creek, Michigan, and studied at the School of the Art Institute. While a student, he painted a large mural for Lane Technical High School and also a series of four murals for the Jahn School. He moved to New Jersey, where he designed and wrote books on design for printing and was vice president of Mergenthaler Linotype Company.

Miklos Gaspar (1885–1946) Miklos Gaspar was born in Kana, Hungary, and trained at the Art Academy of Budapest and also in Florence and Venice. He was the official war artist for the Austro-Hungarian government during the First World War. Only a year after he came to the United States in 1921 and settled in Chicago, he won the *Chicago Tribune* prize in historical mural painting, and this became his specialty. He depicted two episodes in the life of Columbus for the Knights of Columbus Building in Springfield, Illinois, and painted a ceiling for the Fisher Building in Detroit. He produced nine inlaid wood panels (marquetry) and thirteen of the forty murals of the states for the General Motors Building at Chicago's 1933 Century of Progress Exposition; they are now at Lane Technical High School. In addition, he painted a sixty-four-foot mural for the Atlas Brewing Company exhibit in the Agriculture Building, created dioramas of the life of Thomas Edison for the Electrical Building, and produced other works for the Elgin Watch Company display. A procession of knights and battle scenes illustrating medieval warfare dec-

orates a ballroom in the Medinah Temple (now the Intercontinental Hotel), and his history of the Boys' Club activities is at the Union League Club.

Elizabeth Gibson Elizabeth Gibson's WPA mural is at the Mozart School.

James J. Gilbert James J. Gilbert's mural is at the Pulaski Park Fieldhouse.

Ablade Glover (1934–) Ablade Glover was born in Accra, Ghana, and was educated in Africa and at the University of Science and Technology in Kumasi, Ghana, the Central School of Art and Design in London, the University of Newcastle-upon-Tyne, and Kent State and Ohio State Universities. As an artist and teacher for over twenty years, he has exhibited in Washington, D.C., London, Paris, Geneva, and Lagos. His mural for the Sister Cities International Program at O'Hare International Airport is called *Ethnic Tapestry.*

Ralph Graham Ralph Graham was a painter, photographer, and designer. He designed the "stained glass" windows for the Anatomy Museum of the University of Illinois Medical Center in Chicago (now the University of Illinois at Chicago) under the direction of Rainey Bennett, who was supervisor of the entire WPA project. The project lasted two and one-half years and employed thirty people. After completing the windows, Graham left the project to become head of the poster and silkscreen division of the Illinois Art Project at 433 Erie Street. He also produced work for the Shedd Aquarium and Brookfield Zoo.

Marion Mahony Griffin (1873–1962) Born in Chicago, Marion Mahony Griffin was only the second woman to receive the bachelor of science degree in architecture from Massachusetts Institute of Technology and the first woman architect to be licensed in Illinois. She worked in Dwight Perkins's office before joining Frank Lloyd Wright, working as his assistant from 1895 to 1909. She is credited with the secondary decorative designs for Wright's initial plans and exquisite architectural renderings including his "Japanese" presentation drawings. Although she is best known for her superb graphic work, she was also an accomplished architect. With her skill as a draftsman she was able to help her husband, Walter Burley Griffin, whom she married in 1911, win the competition for designing the new capital city of Canberra, Australia. They spent twenty years in Australia supervising the construction of the new government buildings and developing other projects. In 1935,

with plans for a university library, they moved to Lucknow, India. Her husband died suddenly within the year, however, and she returned to the United States, where she wrote her memoir *The Magic of America* and continued to design. Her mural is at Armstrong School.

Oliver Dennett Grover (1861–1927) Oliver Dennett Grover was born in Earlsville, Illinois. In 1876 he moved to Chicago, where he attended the University of Chicago and the Academy of Design. In 1879 he spent the first of a number of years in Europe at the Royal Academy in Munich. For the next four years he studied in Florence at the Duveneck School and spent the summers in Venice. After this he was in Paris, studying with Gustave Boulanger and Jean-Paul Laurens, and then he visited Italy again. After his marriage in 1887, he returned to Chicago and became an instructor at the School of the Art Institute from 1887 to 1892. Deciding to concentrate on painting, he worked as a portraitist and muralist for the 1893 World's Colombian Exposition, decorating panels, ceilings, and lunettes in several of the buildings. His commissions include the Brantford Memorial Library in Brantford, Connecticut, and the Blackstone Memorial Library, Fine Arts Building, and Roosevelt University Library in Chicago.

Olivia Gude (1950–) Olivia Gude received her art training at Webster College in St. Louis, where she was born, and she began her career in 1973 as an art instructor at a St. Louis high school. Moving to Chicago, she taught at Bloom Trail High School in Steger. There she met fellow artist Jon Pounds, whom she later married. She earned a master's degree at the University of Chicago in 1982 and became "mesmerized" by the outdoor murals of the Hyde Park neighborhood. She and her husband did their first public mural together in Pullman in 1981, and a few years later Gude entered the Chicago mural movement, hoping to energize "public space for the common man and woman and the common good." As a member of the Chicago Public Art Group, she has collaborated with volunteers and students in many Chicago neighborhoods and also in Los Angeles, Madison, Wisconsin, and downstate Valmeyer, Illinois. In recent years she has worked with students on mural and mosaic projects at Phillips, Lowell, and Nobel Schools. She has taught at the University of Chicago, the University of Illinois at Chicago, and Columbia College and is currently coordinator of the art education program and assistant professor in the School of Art and Design at the University of Illinois at Chicago. She is coauthor with Jeff Huebner of *Urban Art Chicago*, published in

2000. Her murals are in Hyde Park and Pullman and at Navy Pier and the Harold Washington Library.

Jules Guerin (1866–1946) Jules Guerin is best known to Chicagoans for his watercolor, tempera, and pencil drawings for Daniel Burnham and Edward Bennett's 1909 *Plan of Chicago*. These eleven panoramic aerial illustrations present an extraordinary vision of the city. He was born in St. Louis, but his earliest training is believed to have been in Chicago, where he lived and exhibited from 1880 to 1896. He also studied in Paris in the studios of traditional French painters Benjamin Constant and Jean-Paul Laurens. The chance to watch America's leading painters, sculptors, and architects at work at Chicago's 1893 World's Columbian Exposition had a profound effect on his development, although he was only a minor participant. With his move to New York in 1900, he began his career as a magazine illustrator and developed a special talent for color through his exposure to the new color photolithography. As architectural delineator, muralist, and decorator, Guerin participated in some of the most significant architectural projects in the country from 1890 to 1930. His major accomplishments include interior murals for the Lincoln Memorial in Washington, D.C. (1913), and New York's Pennsylvania Station (1902–11). In Chicago his murals can be seen at the Continental Illinois Bank, Merchandise Mart, and Civic Opera House.

José Guerrero (1938–) Born in San Antonio, Texas, José Guerrero moved to Chicago in 1964. He studied drawing at the American Academy from 1967 to 1974 and took mural painting classes with John Pitman Weber at the School of the Art Institute. He furthered his mural education with several trips to Mexico, where he observed the Mexican masters' materials and techniques of mural painting. He believes that murals can be a powerful means of communication. He worked with Weber on the United Electrical Workers mural.

Richard John Haas (1936–) Richard John Haas has been interested in architecture since his boyhood in Spring Green, Wisconsin, where he helped his uncle, who worked as a stonemason at Frank Lloyd Wright's school Taliesin. He studied painting at the University of Wisconsin and earned his M.F.A. at the University of Minnesota. Architectural references appeared in his work from the very beginning. Moving to New York in 1968, he began making diorama models of his Soho neighborhood. His printmaking reflected his continuing interest in cityscapes, but he

painted his first large-scale mural on the blank wall of a building in the middle 1970s, duplicating the design of its front facade. Using "walls as his canvases," Haas creates trompe l'oeil murals that pay tribute to architects of earlier times and express his own ideas on architecture and urban planning. In Chicago, his murals are on the facades of the Reliable Corporation warehouse and LaSalle Towers and in interiors at Chestnut Place and 225 North Michigan Avenue.

Otto Hake (1876–1965) Otto Hake, painter, muralist, printmaker, illustrator, and teacher, was born in Ulm, Germany, and came to the United States in 1890. He studied in Munich at Debschitz Academy, at the Académie Colarossi in Paris under Heim Morisset, and at the School of the Art Institute. He worked as a commercial artist and taught at the Chicago and Evanston Academies of Fine Art, American Academy of Fine Arts, and the Palette and Chisel Academy of Fine Art. He exhibited at the Art Institute eight times from 1917 to 1932 and won the Municipal Art League Prize in 1926 and the Worcester and Palette and Chisel prizes in 1928. He was a member and several times president of the Palette and Chisel Academy, where his mural is in the lower level of the building. His other mural commissions include the Champaign, Illinois, Senior High School, Lincoln School in Evanston, the Blackhawk Memorial in Rock Island, and the Wheaton Public Library.

Norman Philip Hall (1885–1967) Born in Chicago, Norman Philip Hall was a painter and illustrator and studied with John Vanderpoel, John Johansen, Walter Clute, and others. He was a member of the Art Students' League and Artists' Guild of Authors League. He may have lived in Elmhurst, Illinois. His mural is at the Wentworth School.

Roy S. Hambleton Roy S. Hambleton's mural is at the Smyth School.

Ralph (or Ralf) Christian Henricksen (1907–73) Ralph Christian Henricksen earned his B.F.A. at the School of the Art Institute and his M.F.A. from Instituto Allende in Mexico. He also studied with Boris Anisfeld and was active in Chicago as a painter and muralist, working for the WPA's Illinois Art Project in both easel and mural divisions. He exhibited at the Art Institute during these years and executed mural commissions for the WPA at the Gorton School in Lake Forest, Hookway (now Cecil A. Partee), Mann, and West Pullman Schools, Scott Field, and the Park District Administration Building and at the Stanton, Illinois, and Monroe, Michigan, Post Offices for the Treasury Section of Fine Arts. He exhibited at the Art Institute

of Chicago, the Museum of Modern Art, and Phillips Gallery and taught at Michigan State University in East Lansing until his retirement.

Margaret A. Hittle (1886–1984) Margaret A. Hittle, illustrator, etcher, lecturer, and teacher, was born in Victor, Iowa, and lived in Chicago. She studied at the School of the Art Institute and the Art Students' League, and as part of a team she painted decorations at Garrett Biblical Institute and Northwestern University, where she depicted Christian catacombs in Rome. Her mural at Lane Technical High School was executed when she was a student at the Art Institute.

Charles Holloway (1859–1941) Born in Philadelphia, Charles Holloway attended and later taught at Washington University Art School in St. Louis. He moved to Park Ridge, Illinois, in 1895 and entered the Wells Company stained glass workshop, where he stayed for two years. He is best known for the Auditorium Theater proscenium arch mural, which he called "his own conception and execution." He decorated the ballroom and library of the Potter Palmer mansion and exhibited at the Paris Exposition of 1900, winning a gold medal for his stained glass and painted decorations. He moved to Los Angeles in 1932. His commissions include decorations for the Fort Wayne, Indiana, courthouse, the Pierre, South Dakota, state capitol, and many college theaters. In 1892 he created the first prize –winning symbolic figure *Chicago, I Will,* for the Chicago newspaper *Chicago Inter-Ocean.* He died in Philadelphia.

Jacob Adolphe Holzer (1858–?) Born in Bern, Switzerland, Jacob Adolphe Holzer was a student of Fournier in Paris. He settled in New York, where he worked with the American sculptor Augustus Saint-Gaudens and John La Farge, who, with Louis Tiffany pioneered stained glass in the late nineteenth and early twentieth centuries. Primarily a mural painter, Holzer was the designer of the Tiffany mosaic murals in the Marquette Building and also much of the Tiffany mosaic work in the Chicago Cultural Center and Marshall Field Department Store.

Emmanuel Jacobson Born in Chicago, Emmanuel Jacobson earned his B.F.A. and M.F.A. at the School of the Art Institute and also studied at the Universities of Chicago and Colorado and at Northwestern University. He traveled widely in the United States and Europe and was active in the WPA, with commissions at the Mann School in Oak Park and the Henry Street Settlement in New York.

Edwin Boyd Johnson (1904–?) Edwin Boyd Johnson was born in Nashville, Tennessee, and studied at the School of the Art Institute with Louis Rittman, John Warner Norton, Boris Anisfeld, and others. He had additional training at the National Academy of Design and the Kunstgewerbeschule in Vienna, Atelier de Fresque and Académie de la Grande Chaumière in Paris, and Académie Égyptienne des Beaux-Arts in Alexandria, Egypt. He exhibited at Chicago's 1933 Century of Progress Exposition and at the Art Institute of Chicago eight times between 1931 and 1942 and was awarded several prizes and two traveling fellowships. He worked for the Federal Art Project, supervising the Elgin mural project. His WPA mural commissions in the Chicago area include Cook County Hospital, Fenger and Flossmoor High Schools, and the University of Illinois at Chicago Medical Center. For the Treasury Section of Fine Arts, he decorated the post offices in Melrose Park and Tuscola, Illinois.

J. Theodore Johnson (1902–?) J. Theodore Johnson was born in Oregon, Illinois, and studied at the School of the Art Institute and in Paris with André Lhote. His work was exhibited at the Art Institute and the Guggenheim Museum, and he taught at San Jose State College, the School of the Art Institute, and the schools of the Toledo Museum and Indiana Museum, and the Minneapolis Institute of Art. His Treasury Section mural commissions are at the Oak Park and Morgan Park Post Offices.

Fred Jones (1915–96) While Fred Jones was attending Clark College in Atlanta in the 1930s and working part time for the Coca-Cola Company, through a fortunate accident his sketchbook was seen by the chairman of the company, who was impressed with his talent. He had Jones transferred to the Chicago plant on the South Side and arranged for him to attend the School of the Art Institute on a scholarship. Jones said he "hung around with a little beehive of artists" at the South Side Art Center at Thirty-ninth and Michigan, which flourished during the New Deal era, and there he met the Reverend Clarence H. Cobbs, who had an interest in art. When Cobbs's Church of the Deliverance moved to its new quarters, he chose Jones to paint its murals.

Sandra Jorgensen (1934–99) Born in Evanston, Illinois, Sandra Jorgensen received her B.A. from Lake Forest College in 1957 and her M.F.A. from the School of the Art Institute in 1964. She taught at Elmhurst College from 1966 to 1996 and

was chairman of the Art Department from 1975 to 1986. She was an important presence at the college for thirty years and often gave lectures and guided tours of its art collection. She exhibited widely in the Midwest. Commenting on her work at the time of her commission for the Sulzer Library, she said, "My works are gradually moving from a metaphysical to a spiritual vision."

Alex Katz (1927–) Alex Katz is a realist artist who came of age in the 1950s during the era of abstract expressionism. He was born in New York and educated at Cooper Union and the Skowhegan School of Painting and Sculpture in Maine. Chicago's *Harlem Station,* made up of two-dimensional cut-out portraits that exist in three-dimensional space, is typical of his work, portraits characterized by dramatically cropped and oversized heads. Critics have suggested that his simplified style may have been inspired by the paintings of Henri Matisse and Milton Avery. He has received many awards and prizes, and his work is in the collections of the Art Institute of Chicago, Hirshhorn Museum, and Tate Museum, among many others worldwide. He has taught at Yale and at New York University.

Camille Andrene Kauffman (1905–93) Born in Chicago, Camille Andrene Kauffman received her B.F.A. from the School of the Art Institute and her M.F.A. from the University of Chicago. She also attended Illinois Institute of Technology and studied in Paris with André Lhote. She was professor of painting and drawing at the School of the Art Institute for forty-one years, from 1927 to 1967, and chairman of the Division of Fine Arts from 1963 to 1966. She also taught at Rockford College and Valparaiso University. During the New Deal period she executed twenty-five murals and seven sculpture commissions in the Chicago area, including Burbank and Hirsch High Schools in Chicago, Lincoln and Washington Schools in Evanston, Lowell School in Oak Park, and Cook County Hospital. She also worked in ceramic and stained glass and was represented by the Art Institute Rental Gallery.

Karl Kelpe (1898–1973) Born near Hanover, Germany, Karl Kelpe came to the Chicago area about 1925. He had studied architecture in Germany but earned a Ph.D. in art history from the University of Chicago in 1957. His WPA commissions included Hawthorne School in Oak Park, the Southern Illinois University library, and the Champaign, Illinois, Junior High School. He taught at Howard University and East Texas Teachers College. His mural is at Percy Julian Junior High School in Oak Park.

Boguslaw Kochanski (1952–) Born in Warsaw, Poland, Boguslaw Kochanski graduated from the Warsaw Academy of Arts in 1977. His work has been shown in Poland, Germany, the United States, and England, where he was one of twenty chosen from several hundred for the final selection of London's TV Times Silver Jubilee Painting Competition. *Admiration of Chicago* is his imaginative scene of the city for the Sister Cities International Program at O'Hare International Airport.

Marguerite Kreutzberg (1886–1978) Marguerite Kreutzberg lived in Lake Bluff, Illinois, and moved to Tucson, where she resided until her death. She was a Lake Bluff resident when she painted her mural at the East School.

Ellen Lanyon (1926–) Born in Chicago, Ellen Lanyon earned her B.F.A. from the School of the Art Institute in 1948 and her M.F.A. from the University of Iowa, where she studied with Mauricio Lasansky. She also studied with Helmut Reuhman at the Courtauld Institute and attended the University of London as a Fulbright scholar. She taught at the School of the Art Institute, at Ox-Bow, the summer school of art at Saugatuck, Michigan, and at Parsons School of Design and Cooper Union in New York. She has been a visiting artist-lecturer at universities including Stanford, the University of California at Davis, Pennsylvania State, Iowa, and State University of New York at Purchase. Her mural commissions include the State of Illinois Building in Chicago, the Illinois State Capitol in Springfield, and the Police and Court Facility in Miami Beach. She is both painter and printmaker, and her work has been collected and exhibited widely by museums and galleries across the country. Having lived many years in Chicago, she now resides in New York. Her Riverwalk Gateway Project was completed in 2000. An earlier mural with scenes of Chicago is at the State of Illinois Building.

Jacob Lawrence (1917–2000) Jacob Lawrence was born in New Jersey and grew up in Harlem during the depression, when the government-sponsored WPA program created the Harlem Workshop. Lawrence received his early training at the workshop, and his first important work was in the late 1930s, as a member of the WPA's Illinois Art Project. The "Harlem Renaissance" of the 1920s and 1930s gave Lawrence the chance to know many of its writers and artists. Throughout his career he employed the same deceptively naive style, using simplified forms, limited colors, and powerful symbols to recount the black American experience. He

is best known for his narrative series that dramatize the lives of historical heroes such as Toussaint-Louverture, Frederick Douglass, Harriet Tubman, and John Brown. *The Migration Series,* his powerful and moving account of the movement of more than a million black Americans from the rural South to the industrial North during the years 1916 to 1930, painted at the age of twenty-four, has been called his greatest achievement. As important influences on his work, Lawrence cites early Italian Renaissance panel paintings, Mexican mural paintings, and African textiles. His mosaic mural illustrating the life and accomplishments of Harold Washington is at the library named for the late mayor.

Tom Lea (1907–) Tom Lea, who was born in El Paso, Texas, and lives there today, came to Chicago to study at the School of the Art Institute. He was John Warner Norton's first student and became his assistant from 1927 to 1933, working on some of Norton's most important murals. At Norton's urging, he traveled in Europe and studied mural painting in Italy, returning to Chicago only briefly. During this period he painted murals for the Calumet and Gage Park Fieldhouses and worked with Norton on the Daily News and Loyola Library murals and at the 1933 Century of Progress Exposition. After Norton's death, Lea wrote a book about his mentor, *John W. Norton, American Painter (1876–1934).* He shared Norton's belief that art provides the means whereby man "might come to a deeper understanding of his life." Lea moved to Santa Fe in 1933 and was active in the New Mexico Art Project, executing murals in 1937 for the Santa Fe courthouse, the Las Cruces library, and the Post Office Department building in Washington, D.C. He worked as an illustrator for *Life* magazine during World War II, traveling more than 100,000 miles and painting Chiang Kai-shek's portrait among other subjects.

Thomas Jefferson League (1892–?) Thomas Jefferson League, an art teacher at Lane Technical High School, was born in Galveston, Texas, and came to Chicago at age sixteen to study art. He worked for the WPA from 1933 to 1943 executing murals for Lane Tech and for Clissold School. His series of three murals titled *The Story of Natural Drugs* is at the University of Illinois Medical Center.

Sol LeWitt (1928–) Sol LeWitt, a sculptor, painter, author and exponent of conceptual art, was born in Hartford, Connecticut, and received his B.F.A. from Syracuse University. His first job was for architect I. M. Pei, and his earliest reliefs date

from 1962. These structures were made from wood or metal, composed of open squares in various combinations. He also produces wall paintings, which he plans and then leaves for others to execute, stating that for him the "concept" is the most important part of a work. Since the 1970s his palette has expanded to include primary colors as well as his usual black, white, and gray. Another artist once described LeWitt's work as trying to make the nonvisual visible. His wall painting is at the Standard Club, and nearby on the outside wall of 10 West Jackson Street is his painted aluminum sculpture from 1985, *Lines in Four Directions.*

Frank Xavier Leyendecker (1877–1924) Frank Xavier Leyendecker was born in Montabour, Germany, and studied at the Académie Julian and the Académie Colarossi in Paris and at the School of the Art Institute. He was a painter, illustrator, and designer who also worked in stained glass and was supervisor of the Fine Arts Building mural project in which he participated. Although he was an excellent artist and executed a series of monthly covers for *Collier's Weekly* magazine from 1902 to 1905, he was not able to match the success of his older brother, Joseph Christian Leyendecker.

Joseph Christian Leyendecker (1874–1951) Joseph Christian Leyendecker, known as J. C., was born in Montabour, Germany, and came to Chicago with his family at age eight. He became the most successful illustrator of his time, as the top cover artist for the *Saturday Evening Post* for twenty years and as a fashion illustrator who created the famous "Arrow Shirt Man" for the Arrow Collar Company. He was the artist the young Norman Rockwell most admired. Leyendecker had been apprenticed to a printing firm at fifteen and later studied at the School of the Art Institute. In 1896 he won a commission to design a year's worth of monthly cover designs for the *Inland Printer.* He and his brother then spent a year in Paris studying at the Académie Colarossi and the Académie Julian. His teachers were William Bouguereau, Jean-Paul Laurens, and Benjamin Constant. Upon their return in 1897, they opened their studio in the Fine Arts Building, where they both executed murals. He spent the rest of his life in New York.

Arthur Hershel Lidov (1917–90) Born in Chicago, Arthur Hershel Lidov received his B.A. in philosophy and sociology from the University of Chicago in 1936. He spent the next year studying art with Emil Armin at the School of the Art Institute,

where he exhibited during the 1930s and 1940s. He traveled abroad and taught painting and drawing in Palestine for a year. He also worked as an illustrator for *Fortune* magazine. His WPA murals are at the Christopher School.

Axel Linus (1885–1980) Axel Linus was born in Orebro, Sweden, and attended the Royal Academy of Arts in Stockholm 1905–10 and the Académie Colarossi and Académie Moderne in Paris 1911–12. He immigrated to Chicago in 1920 and exhibited a landscape painting at the Art Institute of Chicago in 1922. He specialized in murals, portraits, and landscapes. Sometime later he moved to California, and he died in Palm Springs.

Dorothy Loeb (1887–1971) Dorothy Loeb was born in Starnberg, Bavaria, to American parents who were traveling abroad. A mural painter and printmaker, she studied in Paris under Fernand Léger, Louis Marcoussis, Henri Martins, and others. She also studied at the School of the Art institute and in Provincetown, Massachusetts. She was active in Chicago until 1940, when she moved to South Orleans, Massachusetts. She exhibited at the Art Institute from 1912 to 1917, while she was a student, and also at the Boston Museum of Contemporary Art. Her mural commissions included the Hall of Social Sciences at the 1933 Century of Progress Exposition, Lane Technical High School, and Smyth School.

Lu Xiang-tai (1941–) Lu Xiang-tai graduated from East China Hai Dung Teachers College in Shanghai, where he is associate professor and chairman of the Environmental Artistic Study Program. He has designed interior spaces for Caesar's Palace, the Silk Row Hotel, and Shanghai Golf and Country Club. He participated in the Chinese/Japanese Artistic Work Exchange Exhibition in 1992 and has won several awards. His abstract mural at O'Hare Airport for the Sister Cities International Program is titled *Black and White Movement amid Stillness.*

Mary Fairchild MacMonnies Low (1858–1946) Born in Bronxville, New York, Mary Fairchild MacMonnies Low studied at the St. Louis School of Fine Arts and in Paris at the Académie Julian and privately with Émile-Auguste Carolus-Duran. Her mural for Chicago's 1893 World's Columbian Exhibition was exhibited later at the Paris Exposition of 1900, and her work was also shown at the Pan-American Exposition of 1901 in Buffalo, New York, and at the Normandy Exposition in Rouen,

France, in 1903. Her paintings are in the collections of the Rouen museum, Union League Club, City Art Museum of St. Louis, and Art Institute of Chicago. She was married to sculptor Frederick MacMonnies and subsequently to artist Will Low.

Kerry James Marshall (1955–) Born in Birmingham, Alabama, Kerry James Marshall grew up in Los Angeles, and since kindergarten knew he wanted to become an artist. A summer scholarship to the Otis Art Institute when he was in junior high school provided his first drawing classes and also brought the acquaintance and encouragement of Charles White, a black artist who taught at the school. He entered Otis (now the Otis College of Art and Design) after high school and received his B.F.A. in 1977. After a two-year stay in New York as artist in residence at the Studio Museum in Harlem from 1985 to 1987, he moved to Chicago, where he now lives. His work has been shown in Chicago at the Renaissance Society, Museum of Contemporary Art, and Art Institute. He has also been included in the Whitney Biennial, Documenta in Kassel, Germany, and the Venice Biennale. The recipient of a MacArthur "genius grant," Marshall has been associate professor of art at the University of Illinois at Chicago since 1993. His mural is at the Legler Library.

Oscar Martinez Born in Mayagüez, Puerto Rico, Oscar Martinez studied art and science at the University of Illinois at Champaign, earning his B.A. in medical art from the university's medical center in 1977. He has shown work in many group and solo exhibitions throughout the Caribbean, Mexico, and the United States and in museums, including the National Historical Museum of Mexico and the State of Illinois galleries in Springfield and Chicago. Martinez was actively involved in the Chicago mural movement in the 1970s and has served on many cultural boards and commissions in the city. His attachment to his home in Puerto Rico is still strong. He writes that he was able to survive being "transplanted to Chicago . . . by dreaming of the wonderful tropical paradise and playground where I grew up." In his paintings, he says, "I attempt to capture a bit of Mayagüez full of folklore, myth, spirituality and beauty."

James Edward McBurney (1868–1947) Born in Lore City, Ohio, James Edward McBurney studied with John Henry Twachtman at Pratt Institute and also in Paris. He served in the American Expeditionary Forces in Beaune, France, in 1919 and taught there at the College of Fine and Applied Art, AEF University. During the 1930s he was director of art for the Chicago Park District and was responsible for

the mural decorations in several park fieldhouses. His commissions in Chicago include Palmer Park Fieldhouse, Woodlawn National Bank, the 1933 Century of Progress Exposition, Parkside School, Wentworth School, and Tilden Technical High School. He created murals for banks in Dubuque, Iowa, and Cheney, Washington.

Hildreth Meiere (1893–1961) Hildreth Meiere was born in New York and studied at the Art Students' League, California School of Fine Arts, and Beaux Arts Institute of Design. Her murals are at the Nebraska State Capitol in Lincoln and the dome of the National Academy of Sciences in Washington, D.C. She created mosaic medallions and panels illustrating Saint Francis's "Canticle of the Sun" for the ceiling of Rockefeller Chapel at the University of Chicago and miniature paintings for the chapel and other rooms in the Thorne Miniature Rooms at the Art Institute of Chicago. Working primarily as a mural painter and lecturer, she was also known for her art deco fabrics. Meiere's design for the facade of the Logan Branch Library (Chicago), created for the Treasury Section of Fine Arts in 1937 and called *The Post,* is a series of metal outlines that form the figure of the god Mercury, suggesting the speed (not always achieved) of mail delivery.

Francisco Gerardo Mendoza (1958–) Born in Blue Island, Illinois, Francisco Gerardo Mendoza grew up in the South Side of Chicago and graduated from Bowen High School. He spent a year studying art in Spain and earned his B.F.A. from the School of the Art Institute in 1985. He has taught art at José Clemente Orozco Academy in Pilsen since 1985 and has directed many mural projects with students, including the Eighteenth Street Metra station and the Orozco Academy facade, an ongoing project begun in 1991. As an artist, he has exhibited his work in community galleries, cultural centers, and museums in Chicago.

Edgar Miller (1899–1993) Edgar Miller was born in Idaho Falls, Idaho, to a family that nurtured his artistic talent. He came to Chicago at age seventeen to study at the School of the Art Institute. His early training in china painting enabled him to help ceramist Eugene Deutch establish a pottery that operated in Chicago until the 1950s. During his four years as apprentice to artist-craftsman Alfonso Ianelli, he developed the many artistic skills that led to his reputation as a Renaissance man. He worked as sculptor, muralist, graphic artist, ceramist, mosaicist, stained glass artist, architect, and designer. In 1927 he and portrait painter Sol Kogen

transformed a group of small residences on West Burton Street into artists' studios, embellishing them with carved wood and plaster reliefs, leaded glass, tiles, mosaic, and frescoes. This was the beginning of the artistic community known as Old Town. He worked with many of the leading Chicago architects to design decorations for their buildings. The murals he created for the 1933 Century of Progress Exposition brought him sculptural relief commissions for the Technological Center at Northwestern University and the U.S. Gypsum Building. His etched glass panels from the now demolished Diana Court are in the collection of the Art Institute. His work can be seen at the Tavern and Standard Clubs and at Kelvyn Park High School.

Edward Millman (1907–64) Born in Chicago, Edward Millman studied at the School of the Art institute under Leon Kroll and John Warner Norton and in Mexico with muralist Diego Rivera. He was Illinois State supervisor of mural projects for the WPA during 1935–36 and collaborated with Mitchell Siporin on the largest single government commission for the St. Louis Post Office from 1939 to 1941. He was art correspondent for several Chicago newspapers and executed murals for Chicago's 1933 Century of Progress Exposition, the City Hall Water Bureau, Lucy Flower High School, the Moline, Illinois, Post Office, and the New York World's Fair of 1939–40. He was an official navy combat artist in the South Pacific during World War II, and his work appeared in *Life* and *Fortune* magazines. In 1945 he won a Guggenheim grant. His work was exhibited widely and is represented in many museum collections. He spent one year as artist in residence at the School of the Art Institute and taught at Hull House. He lectured and taught at many other schools, including Cornell, Indiana, and Washington Universities and the Albright School of Art. He was professor of art in the School of Architecture at Rensselaer Polytechnic Institute at the time of his death in Woodstock, New York, where he had lived for many years.

Julius Moessel (1871–1957) Julius Moessel was born in Furth, Germany, studied at the Nuremburg Industrial Art School and Munich Academy of Arts, and founded his own architectural decoration firm when he was in his twenties. An important architectural decorator in Germany, he had work in theaters, department stores, government buildings, churches, and homes. In 1926 he left Germany, and he settled in Chicago in 1929. His murals for the Stop-and-Shop store at Washington and State Streets in Chicago and for the foyer of the Hotel Jefferson in St. Louis were

both destroyed. Praised by art critics as "among the living masters of the world," Moessel supported himself during the 1930s and 1940s through easel paintings of exotic birds and animals, religious scenes, and landscapes. His style of painting was compared to the work of Hieronymus Bosch and Max Ernst. The WPA commissioned his last major work for the Field Museum, a series of eighteen murals called *The Story of Food Plants,* completed in 1940. He was plagued by progressive blindness in his last years. Recent research by German art historian Judith Breuer has documented forty-seven of his architectural frescoes and murals in Europe that have been rediscovered and restored. In this country his paintings are in the collections of the Union League Club, Southern Utah Museum, and Illinois State Museum, among others.

Charles L. Morgan (1890–1947) Born in Mount Vernon, Illinois, Charles L. Morgan received his bachelor of architecture degree from the University of Illinois in 1914. He taught at the University of Kansas and at Southern College in Lakeland, Florida, where he supervised the construction of buildings designed by Frank Lloyd Wright. He had his own firm and was also associated with Wright after 1929. Believing that architects should also be artists, he spent three years in Bogotá, Colombia, and also traveled through Europe making sketches. The Italian government decorated him for his work on the Italian Pavilion at the 1933 Century of Progress Exposition. He was responsible for the design and manufacture of the tile decorations of the Powhatan Building.

Datus E. Myers (1907–89) Datus E. Myers was born in Jefferson, Oregon, and between 1905 and 1910 he studied at the School of the Art Institute. There he met his wife, Alice Clark, who became one of the first women architects in the country. He completed a mural at the Linné School in 1910 and was active in Chicago, exhibiting five times at the Art Institute between 1909 and 1914 before moving to Santa Fe in 1926. He became field coordinator for the Indian Division of the Public Works of Art Project in 1934 and executed a Treasury Section mural for the Winnsboro, Louisiana, Post Office in 1939. He died in Shasta Springs, California, where he had lived since 1953.

Hideo Nakai Born in Hyogo, Japan, Hideo Nakai graduated with honors from Kwansei Sakuin University and Osaka Municipal Art Institute. He won the Kansai Shin Prize and Osaka Mayor Prize in 1986 and the Kanji Maeda Grand Prize in

1992. His mural for the Sister Cities International Program at O'Hare International Airport, titled *My Collection in Chicago,* features many small images set within an architectural framework.

George Mann Niedecken (1878–1945) Born in Milwaukee, George Mann Niedecken was trained at the Wisconsin Art Institute, the Milwaukee Art Students' League, and the School of the Art Institute. In Paris he studied at the Académie Julian with Alphonse Mucha, who was also at the School of the Art Institute from 1906 to 1911. Niedecken was attracted to the contemporary stylistic movements of art nouveau, Arts and Crafts, and Vienna secessionist during his grand tour of Europe from 1899 to 1902. When he returned to Milwaukee, he collaborated with many Prairie school architects, including Frank Lloyd Wright and the firm of Purcell and Elmslie, as an interior architect-designer. In 1907 he opened his own firm, Niedecken-Walbridge, in Milwaukee, with his brother-in-law as business manager, and supervised the execution of the furniture for Wright's Avery W. Coonley and Frederick C. Robie houses. In 1910 he added his own custom workshop, serving many of the leading architects. He believed in the concept of total design, working closely with architects and clients to integrate his interiors to the architectural whole. His mural is in a private firm in the Rookery Building.

John Warner Norton (1876–1934) Born to a prominent family in Lockport, Illinois, John Warner Norton enjoyed a distinguished career as illustrator, painter, muralist, and teacher. He was the most prolific muralist of the pre-WPA period, and his work progressed from an early Beaux Arts style to modernism in response to the direction of art in his time. He provided designs for the interior of Frank Lloyd Wright's Midway Gardens in 1914, unfortunately never realized, and continued to work in close collaboration with many of the most important architects in Chicago. He was educated at Harvard University and the School of the Art Institute, where he taught composition, life drawing, illustration, and mural painting from 1910 to 1929 and became head of the Mural Department. Considered a "progressive voice in a conservative, academic school," he taught such students as Tom Lea, Ethel Spears, Archibald Motley Jr., Theodore Roszak, and John Steuart Curry. With Lea, he created murals for the 1933 Century of Progress Science Building, which were later moved to the Museum of Science and Industry, and designed a terrazzo mosaic esplanade with shallow pools representing the twelve months

of the year for the entrance of the Adler Planetarium. During the 1920s he lived and worked in the Tree Studios, often assisted by Tom Lea. In Chicago his murals may be seen at the Cliff Dwellers and Tavern Clubs, Wacker Tower, Chicago Board of Trade, Loyola University Library, Fuller and Hamilton Park Fieldhouses, and Peirce School. His great modernist mural of 1929 for the Daily News Building was removed from the ceiling in 1993, and there is great concern in the city for its future. He also did a series of murals for the Logan Museum at Beloit College, Notre Dame University, a bank in Aurora, Illinois, and a courthouse in St. Paul, Minnesota.

Angela Occhipinti Angela Occhipinti lives in Milan, where she has been chair of engraving techniques at the Academy of Fine Arts since 1978. Specializing in graphics, she received her degrees from the State Institute of Arts and State Faculty of Arts in Florence. She called her abstract mural for the Sister Cities International Program at O'Hare Airport *Shadow on the Lake.*

Anita Parkhurst (1892–?) Anita Parkhurst was born in Chicago and settled in New York, where she became an illustrator. Her commissions included covers for the *Saturday Evening Post* and *Collier's* magazines. Her mural is at the Sherman Park Fieldhouse.

Ray Patlan Ray Patlan is one of the leaders of the contemporary mural renaissance in the United States, and his earliest work had its roots in the Mexican barrio of Chicago's Pilsen area. He studied at the School of the Art Institute, where he also became an instructor, and spent time in Mexico studying the work of the great Mexican muralists. Returning in 1969 from fighting in the Vietnam War, he began to work with young people in Pilsen. His 1970 murals for Casa Aztlan Community Center in Pilsen are his earliest mural work. While teaching and lecturing at schools including the University of California at Berkeley and Academia San Carlos in Mexico, he directed and participated in numerous mural projects. He moved to San Francisco in 1975.

Lucille Patterson Lucille Patterson's mural is at the Sherman Park Fieldhouse.

Bertha Sophia Menzler-Peyton (1874–ca. 1950) Bertha Sophia Menzler-Peyton was born in Chicago and studied at the School of the Art Institute and in Paris. She

was active in Chicago before 1921 and worked as a painter, teacher, and writer. Her work was exhibited at the Art Institute, Detroit Institute of Arts, Corcoran Gallery, and National Academy of Design. Her mural is in the Fine Arts Building.

Henry Varnum Poor (1888–1970) Born in Chapman, Kansas, Henry Varnum Poor studied at Stanford University, at the Slade School of Art in London, and at the Académie Julian in Paris. He returned to Stanford as an instructor and worked as a ceramist. During the First World War he was a regimental artist, and afterward he moved to upstate New York, where he concentrated on painting the American scene. His landscapes and portraits were realistic if somewhat austere. His Treasury Section mural is at the Uptown Post Office. He also executed frescoes for the Departments of Justice and the Interior in Washington, D.C. He taught at Columbia University and at Skowhegan School in Maine and was celebrated for his illustrations for Jack London's *Call of the Wild.*

Jon Pounds (1948–) Born in a farming community in Wisconsin, Jon Pounds received his undergraduate and graduate education at Illinois State University. He moved to Chicago and taught at Bloom Trail High School in Steger, where he ran a student mural program with his fellow teacher and future wife, Olivia Gude. Together they became involved in creative community projects and were especially active in Pullman, where they lived. Although he is primarily a sculptor he also paints, and he is now director of the Chicago Public Art Group, having initially served as its part-time director since 1988. He has trained young artists and directed and participated in many large-scale art and mixed-media projects in the Chicago area, both temporary and permanent. He designed the benches and delineated the site layout for Navy Pier's Gateway Park and collaborated with Olivia Gude on the mural in Pullman.

Marcos Raya (1948–) Born in Irapuato, Guanajuato, Mexico, Marcos Raya came to Chicago in 1964 with his mother, a native of Springfield, Illinois. He said that when he first came to the Pilsen neighborhood, it reminded him of Tijuana and that today it still feels like Tijuana in the 1970s. He took courses at the School of the Art Institute while in high school and later was a scholarship student at Windsor Mountain School in Lenox, Massachusetts. He left school to study in Mexico and joined the student protest movement. Returning to Pilsen, he became a major

participant in the local community mural movement and has been a teacher to many of the artists. His paintings have been shown extensively in traveling exhibitions and locally at the Museum of Contemporary Art's *Art in Chicago: 1945–95*, at the State of Illinois Gallery's 1995 *Healing Walls*, a retrospective exhibition at the Cultural Center 2000, and at the Mexican Fine Arts Museum, and in Europe and Mexico. His work is at the Casa Aztlan Community Center in Pilsen, and his mural *Cataclysm* was part of the Chicago Historical Society's 1996–97 exhibition titled *Pilsen/Little Village: Our Home, Our Struggle,* and the recent Cultural Center exhibition, Winter 2000.

Nicolai Remisoff (or Remisov) (1887–1975) Nicolai Remisoff, who was born in St. Petersburg, entered the Royal Academy of Art at an early age. He served in the Russian army until the 1917 revolution, when he escaped to Paris. Joining such avant-garde artists as Léon Bakst, Boris Anisfeld, Mikhail Larionov, and Natalya Goncharova, he designed stage decorations for Sergei Diaghilev's ballet company. He came to the United States in 1922 to help create a theater production for a Russian group performing in New York and remained in this country, becoming a United States citizen. He created decorations for Chicago ballet companies, the Museum of Science and Industry, country houses, and the Women's Athletic Club. His murals are at the Lake Forest Library.

Louis Pierre Rigal (1889–1955) French artist Louis Pierre Rigal was born in Marvejols, France, and died in Paris. He won the Grand Prix de Rome in 1919, a gold medal at the International Exposition of 1937, and other awards. He painted his Palmer House ceiling murals in Paris on twenty-one separate pieces of canvas and shipped them to Chicago. He exhibited in New York in 1932 and executed a series of murals on classical subjects for the Park Avenue foyer of the Waldorf-Astoria Hotel. The foyer also has a marble mosaic floor known as *Wheel of Life,* designed by Rigal.

Mark Rogovin (1946–) Born in Buffalo, New York, Mark Rogovin received his B.F.A. from the Rhode Island School of Design in 1968 and his M.F.A. from the School of the Art Institute in 1970. He worked for Chicago's Urban Gateways for nine years, teaching and conducting mural workshops. He founded the Public Art Workshop several years later. After working with David Alfaro Siqueiros, one of the great Mex-

ican muralists, on his last mural, he felt it was important to make the work of the masters of the Mexican mural movement better known in Chicago. To this end he assembled a slide collection that he donated to the Mexican Fine Arts Museum. Another significant contribution to the mural movement was the *Mural Manual,* which Rogovin wrote in 1972 as a step-by-step guide to producing murals. The book sold fourteen thousand copies and spawned workshops all over the world. In 1980 he founded the Peace Museum and was its curator and director for five years. His mural is at Engine 44 Firehouse.

Oscar Romero (1954–) Oscar Romero was born in Mexico City into a creative family: two of his brothers are artists, and a third is professor of art and philosophy at the University of Mexico. Romero works in many media, including painting, drawing, engraving, fresco, and sculpture. He has exhibited his work in Mexico, South America, Europe, and the United States and has studios in Chicago and Mexico City. His mural is at the Walker Branch Library.

Paul Turner Sargent (1880–1946) Paul Turner Sargent was born and died in Coles City, Illinois. He studied at Eastern State Illinois Normal School and the School of the Art Institute, where he taught from 1938 to 1942 and exhibited four times during his student years. His mural commissions include the Crippled Children's Home, Sherman Park Fieldhouse, and Smyth School.

Eugene Savage (1883–1966) Eugene Savage was born in Covington, Indiana, and grew up in Washington, D.C., attending Gonzaga College and the Corcoran School of Art. He also studied at the School of the Art Institute, the Chicago Academy of Fine Arts, and the American Academy in Rome, where he learned the technique of fresco. His Treasury Section murals of 1937 titled *Carrier of News and Knowledge* and *Messenger of Sympathy and Love* are in the Federal Building in Washington, D.C. He settled in Ossining, New York, and taught at Yale University, Carnegie Institute, and Cooper Union. His murals are at the Elks Memorial.

Philip Ayer Sawyer (1863–1949) Born in Chicago, Philip Ayer Sawyer studied under John Vanderpoel at the School of the Art Institute and with Léon Bonnat in Paris at the École des Beaux-Arts. His commissions include an etching titled *El Bridge* for the Library of Congress and murals for the New York Public Library and

the Gary School in Chicago. He spent some years in Detroit and later taught at Clearwater Academy in Florida.

Carl Scheffler (1883–1962) Born in Chicago, Carl Scheffler studied at the School of the Art Institute and was art director of the Evanston schools for fifteen years. He also taught at the Chicago Academy of Arts and the Academy of Fine Arts in Evanston. Another WPA mural by him is at the Haven School in Evanston.

Raymond J. Schwab (1912–80) Raymond J. Schwab graduated from the University of Illinois at Urbana in 1931, two years ahead of his class. He earned a master's degree in architecture and engineering from Armour Institute (now Illinois Institute of Technology), supporting himself as night watchman at the Curtis Candy Company. He worked for Chicago architect James Eppenstein, a firm that specialized in the design of offices, showrooms, stores, and restaurants, and usually designed the furniture as well as the interiors. He was friendly with Frank Lloyd Wright. His mural in collaboration with Robert Bruce Tague was in the WGN Broadcasting Studios Building.

William Edouard Scott (1884–1964) William Edouard Scott painted more than seventy-five murals during his lifetime. He was born in Indianapolis, Indiana, and spent four years at the School of the Art Institute, where he received his early training in mural painting and won several awards and scholarships. After further study in Paris at the Académie Julian and the Académie Colarossi and with the noted black artist Henry Ossawa Tanner, he returned to Chicago. Searching for new ways of treating black themes, he made many trips to the South, painting rural genre scenes and over thirty portraits of prominent black men and women. During World War I he sketched black soldiers in action and illustrated several covers for *Crisis,* a magazine of the National Association for the Advancement of Colored People, edited by W. E. B. Du Bois, who founded the NAACP in 1909. Scott spent 1931 as artist in residence in Port-au-Prince, Haiti, on a Julius Rosenwald fellowship, and he is credited with stimulating the interest of Haitian artists in painting local scenes and with initiating the establishment of the Haitian Art Center, which became the focus of an artistic explosion of folk art in the 1950s. Always a realistic painter, his art encompassed both easel and mural formats and historical as well as religious themes "peopled," as art historian Barry Gaither wrote, with men

and women "who . . . sweat, strain, laugh, talk and labor in a context of equality." His murals are primarily in Illinois and Indiana, in churches, schools, hospitals, government buildings, and banks. There are four surviving examples in Chicago, at Shoop School, Lane Technical High School, Pilgrim Baptist Church, and the Wabash YMCA. Chicago saw his retrospective exhibition in 1996 at the Terra Museum.

Novart Seron Novart Seron's mural is at the Sherman Park Fieldhouse.

Irene Siegel (1932–) Born in Chicago, Irene Siegel received her B.A. from North-western University, M.A. from the Institute of Design of Illinois Institute of Technology, and M.A. in Spanish from the University of Chicago. She has exhibited widely, lectured, and taught, and her work is in many private collections. For her mural at Sulzer Library, she traveled widely and did extensive research on the fresco technique. Siegel included many quotations from widespread literary sources in her mural, and these and its expressionistic style provoked a controversial response from the community. Siegel recognized the struggle as "a tradition with artists."

Henry Simon (1901–95) Henry Simon, painter, lithographer, photographer, and poet, was born in Poland and came to Chicago at age five. He dropped out of high school to go to work as an apprentice in a sign shop where he was fortunate to meet an artist who encouraged him to study art. After attending the Chicago Academy of Art and the School of the Art Institute, he worked for eight years with Chicago painter A. Raymond Katz, creating movie posters for the Balaban and Katz movie theater chain. In 1933 he produced dioramas for Chicago's Century of Progress Exposition. In what he called his most prolific period, from 1936 to 1942, his artwork for the WPA's Illinois Art Project appeared in magazines and galleries, and his mural commissions included Cook County Hospital, the Osbourne, Ohio, Post Office for the Treasury Section, and McKendree College in Lebanon, Illinois, now hanging at Wells High School in Chicago. He was art director at Hull House from 1944 to 1945. Simon turned to photography in the 1970s, concentrating on people and street scenes, and his work was given a one-man exhibition at the Art Institute in 1973. In his last years, after using surreal imagery, he began to work in an abstract style. In 1997 the work of this long-lived artist was shown in a retrospective exhibition at the Mary and Leigh Block Gallery, Northwestern University.

Gerritt V. Sinclair (1890–1956) Gerritt V. Sinclair was born in Grand Haven, Michigan, studied with John Warner Norton at the School of the Art Institute, and was awarded a scholarship for travel to Europe. He taught painting and drawing at the Layton School of Art in Milwaukee for thirty-five years until his death. During 1927–45 he exhibited at Paris salons, the Philadelphia Academy of Fine Arts, the Carnegie Institute, the National Academy of Design, the Brooklyn Museum, and the Whitney Museum and had a mural commission from the Treasury Section for the Wausau, Wisconsin, Federal Building. He was highly praised for his outdoor scenes of Wisconsin, which were also exhibited in New York. His mural is at Sherman Park Fieldhouse.

Mitchell Siporin (1910–76) Mitchell Siporin, active in Chicago as a painter, muralist, theatrical designer and teacher, was born in New York City but received his early training in Chicago. The encouragement of a zoology teacher at Crane Junior College, who saw his notebook, led him to study with Todros Geller, a Chicago painter and stained glass window designer, and later to attend the School of the Art Institute. He worked for the WPA and the Treasury Section from 1939 to 1942, during which time he collaborated with Edward Millman on a fresco mural series for the St. Louis Post Office that was the highest-paid federal government commission at that time. He also did murals for Lane Technical High School. His illustrations appeared in *Esquire* and *New Masses* magazines, and he won a Guggenheim fellowship in 1945. From 1949 to 1950 he was at the American Academy in Rome on a Prix de Rome fellowship. The influence of the Mexican mural movement's use of social realism is apparent in his work. He taught at the Boston Museum School and Columbia University, and in 1951 he organized the Fine Arts Department at Brandeis University, where he remained as a professor until his death. The Art Institute, Phillips Gallery, Museum of Modern Art, Whitney Museum, Carnegie Institute, and museums in Portland, Toronto, and St. Louis have exhibited his work, and it is in numerous collections including Brandeis University, the Metropolitan, Philadelphia Museum, Chicago Art Institute, Harvard University, and the New York Public Library.

George Melville Smith (1879–?) Born in Chicago, George Melville Smith studied at the School of the Art Institute and with the French artist André Lhote in Paris. He traveled and painted in France, Spain, England, Italy, and the United States. He exhibited at the Art Institute and was active in arts organizations in Chicago.

At the 1933 Chicago Century of Progress Exposition he created a mural titled *Paint, Powder, and Jewels* for the General Exhibits Building. He was supervisor of the Applied Art Project of the Federal Art Project in 1936, and his mural commissions for the Treasury Department include post offices in Elmhurst and Park Ridge, Illinois, and in Crown Point, Indiana. For the WPA, he created two murals for the Schubert School in Chicago.

Kiela Smith (1970–) Kiela Smith was educated at the School of the Art Institute, where she earned her degree in photography in 1991. That year she spent a month in Africa studying art techniques from the Baule and Senufo villages on West Africa's Ivory Coast through Parsons School of Design. She has worked in collaboration with community artists, architects, schools, and others to organize and produce public art projects. She has developed arts-in-education programs, conducted workshops and residencies, and organized special projects with the Chicago Public Schools. She joined the Chicago Public Art Group in 1990. She has created murals using fresco and other mediums and worked as a photographer and researcher for the Du Sable and Field Museums. Two of her mosaic works are at the Pullman Branch Library and Navy Pier's Gateway Park.

Nina Smoot-Cain (1943–) Nina Smoot-Cain was born in Ohio and is the special projects director for Urban Gateways. She has worked on a number of mosaic projects for the Chicago Public Art Group, including the Pullman and Harold Washington Libraries.

Miriam Anne Socoloff (1949–) Miriam Anne Socoloff earned a B.S. in art education from Northern Illinois University in 1971 and an M.S. from Spertus College of Judaica in 1985. She was also a student at large at the School of the Art Institute from 1975 to 1995. Since 1972 she has taught art at Lake View High School, where she chairs the Art Department. In 1998 she was one of three Chicago public school teachers to win a Golden Apple Award for excellence in teaching. She has exhibited at the Art Institute and Wood Street Galleries. As a mosaic artist, her commissions include North Shore Congregation Israel, Lake View High School, and Meyer Kaplan and Bernard Horwich Jewish Community Centers.

Jiři Sopko (1942–) Born in Sub-Carpathian Russia (Ruthenia), Jiri Sopko studied at the Prague Academy in the 1960s. He has exhibited in Prague, where he lives,

and in Munich, Amsterdam, and Belgrade. His Sister Cities International Program mural at O'Hare International Airport is called *Chicago*.

Ethel Spears (1903–74) Ethel Spears was born in Chicago and graduated from the School of the Art Institute, where she worked with John Warner Norton. She also studied in Woodstock, New York, with Aleksandr Archipenko, at the Art Students' League in New York, and in Europe. She returned to the School of the Art Institute in 1930 to earn her M.F.A. and later taught and exhibited there. Her WPA commissions in the Chicago area include Cook County Hospital, Nettelhorst, Kozminski, and Linné Schools in Chicago and Carroll, Barrie, and Andersen Playground Fieldhouses and Lowell School in Oak Park. She died in Texas, where she had lived since 1961.

Nancy Spero (1926–) Since the 1970s, Nancy Spero's work has been concerned with the position of women in history. At that time she wrote, "Women must have been present in history, it's just that we've been written out and we must write ourselves back in." Her mural at the Harold Washington Library depicts women from earliest civilizations to the present. She was born in Cleveland and studied at the School of the Art Institute and in Paris at the Atelier André Lhote and the École des Beaux-Arts. Her public art commissions include installations for the Museum of Contemporary Art in Los Angeles, the Kunsthalle in Frankfurt, and Smith College.

Grace Spongberg (1904–92) Born in Chicago, Grace Spongberg graduated from Morgan Park High School, Crane Junior College, and the School of the Art Institute, where she studied under Albert Krehbiel, Louis Rittman, and others, and at Ox-Bow, the summer school of art at Saugatuck, Michigan. She traveled extensively through Europe and the Far East. Her work was exhibited at the Art Institute of Chicago, the Pennsylvania Academy of Fine Arts, and the Joslyn and Cincinnati Art Museums. She worked as a photographer and painter, in the mediums of oil, watercolor, serigraphy, lithography, ceramics, and enamel. Her WPA commissions are at the Mason and Bennett Schools.

George F. Steinberg George F. Steinberg's mural is at the Sherman Park Fieldhouse.

Harry Sternberg (1904–) Harry Sternberg has had a long career as a painter, printmaker, teacher, and author. He was born to a poor immigrant family in New York,

and he worked his way through the Art Students' League and joined its faculty after graduation, teaching from 1934 until 1966. During the New Deal period he created murals for the Treasury Section for post offices in Ambler and Sellersville, Pennsylvania, and in Chicago (Lakeview), and he was an adviser to the Graphics Division of the Federal Art Project. In 1936 he spent several months on a Guggenheim fellowship documenting the lives of steel and agricultural workers in Pennsylvania mining towns. In the depression years of the thirties and forties he shared the struggle for survival with fellow artists and friends Will Barnet, George Grosz, Marsden Hartley, Jacob Lawrence, and others as part of the New York art scene and said it was the most exciting period of his life. He also knew Mexican muralists David Alfaro Siqueiros and Diego Rivera, who worked in New York during some of these years. He participated in the first Whitney Museum Invitational Annual in 1937, taught at various schools, and exhibited for many years at the ACA Gallery in New York. Since 1966 he has lived in Escondido, California. There were retrospective exhibitions of his work at the University of Minnesota Gallery and Edwin A. Ulrich Museum of Art, Wichita State University, in 1975 and at the San Diego Museum of Art in 1994. He wrote books on etching and silk-screen color printing and on woodcuts, including an autobiography, *Sternberg: A Life in Woodcuts,* in 1991. Many museums collected his work, including the Whitney, Metropolitan, Brooklyn, Cleveland, and National museums, as well as the Art Institute of Chicago. An exhibition in October and November 1999 at a New York gallery, called *Harry Sternberg and His Circle,* marked his ninety-fifth birthday.

Gordon Stevenson (1892–1984) Born in Chicago, Gordon Stevenson studied at the School of the Art Institute, where he was a student when he executed his mural at Lane Technical High School. Settling in New York City, he specialized in portraiture. His paintings were exhibited at the Berlin Olympics of 1936, the Art Institute, and the National Academy of Design, and his work is in the collection of the Brooklyn Museum. *Time* magazine featured his portrait of David Lloyd George on its cover in 1923. Another example of his mural work is in a private office in the Rookery Building.

Ginny Sykes (1957–) Ginny Sykes was born in Washington, D.C., and received her B.F.A. in painting from Washington University, St. Louis, in 1979. She also studied in Florence at the Studio Cecil Graves. She assisted in the 1998 Navy Pier *Water Marks* benches project and in other mural projects in the city, through the Beacon

Street Gallery and the Chicago Public Art Group. She is on the faculty of the School of the Art Institute. Her Erie Terraces mosaic murals were commissioned by the Public Art Program as part of the Riverwalk Gateway Project.

Robert Bruce Tague (1912–84) Born in Chicago, Robert Bruce Tague studied at the Chicago School of Design and Armour Institute (now Illinois Institute of Technology), where he was later a member of the faculty in 1939–43, 1946–50, and 1953–54. He was a member of the American Institute of Architects. His artwork was exhibited at the Renaissance Society, North Shore Art League, Benjamin Gallery, Riccardo's Restaurant, Well of the Sea, Baldwin Kingery, and Associated American Artists Gallery. His mural, done in collaboration with Raymond J. Schwab, was in the WGN Broadcasting Studio.

Edwin Terwilliger (1872–?) Edwin Terwilliger was born in Mason, Michigan, and lived in Chicago, where he was a member of the Palette and Chisel Academy of Fine Arts. His mural is in the Columbus Park Fieldhouse.

Edward Trumbull (1884–1968) Edward Trumbull was born in Detroit and grew up in Connecticut. He studied at the Art Students' League in New York and worked his way to England to study with Frank Brangwyn from 1906 to 1912. He began his career in Pittsburgh, where he taught mural painting at the Carnegie Institute of Technology and completed mural commissions for the Grant Building and the H. J. Heinz Company Administration Building. He moved to New York in the 1920s and created murals for the concourse connecting the Graybar Building to Grand Central Station, as well as for Grand Central's Oyster Bar and Restaurant, the lobby ceiling of the Chrysler Building, Chase National Bank, and Metropolitan Life Insurance Building. He was appointed color director for Rockefeller Center in 1932. Other commissions include the San Francisco Panama-Pacific International Exposition and Union Station, Washington, D.C. He has been called a "spirited Maxfield Parrish." His only Chicago murals are at the Museum of Science and Industry.

Charles Turzak (1899–1986) Charles Turzak was born in Streator, Illinois, to Czechoslovakian immigrant parents and began drawing and carving peach pits into miniature monkeys when still in elementary school. He became a painter, printmaker, illustrator, cartoonist, designer, author, lecturer, and teacher. He was educated at the School of the Art Institute and settled in Chicago, where he lived

until he moved to Orlando, Florida, in the 1950s. During the New Deal era, he executed mural commissions for Chicago's main post office and the Lemont, Illinois, Post Office, and his work was exhibited at the 1933 Century of Progress Exposition. Working as an illustrator for various commercial firms, he met the young architect Bruce Goff and in 1938 commissioned him to build his house in the northwest suburbs, now given Chicago landmark status. Among the museums that exhibited his artwork are the Kansas City, Milwaukee, and Chicago Art Institutes, and his work is in the permanent collections of the Library of Congress, Chicago Historical Society, and Art Institute of Chicago, among others. Books he illustrated include *Abraham Lincoln, Biography in Woodcuts, All about Chicago,* by John and Ruth L. Ashenhurst, and *Benjamin Franklin, Biography in Woodcuts,* with text by Florence Turzak.

Roy Tyrell Roy Tyrell's mural is at the Sherman Park Fieldhouse.

Roberto Valadez (1962–) Roberto Valadez's participation in a community mural while a high school student led him to enroll at the School of the Art Institute. He has been active in the Pilsen area as a youth organizer at Casa Aztlan Community Center, and he is one of the first muralists to work with young graffiti artists. He has directed many projects, designed posters, and exhibited in various galleries. He was one of the participants in the Harold Washington Library mural.

William Walker (1927–) William Walker was born in Birmingham, Alabama, but grew up in Chicago, where he attended Betsy Ross and Sexton elementary schools and Englewood High School. He served in World War II and also in the Korean War, entitling him to four years of college on the GI Bill. At the Columbus Gallery of Art (now Columbus College of Art and Design) he studied fine arts and won the school's forty-seventh annual group exhibition award, the first African American to be so honored. After graduating in 1954 he went to Memphis, where he painted his first murals. It was there, while supervising the photographing of a group of "toilworn" men, women, and children picking cotton on a plantation as the subject of a mural commission, Walker said, that "I decided to dedicate my work to speaking for them and their cause, and others like them" (interview by Jeff Huebner, *Reader* [Chicago], August 29, 1997). He returned to Chicago in 1955, earning his living as a decorative painter and later postal worker, with the idea of wall painting always in his mind.

In 1967 he became involved in a project with members of the Organization for Black American Culture, which involved not only artists but musicians, writers, and educators, to create a mural that honored African American heroes. Located in the black community where he lived and intended for a black audience, the resulting *Wall of Respect* was the first outdoor community effort and is credited with inspiring a "people's art" movement that spread across the country. Although *The Wall of Respect* was in a high-crime area, it was never defaced, but only a few years after it was completed the building was declared unsafe and had to be demolished. A small panel fragment remains, in the collection of the Du Sable Museum. Walker became active in the newly developing Chicago mural movement, because he saw public art as a way of building self-respect among his fellow blacks. In 1970 he, Eugene Eda, and muralist John Pitman Weber formed the Chicago Mural Group, made up of artists of many ethnic groups, which is still active today, now renamed the Chicago Public Art Group. Walker has won numerous awards and is responsible for many community murals. His strongest belief, he says, is in the brotherhood of man.

John Edwin Walley (1910–74) John Edwin Walley came to Chicago from Sheridan, Wyoming, and graduated from the Chicago Academy of Fine Arts in 1930. His continuing studies included political cartooning, painting, and design with Rudolph Weisenborn, scenic design at the Goodman Theater, and large-scale architectural mural production. In 1933 he spent a year at the University of Wyoming teaching and painting, and he returned to Chicago to join a commercial firm where he designed sets and displays. For the WPA's Illinois Art Project, he completed murals for two Chicago high schools and became director of its design workshop in 1939. Appointed assistant state director for all projects in 1942, Walley supervised 2,400 unemployed craftsmen, who were put to work producing equipment and environments for such government-sponsored projects as schools, state and city parks, hospitals, and zoos throughout Cook County and Illinois. After a stint in the army in 1943, working as a draftsman, camouflage expert, and traveling lecturer-teacher, he was asked to join the original faculty of László Moholy-Nagy's Institute of Design. Five years later it became part of Illinois Institute of Technology. He joined the Architecture Department at the University of Illinois at Chicago in 1953 and became chair of the Art Department in 1971, where he was the innovator of many projects in art and design education. He lectured and wrote, always continuing to create art and furniture and to design interiors. His book *The Influence*

of the New Bauhaus in Chicago: 1938–42 was published in Chicago in 1965. His WPA commission is at Lane Technical High School.

Mildred Waltrip (1911–) Mildred Waltrip was born in Madisonville, Kentucky, and studied at the School of the Art Institute in 1928–29, at Northwestern University, and with László Moholy-Nagy and Aleksandr Archipenko. Traveling fellowships allowed her to visit Europe in 1934. She worked for Marshall Field and Company as a commercial artist, did illustrations for a guidebook to Cairo, Illinois, and worked for an advertising agency in New York City. Her mural commissions in Chiçago include the Congress and Sherman Hotels and Henrici's Restaurant, and for the WPA's Illinois Art Project in Chicago they include Cook County Hospital, the Chicago Park Administration Building, Ravinia School in Highland Park, and Hatch School in Oak Park. Only the last two are extant.

Lucille Ward (1907–) Born in Hermann, Missouri, Lucille Ward studied at the School of the Art Institute, receiving her B.F.A. in 1932. She was attracted to the work of the Mexican muralists on a trip to Mexico and joined the WPA's Illinois Art Project in 1936. Although her murals at Harrison Technical High School and Cook County Hospital have disappeared, those at Morrill, Pasteur, and Sawyer Schools in Chicago are extant.

John Pitman Weber (1942–) "I learned my craft as a public artist in the streets of Chicago," said John Pitman Weber. He was raised in New York City, graduated from Harvard in 1964, and attended the École des Beaux-Arts in Paris from 1964 to 1966, consulting with Jean Hélion. He studied with Stanley Hayter at Atelier 17 in 1966 and earned his M.F.A. at the School of the Art Institute in 1968. Describing himself as one of the first "Euro-American" artists to participate in mural painting, he was a founding member with William Walker and Eugene Eda of the Chicago Mural Group in 1970 and its main administrator for ten years. He was coauthor with Eva and Jim Cockcroft of *Toward a People's Art: The Contemporary Mural Movement,* first published in 1977 and reissued in 1998 in an expanded format. In addition to his activity in Chicago, he has worked in Europe, New York, and Los Angeles. Muralist, teacher at Elmhurst College, writer, and conductor of workshops, he is an active participant in the Chicago artistic community. Among his murals are those at Holy Covenant Church, the Harold Washington Library, and the United Electrical Workers Hall.

Egon Weiner (1906–89) Egon Weiner was born and educated in Vienna and came to the United States in 1938 to escape Nazi persecution. He soon joined the faculty of the School of the Art Institute and was active in Chicago, primarily as a sculptor. His large outdoor bronze works include the 1954 *Brotherhood* and *Pillar of Fire*. He exhibited in Europe and at the Art Institute, and his work is in the collections of Beloit, Rock Island, and Augustana Colleges and the University of Illinois. His etched glass window murals are at the Standard Club.

Rudolph Weisenborn (1881–1974) Rudolph Weisenborn, who was orphaned at nine, paid for his training at the Students School of Art in Denver by working as a gold miner, cow puncher, and janitor. Proud at first of the academic approach to art he had mastered, he soon rejected it, saying that it took him ten years to get it out of his system. He returned to Chicago, his birthplace, in 1913, the year the radical Armory Show came to the city. He had a long career in Chicago as an avant-garde artist and was called "a pioneer abstract painter and visionary" because of the references in his work to the European art movements of cubism, expressionism, and fauvism. His anti-institutional attitude led him and several other artists to form the Chicago No-Jury Society of Artists. When his painting *Chicago* was exhibited at the Art Institute in 1928, it was described as "a unique marriage of modernistic formal vocabulary with a contemporary Chicago subject." His WPA mural, also titled *Chicago,* is at the Nettelhorst School. He exhibited widely and taught at the Chicago Academy of Arts and in his studio until 1964. He was also known for his portraits in charcoal, casein, and oil.

Cynthia Weiss (1948–) Murals were one of Cynthia Weiss's earliest memories from a childhood spent in Mexico City. Later she encountered the mosaics of Antonio Gaudi during the time she spent in Barcelona while earning her B.A. at Colorado College in 1975. She continued to focus on public art at the University of Illinois at Chicago, where she received her M.F.A. She has worked for many years as a professional artist and arts educator, with expertise in teacher training, project development, and integrated arts curriculum design. She developed her own business, Cynthia Weiss Mosaics, through which she produced more than twenty-five large-scale mosaic murals for private and public spaces. Teaching and directing art programs, Weiss has worked with students at many schools on projects sponsored by Urban Gateways, Erickson Institute, Pulaski Community Academy, and other organizations. Among her mosaic mural commissions in

Chicago are installations at the Chicago Children's Museum, North Shore Congregation Israel, Jackson Language Academy, Bernard Horwich Jewish Community Center, Lozano Library, and Navy Pier's Gateway Park.

G. Werveke G. Werveke's mural is at the Smyth School.

Bernard Williams (1964–) Bernard Williams grew up in Chicago's Roseland Community. He studied art in Paris, Rome, and Germany and holds a B.F.A. from the University of Illinois at Urbana and an M.F.A. from Northwestern University, where he concentrated on large-scale historical paintings. He has taught at the School of the Art Institute since 1990. As an instructor at the Marwin Foundation since 1991, he teaches drawing and painting and directs murals with Chicago public school children. He is an active member of the Chicago Public Art Group, both creating and restoring murals. His mural at the Pullman Library is typical of his work, with its emphasis on historical, political. and cultural themes. Another of his murals is also in the Pullman neighborhood.

Karl Wirsum (1939–) "Being able to be serious but not taking yourself so seriously is important to me," said Karl Wirsum. In 1966 he joined five other Chicago artists to form "The Hairy Who." After three exhibitions at the Hyde Park Art Center, the artists became a powerful group whose work employed humor in questioning the art establishment. Wirsum was born in Chicago and earned his B.F.A. at the School of the Art Institute in 1961. Interested in comic strips since boyhood and attracted by the bold colors he saw during travel in Mexico after his college graduation, he considers these his strongest influences. Taking his themes from popular culture, he creates a fantasy world filled with playful figurative objects that are boldly colored and outlined. He continues to be active in the Chicago "Imagists" movement, has exhibited widely, including a retrospective in 1991 at the Krannert Museum, University of Illinois, has won a number of awards, and is a part-time instructor at the School of the Art Institute. His most visible mural commission is on the facade of the Commonwealth Edison Substation, and his work is also at the First National Bank and at the Harold Washington Library.

Caryl A. Yasko (1941–) Born in Racine, Wisconsin, Caryl A. Yasko earned her B.A. at Dominican College and today lives in Whitewater, Wisconsin. She has played an important role in the American mural movement, as an original member of the

Chicago Mural Group and a prizewinning muralist in Chicago in the 1970s. Both muralist and sculptor, Yasko has been active in Wisconsin schools in a program called Wisconsin Artists and as an innovator in contemporary public sculpture. She has taught public art techniques at the School of the Art Institute and at other schools, lectured, participated in symposiums, led workshops, and worked with children on many mural and sculpture commissions. Because she believes that "the real significance of public art is the public's contribution to the idea of the piece," she solicits the participation of the community in the creation of these works of art.

Amy Yoes (1959–) Born in Heidelberg, Amy Yoes studied at the School of the Art Institute, receiving her B.F.A. in 1984. She has exhibited in Chicago and abroad and won a number of awards and travel grants. She also works in sculpture. Her mural is at the McKinley Branch Library.

Zheng Bo (1957–) Zheng Bo was born in Shen-yang, China, and graduated from Lu Xun Fine Arts Academy in that city, where he focused on oil painting. As a member of China's Oil Painting Circle, he has exhibited in Canada and was awarded the 1990 Outstanding Prize in the First China Oil Painting Best Selection Contest. *Chicago Impression,* his Sister Cities International Program mural at O'Hare International Airport, is set in Grant Park.

Denice Zwetterquist (1928–) Born in Sweden, Denice Zwetterquist spent her childhood in Brooklyn. Today she lives in Gothenburg, where she studied at the School of Arts and Crafts at the Valands Art School. She has won the Swedish government's award four times and has exhibited at the National Gallery in Stockholm, the Gothenburg Art Museum, and other places. Her mural for the Sister Cities International Program at O'Hare International Airport, *Chicago Pulse,* uses abstract images.

Mirtes Zwierzynski Born in São Paulo, Brazil, Mirtes Zwierzynski received her psychology degree from the University of Brazil in Rio de Janeiro in 1971 and her M.A. in sociology from the Sorbonne. Learning of Chicago's activist mural movement of the 1970s, she moved to the United States, settling in Chicago in 1984, where she sought to combine her political beliefs and her artistic abilities. She is fluent in several languages and has worked with the Coordinating Committee for Inter-

national Voluntary Services for UNESCO to produce materials for educational and economic development programs in Latin America. She has exhibited in São Paulo, Paris, Managua, New York, Vienna, and Chicago. A member of the Chicago Public Art Group, she participated in the mosaic project at Navy Pier's Gateway Park.

Glossary

A.R.T. A nonprofit visual arts literacy organization with programs presented by Chicago-area working professional artists. Art Resources in Teaching was founded in 1894 as the Chicago Public School Art Society. Working with Chicago public and parochial schools, it places teacher-artists in the classroom to teach and explore the arts, enhancing the education of Chicago school students and enriching a curriculum that often lacks art education. Mosaic and painted murals have been created under its direction.

ART DECO A style of art and design popular in the 1920s and 1930s in America and Europe, combining characteristics of art nouveau with geometric forms inspired by industrial design.

ART NOUVEAU A design style originating in the late nineteenth century, characterized by foliate forms and sinuous lines.

ARTS AND CRAFTS MOVEMENT A movement that began in England in the second half of the nineteenth century in reaction to the industrialization of crafts and favored a return to handcrafted design.

BEAUX ARTS A French phrase that means "fine arts." It is usually applied to architecture that uses classical forms, sometimes called "Beaux Arts classicism." The White City of the 1893 World's Columbian Exposition is a notable example of this style. Many of the American artists who studied at the École des Beaux-Arts in Paris in the nineteenth century absorbed its ideology.

COFFERED A term usually applied to a ceiling consisting of recessed panels that are square or of other geometric shapes.

CORNICE Ornamental molding along the top of a wall or building.

CPAG As "a multicultural coalition of professional artists working with communities to produce permanent public art," the Chicago Public Art Group continues the work of the Chicago Mural Group (CMG), a cooperative of twelve artists dedicated to producing meaningful public art in Chicago neighborhoods, founded

in 1970 by William Walker, Eugene Eda, and John Pitman Weber. CPAG considers all its programming as outreach to underserved communities. Its artists hold workshops for neighborhood volunteers, public school students, faculty members, and youth teams. In 2000 they cooperated in the publication of *Urban Art Chicago,* a guide to community murals by Olivia Gude and Jeff Huebner.

CUBISM An art movement explored initially in 1907 by Pablo Picasso and Georges Braque, in which the artists combined several points of view using fragmented geometric forms.

FAP One of the divisions of the WPA, comprising four cultural projects. The Federal Art Project, designated "Federal Project Number One," sponsored art, theater, music, and writers' projects. The Federal Art Project included eight divisions: murals, easel paintings, graphics, posters, sculpture, motion pictures, photographs, and the Index of American Design. During its existence from 1935 to 1943, it employed about five thousand artists and produced 2,566 murals nationwide.

FRESCO From the Italian word for "fresh," here the term refers to painting done with water-based pigment on fresh or wet plaster. This technique is known as "true fresco." In "fresco secco" paint is applied to dry plaster, and it is less permanent.

FRIEZE A decorative band, often at the top of a wall.

GALLERY 37 Conceived in 1991 as a summer jobs program, the nonprofit organization has expanded into a year-round program. Through its partnerships with schools, other city organizations, and independent artists, young people aged fourteen to twenty-one are paid to work as apprentice artists under the guidance of professionals at the original downtown site and in Chicago neighborhoods, parks, and public schools. There is also a "Connections Program" for younger students in grades five through eight. Murals, both temporary and permanent, have been created under its direction.

GOLD LEAF Gold that has been beaten into paper-thin leaves and painstakingly applied as gilding.

GOUACHE An opaque water-based paint. A painting in this medium is also called a gouache.

GRISAILLE A monochrome painting usually done in shades of gray.

GSA A program created in 1949 to provide and oversee government workplaces. The General Services Administration is the custodian of all works of art in federal buildings, dating from the 1850s to the present, including art produced in

the 1930s and 1940s under the WPA and the Treasury Section of Fine Arts. Its Art and Architecture program, established in 1968, seeks to incorporate works of art into the design of federal buildings, primarily works by living American artists. Over two hundred artworks have been installed in buildings across the country.

IAP The Illinois Art Project, the local arm of the Federal Art Project of the WPA that existed from 1935 to 1943. With headquarters in Chicago, it provided jobs for unemployed artists, who worked in various of the twelve divisions. Under the creative arts were easel painting, sculpture, murals, and graphic art. Under applied arts and service sections were ceramics, dioramas, Index of American Design, mosaics, photography, posters, stained glass, and exhibitions.

LUNETTE A semicircular panel or window, sometimes above a doorway or window. It is also called a tympanum.

MARWIN FOUNDATION A nonprofit organization, founded in 1987, that offers free programs in visual arts education, career development, and college planning to Chicago's underserved youth in grades seven to twelve. Its mission is to be the agent of education and social change through long-term commitment to each student. Its programs are led by professional artists, and the organization has sponsored many murals, both permanent and temporary.

MEXICAN MURAL MOVEMENT A term used to describe the mural work of three great Mexican artists, Diego Rivera, David Alfaro Siqueiros, and José Clemente Orozco, created during the 1920s and 1930s. The artists were sponsored by the Mexican government, and the murals they created for many public buildings dealt with Mexican history and the social problems of the country.

MURAL Painting on a wall or ceiling that is done directly on the surface, on canvas cemented to a surface, or on a panel fastened to the surface.

NEW DEAL A program adopted by President Franklin D. Roosevelt soon after his election in 1933 to alleviate the effects of the Great Depression. He created agencies to help the recovery of banks, farms, and the construction industry and to relieve unemployment and poverty. Social Security was established in 1935, and jobs were created by the WPA.

PERCENT FOR ART/PUBLIC ART PROGRAM An ordinance enacted by the city of Chicago in 1978 that "mandates a percentage of the cost of construction or renovation of municipal buildings to be set aside for the commission or purchase of artworks." The original 1 percent was later raised to 1.33 percent. The program is administered by the Chicago Department of Cultural Affairs. Similar programs

have been established in other United States states and municipalities. The Percent for Art Program is now called the Chicago Department of Cultural Affairs Public Art Program.

PRE-RAPHAELITE A style of painting adopted by a group of Victorian English artists who loved the medieval period and admired the simplicity of Italian pre-Renaissance art (before Raphael).

PWAP The first New Deal nonrelief project for artists, the Public Works of Art Project was part of the U.S. Treasury Department. During its seven short months of existence in 1933–34, it employed over three thousand artists nationwide. Its goals were to provide work for unemployed but qualified artists in decorating public buildings and to increase the public's interest in art.

SGRAFFITO A method of decoration or design made by scratching, incising, or cutting through wet pigmented plaster to reveal the color of the underlayer.

TEMPERA A paint medium composed of ground pigment in a water-soluble emulsion mixed with a gelatinous substance, most often egg yolk. Tempera preceded the development of oil paint.

TERRA-COTTA A material of baked clay, often glazed and used as architectural decoration.

TONDO From the Italian word for "round," it means a circular painting or work of art.

TRAP The Treasury Relief Art Project, administered by the Treasury Department but funded by the WPA. TRAP functioned from 1935 to 1939, producing eighty-nine murals, primarily in federal buildings including hospitals, post offices, and housing projects that were already completed or had no money in their construction budgets for decoration. A small percentage of its staff and artists were nonrelief at different times.

TREASURY SECTION The Treasury Section of Painting and Sculpture, later called the Treasury Section of Fine Arts, and known as "the Section." It was set up by the U.S. Treasury Department in 1934 to employ artists of merit to create sculpture and painting for new government buildings, mostly post offices, with funding through 1 percent of the cost of construction. Commissions were awarded through competitions and directly, and the work was meant to be uplifting. The agency operated until 1943, awarding 1,124 mural contracts involving 1,205 artists.

TROMPE L'OEIL A French term meaning "fool the eye," applied to painting that creates an illusion of three-dimensional reality.

URBAN GATEWAYS A nonprofit organization, founded in 1961, that provides multicultural literary, performing arts, and visual arts programs for children, teachers, and parents in the Chicago metropolitan area. Its mission is to serve locally as a resource and nationally as a model for incorporating the arts at all levels of education. More than a hundred murals have been created for schools in Chicago by professional artists from the Urban Gateways roster through its visual arts program. Mural projects can involve the students or not, according to the schools' wishes.

WHITE CITY The name given the dominant group of Beaux Arts, neoclassical buildings at the World's Columbian Exposition of 1893 in Chicago that were an important influence on city planning. The Museum of Science and Industry is a replication in permanent materials of the fair's Fine Arts Building. It was originally built of "staff," a mock stone substance of plaster, cement, and fiber that was meant to be temporary.

WPA One of President Franklin D. Roosevelt's New Deal programs, the Works Progress Administration, called the Work Projects Administration after July 1939, functioned from 1935 to 1943. It gave jobs to hundreds of thousands of unemployed people, many of them unskilled, who lost their jobs during the depression. It sponsored the building of dams, highways, bridges, public housing, schools, and libraries as well as offering job training and education services. The Federal Art Project (FAP) was one of its divisions. Work produced under its program totaled 2,566 murals, 17,744 pieces of sculpture, 108,099 easel paintings, and 240,000 prints.

Bibliography

I consulted many books and periodicals in the course of research. This partial list reflects my belief that its murals are part of Chicago's history and also an integral part of the architectural framework that supports them. It includes books and booklets, both general and specific, on Chicago buildings, history, the two fairs, art and artists, art in Illinois, community murals, and New Deal art.

The American Renaissance, 1876–1917. Brooklyn, N.Y.: Brooklyn Museum, 1979.

Art in Chicago: 1945–1995. New York: Thames and Hudson and Museum of Contemporary Art, 1996.

Block, Jean F. *The Uses of Gothic: Planning and Building the Campus of the University of Chicago, 1892–1932.* Chicago: University of Chicago Press, 1983.

A Breath of Fresh Air: Chicago's Neighborhood Parks of the Progressive Reform Era, 1900–1925. Chicago: Chicago Public Library Special Collections Department and Chicago Park District, 1989.

Bustard, Bruce I. *A New Deal for the Arts.* Seattle: National Archives and Records Association and University of Washington Press.

Chappell, Sally A. Kitt. *Architecture and Planning of Graham, Anderson, Probst and White, 1912–1936.* Chicago: University of Chicago Press, 1992.

Chicago and Suburbs, 1939. WPA Federal Writers' Project. Reprinted Chicago: Chicago Historical Bookworks, 1991.

Cockcroft, Eva, John Pitman Weber, and James Cockcroft. *Toward a People's Art: The Contemporary Mural Movement.* Albuquerque: University of New Mexico Press, 1977; reprinted 1998.

Friendly, Marie Louise Pinckney. "John Barton Payne, Patron of the Arts." M.A. thesis, University of Chicago, 1994.

Frueh, Erne R., and Florence Frueh. *The Second Presbyterian Church of Chicago: Art and Architecture.* 2d ed., ed. Ann Bretz. Chicago: Second Presbyterian Church, 1988.

Gude, Olivia, and Jeff Huebner. *Urban Art Chicago: A Guide to Community Murals, Mosaics, and Sculptures.* Chicago: Ivan R. Dee, 2000.

Harris, Neil, Wim de Wit, James Gilbert, and Robert W. Rydell. *Grand Illusions: Chicago's World's Fair of 1893.* Chicago: Chicago Historical Society, 1993.

Haskell, Barbara. *The American Century: Art and Culture, 1900–1950.* New York: Whitney Museum of American Art and W. W. Norton, 1999.

Jacobson, J. Z. *Art of Today: Chicago 1933.* Chicago: L. M. Stein, 1932.

Lloyd, Judith Thurston. "Healing Walls: Murals and Community, a Chicago History." Unpublished catalog, State of Illinois Art Gallery, Chicago, 1996.

Lowe, David. *Chicago Interiors: Views of a Splendid World.* Chicago: Contemporary Books, 1979.

Marling, Karal Ann. *Wall to Wall America: A Cultural History of Post Office Murals in the Great Depression.* Minneapolis: University of Minnesota Press, 1982.

Mavigliano, George J., and Richard A. Lawson. *The Federal Art Project in Illinois, 1935–1943.* Carbondale: Southern Illinois University Press, 1990.

Melosh, Barbara. *Engendering Culture: Manhood and Womanhood in New Deal Public Art and Theater.* Washington, D.C.: Smithsonian Institution Press, 1991.

Miller, Donald. *City of the Century: The Epic of Chicago and the Making of America.* New York: Simon and Schuster, 1996.

O'Connor, Francis V., ed. *Art for the Millions.* Boston: New York Graphic Society, 1973.

Pacyga, Dominic A. *Chicago, City of Neighborhoods: Histories and Tours.* Chicago: Loyola University Press, 1986.

Park, Marlene, and Gerald E. Markowitz. *Democratic Vistas: Post Offices and Public Art in the New Deal.* Philadelphia: Temple University Press, 1984.

———. *New Deal for Art: The Government Art Projects of the 1930s with Examples from New York City and State.* Hamilton, N.Y.: Gallery Association of New York State, 1977.

Prince, Sue Ann, ed. *The Old Guard and the Avant-Garde: Modernism in Chicago, 1910–1940.* Chicago: University of Chicago Press, 1990.

Saliga, Pauline. *The Sky's the Limit: A Century of Chicago Skyscrapers.* New York: Rizzoli, 1990.

Scheinman, Muriel. *A Guide to Art at the University of Illinois.* Urbana: University of Illinois Press, 1995.

Schulze, Franz, and Kevin Harrington, eds. *Chicago's Famous Buildings.* 4th ed. Chicago: University of Chicago Press, 1993.

Sinkevitch, Alice, ed. *AIA Guide to Chicago.* San Diego: Harcourt, Brace, 1993.

Smith, Clark Sommer. "Nine Years of Federally Sponsored Art in Chicago, 1933–1942." M.A. thesis, University of Chicago, 1965.

Sorell, Victor A., ed. *Guide to Chicago Murals: Yesterday and Today.* Introduction by Barbara Bernstein. 2d ed. Chicago: Chicago Council on Fine Arts, 1979.

——. *Images of Conscience: The Art of Bill Walker.* Chicago: Absolute Graphics, 1987.

Sparks, Esther. *A Biographical Dictionary of Painters and Sculptors in Illinois, 1808–1945.* Ann Arbor, Mich.: University Microfilms, 1974.

Taylor, William E., and Harriet G. Warkel. *A Shared Heritage: Art by Four African Americans, Burroughs, Coleman, Gaither, and Jennings.* Indianapolis: Indianapolis Museum of Art and Indiana University Press, 1996.

Terkel, Studs. *Chicago.* New York: Pantheon, 1986.

Yochim, Louise Dunn. *Harvest of Freedom: Jewish Artists in America, 1930–1980s.* Chicago: American References, 1989.

——. *Role and Impact: The Chicago Society of Artists.* Chicago: Chicago Society of Artists, 1979.

Zimmer, Jim L. *John Warner Norton.* Springfield: Illinois State Museums, 1993.

Index